D1252700

BOSTON
PUBLIC
LIBRARY

WITHDRAWN

No longer the property of the
Boston Public Library.
Sale of this material benefits the Library

Australian Art and Architecture
Essays presented to Bernard Smith

EDITED BY ANTHONY BRADLEY & TERRY SMITH

Melbourne OXFORD UNIVERSITY PRESS Oxford Wellington New York

OXFORD UNIVERSITY PRESS

Oxford London Glasgow
New York Toronto Melbourne Wellington
Kuala Lumpur Singapore Hong Kong Tokyo
Delhi Bombay Calcutta Madras Karachi
Nairobi Dar es Salaam Cape Town

This book is copyright. Apart from any fair
dealing for the purposes of private study,
research, criticism or review, as permitted under
the Copyright Act, no part may be reproduced
by any process without written permission.
Inquiries should be made to the publishers.

© Anthony Bradley and Terry Smith 1980
First published 1980

National Library of Australia
Cataloguing-in-Publication Data:

Australian art and architecture

Index
Bibliography
ISBN 0 19 550588 3

1. Art — Australia — Addresses, essays, lectures.
2. Architecture — Australia — Addresses, essays,
lectures. I. Bradley, Anthony, joint ed. II. Smith,
Terry. III. Smith, Bernard William, 1916-

709'.94

This publication has been assisted by
the Visual Arts Board of the Australia Council

Designed by Alison Forbes
V-I-P Computerset by Meredith Trade Lino
Printed by Brown Prior Anderson Pty Ltd
Published by Oxford University Press, 7 Bowen Crescent, Melbourne

CONTENTS

FOREWORD

his volume was conceived in an attempt to fulfil two related needs: to make publicly available some of the recent research into the history of Australian art and architecture, and to pay tribute to the key role of Bernard Smith in laying the foundations for this research. Both editors were colleagues of Bernard Smith at the Power Institute of Fine Arts at the University of Sydney and, on his retirement in 1977, independently conceived the idea of a volume such as this. We soon joined forces and agreed on the present framework: a collection of essays on Australian art and architecture, written by former students and colleagues of Bernard Smith and by those who considered themselves indebted to his work and example. Contact was made with everybody known to the editors who might fall into these categories, and all responded warmly to the invitation to write essays specifically for this volume. Many people, however, were not able to contribute due to circumstances beyond their control. It is evidence of the catholicity of Bernard Smith's teaching that it would be quite possible to produce another volume consisting of essays by former students and colleagues specializing in the art and architecture of countries *other* than Australia.

Scholarly research into the history of Australian art and architecture has grown very slowly—much of it, indeed, was done single-handedly by Bernard Smith, as the bibliography by one of the editors, which concludes this volume, attests. *Place, Taste and Tradition* (1945), written at a time when its author perceived democratic civilization to be threatened by fascism, was the first attempt to see the historical development of Australian art in relation to the European culture from which it had sprung, and to which it often returned. This approach was systematically pursued in his *Australian Painting 1788-1960* (1962; 2nd edn, 1788-1970, 1971), which remains the standard text in the field. In between writing these two books, Bernard Smith published *European Vision and the South Pacific* (1960), a classic study of the ways in which the early white visitors to and settlers of Australia saw an alien environment. He has also provided the first *Documents on Art and Taste in Australia* (1975), and charted his own intellectual development in a collection of essays, *The Antipodean Manifesto* (1976), named after one of his notable interventions into the development of Australian art. All studies of Australian art take these works as their foundation. We are indebted to him not only for bringing order to a field which lacked guiding principles of organization but for the exacting standards which he set.

The editors see this volume as complementing the work of Bernard Smith and other authors who have published histories, monographs, catalogues and notes on Australian art and architecture. The essays are arranged in approximately chronological order, and we have invited contributors to concentrate on aspects of the subject hitherto relatively unexplored, or to attempt new interpretations of known works. We particularly welcome the opportunity to present essays in nineteenth-century Australian architecture and on photography. In 1978 two volumes of studies in Australian art and architecture were published, *Studies in Australian Art*, edited by Ann Galbally and Margaret Plant, and *Readings in Australian Art*, edited by Peter Quartermaine; and the Art Association of

Australia launched a journal, the *Australian Journal of Art*. It is our hope that this volume might join with these and others, alongside Bernard Smith's pathfinding work, to provide the basis for a growth in the study of Australian art and architecture at schools, universities and colleges in this country and abroad. There can be few amongst us who could deny that the subject is worthy of such attention, or resist the claim that the study of our art and architecture is essential to our development as a nation.

We would like to thank the following institutions for allowing the reproduction of works in their possession: Archives Office of New South Wales, Sydney; Art Gallery of New South Wales, Sydney; Australian National Gallery, Canberra; Ballarat Art Gallery; Dixson Galleries, Sydney; Government Printing Office, Sydney; Mitchell Library, Sydney; National Gallery of Victoria, Melbourne; National Library of Australia, Canberra; National Trust, Canberra; State Library of Victoria, Melbourne; University of Melbourne (Russell Grimwade Bequest). We would also like to thank those many individuals who have allowed reproduction of works in their private collections or have assisted us in other ways.

The editors are grateful to Oxford University Press for extending their long association with Bernard Smith to include this volume, and to the Visual Arts Board of the Australia Council for so generously supporting its publication. We wish to thank Mrs Norma Brownlee, who typed many of the manuscripts, and our colleagues at the Power Institute of Fine Arts for their advice and encouragement. We present these essays to Bernard Smith on behalf of all of the contributors, and with the best wishes of those who were unable to contribute.

<div align="right">

Anthony Bradley
Terry Smith
March 1979

</div>

RÜDIGER JOPPIEN Sir Oswald Walters Brierly's
*First Arrival of White Men amongst the Islands of
the Louisiade Archipelago:* A Nineteenth-Century
Painting of New Guinea and Related Sketches

Among the numerous important works of art in the National Library of Australia, most of which relate to Australasia, is a picture by Sir Oswald Walters Brierly (1817-94) representing H.M.S. *Rattlesnake* in the Louisiade Archipelago (1). It is executed in watercolour and gouache on vellum and measures 61 x 107.5 cm. An old label on the back, perhaps in Brierly's hand, reads:

No. 1 First arrival of white men amongst the islands of the Louisiade Archipelago, S.E. C.° New Guinea. A 'Mydallaga' or chief charm man warning off the 'Markian Gool' — Ghost Ship. Little was known of these islands until visited by Captain Owen Stanley — who — in H.M.S. Rattlesnake (the Vessel shown in the drawing) found a passage thro the dangerous Reefs which surround them and laid down their position accurately for the first time. The natives had no iron, and apparently had not communicated with white men up to the time of our visit. All the detail of their dress, canoes, &c are from Sketches made on the spot. O. W. Brierly, 8, Lidington Place, Oakley Square.

A second label states ' "H.M.S. Rattlesnake" Captain Dayman. Left by Mr. Dayman of Oxford to Sir G. Dashwood'.

The first of the two inscriptions is the same as the title of a picture shown by Brierly at the Royal Academy in 1860[1], and there can be no doubt that both pictures are identical. The painting is unusually large for its execution in watercolour. Though it shows signs of having once been touched up, its colours have retained their freshness, which renders the scene appropriate to the climate in which it is set. The general tone is of whitish sand colour to which hues of faint blue, turquoise, purple and silvery green have been added. A very fine cloudy haze covers the whole scene, giving the impression of a hot, sultry day.

The evenness of the colouristic treatment is in contrast to the inner tension of the scene. The picture is dominated by the frigate *Rattlesnake* in the back, steering diagonally towards a cluster of native canoes on the left, which appear to be blocking her course. An element of defiance is introduced by the figures in the boat at centre left, which are warning off the ship with animated gestures. On the canoe on the outer left, natives are seen lined up with spears in their hands. Some other canoes are approaching from the deep back, while another craft is launched from the shore. In the foreground the feeling of excitement is echoed in the figure of a native youth sitting on the front raft and holding his spear ready to strike. Behind him there are three women expressing wonder and excitement at the sight of the white ship. Showing no fear but a relaxed and composed disposition is an older man at the stern of the raft. His calmness stands in marked contrast to the rest of the natives in the picture, who display agitation and a keenness to fight.

The ambiguity of the action and of the human responses involved is fittingly expressed in the viewpoint from which the scene is represented. The action is represented from the natives' point of view, looking towards the approaching ship. Their conception as figures

to be seen from the back, and the zig-zag structure of the composition, create an illusion of depth. In this way the various centres of action are separated, and the natives and their canoes are shown in a sufficiently individual manner so as to reflect their emotions and to give an idea of their particular ethnic character.

The message which the picture conveys is evidently one of an historical encounter between two races, two cultures and two technologies. In this Brierly took up a theme which had been known in European art for some time but which, somewhat surprisingly for an age actively involved in exploration and travel, had not played a very prominent part. Travelling artists of the eighteenth century, in particular those who had accompanied Captain Cook on his voyages to the Pacific, had illustrated the moment of physical contact between the European explorers and the South Sea Islanders. But only few of their works had gone beyond documentary evidence and attained the stature of pictures in their own right which could be publicly exhibited. William Hodges' oil paintings of the landings of Cook and his party in the face of hostile and friendly crowds of natives are the closest parallels to Brierly's picture.[2] They have a similar sense of drama and give full characterization to the gestures of the natives. Their polarization into opposing parties, however, falls short of the ambiguity of the action and the inner tension which Brierly's picture possesses. While Hodges' pictures appear to have been painted on the spot, Brierly composed his ten years after his return from New Guinea, using earlier sketches, such as one of the *Rattlesnake* in New Guinean waters (2), and by working out figurative and compositional studies. We do not know what actually led to the creation of the picture, whether it was painted solely for showing at the Royal Academy or whether it was commissioned. Its ambitious execution makes it stand out from Brierly's *oeuvre*. Its creation is remarkable not only as Brierly's only painting from his voyage in the *Rattlesnake,* but as an artist's belated vision of his exposure to meeting coloured indigenous people and experiencing their environment and culture.

II

Oswald Walters Brierly was a highly regarded marine painter during the nineteenth century.[3] Born in Chester in 1817, he studied ships and shipping from an early age and exhibited drawings of men-of-war at the Royal Academy as early as 1839. In 1841 he accompanied the merchant adventurer, Benjamin Boyd, to Australia in his yacht *Wanderer,* and stayed in Australia for the next eight years. For most of his time there he acted as manager of Twofold Bay in New South Wales, a town and whaling station founded by Boyd. In 1848, at Twofold Bay, Brierly met Captain Owen Stanley, and on the invitation of the latter joined the expedition of H.M.S. *Rattlesnake* on its surveying cruise to Cape York, the southern coast of New Guinea and the Louisiade Archipelago.

The expedition left Sydney on 29 April 1848. After it had assisted in Edmund Kennedy's landing at Rockingham Bay, in May 1848, the *Rattlesnake* and its tender, the *Bramble,* proceeded northward to Torres Strait, criss-crossing the Inner Passage for the next four months. Stanley reached Cape York on 7 October and on 2 November left for Port Essington. There he stayed between 9 and 17 November, and was back in Sydney on 24 January 1849. After three months of refitting, both ships set out north again. They were at Moreton Bay on 25 May 1849, and on 10 June they reached the Louisiade Archipelago. Rossel Island, the outermost island in the south-east, was circumnavigated and surveyed on 13 June. For the next two months the ships stayed within the Archipelago, charting and surveying, before Brumer Island (also called Bruinie Island by some members of the expedition), the last of the Archipelago, was reached on 17 August.

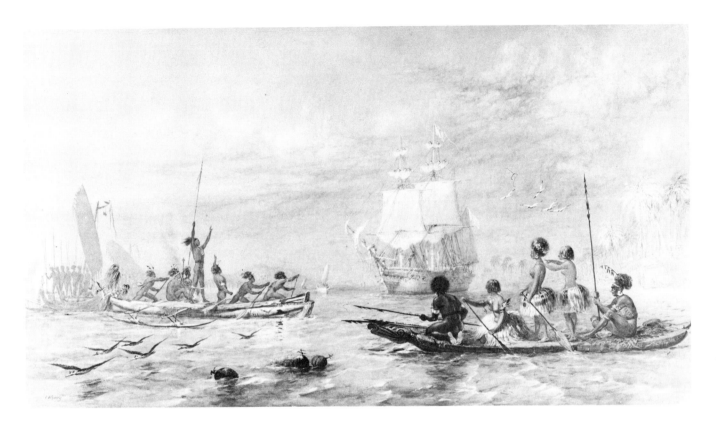

1 Oswald Walters Brierly, *First Arrival of White Men amongst the Islands of the Louisiade Archipelago*, watercolour and gouache on vellum, 61 x 107.5 cm. National Library of Australia, Canberra

From there the ships followed the southern coastline of the New Guinea mainland. In early September they arrived at Dufaure Island and Orangerie Bay. After continuing along the coast up to Cape Possession, lying further to the East (the point up to which Captain Blackwood of the *Fly* had previously charted the coast), Evans Bay at Cape York Peninsula was reached on 1 October 1849. The ships left again on 3 December, and after some more surveying along the New Guinea and Louisiade coast they returned to Sydney. Within a fortnight of their arrival the commander, Captain Stanley, died on 13 March 1850.

The voyage of the *Rattlesnake* was subsequently described by John MacGillivray in his *Narrative of the Voyage of H.M.S. Rattlesnake*, published in two volumes in London in 1852.[4] The illustrations were provided not by Brierly but by the young Thomas Henry Huxley, who had acted as assistant naturalist and amateur draftsman. Huxley's private diary, together with some of his drawings, was edited and published posthumously in 1935.[5] Huxley referred to Brierly several times, and there is no doubt that Brierly was a valuable supporter and perhaps the instigator of Huxley's artistic ambitions. MacGillivray mentioned Brierly only once, calling him 'A talented marine artist who accompanied us upon this and the preceding cruize as Captain Stanley's guest'.[6] Stanley himself had a lively interest in drawing and watercolour painting and for this reason had asked for Brierly's company. It thus seems that when Brierly joined the *Rattlesnake* he did so without an official commission, inspired by artistic curiosity and a thirst for adventure.

A week after Stanley's death Brierly made the acquaintance of Captain (later Admiral) Henry Keppel and, at the invitation of that commander, he transferred to H.M.S. *Meander*, accompanying Keppel for the rest of his trip around the world. He was back in England in July 1851. When in 1853 Keppel published the narrative of his circumnavigation, Brierly provided illustrations for the work. In 1854 Brierly joined the Baltic Fleet in

the *Jean d'Acre* as war artist, to make drawings and paintings of the naval operations in the Crimean war. From there he sent sketches to the *Illustrated London News*. His marine work brought Brierly to the attention of the Royal family, and in the 1860s he undertook two major voyages in the company of the Duke of Edinburgh: in 1863 to Norway and in 1867-68 around the world in H.M.S. *Galatea.* The narrative of the latter voyage, written by the chaplain John Milner and published in 1869, was illustrated with Brierly's sketches, 'intended to preserve a record of the principal events connected with the visit of H.R.H. the Duke of Edinburgh to the Australian colonies and his reception there . . .'[7] In 1868 Brierly undertook a journey to the Middle East in the company of the Prince of Wales, visiting Egypt, Constantinople and the Crimea.

Brierly's subsequent career is distinguished by even higher social honours. In 1874 he was made marine painter to Queen Victoria.[8] He became an associate of the Royal Watercolour Society in 1872 and was made a member in 1880. He regularly contributed to the Society's exhibitions, but showed only a few works at the Royal Academy. Brierly was also a fellow of the Royal Geographical Society. In 1881 he became curator of the Painted Hall at Greenwich and in 1885 he was knighted. He held a large exhibition of his work in London in 1887 and died in 1894.[9]

Nowadays Brierly is only rarely mentioned among Victorian artists and to my knowledge there has been no attempt to gather the body of his works. Of the several paintings of marine history past and present which Brierly exhibited at the Royal Academy and elsewhere, most are at present untraceable.[10] English collections which preserve his works are the Royal Collections at Windsor and the National Maritime Museum at Greenwich.[11] He is more extensively represented in Australia, at the Mitchell Library, the Dixson Galleries, the National Library of Australia, the Art Gallery of New South Wales and at the Melbourne Club.[12] Most of these works are drawings and watercolours, covering the years which Brierly spent in Australia (1842-50). It is partly owing to Australia's interest in early draftsmen as part of her cultural and historical heritage that Brierly's artistic output from his Australian years is more extensively preserved than that of any other period of his life. This allows for a unique opportunity to study Brierly's style and method of working.

III

The most complete and perhaps important group of drawings is that which Brierly did on the *Rattlesnake,* now mostly preserved in the Mitchell Library in Sydney.[13] Most of them are quick sketches. In their feeling for the distribution of objects on paper and in their concern for engineering detail—in the way that they are loosely yet in an orderly way jotted on the sheet—they give a surprisingly modern impression. Brierly's artistic curiosity about objects is that of a craftsman wishing to find out what their materials or their colour were, how they worked and to what geographical location they belonged. Many of them are located and dated to the hour. Added to them are keys of references, long inscriptions, numbers and annotations, occasionally in native idiom. An illuminating example of Brierly's method of drawing would be his sheet, 'Inside Fittings, Canoes, Louisiade Archipelago', which combines very detailed technical drawings with elaborate descriptions of the material used and of the construction of the canoes.[14] Visual and verbal means become part of the exploring process, in which the artist acts as a quasi-ethnographical field-worker and data collector. Many of Brierly's drawings have an unfinished, sketchy quality, which in the eyes of a modern spectator appears as a conscious *maniera* of expression.

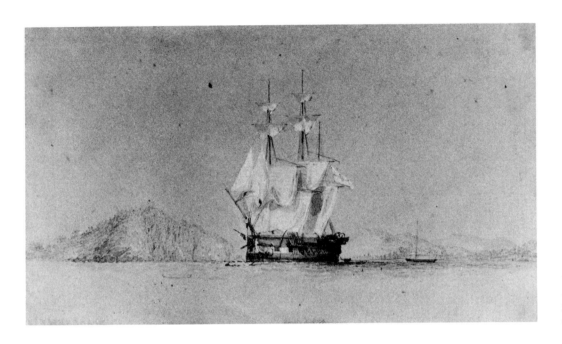

2 Oswald Walters Brierly,
'H.M.S. Rattlesnake', pencil
and chalk body colour, 12.3
x 20.7 cm. National Library
of Australia, Canberra

Most of Brierly's sketches from the voyage of the *Rattlesnake* are in pencil, on coloured carton paper. A special technique employed is the smudging of pencil lines, by which soft and diffuse tones of light and darkness are achieved; this is particularly applicable to his landscape drawings. Pencil work is predominant in Brierly's sketches, occasionally touched up by watercolour, white chalk or lead white, mostly for purposes of contrast or as an indication of light. Rather typical of the nineteenth-century technique of drawing, and fully exploited by Brierly, is the predilection for leaving the objects isolated on their whitish ground and using the paper as an additional aesthetic factor.

IV

Artistically, Brierly was the dominant figure on board the *Rattlesnake* between April 1848 and December 1849, and would surely have inspired the two amateur draftsmen, Huxley and Stanley. Seen as a whole, their drawings, now in the Mitchell Library, form a most complete visual record of the voyage and make a valuable addition to MacGillivray's *Narrative*.[15] Among them there are coastal profiles of mountain ranges, bays and islands, studies of waves and clouds, drawings of natives' huts and artefacts, and above all of different boats. Because only a few landings on firm ground were effected during the voyage along the Louisiade Archipelago and the New Guinea Coast, drawings of topographical content and of natives in their canoes approaching the ships are particularly numerous. When placed side by side the drawings of all three artists suggest a good deal of mutual influence, with regard to style as well as to subject matter. In some cases they sketched the same objects, in others they appear to have copied from each other. Stanley's watercolour drawing of a brook with mangrove trees seems strikingly similar to a study by Brierly.[16] Closer examination is needed before their works can be distinguished in every instance. The watercolour of the *Rattlesnake* being approached by a native canoe is preserved in a volume of drawings all attributed to Stanley, and the style of his works would support that judgement; however it is signed 'Oswald W. Brierly' and shows a composition which would well fit into Brierly's general work.[17] It is equally difficult to decide whether the watercolour of 'Mt. Ernest Island, Torres Straits', which is again

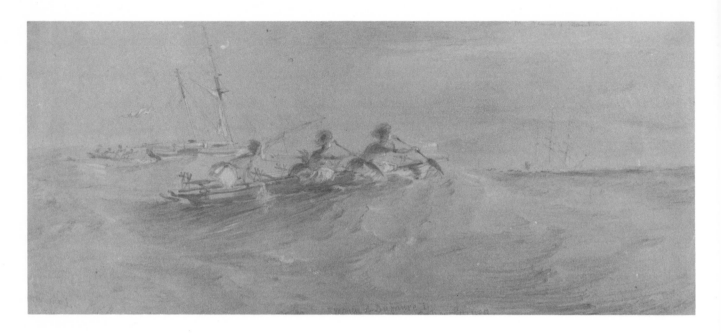

3 Oswald Walters Brierly, 'Women of Dufaure Island, Co. New Guinea', pencil and watercolour, 15.5 x 35 cm. Dixson Galleries, Sydney, DG D19, f.18

preserved in Stanley's volume, is by Stanley or by Huxley. One would have no doubt in attributing it to Stanley, were it not recorded in MacGillivray's *Narrative* as being by Huxley.[18]

More to the point of the present argument is the artistic relationship existing between Brierly and Huxley. It appears for example in Brierly's drawing of 'Women of Dufaure Island' of 9 September 1849 [19] (3), which shows a dug-out outrigger canoe in a choppy sea manned by three women paddling towards the *Rattlesnake* at a distance. The drawing catches a moment when the women are vigorously paddling over a wave that has just seized their boat. The forward leaning position of their bodies and the rough sea mutually enforce the impression of speed and turbulence. A drawing of similar quality is Brierly's 'Catamaran off Bruinie Island' of 21 August 1849, which in its upper left corner shows a native paddling a raft. A similar type of vessel is depicted in the other studies on the same sheet. This can again be observed in Huxley's pencil drawing of natives on a raft, paddling towards the *Rattlesnake*, seen from the rear (4). Huxley's style of drawing is neat and full of ethnographical information with regard to the physical and ornamentational appearance of the natives. It can be expected that Brierly and Huxley were well informed about each other's work, that they not only sketched together side by side but discussed aspects such as composition and expression.[20] Huxley's compositional device of the raft shooting diagonally across his drawing, speeding towards the ship, is a feature observed in Brierly's work. In fact the subject and composition had been exactly prefigured in one of Brierly's sketches (5).[21] Differences in the movements of the arms and in the hairstyle of the natives suggest that Brierly's sketch was done before Huxley's drawing, rather than the other way round. It may have served as a *concetto* and thus as a basis of discussing their work.

These drawings are an indication of the close artistic and scientific co-operation on board the ship, with all the participants keenly interested in ethnology and the natural sciences. Huxley's collection of artefacts contained various kinds of arms, shell necklaces, combs, nose sticks and other ornamental items that could be bartered. MacGillivray collected information on a comparative vocabulary. Proceeding from east to west from Rossel Island to Cape York, their attention was permanently attracted by material differences between the natives and particularly between the varying types of vessels. Both

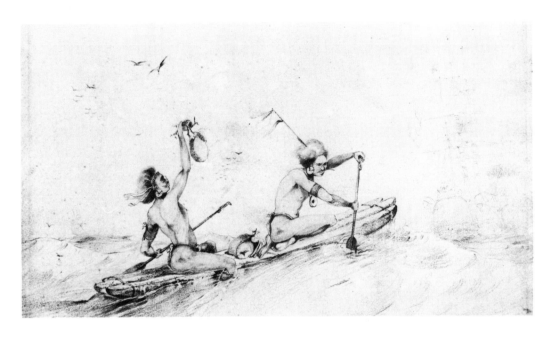

4 Thomas Henry Huxley, 'Native cattamaran, Co. New Guinea 1849', pencil, 26 x 32.4 cm. Mitchell Library, Sydney, PXD 74, f.63

Huxley and MacGillivray wrote extensively about the natives and gave long descriptions of their canoes.

Like his fellow-voyagers Brierly paid great attention to canoes, certainly because as a marine artist he was able to appreciate them both for their visual quality as well as for their construction and nautical prowess. Surviving among his drawings are studies of different types of boats, extending from the Eastern Louisiades to Torres Strait. Distinguished from each other by construction, ornamentation and function, they required close examination as typical objects of the human cultures which existed along the coast of Papua New Guinea and Australia's Northern Territory. In his painting of the *First arrival of white men* the most common types of these canoes were joined together. They are based upon 'sketches made on the spot', as was expressly stated in the Royal Academy catalogue of

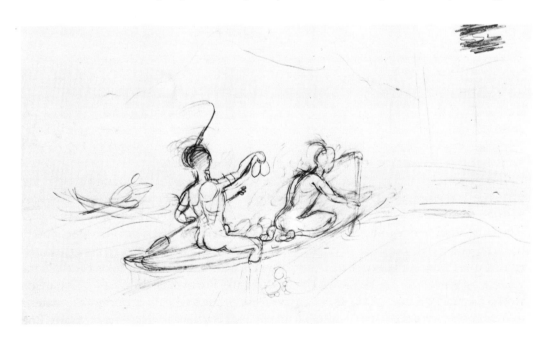

5 Oswald Walters Brierly, 'Study of men paddling canoe', pencil, 27.2 x 30.8 cm. Mitchell Library, Sydney, PXD 74, f.63

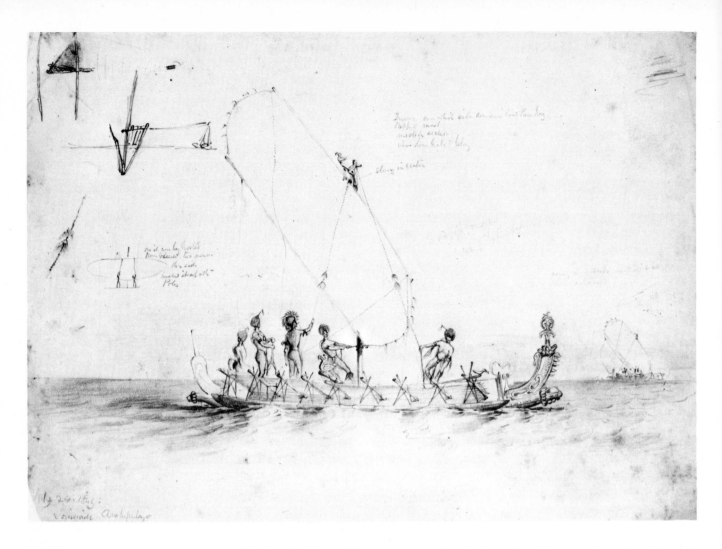

6 Oswald Walters Brierly, 'Boat of the Louisiade Archipelago', pencil, 26.1 x 35.2 cm. Mitchell Library, Sydney, PXD 74, f.53

1860, and it is indeed possible to compare the final work with a number of studies still extant.

V

At almost every island that the ships passed they were met with and surrounded by canoes. The reactions of the natives were not always friendly and inviting. A passage in MacGillivray's *Narrative* on the natives of Coral Haven in the Louisiades comes nearest to the subject of Brierly's painting; in fact it may have given some inspiration to the artist:

June 18th. Five canoes came off this morning with seven or eight natives in each, but apparently not with the intention of bartering, although they remained for a short time near the *Bramble* . . . After a while they crossed to the ship, and from a respectful distance—as if afraid to come closer—used many violent gesticulations, talking vehemently all the while, and repeatedly pointed to the break in the reef by which we had entered Coral Haven, waving us off at the same time. Our red friend from Pig Island made himself as conspicuous as on former occasions and none shouted more loudly or wished to attract more attention to himself. Unfortunately his eloquence was quite thrown away upon us, nor had his threatening gestures the desired effect of inducing us to leave the place and proceed to sea.[22]

If the huts seen on shore in Brierly's picture, which could be described as 'long and tunnel-like, drooping and overhanging at each end, raised from the ground upon posts and thatched over'[23], are any indication of the scene, then this appears to be some island in the Louisiades. The different types of boats, however, which represent some geographically distinct examples, render the action slightly fictitious and give the picture a certain amount of artistic licence, surely justified.

The boats which are geographically most appropriate to the place of the action are the *wagas* on the far left, the most characteristic boats of the Southern Massim region.[24] They

are large, sea-faring boats, suitable for long distance trade voyages, and recognizable from their single oval sails of pandanus leaf and from their elaborately carved and decorated figure heads and sterns. Their ingenious construction and the manner in which the sails were attached drew profuse comment[25], and Brierly made several drawings of them during June and July 1849. The one reproduced here (6) was done on 24 July 1849 during the expedition's stay at the Duchâteau Islands.[26]

In a more prominent place in Brierly's picture is the canoe in the middle left, populated by about six dark-skinned natives, most of them paddling. Amongst them, distinguished by his height, standing on a raised platform and holding a spear in his right arm, is what appears to be their chief. With his arms upraised, he makes signals to the approaching ship, warning it against coming nearer. No doubt this figure is the chief 'charm man', to which the title of the picture refers. The scene recalls another of Brierly's compositions, 'H.M.S. Rattlesnake in Evans Bay, Cape York 1849', a watercolour drawing of extensive length, showing in its half right section the *Rattlesnake* anchoring, while from the front she is approached by a similar canoe and natives with quite similar gestures.[27] It is quite possible that the scene, now central in Brierly's picture in the National Library of Australia, was originally witnessed in Evans Bay. The un-English words of *Markian Gool*, meaning 'white, ghost-like canoe' when translated from the Kowrarega language, in fact

7 Oswald Walters Brierly, 'Two studies of a canoe of Prince of Wales's Island', pencil and watercolour, heightened white, 25.8 x 35.5 cm. Mitchell Library, Sydney, PX+D 81, f.64

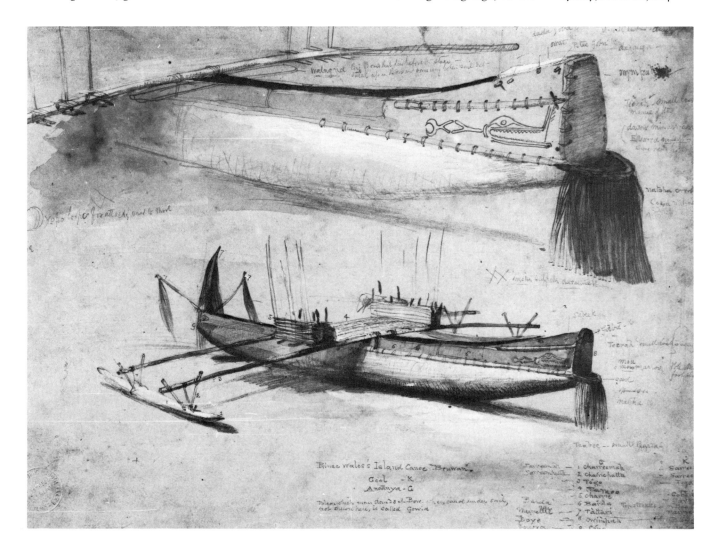

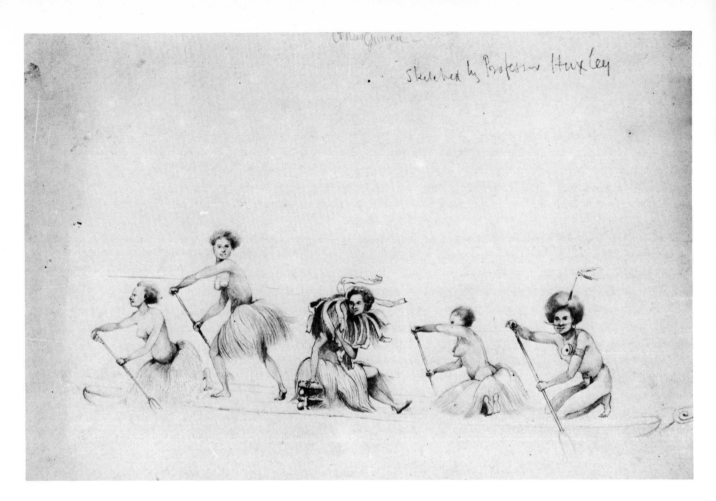

sketched by Professor Huxley

8 Thomas Henry Huxley, 'Women of Dufaure Island, Co. New Guinea', pencil, 27.7 x 36.6 cm. Mitchell Library, Sydney, SV+NG—E/3

originate from the Torres Strait area.[28] A number of stays there had allowed Brierly to make some detailed studies of natives' canoes. They were mainly characterized by a hollowed-out log, a central platform and a double outrigger of two poles and smallish floats; their hulls were heightened by a gunwhale board, which on its foremost part was decorated by totemistic designs; bow and stern were vertically shaped by a flat-endboard and decorated with tufts of grass probably of magical significance.[29] Brierly's double study of the canoe 'Bruwan' of Prince of Wales Island[30], drawn in October-November 1849, shows all these points with fine precision (7). It bears annotations of the various parts of the boat in the natives' tongue, with the word *gool* referring to 'K', the Kowrarega language. This canoe was the prototype for the one introduced into Brierly's painting. A more accomplished version of it is signed and dated 'O. W. Brierly 1850'.[31] Its more elaborate execution makes it stand apart from Brierly's other works produced on the *Rattlesnake*, but the fact that it is still contained in a volume of drawings mainly by Captain Owen Stanley suggests that it was made as a presentation drawing to Stanley.

The third boat of importance in Brierly's picture is the raft in the foreground, populated by two men and three women. It is formed of three thick planks lashed together, with the middle part projecting and carved in the shape of a crocodile's head.[32] It was observed near Brumer Island and also appears in some other sketches (4-5). A further drawing of the raft is represented in Huxley's drawing of 'Women of Dufaure Island, Co. New Guinea' of early September 1849 (8), showing a man and four women in different positions of paddling. The motif of a woman paddling is introduced into Brierly's picture, and there is a certain resemblance between the two women who in each example occupy the place farthest to the left. Three of the women in Huxley's drawing are naked to the waist, but wear petticoats of some grassy material reaching to the knees; the woman in the centre wears an additional cape of shredded leaves, perhaps of pandanus.[33] Two kneel in the same manner as the male, indicating their position by the upright soles of their feet. They hold their paddles uniformly, with one hand on the shaft and the other on the knob

at the end. A drawing by Brierly which would equally show these characteristics does not exist, and it is just possible that Brierly got to know Huxley's drawing either during the voyage or several years later when they were both back in England. The latter could be assumed by Brierly's special interest in the women figures in the preparation of his picture.

The Mitchell Library holds several figure drawings by Brierly which deal with the group on the raft and its members. They are figurative and compositional studies. Somewhat surprisingly perhaps, they were drawn in Europe from European models and later, during the process of composing the picture, reinvested with native life. Of the paddling woman we have three different studies in successive stages of development and elaboration (9 and 10 are two of these). The figure in the first is fully naked except for a small loincloth. Her hair is done according to the Victorian fashion of the time, combed straight back and rolled into a knot at the back. She is sitting in profile holding the paddle already in the characteristic manner. Her legs are elegantly crossed but neither comfortable nor fitted for paddling, making it impossible to strike the paddle vigorously. In the second study (10) the model is already seen in quite the same way as in the final picture, with her face and body turning away from the spectator. A petticoat which looks as though it is made of grass covers the lower part of her body, making her resemble a ballet-dancer—an impression which was often gained when the women of New Guinea were first encountered.[34] The third drawing, executed in pencil and watercolour, repre-

9 Oswald Walters Brierly, 'Study of a female nude paddling', pencil, 25.5 x 17.5 cm. Mitchell Library, Sydney, PXD 74, f.59

10 Oswald Walters Brierly, 'Study of a half-dressed woman paddling', pencil, 25.5 x 17.5 cm. Mitchell Library, Sydney, PXD 74, f.60

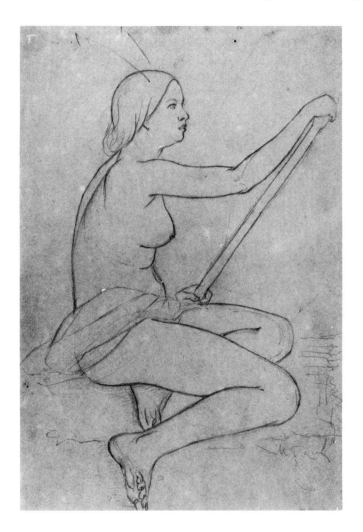

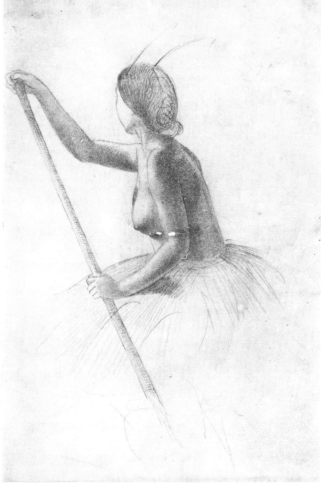

sents a modifed version of the former, giving a more complete idea of the figure by placing her on the ground. Again, her body from the waist down is covered by a petticoat, which in this instance is made of broad stripes, probably meant to simulate pandanus leaves. In fabrication it seems similar to the cape worn by the woman in the centre in Huxley's drawing (8). The larger volume of the petticoat gives it a dome-like, grander and more dignified shape than the grass or straw type. It is very much in this guise that the woman was eventually introduced into the final picture.

In another of his figure studies Brierly has given expression to the position of the two native girls standing behind each other on the raft. They have stopped paddling and are now holding their paddles loosely in their hands. Beside them on the same sheet there are studies of their hands and their feet, suggesting that they were taken from studio models. The contrapposto position of their legs, as well as the gesture of friendship and support of the second girl putting her arm onto the shoulder of the girl in front, stand within a European tradition of the visual arts. Brierly began to draw from the naked bodies, as the transparent petticoat of the second girl indicates; however the contours of the figures are already defined and anticipate the appearance of the girls in the final picture.

In another study in pencil, unfortunately cut off to the left, the whole group on the raft is fully conceived (12). There are still some modifications made in the figures, such as the sitting girl with the paddle, or the second girl standing up with her right arm partly concealed by her rumpled petticoat, but the composition is in all major points defined. At

11 Oswald Walters Brierly, 'Study of standing female figures' pencil and watercolour, 17.7 x 25.5 cm. Mitchell Library, Sydney, PXD 74, f.62

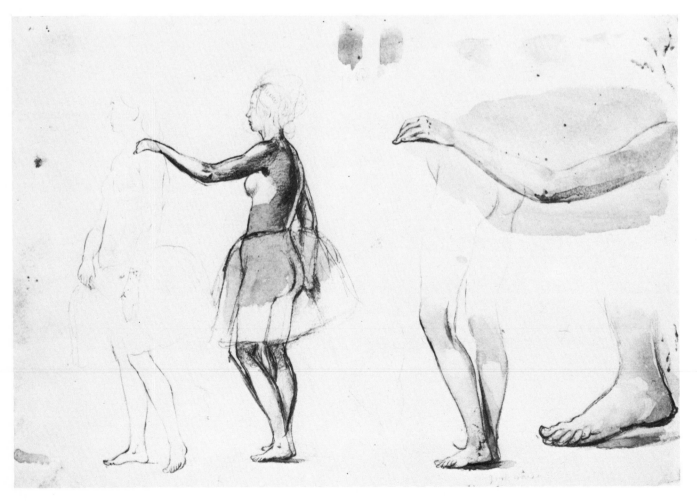

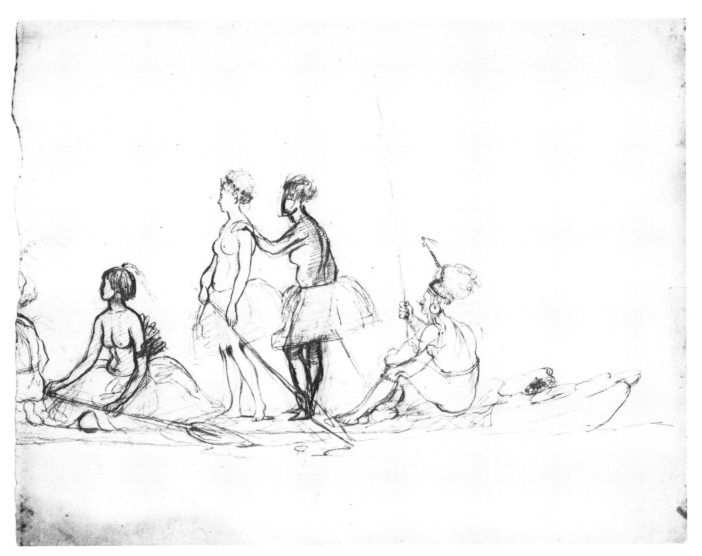

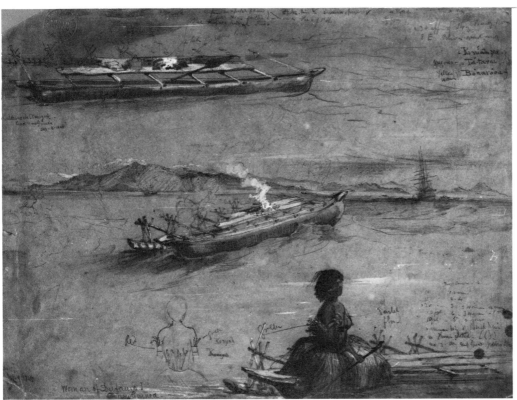

12 Oswald Walters Brierly, 'Study of natives on a raft', pencil, 31.5 x 41 cm. Mitchell Library, Sydney, PXD 74, f.66

13 Oswald Walters Brierly, 'A woman of Dufaure Island in her canoe', pencil and watercolour, heightened white, 25.7 x 35.5 cm. Mitchell Library, Sydney, PX+D82, f.20

this stage the figures are invested with ethnographical features; thus the left arm of the sitting girl is banded with a dark armlet, while her breast shows marks of tatooing; along the rear part of her waist she wears bunches of leaves which, according to information provided by MacGillivray, were customary to the inhabitants of the Louisiade Islands and strongly odoriferous; her hair is decorated with a tuft of perhaps the same plant.[35] Brierly had closely studied such elements in his drawing of a 'Woman of Dufaure Island' (13) and noted their colours. The other two girls are largely lacking the sophistications of personal ornament; their adornment is limited to some flower bands worn over their woolly hair. A hairstyle similar to theirs can be observed on the man sitting on the raft: his hair is banded across the forehead and formed into a bulbous frizzy mop; it is also decorated by a comb projecting in front.[36] Further elements of his decor are a nose-stick, a shell ear-ring and a bracelet of human jaw bones, only slightly sketched in.[37] Brierly's drawing of a 'Woman of Dufaure Island' (13) and small figurative elements introduced into other studies attest to the artist's considerable interest in ethnographical documentation. It was with no less enthusiasm shared by his fellow-voyager Huxley, whose drawing of Louisiade New Guinea natives (14) gives a coherent and reliable visual record of male and female modes of dressing. Huxley emphasizes many of the features of bodily ornamentation, which for

14 Thomas Henry Huxley, 'Natives of the Louisiade Archipelago and of New Guinea', pencil, 26 x 32.4 cm. Mitchell Library, Sydney, SV+NG—E/1

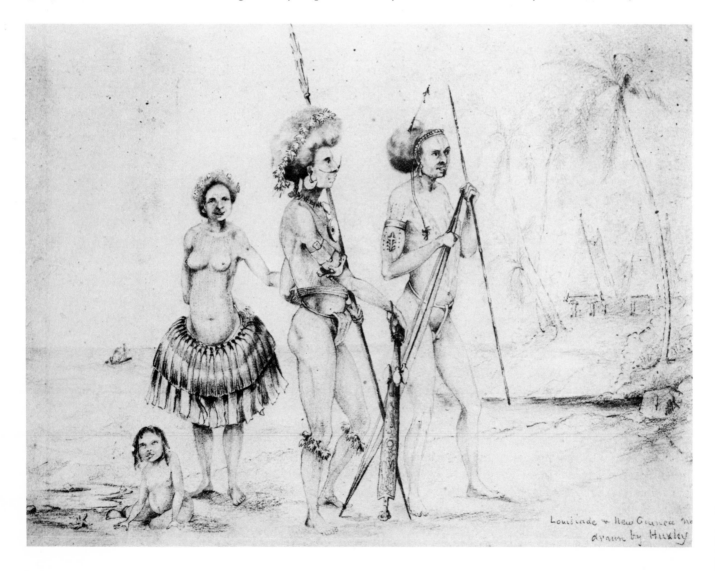

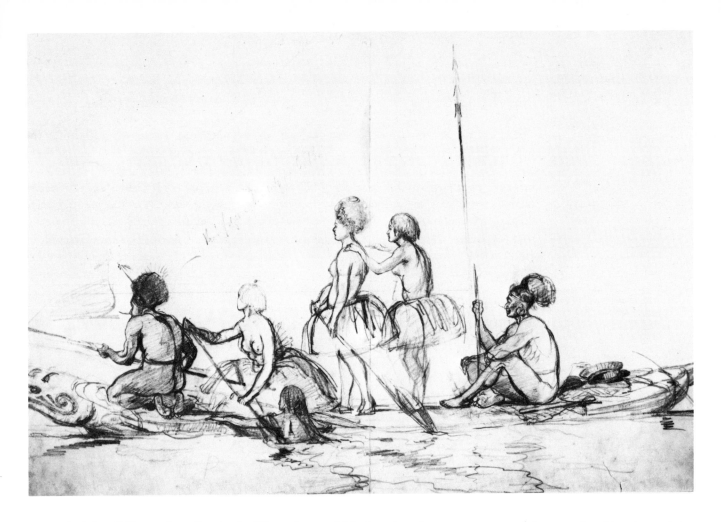

example, MacGillivray describes in the *Narrative*, and his drawing also serves as a useful counterfoil against which the appearance of the figures in Brierly's picture can be checked. In this context one may compare Huxley's two male natives with those in the boat at centre left in Brierly's picture. Though the boat had been identified as deriving from the Torres Strait area, the natives betray ethnographic characteristics of the Louisiade Archipelago and of South-East New Guinea. Of all the ornaments they wear it may suffice to refer to their bracelets, their waist-band, or most conspicuously to the large shell disc which the chief sorcerer wears on his breast.[38]

Of the figure group on the raft, two more compositional studies are preserved with the others. There is the improved version of the previous one, which gives a better idea of the whole length of the boat (15). It contains alterations and corrections, such as in the figure of the paddling girl, or in the position of the sitting native, who is now seen slightly more from the left, with his legs crossed and his back forming a firm and round contour. In the foreground in the water a naiad-like swimmer is introduced, but is dropped from the final version of the composition. A more definite characterization has been given to the second standing girl, who is now pointing towards the ship with her right arm, in which formerly (12) she held a paddle. The other is a tracing of the group on transparent paper.[39] The reason for the execution of the tracing is not quite clear, but it may have been made to show to someone to ask for approval and advice. The second compositional study (15) and the tracing are both annotated. Among the inscriptions which can be deciphered we read, for example, on the tracing, 'this drooped and a little larger', with reference to the head ornament of the boat; or 'to be a man' on the same sheet, written alongside the girl in the water. It is conceivable that during the process of composing the figure group Brierly asked another person for his opinion. One would like to think that this other person was Huxley, but unfortunately we do not know whether Brierly and Huxley kept up their relationship after their return to England.[40]

15 Oswald Walters Brierly, 'Study of natives on a raft', pencil, 38 x 55.7 cm. Mitchell Library, Sydney, PXD 74, f.64

Both of the last-mentioned compositional studies very much anticipate the final appearance of the natives on the raft. Together with the other studies they are the only ones extant which refer to the general composition of the picture. They are valuable in documenting a particular pictorial *motif* and in giving an idea of Brierly's developing concept of the scene. This is the more important, since the picture was not a straightforward documentary painting of a historical incident but an ideal reconstruction of apparently several incidents, and as such a synthesis of scenery and places seen about ten years before. As a primarily marine artist, Brierly was not accustomed to dealing with figures like the group of natives on the raft situated so prominently in the foreground. If the number of extant studies are any indication, then this particular group may have occupied him more than any other part of the picture. In terms of content and of ethnographic information it was the most significant. Involved in the conception of that scene was the transformation of some of the group members from white European studio-models to coloured Melanesian 'savages', by which Brierly worked out and mastered the arrangement of the figures and their characteristic appearance. Though in the final picture the women clearly represent inhabitants of New Guinea, there is a European feeling about them; though ethnographically truthfully depicted they do not look the same as those whom Brierly had drawn during the voyage. Brierly's problems in painting exotic subject-matter in 1860 were similar to those which Hodges had encountered about one hundred years before: to represent the South Seas faithfully and yet make his pictures compatible with European taste and understanding.

It was perhaps partly due to that unsolved problem that from the time of the return of Captain Cook's artists from the South Seas only a few artists had made the Pacific the subject of a history painting. Brierly's 'First Arrival of White Men' was one of the few.[41] In some respects it also was one of the most successful, as his description of the natives facing the approaching ship with signs of fear, determination, or cool indifference is sympathetic and leaves room for dignity and greatness on their part. Though the scene of the painting is fictitious in a narrow sense, it is truthful and commendable for its observation of detail. This the sketches from the voyage of the *Rattlesnake* have shown. Focusing on the picture and its various pockets of action, the preceding drawings remind us that in Oswald Walters Brierly we have one of the most conscientious and informative ethnographic draughtsman of the travelling age.

JOAN KERR Early and High Victorian:
The Gothic Revival architecture of Edmund
Thomas Blacket and John Horbury Hunt

Recent architectural historians have tended to denigrate Edmund Thomas Blacket (1817-83) for being an imitator, while the stylistic eclecticism of John Horbury Hunt (1838-1904) has been ignored and his work praised for its originality. Blacket has been labelled 'a self-taught architect unable to transcend an antiquarian outlook that handicapped his whole career'[1], while Hunt is praised for producing 'highly-individual buildings mostly ahead of their time'.[2] Blacket's Gothic designs, we are told, 'are assemblages of details culled from copy-books'[3], although nobody has yet stated what these copy-books were nor how Blacket put his details together. Hunt's wider and more inventive borrowings have been entirely overlooked, for to trace specific sources and influences on his architecture is somehow assumed to demean its quality.

Instead of judging nineteenth-century architects by modern standards of originality it would seem more just to examine them in the light of their own architectural context. Both Blacket and Hunt were typical products of their respective generations. By the time Hunt arrived in Australia in 1863 the Victorian Gothic Revival had considerably changed in its aims from the Early Victorian style Blacket had known in England before coming to Sydney in 1842. Blacket arrived with the ambition of creating replicas of medieval parish churches on Australian soil. Twenty-one years later Hunt was inspired by the High Victorian Gothic movement to create something more personal out of the language of the Middle Ages.

Blacket's major influences were the books and designs of the Pugins plus examples from the professional English building magazines that had recently begun to be published (*The Civil Engineer and Architect's Journal* in 1837 and *The Builder* in 1843). Hunt learned from books and trade journals too, but when he arrived in Australia their Gothic heroes were of a younger generation—George Edmund Street, William Burges, George Frederick Bodley and James Brooks. These were Hunt's sources of inspiration for his church designs, for despite his Canadian birth and Boston training Hunt claimed to be a 'Britisher'.[4] In any case England was still the major influence on church architecture in America. Like Blacket, Hunt looked to England for inspiration when designing Australian churches. Both architects were most dependent on English sources in their early works, before each established his own repertoire of motifs and personal architectural vocabulary.

According to Blacket's grand-daughter, 'the first church *designed* and built by E.T.B.'[5] (as opposed to the churches he drew up and built for Bishop Broughton between 1843 and 1845) was the little church of Holy Trinity at Berrima, built from 1846 to 1849. Horbury Hunt's first independent design was for the Anglican Cathedral at Newcastle, for a competition held in 1868. Although Newcastle was finally built to a much modified version of this competition entry, Hunt's original design was published in the *Building News* of 20 October 1871 and so preserved for us. The two designs perfectly exemplify

the Early Victorian imitator and the High Victorian eclectic, both architects being of virtually the same age and overseas experience when designing these maiden works.

Berrima church (1) was certainly a copy-book building, deriving almost completely from the medieval church of St Peter, Biddestone, Wiltshire, illustrated in a series of measured drawings published in volume 3 of the Pugins' *Examples of Gothic Architecture* (London, 1838-40) (2). In particular, the distinctive bell-cote (which Blacket used again on St Michael's, Flinders Street, Surry Hills in 1854, and on St Michael's, Wollongong, in 1858) is taken directly from the Pugins' measured drawing of the one at Biddestone. The window tracery for the side windows, the unusually long chancel, the north porch (slightly simplified by the omission of the base moulding and the side window), and the general elevation of nave and chancel of Berrima were also copied from Biddestone.

Berrima's nave was about twice the size of Biddestone's so Blacket added extra buttresses to the building; he also added a large Perpendicular Gothic window to the east and west ends of his church. These are simple three-light windows with extra mullions added in the tracery, very similar to one of the windows of South Wraxhall Manor, Wiltshire, depicted by the Pugins in an adjoining plate in *Examples*. Blacket also had the problem of the interior roof and chancel arch which were not given in Pugin's drawings, as well as the furnishings of the building. The roof was a standard hammer-beam, consistent in style with the church, and the chancel arch was completely simple with no mouldings. Every detail was consistent in style with the basic Biddestone design, for Blacket had profited from his year sketching medieval buildings in England to the extent of thoroughly knowing his Gothic styles and he never mixed motifs in the ignorant 'Commissioners' Gothic' manner of early nineteenth-century architects.

1 Edmund Blacket, Holy Trinity Church of England, Berrima, 1846-49, north-west elevation. National Trust, 1974

2 St Peter's, Biddestone, Wiltshire, plan and elevation. A.C. and A.W.N. Pugin, *Examples of Gothic Architecture*, vol. 3, plate (72), 1

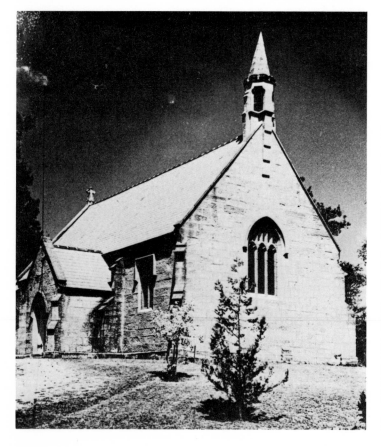

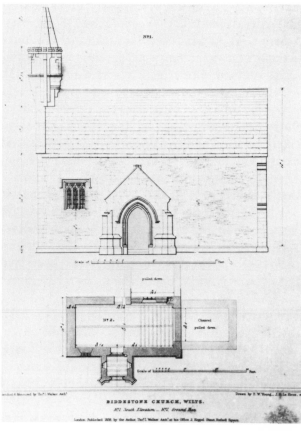

It must be stressed that Blacket's method of design did not make him a second-rate colonial 'copyist'. Welby Pugin himself used the Biddestone bell-cote on his church of Our Lady and St Wilfrid, Warwick Bridge, Cumberland, in 1840, and published his design in *The Present State of Ecclesiastical Architecture in England* in 1843. Archeological Gothic was the Early Victorian fashion. Even the most eminent architects would use details exactly copied from medieval buildings and proudly proclaim their sources if they happened to be attacked by *The Ecclesiologist* for undesirable originality. Any colonial architect had to avail himself of published medieval details and designs, as Phoebe Stanton has pointed out in her analysis of the similar situation in America.[6]

The Pugins intended their book as a source book. In volume 2 of *Examples* they state:

this selection has been made expressly with a view to practical utility. It would have been a more easy task to fill the work with examples of greater splendour, taken from cathedrals and other grand churches; but subjects of that description are very rarely wanted for imitation.

Welby Pugin particularly decried the desire for originality in his *Present State* — a book we know Blacket to have owned.[7]

In the present revival of Catholic architecture, the authorities for which can only be found in the ancient edifices of the country, it is very possible and even probable that two architects may erect precisely the same edifice; and this circumstance, *so far from being injurious to the reputation of either, is creditable to both*. We seek for *authority*, not *originality*, in these matters; for the establishment of a *principle*, not *individual celebrity*.

It is surprising that such a creed should have satisfied a whole decade of architects, who normally crave 'individual celebrity', although even Pugin anticipated that new applications of properly understood and accurately rendered medieval forms would lead to buildings for the nineteenth rather than the fourteenth or fifteenth centuries. A decade later a younger group of English architects started exploring medieval buildings from other countries and obscure locations, and relished the unusual and novel. It is with this group that Hunt's church architecture properly belongs.

Hunt's Newcastle design (3), like Blacket's Berrima, is clearly a young man's work in its dependence on current fashions. Hunt acknowledged when his design was published that it was an amalgam of details culled from A.J.B. Beresford Hope's book, *The English Cathedral of the Nineteenth Century* (London, John Murray, 1861), and this source is very obvious. The unusual stone cloister running around the entire church was a Byzantine notion, adapted for Gothic churches designed for a tropical or semi-tropical climate and first incorporated into English Gothic Revival architecture by R.C. Carpenter in his design for Colombo Cathedral of 1847. This had never been built, and Carpenter's design was not published until it appeared in Beresford Hope's book. However English architects had already adopted its features as the proper ecclesiological solution for a church in a hot climate. Street enclosed the nave of his Memorial Church at Constantinople with cloisters, and Joseph Clarke surrounded the north, south and west sides of his double walls for Pont de Galle, Ceylon, with an Early French version of a 'verandah'.[8] George Frederick Bodley's Mission Church for Delhi of 1861 had a rather narrow aisle around the whole church, completely isolated from the interior except at the west, which formed a narthex. *The Ecclesiologist* thought this was the 'best design for a tropical church which has come under our notice'.[9] Bodley's design, like Hunt's, also had an apsidal chancel.

William Burges' design for Brisbane Cathedral, as illustrated in the *Building News* of 26 December 1860, probably inspired Hunt's chevet with ambulatory, despite the fact that this drawing was actually a misreading of the architect's design. Clearly the engraving rather than the reality would have influenced Hunt, who added all these tropical sun-

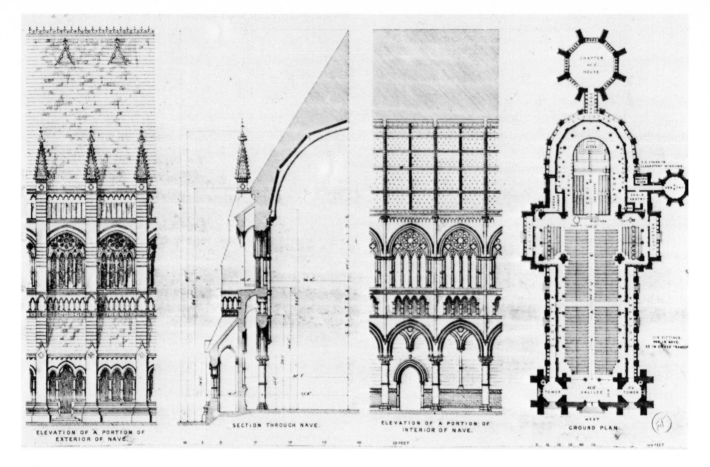

ELEVATION OF A PORTION OF
EXTERIOR OF NAVE.

SECTION THROUGH NAVE.

ELEVATION OF A PORTION OF
INTERIOR OF NAVE.

WEST
GROUND PLAN.

3 J. Horbury Hunt,
'Proposed Design for
Cathedral, Newcastle,
N.S.W.', 1868. *The Building
News*, 20 October 1871,
p.289

protective devices together and had both ambulatory and cloisters in his plan. He also had a small 'space for monuments' between his chevet columns and inner cloister wall. It would be difficult to have conceived a more heat-defensive—or 'speluncar'—wall arrangement; particularly as it was for the very moderate Newcastle climate.

Hunt took the idea of his octagonal chapter house from R.H. Carpenter and William Slater's Inverness Cathedral plan[10], and was able to place it beyond the east end because of his encircling cloisters. Carpenter and Slater's subsequent design for Grafton Cathedral, discussed in the *Builder* of 24 April 1869, although not illustrated, also had its octagonal chapter house situated behind the east end. Both were clearly independent developments from Inverness.

Hunt's extremely narrow aisles probably derived from an architect outside the ecclesiological circle—James Brooks—whose contemporary church designs were published in the English building magazines, which we know Hunt subscribed to. (A single scrapbook of the many compiled by Hunt, now in the State Library of New South Wales, contains cuttings from eleven different English and American architectural periodicals—virtually all that existed at the time.) The *Building News* thought Hunt's five-foot passage aisles were far too narrow and could profitably have been dispensed with altogether, particularly if Hunt added a stone vaulted roof on the model of Gerona or Albi. As it was, Hunt was only proposing to vault his aisles and cloisters in stone—a 'semi-speluncar' solution. The magazine also commented that Hunt's Early French Gothic detailing, which mainly consisted of patterns of lancets, large clerestory windows and pinnacled buttresses in the style of George Edmund Street, needed to be improved.

On the whole, like his American contemporary, Henry Hobson Richardson[11], Hunt seems to have been most influenced by Burges and Street at this stage of his career, and his next church design confirmed these influences. This was for the little Anglican Church of the Good Shepherd, Kangaroo Valley (1870-72), a building comparable in scale with Blacket's Berrima church. A 'Norman' style had been stipulated by the local church committee[12], but Kangaroo Valley ended up being simply a round-headed version of the

Anglo-French High Victorian style. Large expanses of sheer unbuttressed brick wall were pierced with simple unmoulded lancets in typical 'muscular Gothic' fashion, and even Hunt's over-hanging eaves and projecting gables had been anticipated by Street in his 1851 design for a church at Hobart.[13]

The wide abutting narthex at Kangaroo Valley was of the same type as Street's porch at Howsham, Yorkshire (1859-60), or J.F. Pearson's at Appleton-le-Moors (1863-65) in the same county, although of wood instead of stone. Still, William Burges had already built a wood and brick porch on Lowfield Heath church in Surrey in 1867 of a very similar type. Street, Pearson, Burges and Hunt were all adapting the medieval French form of separate narthex with rose window above. Hunt would have known the type from Burges' book *Architectural Drawings* (London, 1870), or W.E. Nesfield's *Specimens of Medieval Architecture* (London, 1862)—publications that he would certainly have included in his vast library, which ultimately consisted of over 4,000 books on architecture.[14]

Hunt's division between nave and chancel at Kangaroo Valley was only marked externally by a shingled bell-cote with a sharp pyramidal spire, and by the transept-like vestry and organ chamber on north and south sides. Internally the division was signified by a pair of square brick piers and a pierced wooden infill between two of the scissor-beam trusses. Such subtle breaks in continuity and the irregular window patterning were also characteristic High Victorian devices. Whereas Early Victorian church architects, led by Pugin, had believed in picturesque groupings of separately roofed parts, the High Victorian style was characterized by solid unbroken forms and detailing placed rationally rather than in a balanced way. Although Kangaroo Valley was a smaller and simpler church than even Street's most modest efforts for Sir Tatton Sykes in Yorkshire, its architectural character was as fully High Victorian as Hunt's more ambitious cathedral design had been.

Blacket, on the other hand, never really developed beyond an Early Victorian approach to church architecture, although he had a small flirtation with High Victorian forms under the influence of Hunt, who worked in his office from 1863 to 1869. He even independently essayed a slight French Gothic mood in some of his later church designs, like All Saints at Woollahra of 1874-76, with its apsidal chancel and naturalistic carving. But on the whole his later style fossilized into a collection of carefully varied applications taken from a repertoire assembled in his youth, and his early churches are usually more varied and lively than his later ones.

After having been promoted to diocesan architect by Bishop Broughton in 1847, Blacket was given the commission to design three churches. Following the stylistic impartiality of the building magazines, rather than the exclusive adherence to Decorated Gothic promoted by the *Ecclesiologist*, Blacket decided to employ a different Gothic style for each: St Philip's, Church Hill, Sydney, is Perpendicular; St Mark's, Darling Point, is Early English; and St Paul's, Redfern, is Decorated Gothic. He also seems to have been content to adapt contemporary English churches for his general plans and elevations, rather than to draw on his less precise knowledge of original Gothic buildings. We know that he was encouraged to do this at Darling Point, and there is enough evidence to show that this was also the case at Redfern. St Philip's also looks more like a contemporary version of a Perpendicular Gothic church than an original adaptation of a medieval one, although no exact prototype has been discovered for it.

In a general external form St Philip's relates closely to Welby Pugin's St Mary's, Bridgegate, Derby (1838-39), a church Blacket is very likely to have visited before coming to Australia, for it is not too far from the Stockton to Darlington railway line on which he was working and it was a well-known new building. However Blacket chose a traditional,

4 Edmund Blacket, St Paul's Church of England, Cleveland Street, Redfern, 1848-56 (now Greek Orthodox). This photograph was taken before the completion of the tower in 1872

straight-ended English chancel for Sydney instead of Pugin's polygonal one, and the interiors of the two churches are quite dissimilar. Blacket's is far more archeologically correct than Pugin's earlier one had been. His careful Perpendicular Gothic detailing must derive from contemporary publications supplied for emulation, like F.A. Paley's *Manual of Gothic Mouldings* (London, John van Voorst, 1st edn, 1845).

The string-course mouldings and the columns, capitals and bases at St Philip's are identical to examples given by Paley; the label stops are the same type as given in Augustus Pugin's *Gothic Ornaments* (London, 1831); and the tracery of the clerestory is the same as that given in detailed drawings in the Pugins' *Examples* for South Wraxhall Manor House, Wiltshire. This tracery also occurs in a more general form in Raphael and J. Arthur Brandon's illustration of St Peter's Church, Walpole St Peter, Norfolk, in their book *Parish Churches* (London, Bell, 1848, vol. 2, p.49), which also shows the use of twice as many windows in the clerestory as in the arcade with false buttresses between them. This clerestory arrangement was an emendation to Blacket's 1847 design for the church, which had a single large Perpendicular Gothic window to each bay. Presumably Blacket changed it after he received his copy of the Brandons' book (now in the Fisher Library of the University of Sydney). Thus the whole church would appear to be an amalgam of Perpendicular Gothic detailing taken from various contemporary source books and used in an appropriate general plan.

In the case of St Mark's, Darling Point (1847-53: enlarged 1861-70), we know that Blacket's general design was taken from a recently published illustration of a church in Lincolnshire by Stephen Lewin. At one of the preliminary parish meetings,

Mr Edmund Blacket, the celebrated architect, was present by invitation, and disclosed a sketch of a Church, Holy Trinity, Horncastle, Lincolnshire, a print of which had appeared in the 'Illustrated London News' dated April 17, 1847.[15]

This became the pattern of the Sydney church. Both buildings originally had a nave of five

bays with low abutting aisles and a tiny clerestory (Darling Point had all trefoils while Horncastle had alternate trefoils and quatrefoils). Both had a two-bay chancel, a porch at the second bay from the west, and were in the Early English style of a single lancet to each buttressed bay. The major external difference was that St Mark's was designed with an engaged south-west tower (possibly deriving its details from Blacket's known copy of Charles Wickes' *Illustrations of the Spires and Towers of the Medieval Churches of England* [John Weale, London, 1853-4]), while Horncastle only had a bell-cote.

The general source of St Paul's, Cleveland Street, Redfern 1848-56 (4) (now a Greek Orthodox church), also seems to have been a contemporary illustration, in this case a lithograph appearing in the *Builder* on 12 June 1847 (5). This showed a new church at Homerton, London, designed by Arthur Ashpitel, to be called St Barnabas. It is so close to Redfern that the similarities must have been more than Pugin's common medieval source.

Both were designed initially to have a nave and only one aisle (south in the case of Homerton and north for Australia), and both have the same sort of nave with buttresses between each two-light Decorated Gothic window. Homerton's windows all have the same elongated quatrefoil tracery, but Blacket got out his copy of Edmund Sharpe's *Treatise on the Rise and Progress of Decorated Window Tracery in England* (London, van Voorst, 1849), and made all his windows different. His copy of the book in the Fisher

5 Arthur Ashpitel, St Barnabas's, Homerton, 1845-47. *The Builder*, 12 June 1847

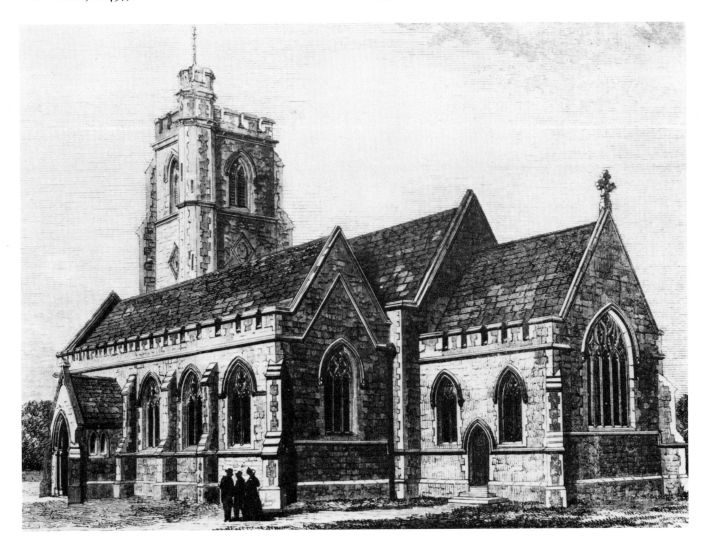

Library of the University of Sydney even has pencil numberings on some of the illustrations he used.

Both churches, at the second bay from the west, have a porch of single bay length squeezed in between the buttresses, and a two-bay chancel. The towers are almost identical, with clasping buttresses on three sides and a stair turret on the fourth (south-east at Homerton and north-east at Redfern: Blacket took being in the antipodes very literally). Neither has a spire. The major difference between the two buildings is that Homerton has battlements running along the length of nave and aisles with string course under, while Blacket's church ends more appropriately in his normal gabled roof.

The final argument in favour of this source is the size of the two buildings. Homerton's dimensions were given in the *Builder* as: nave 70 feet by 24 feet (Redfern is one bay shorter than Homerton and measures 60 feet by 24 feet), south aisles 65 feet by 17 feet (north aisles c.60 feet by 17 feet), chancel 24 feet by 19 feet (24 feet by 19 feet), and tower 20 feet square and nearly 80 feet from the ground (20 feet square and 76 feet from the ground including turret). So the sets of measurements are virtually identical. However Blacket's detailing is of his usual meticulous sort and far superior to Homerton's, which was slated in the *Ecclesiologist* for its inaccurate mouldings and poor attempt at Decorated Gothic tracery. The magazine also thought that the chancel and tower of Homerton were too short—a criticism that presumably would also apply to Blacket's version, although all the *Ecclesiologist* was able to publish on it was praise from Blacket's faithful Sydney supporter, Canon William Horatio Walsh, a local member of the English Ecclesiological Society.[16]

All Blacket's early and varied designs before about 1860 must have derived from published sources, although these were rarely recorded at the time and are difficult to discover in retrospect. Some were probably inspired by no more than a small engraving, like his unusual church at Carcoar, whose crossing tower between nave and chancel without transepts probably derived from an engraving of the twelfth-century church at Cassington, Oxfordshire, published in James Barr's *Anglican Church Architecture* (Oxford, Parker, 1841)—another book known to have been owned by Blacket.

Blacket's early method of design is best exemplified in his most ambitious early building, the main block of Sydney University (1854-59). The appearance of Blacket's University buildings did not derive from any particular college at Oxford or Cambridge, despite the fact that the general choice of style was dependent on such prototypes. As Blacket himself said:

It is impossible for an Englishman to think of an University without thinking of Medieval Architecture. We cannot entertain the most visionary idea of study or learning without associating in some way or other the forms and peculiarities of the Gothic styles.[17]

However Blacket's specific source was another illustration in the *Builder:* J. T. Emmett's 'New College, London, for the Congregational Dissenters' (6), illustrated in the 13 December 1851 issue with a full-page engraving. Both buildings are Late Perpendicular/ Early Tudor in style, with a symmetrical, two-storeyed battlemented front on either side of a central tower, plus a terminating Great Hall (Library) on one end and a balancing gabled mass on the other. Blacket modified his original plans over the years, particularly the top of the central tower, which became much more fully Tudor than Emmett's had been. Sydney's tower and external detailing were clearly inspired by Barry and Pugin's Houses of Parliament building at Westminster. Blacket's first design was probably even closer to the *Builder's* elevation than the final building now appears.

The most spectacular part of Blacket's University was the Great Hall. Its general

external form followed Emmett, but it was modelled internally on the lines of a medieval collegiate great hall, with steps up to a dais and bay window at the high table end and a screened effect with gallery at the entrance end. The roof was intended to have an entirely ornamental lantern to emphasize this pseudo-medieval function.

The Great Hall roof is a very close imitation of measured drawings of Westminster Hall's hammer-beam with arched braces and traceried infill, given in Pugin and Willson's *Specimens of Gothic Architecture* (vol. 1 (1821), plates 32 and 33 — a copy of which we know Blacket owned). Blacket adapted the mouldings slightly, but otherwise the roof is a faithful copy. However Sydney's angels (designed and carved by James Barnet, then Blacket's clerk of works) are far more primly Victorian than Hugh Herland's earthier personalities and hold books instead of shields. Blacket was proud of his Westminster adaptation, and it figures somewhat larger than life in his illustration of the interior of Sydney Great Hall published in the *Building News* in 1859.

The Sydney Great Hall fireplace is an adaptation by Blacket of one of the Tudor fireplaces at Thornbury Castle, Gloucestershire, illustrated in the Pugins' *Examples of Gothic Architecture* (vol. 2, plate VI). This original was nearly 8 feet wide, so Blacket reduced the number of formal square motifs from six to five and the small square paterae from eighteen to twelve. In addition he slightly simplified the cornice and jamb mouldings. Two of the large decorative square motifs on the fireplace have been taken from the Pugins' plate VI, and the other three from a Thornbury fireplace illustrated in plate XIII — fairly conclusive evidence for Blacket's use of this book as well as this example.

Blacket's method of designing was not unique to the colony. It was the common way of putting a medieval revival building together in England too, as the building magazines frequently pointed out. The point is that this was the *only* possible design method for Australian conditions when a medieval style was wanted, at least until an architect had worked out his own repertoire of motifs. Blacket certainly seems to have been unnecessar-

6 J.T. Emmett, New College, London. *The Builder*, 13 December 1851, p.787

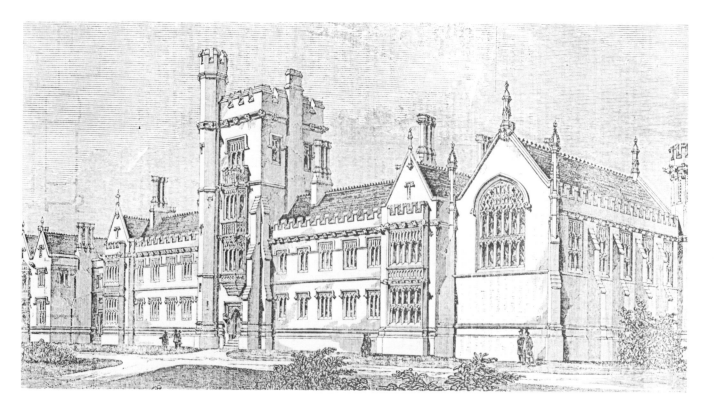

ily dependent on his contemporaries for his general plans and elevations, but the way he put together his stylistic motifs was always consistent, knowledgeable and effective. 'I think', said the architect Charles Nicholson in 1943, 'he must have kept abreast of the "Gothic" movement and have had great natural talent as well'.[18]

Anthony Trollope, an earlier visitor, was particularly impressed with Blacket's Great Hall. He wrote:

I think no one will dispute the assertion when I say that the college-hall—or public room, for it is put to none of the comfortable festive uses for which college halls have been built at our universities—is the finest chamber in the colonies. If I were to say that no college either at Oxford or Cambridge possesses so fine a one, I might probably be contradicted. I certainly remember none of which the proportions are so good.[19]

Within the constraints of the fashionable style of his generation, Blacket was more than competent. His chief defect was his inability to develop when cut off from his source of inspiration. Books and building magazines helped him keep up only to the extent of adding a novel feature or veneer to his established Early Victorian manner. The inability to develop was, of course, an endemic colonial problem but not an inevitable one, for to some extent Horbury Hunt managed to overcome it. His latest buildings are just as interesting as his early ones, and with maturity Hunt gained the ability to adapt to the necessities of his environment as well as a more individual interpretation of his overseas sources. His domestic adaptations of the American 'Shingle Style' are reasonably well known and outside the range of this essay, but his church designs show just as personal a development.

Hunt's next five parish church commissions after Kangaroo Valley were still in stone archeological Gothic of a normal Anglo-French sort. The best of them is St James', Jerry's Plains (1874-79), in the Newcastle diocese. It is chunky, rough and broad, with irregular window patterning and has a chancel arch that appears to burst outside the church to form a buttress and bell-cote. This arrangement was probably inspired by that of the mountain chapel designed by Paley and Austin for the Carlisle Church Building Society, published in the *Architect* in September 1873 (7), for Hunt used his building magazines to keep right up to date. Jerry's Plains also has a good Street-like interior, with trumpet corbels to the chancel arch and a low stone screen, plus a complicated thin wooden roof combining a scissor truss with collar, arched braces and a hammer-beam in a characteristic Hunt amalgam. Altogether the church is a worthy climax in a material Hunt was to abandon for the next ten years, when he built exclusively in brick and in a rather different style.

The first of Hunt's major brick churches was probably the most successful, and certainly the most unusual, of the lot. This was the Anglican cathedral of St Peter at Armidale (1871-75), which was extremely different from Hunt's normal Anglo-French style. Instead of owing its general features to Burges or Street, it belongs with the group of High Victorian churches that Goodhart-Rendel has labelled the 'rogues'[20] — perversely original Gothic designs which deliberately choose the atypical Gothic motif and complicate rather than simplify spaces and detailing.

It seems that this antipodean brick perversity owed a lot to Hunt's patron, James Frances Turner, Bishop of Armidale and Grafton from 1869 to 1893. According to Freeland[21], Hunt's first design for Armidale cathedral was in his stone Anglo-French style, with overhanging gables, a heavy combination hammer and scissor beam roof, and a complex belfry with a broken outline. The church committee decided that it was too expensive, and so Bishop Turner proposed a joint revision to bring it within the £4,000 limit. Turner was by no means a passive client: 'You will not object I presume to my

7 Paley and Austin, Mountain Chapel for the Carlisle Diocesan Church Building Society, design no. 2. *The Architect*, 20 September 1873, p.147

revising your sketches. I was brought up to your profession in England in two of the first offices in London'.[22]

The plans of this revised design, 'prepared by Hunt and the Bishop conjointly'[23], were accepted in 1871 and were even more powerful than the present building. Financial limitations led to 'temporarily' abandoning the massive crossing tower, the chancel aisle and two bays of the chancel. These are still awaiting completion, while the chapter house was not built until 1910 and the tower not until 1938.

St Peter's Cathedral, Armidale, is the most 'roguish' of all Hunt's buildings, ecclesiastical, public and domestic. It is hard to believe that its unusual character was mainly due to Turner—who, after all, had only been in the offices of George Basevi and Philip Hardwick when aged 15 to 19 and had subsequently become quite a conservative architect, judging by his two known English churches and his few Australian designs.[24] But Armidale was a great change from Hunt's previous (and subsequent) Anglo-French style, and although Hunt later developed one manner for stone and one for brick, his previous Kangaroo Valley church was still conventionally Anglo-French, despite its brick material.

Motifs like the perverse buttress leg cocked over the porch door, the scissor-truss roof cutting right across the rose window in the west gable and into the apex of the chancel arch, and the multiple variations in colour and patterning in the brickwork of Armidale are very reminiscent of the work of William White—particularly his church of St Saviour, Aberdeen Park, Islington (1859), illustrated in the *Builder* in 1867 (p. 551). White's Aberdeen Park church also had a chancel aisle and a heavy crossing tower, while George Truefitt's Catholic Apostolic Church at Islington, illustrated in the *Builder* in 1858 (p. 798), had flying buttresses over the west porch and one in front of a side door in a comparable, although more severe, manner to Armidale's.

Yet despite a similar passion for coloured and moulded bricks and for surprises in detailing, Armidale was very different from churches by William White and the English polychrome school. The latter are high, narrow, rich and self-consciously archeological, while Hunt is exactly the reverse. His flush lancets and large expanses of plain wall are as simple as James Brooks', but again not at all similar in effect. Compared with Brooks, Hunt's clusters of lancets are dainty, and at the end of every expanse of plain wall there is an eruption of moulded or contrasting brick.

Perhaps the oddest effect of the church comes from its broad and low proportions. The

nave is very wide and without aisles, although the transept is disguised by arcading to appear part of an aisle, thus making the building seem even broader. Then behind the wide chancel arch—which seems to have exploded into the roof—is a very wide (and if built as designed, exceptionally long) straight chancel. Above these low walls broods a heavy roof whose members are as tightly spaced as those in a medieval Norwegian church. This ties Armidale even more to the ground, and gives the impression of being a roof from some other building that has been dropped on to this one and does not fit very well.

Other motifs surprise one with their originality (or strained whimsicality—depending on one's point of view). Hunt complicated the flat planar surfaces and simple unbroken lines of his own approved English Victorian church types, and interrupted the exterior walls with plenty of buttresses, string courses and rows of moulded brickwork. The west front is a clever essay in multiple surface planes, with three planes to the west window and an ambiguous arcading on each side of the west door, where the recessing of the niches is partially contradicted by being cut with a continuous string course. There are aggressively obvious New England granite keystones to the heads of the arches on the west front (the side windows have normal High Victorian vertical jointing), as if to show that this architect can afford to break rules that other men have yet to master.

Turner supplied all the furnishings for the cathedral which were mostly made in England to his specifications. They included stained glass windows in the nave by Lavers, Barraud and Westlake, installed not long after the opening of the church in 1874. (Their east window dates from 1891.) Turner's design for laying the tiles is still extant at the cathedral. These were made by Godwin of Lugwardine, Herefordshire, a firm specializing in copies of medieval tiles. He also designed the pulpit and lectern, and the low communion rails—made by Hart, Son, Peard and Co.

It seems fair to conclude that the cathedral was the joint production of both men, although Hunt no doubt made more of Turner's apparent interest in brick and in eccentric detail than the Bishop would ever have been capable of on his own. By the time the cathedral was opened in 1875 Hunt alone was cited as architect. Still, even by this date, this could mean no more than the fact that he was in charge of erecting the building.

From 1874 until 1884 all Hunt's known churches were built in brick. These included the design of two more cathedrals—Grafton and the revised Newcastle—as well as nine parish churches and a pro-cathedral. They were all in a lancet Gothic style, with continuous roofline over nave and chancel marked externally by a buttress, bell-cote or change in fenestration, and they all have complicated wooden roofs. The interiors were mostly furnished with low chancel screens, and the decoration consisted of brick patterning, an occasional use of coloured tiles, and stained glass windows (mostly by the Sydney firm of Lyon and Cottier). Neither Hunt nor Turner believed in painted and plastered interiors, although several have since been altered as such ecclesiastical austerity was never much liked.

Christ Church Cathedral, Grafton, 1874-84 (completed 1937 minus tower and chapter house) now looks a rather monotonous Hunt exterior except for its impressive giant niche at the west end. Still, the multiple clerestory buttresses slide over the aisle roof to link up with the aisle buttresses in an unusual way, and the external appearance of the unvarying triple lancet windows must have been very much more interesting when all the aisle lancets were filled with double wooden louvres. The inside louvre would have given a double-plane effect, like the series in the present west gable, while the outside ones would have added a very functional variety to the basic brick walls.

A long anonymous review of the church (which was clearly by Turner) appeared in the

Australian Churchman of July 1884, and was duly pasted by Hunt into his cutting book with occasional red underlining. It drew attention especially to the louvred aisle windows:

That is a totally new feature in these colonies, and deserves special notice as indicating on the part of the architect of the church, and the building committee, a sense of the easy application of the principles of Medieval Architecture to the necessities of any climate . . .[24]

Hunt underlined the entire passage, but the idea was not quite as original as Turner thought. An English architect, Frederick Rogers, had previously designed the church of St John the Baptist, Yengarie, Maryport, Queensland, with external and internal wooden louvres to its nave lancets, and his design was illustrated in the *Building News* of 14 November 1873. This seems very likely to have been Hunt's source for Grafton. Rogers' church was more progressive than Hunt's in other ways too. It had far more exaggerated overhanging eaves than Hunt ever used, and they form a sort of verandah around the church. Rogers' planning was more experimental, and so was his building material of concrete with stone dressings. Grafton was still High, rather than Late, Victorian, and Hunt never attempted any sort of 'quaint' style like some of the English Arts and Crafts architects.

When Hunt came to redesign Newcastle Cathedral in about 1881 he again added features deriving from the Late Victorian Arts and Crafts movement, but the basic style of the building remained his lancet Gothic brick one. He abandoned much of the detailing of his early Anglo-French effort, and apparently took the advice of the *Building News* for other modifications. They had suggested vaulting the entire church on the model of Gerona or Albi, and Hunt now intended to vault his nave with a white New Zealand stone barrel vault, although this was never carried out. Only the aisles are vaulted in stone according to his plans. The exterior of the cathedral is, as Basil Clarke has pointed out[26], extremely impressive. Its enormous size and magnificent position give it a very fortified appearance, which—despite the flying buttresses—is also reminiscent of Albi.

Hunt did not dispense with the passage aisles of his first design but he widened them to seven feet, the size the *Building News* had recommended as minimal on the precedent of Brooks' St Columba's, Kingsland Road, London. The twin west towers of the original design were abandoned for turrets, and the enclosing cloisters and eastern chapter house were removed. There is still a continuous ambulatory around the building.

The contrasting dark brick exterior and pale interior of Newcastle, the vaulted aisles and ambulatory, and the semi-fortified appearance of the whole remind one of J. L. Pearson's St Augustine's, Kilburn, London (1870-80)—the most famous of the Albi-inspired English High Victorian churches. But the major obvious influence in the revised interior elevation was Edmund E. Scott's St Bartholomew's, Brighton (8), a dramatic Arts and Crafts building which was illustrated in the *Builder* of 30 January 1875. Hunt's square piers and his original flat brick vaulting shafts (since replaced with slim mounded stone ones) were particularly like Scott's (9).

Hunt was clearly capable of adopting motifs from the work of contemporary English architects throughout his life, and around 1883 he seems to have tried to absorb the elements of a new style into his work. Blacket's 'queer' period can be explained as his attempt to graft High Victorian motifs on to his normal Early Victorian style, while Hunt's church designs from 1883 until his final design for Rose Bay Convent in 1896 can all be seen as different attempts to combine his customary planning and detailing with new architectural ideas. The necessity of absorbing these ideas second-hand through books and periodicals, the limitations of money and environment, and the fact that Hunt was now an established mature architect meant that this third and final phase in his

ecclesiastical career was not simply an echo of either England or America but a local and personal reworking of general themes of the day.

Newcastle Pro-Cathedral (1883-84) was the first of these experiments, and it can hardly be claimed to have been a great success. Its 'ponderous, barn-like appearance'[27] was so detested that the architect was dismissed before the interior was completed. This was decorated by a local German immigrant architect, Frederick B. Menkens, who added plenty of paint, gilding and archeological Gothic furnishing to give 'some evidence of refinement and ecclesiastical taste'[28] to Hunt's barn. The general public did not much like Hunt's High Victorian brick style: they were certainly not ready for adaptations from a vernacular Queen Anne.

8 Edmund E. Scott, St Bartholemew's, Brighton. *The Builder*, 30 January 1875, p.99

9 J. Horbury Hunt, Christ Church Cathedral, Newcastle (begun 1885), present nave arcade. By courtesy of W.J.S. Kerr

The mixture still looks the antithesis of the Picturesque. Hunt's normal style of groups of lancets, single stepped brick buttresses, string courses and simple plate tracery is combined with Late Victorian details like the shingled clerestory walls, the wooden mullioned and transomed domestic windows in clerestory and porch, an American 'Stick Style' interior arcade, and a low pitched roof to nave and abutting aisles. (The roof is now iron, and the original western bell-cote has been removed.) Hunt's American 'Queen Anne' domestic buildings were far less stark, and his subsequent brick church of St Peter, Hamilton (1884-85) was a more graceful mixture of 'Queen Anne' and 'Early English'. The idea of combining these two styles owed something to the English architect Philip Webb, but the results were all Hunt's own.

After these two last churches Hunt abandoned brick for the more fashionable Arts and Crafts materials of rock-faced stone (All Saints, Hunters Hill: begun 1884) or weatherboard. The first and best of Hunt's weatherboard church designs was for Narrabri, and it seems that Turner also had a hand in this successful switch to wood. On 2 August 1882 Turner gave the local churchmen at Narrabri a lecture

upon the general style of church architecture in this colony and at home, and illustrated his remarks upon the blackboard . . .

With regard to the church to be built there, the Bishop said that a really good, plain church, to accommodate 200 persons, could be built for £1,500, and that Mr Horbury Hunt was the man to do it well—so that it would be at the same time a monument of durability, and something to please the eye.[29]

Hunt's design of the following year, for a combination of weatherboard and shingles, was satisfactory in both respects. Its shingled gables referred back to the Queen Anne domestic buildings Hunt had been designing ever since he had begun his own home, Cranbrook Cottage at Rose Bay, in 1873, but not previously thought appropriate for churches. The weather-boards are used in two directions, so that vertical boarding forms a sort of rusticated basement level below the windows. These are set in a continuous

rectangular body which is diagonally boarded. Most of the windows are small-paned lancets with wooden Y tracery, but the west window is a deliberate conceit of piling lancets on lancets to give a Perpendicular Gothic effect. Such tracery seems a deliberate echo of Australia's 'vernacular' church style of the 1830s—a sophisticated parody of 'Church Act' Gothic. This seems deliberate, because Hunt's later wooden church at Bodalla has windows which repeat the same sort of Church Act parody to a Tudor tune.

On the other hand, the sunflower pattern in the shingles of the porch at Narrabri was a very popular English Arts and Crafts motif, although normally realized in terra-cotta rather than shingles.[30] Hunt's traditional Australian materials of weatherboard and shingles could hardly have been employed in a less bucolic manner. Yet the fact that these *were* traditional materials, combined with references to Australia's past in the design, suggests that these wooden churches can be read as rather wry manifestations of Australian nationalism—a movement in the arts which was emerging around this time, culminating in the paintings of the Heidelberg School at the end of the 1880s.

Hunt was not only a more stylistically sophisticated architect than Blacket, but a more intelligent one. His greater intellectual capacity (and his larger library) prevented him from fossilizing in the Australian architectural desert. He was capable of modifying the undigested English style of his first Newcastle design to suit local conditions because he thoroughly understood the real nature of the Victorian Gothic Revival as well as its external features. It was hard for any architect to alter or develop when so entirely cut off from the artistic centre of the world, yet, although Hunt's respect for overseas developments seems to me to have always been greater than his understanding of local needs, he was to some extent a pioneer in adapting to his environment. All Blacket ever wanted to do was to reproduce England. His commitment to archeological Gothic was in itself a barrier against the antipodes. Hunt's stylistic eclecticism actively encouraged local adaptations.

Yet each achieved his aim. If today we prefer the local adaptations to the English parish church replicas, it is probably because we no longer see ourselves as a society of exiled Englishmen. The words of the 'Church of England Lay Association for New South Wales' (for which Blacket was 'Honorary Consulting Architect') need to be kept in mind when we are considering the sort of patron Blacket was working for. They carry all the nostalgic glory of our colonial past and aptly summarize the Early Victorian viewpoint:

The Parish Churches of England, the most venerable, the most truly beautiful, the most durable of their class, are endeared in our recollections by every association. And how worthy of Churchmen to perpetuate these beautiful models in this their adopted land. How worthy of a Church Society would be the promotion of a School of Art, which from its beauty, abundance, and variety of examples for instruction is unrivalled; from its nationality so appropriate; and in its ancient associations so glorious.[31]

HEATHER CURNOW William Strutt: Some
Problems of a Colonial History Painter in
the Nineteenth Century

In November 1850 the settlement of Port Phillip separated from New South Wales and
became the self-governing colony of Victoria. A three-day public holiday was pro-
claimed, and even the newspapers suspended publication. Present at most of the
Separation celebrations was William Strutt (1825-1915), a 25-year-old artist who had
trained in Paris in the ateliers of the history and portrait painters Michel-Martin Drolling
and Joseph-Nicholas Jouy, as well as at the École des Beaux-Arts. He had arrived on the
frigate *Culloden* four months previously, intending to take up life in the bush, but instead
had found employment as an illustrator on a new magazine, published by Thomas,
Theophilus and Jabez Ham, a firm of Melbourne printers and engravers.[1] Strutt claims to
have been the first academy-trained artist to reach Melbourne and, for an aspiring history
painter, he had arrived at a time seemingly rich in possibilities.

At the time of Separation, Strutt commemorated the event with an engraving entitled
'Government but United', published in the *Illustrated Australian Magazine*.[2] He also
executed a large allegorical transparency, which was displayed in the Ham Brothers' shop
on 'Illumination Night', 13 November 1850. The design was much approved, as Strutt
wrote to his mother: 'You would have laughed to have seen the people standing gazing at
it, and the junior partner of the firm delighted with the task of explaining the subject to
any enquirers'.[3]

The Melbourne *Argus*, in its report on the celebrations, singled out Strutt's trans-
parency for special comment:

A large transparency, in which the province of Victoria is represented by a female figure sitting on a
throne, supported by Britannia as a protector; on her right and left the colonists are represented,
rejoicing that their adopted country Victoria takes her place in the scale of British Colonies; in the
centre are various emblems of agriculture, the fine arts, science, and architecture. A group of figures
in the foreground are emblematic of education, the squatting interests, commerce, &c. On the right
hand are some aborigines, in various positions; one figure is on the ground, and some missionaries
are endeavouring to raise him, and instructing him in the way to rise from his uncivilized condition.
Behind them are some of the black police in their uniform, and the background is completed by a
group of colonists. This transparency, one of the best exhibited, was the work of Mr. Strutt, an
artist.[4]

On 15 November, 'Separation Day', the celebrations were at their height. C. J. La
Trobe was sworn in as Lieutenant-Governor of Victoria at Government House, and a
procession moved through the streets to the opening of Princes Bridge. The *Argus* gives
some idea of the excitement on this occasion:

The dense mass of people presenting in their holiday attire a gay variety of colours, the thousands of
children, the waving of banners, the distant strains of music, and the firing of artillery, gave an
aspect of overflowing joy and triumph, and pictured the miracle of Melbourne at once in its true
portraiture and its fancy dress.[5]

During the procession commemorative addresses were struck off on a press from the *Argus* office mounted on a horse-drawn dray. Strutt sketched John Pascoe Fawkner scattering these 'patriotic flysheets' among the crowds.

The design, made by Strutt the night before 'Separation Day',

represented a settler leaning against a bale of wool on one side and an aborigine on the other, clothed with his opossum rug: the central space was filled in with a description of the date of the first meeting petitioning the Home Government for Separation, also giving a copy of the petition . . .[6]

Strutt's drawing of the opening of Princes Bridge was published in December as a zincographic engraving by Thomas Ham, with a dedication to the colonists of Victoria.

The following year, Strutt had his first opportunity to do a really important history painting. On 13 November 1851 the first Victorian Legislative Council was to meet in the St Patrick's Hall, Bourke Street, and John Pascoe Fawkner, one of the legislators and (with John Batman) a contender for the title of 'Founder of Melbourne', suggested that Strutt 'make such sketches of the opening scene as would enable me to paint a picture of the event, promising to get the Members to subscribe towards the execution of the work'.[7] Strutt must have set about his first historical commission with the enthusiasm of a David, making sketches of the meeting from a specially constructed platform at the back of the hall. However the picture,

through the indifference of the principal actors in this historical scene, was destined never to advance beyond the sketch, which is, with a little drawing I made from it . . . all that remains of a very important event.[8]

In 1856, after returning from a stay in New Zealand, Strutt became involved, again through Fawkner, in an agreement to paint a picture of the meeting of the Legislative Assembly in the newly opened Parliament Buildings.

Fawkner promised to get all the members to sit, and himself advanced £120 against the artist's expenses.[9] On the day, 25 November 1856, Strutt made 'numerous sketches of the brilliant scene, embodied in a careful drawing, wherein the Governor, Sir Edward Macarthur, his staff, the Judges, the Members of both Houses, Foreign Consuls and distinguished visitors were introduced'.[10] However, in spite of Macarthur's additional support, he failed to persuade the members of the Legislative Assembly to assist Fawkner in financing the painting. So Strutt was 'compelled to renounce the completion of the picture and let it lapse altogether, although I had secured admirable photographic likenesses of all the parties concerned in the important event'.[11]

As on the previous occasion, five years earlier, Strutt's sketches and a drawing remain the only pictorial records (1)[12], and it was not until 1901 that an event of this type was commemorated on a grand scale by an Australian artist (Tom Roberts' *Opening of the first Commonwealth Parliament*, 1901-03).

During his stay in Melbourne, Strutt recorded other events of major and minor importance in Victoria's history: the visit of the missionary ship, the *John Williams*, in December 1856 (published as a lithograph by de Gruchy and Leigh); the departure of the Burke and Wills Exploring Expedition in August 1860 (2)[13]; and the new governor of Victoria, Sir Henry Barkly, reviewing the Victorian volunteers on the Werribee Plains in April 1861.[14] All these events, however, were recorded by means of drawings, watercolours or lithography. Almost invariably, the oil paintings which Strutt left behind him in Australia were portraits: a small full-length one of J. P. Fawkner, 1853 (La Trobe Collection, State Library of Victoria); Dr Augustus Greeves and Andrew Russell, 1853, both members of the Legislative Council and former mayors of Melbourne[15]; a bust portrait of

J. P. Fawkner, 1856 (National Library of Australia, Canberra); an equestrian portrait of Major-General Edward Macarthur, commander of the forces in Victoria, 1857 (Victorian Parliamentary Library, Melbourne); Frederick James Sargood, first chairman of the municipal council of Prahran, 1858 (Prahran City Council, Victoria); Sir John O'Shannassy, politician and premier of Victoria, 1860 (location not known); and the explorer Robert O'Hara Burke, 1862 (private collection).

Strutt found his most dramatic themes not in the political events of Victoria's bloodless revolution but in the hardships and dangers of colonial life. Two major hazards to colonists in the 1850s were bush fires and bushrangers, which presented Strutt with themes for major historical works painted after his return to England. On 6 February 1851 catastrophic bush fires devastated a great deal of Victoria, putting settlers and squatters to flight. By noon the temperature in Melbourne had risen to 117° and Strutt, who was working in Ham's Collins Street premises on a design for the Anti-Transportation League, had to brush off layers of dust from his lithographic stone. In his memoirs Strutt described the episode, known from that day to the Victorian colonists as 'Black Thursday'.

The terrified squatters and settlers hastily made their escape, leaving everything. The sick, put into drays, were hurried off; it was now a stampede for life, as represented in my picture of Black Thursday. Kangaroos and other animals, immense flocks of birds of all kinds, mingled in mid air, amidst the flying sparks, and in the stifling smoke making for the South. Numbers dropped dead from terror and exhaustion . . .[16]

Strutt transcribed many accounts of the disaster from the Melbourne newspapers. Together with several drawings of animal remains and his personal observations, these were to serve as raw material for his large painting of *Black Thursday* (3), completed in 1864, as well as several smaller watercolours depicting dramatic incidents: an actors' cart which was destroyed by fire *en route* to Sydney, and a stockman who was pursued by the flames through Cape Otway Forest, 'a fiery ride indeed', as Strutt described it.[17]

Another incident which attracted Strutt's attention took place on 11 October 1852,

1 William Strutt, *Opening of the first Legislative Council of Victoria, November 13, 1851*, pencil and sepia wash, 17 x 28.5 cm. Victorian Parliamentary Library, Melbourne. From a photograph in the La Trobe Collection, State Library of Victoria, Melbourne

when four mounted and armed bushrangers bailed up and robbed seventeen people on the St Kilda Road. As Professor Bernard Smith has pointed out, the bushranger theme had by this time become well established in colonial art and literature, and robberies, especially after the discovery of gold in Victoria, were commonplace. The St Kilda Road incident, however, as described by a contemporary newspaper, was 'of so unusually audacious a character, even in Victoria, and was so strikingly illustrative of the lawless condition to which we are tamely submitting . . . that it perhaps deserves rather fuller treatment than ordinary'.[18]

In the Burke and Wills Exploring Expedition, which left Melbourne in 1860 to cross the continent from south to north, Strutt found both a dramatic theme and a hero. The idea of a party of men, which included Strutt's artist friend Ludwig Becker, pitting themselves against the unknown interior of Australia is the old romantic theme of Man versus Nature. In Robert O'Hara Burke he found those qualities of intrepid courage and patriotic self-sacrifice necessary to the older conception of the neo-classical hero:

The Hero . . . was primarily someone—and this was the moralised conception of Hercules—whose noble body sheathed a soul shining with virtue and whose exploits could serve as a model and as an ideal.[19]

On 20 August 1860 the Expedition started from Royal Park, Melbourne. As described by Strutt in his memoirs:

The Leader having seen that all the arrangements for the Expedition were complete, he mounted a beautiful grey Arab charger . . . Reining in his spirited horse in front of the Mayor and the Royal Society, he said, 'Now, Mr. Mayor, we are ready to start,' . . . and with the cheers of the immense gathering witnessing his departure, he led the Expedition from the Royal Park; thus beginning on the 20th August 1860, to fulfil his solemn pledge that he would reach the Gulf of Carpentaria or die in the attempt, that pledge was fulfilled to the letter.[20]

Strutt's beautifully detailed pencil and watercolour drawing captures the excitement of the moment; it was later exhibited in Joseph Wilkie's music shop in Collins Street and reproduced by the photographers Batchelder and O'Neill.[21]

The following day Strutt followed the expedition to their first camp at Essendon, a few miles out of town, where he made numerous sketches and had some photographs taken. His watercolour of *The First Day's Order of March* (La Trobe Collection, State Library of Victoria) 'was taken as it started from their Camp here, and is an accurate representation of the interesting scene'.[22] Strutt painted the scene with a miniaturist's precision; it is full of minor incident and all the major characters are identified.

The tragic fate of the explorers provided Strutt with two further subjects: the Death and Burial of the Hero. When Alfred Howitt, the leader of the relieving expedition, returned to Melbourne, after burying the remains of Burke and Wills at Cooper's Creek, he was besieged by at least five artists wanting to know details.

As well as Strutt, contemporary artists who painted Burke and Wills subjects included Nicholas Chevalier, S. T. Gill, H. J. Johnstone and H. L. van den Houten. From Welch, the surveyor to the expedition, Strutt got 'all sorts of details from the hour of day when the burial took place, the sombre sky, the ground plants growing near the grave to the minutest detail . . .'[23] Brahe and Howitt also furnished Strutt with their accounts of the finding of Burke's remains. Two albums in the Dixson Library, Sydney, contain Strutt's preparation for his picture of the burial of Burke: individual head studies and photographs of the five men; preliminary studies of the flag in which Burke's bones were buried; a large sheet of rough sketches and notations on the vegetation, position of the horses, evidence of eyewitnesses about weather conditions; and several preliminary sketches of

the burial scene, which were submitted to Howitt, Welch, etc., for approval. An oil study of the burial was given to Howitt by Strutt, and this, together with the prayer book from which Howitt read the burial service, was sold at an auction in Melbourne in 1973.[24]

The death of Burke and Wills plunged Melbourne into a frenzy of public mourning. Men wept openly in the streets and the *Argus* immediately apotheosized Burke as 'Victoria's first Hero'. And for the first and only time Strutt realized his ideal image of a colonial hero in a portrait of Burke, completed just before his return to England in January 1862. The full-length portrait, privately commissioned, is a romantic portrayal of the explorer, which conveys not only the visionary aspect of Burke's nature but hints at the imminent tragedy of his situation.

After his return to England in 1862, Strutt began work on 'my large picture of "Black Thursday", a dramatic Australian subject, which occupied me nearly three years to accomplish, and was exhibited in a gallery in the Haymarket . . . where it was much admired and got some excellent press notices'.[25] The images which were fresh in his mind after a trip to Paris in July of that year were Horace Vernet's large Algerian battle-scene, *The Capture of the Smala,* in Louis Philippe's historical picture gallery at Versailles, and Rosa Bonheur's *The Horse Fair* in the Luxembourg.[26] In Black Thursday Strutt managed to capture something of the spirit and dash of Bonheur, especially in the left-hand section with its leaping and frenzied horses, and to Vernet he owes the overall organization of his picture. After its completion in 1864 *Black Thursday* was exhibited in the Scandinavian Gallery in the Haymarket, where it was widely and generally favourably reviewed.

The *Weekly Dispatch* for 10 July concluded its notice by remarking that:

The chief merit of the performance lies in its fidelity to the aspect of colonial life. The red shirts and cabbage-tree hats of the squatters, the lassoes loosely coiled round the horses' necks, the yokes of

2 William Strutt, *The Start of the Burke and Wills Exploring Expedition from Royal Park, Melbourne, August 20, 1860*, pencil and watercolour, 22.2 x 38.1 cm, signed and dated l.l. 'William Strutt 1861'. Mitchell Library, Sydney

3 William Strutt, *Black Thursday, February 6th, 1851*, oil on canvas, 106 x 319 cm, signed l.l. 'William Strutt pinxt.', 1864. La Trobe Collection, State Library of Victoria, Melbourne

the drays, the kangaroos, the birds, are all faithful copies from the originals. The proper destination of this, to the Australians, really historical picture, is the colony itself, where it should be preserved in any public collection as a memorial of a terrible incident in colonial annals. As a glimpse of the visitations that befall our kith and kin abroad, it possesses for us an interest independent of its pictorial claims.

A contemporary Melbourne newspaper, probably the *Argus*, published a selection of the London critiques, and concluded that:

Mr. Strutt's unprosperous career in Australia, and the prompt recognition which his genius has met with in England, furnished another proof of the truth of the remark that 'a prophet hath honour save in his own country.' Some of our rich colonists in London would perform a graceful act by purchasing this picture and presenting it to the Victorian Gallery of Fine Arts.[27]

This was the forerunner of the first attempt to secure *Black Thursday* for an Australian National Collection, which was a plan for Victorian ex-colonists in London to purchase the painting by subscription and send it to the Melbourne Gallery. Among those involved in the enterprise were Lieut.-Colonel Charles Pasley, formerly a Victorian colonial engineer, and Edward Wilson, the proprietor of the Melbourne *Argus* and a noted philanthropist. Pasley wrote to Strutt from H.M. Dockyard at Chatham on 2 June 1866:

I am very glad to hear that there is a prospect of your interesting and admirable picture of 'an episode of Black Thursday' being added to the National Collection in Melbourne. I shall be happy to subscribe three guineas to the fund, and any other assistance that I may be able to give towards the carrying out of so desirable an object will be freely rendered.[28]

On 29 June Edward Wilson also wrote to Strutt:

It seems to me that, failing better means, I might possibly do something for you in the matter of *Black Thursday*. I have a large house here, & of course many visitors interested in Australia. If you wd. hang yr. picture in my dining room possibly I might by degrees swell up the amount subscribed a little. Meantime, it would at least cease to be in your way, and would fill up a gap on my walls . . .[29]

The picture was delivered from the Crystal Palace in Sydenham, where it had been on exhibition, to Wilson's home, Hayes Place, in Kent. Wilson, however, failed to persuade his friends to raise Strutt's 'purely nominal sum' of £300, and *Black Thursday* remained in Strutt's possession in spite of James Smith's continued efforts to interest the National Gallery of Victoria in its acquisition. In 1882 Smith, who was by then a trustee of the Melbourne Public Library, Museum and National Gallery Committee, saw the painting in Strutt's studio during a visit to Europe. Shortly after his departure, Strutt was visited by H. J. Johnstone, the agent for an Adelaide dealer, E. J. Wivell. In December 1882 Johnstone negotiated the purchase of the picture for £260, and in January 1883 it was shipped to Adelaide.[30]

In April it was exhibited in Wivell's Gallery in North Terrace, Adelaide, accompanied by a small pamphlet heralding the arrival of 'William Strutt's great historical picture', which included as well as a biography of the artist, some contemporary newspaper accounts of the disaster and selected newspaper criticism from 1864.

The *South Australian Advertiser* noted that Wivell had disposed of the painting to a private collector, Mr George Hamilton, for £2,000, and that *Black Thursday* had been visited by large numbers since it has been on exhibition in Adelaide, and the opinions expressed have been unanimous as to its great merits as a work of art'.[31]

James Smith, no doubt disappointed to have lost the painting to another colony after such a lengthy crusade on Strutt's behalf, published an article in the *Argus* regretting that the picture had not found a place in the Melbourne collection.[32] In an excess of zeal he also wrote to the editor of the *South Australian Register,* stating that:

When I was in London, a few months ago, Mr. Strutt offered it to me for our National Gallery, at £300, but unfortunately there were no funds available for its purchase. I may assume, therefore, that that was the price Mr. Wivell paid for it.[33]

The letter also expressed a hope that 'the fortunate vendor will give a percentage of his handsome profit to the artist, who parted with his work at a price so far below his value'.

Strutt also wrote to the *Register* on 13 July, summarizing the history of the painting and the abortive negotiations for its purchase from 1866 until 1882. He concluded, 'Though this picture has been a labour of love to me, and also a pecuniary loss, I shall rejoice to hear that Mr. Wivell has obtained £2,000 for it, which is certainly not above its value.[34]

All this controversy in the press may have caused Hamilton to return the picture to Wivell, who toured it round Australia for the next two years. It was exhibited in the Athenaeum Hall in Melbourne, in Sydney, and again in Melbourne in the Jubilee Exhibition of 1884, where it obtained a gold medal. In 1890 it reappeared in exhibitions of the Royal Anglo-Australian Society of Artists in Sydney and Adelaide, priced at £700.

The subsequent history of the painting is puzzling; it appears to have remained in Wivell's possession until at least 1902. On 17 December of that year Thomas Gill, a member of the Public Library Board of South Australia, wrote to the president of the Board with a plea that *Black Thursday* be secured for the Public Gallery in Adelaide. He had learned that Wivell intended to take 'his unsold pictures, including "Black Thursday", to Perth', and had asked him to quote a price for it. He continued:

I now learn with considerable regret that the picture is regarded as unfit to be associated with the 'masterpieces and other considerable works of art at present in the Art Gallery'. As a member of the Board I respectfully enter my protest against the decision awarded by the Committee, for, as the matter now stands, the picture is tabooed to the Art Gallery, even if it were offered as a gift . . . Surely the picture is worth the small amount of £250 for which it is now offered.

After a lengthy description of the historic importance of the incident, Mr Gill concluded his letter by stating:

As a picture for the public gallery, I feel sure that 'Black Thursday' would attract more attention than most of the other pictures in the same building, chiefly because it depicts a phenomenal event in Australia. For this reason I very respectfully urge the Board to secure this valuable historical picture. It cannot depreciate in value, and its removal to another state would, in my humble opinion, be a reproach to South Australia.[35]

Black Thursday was later acquired not for the Adelaide Gallery but by a private collector, Mr W. S. Smith of Adelaide (it was in his possession by 1912)[36], and it remained in his possession until its purchase by the La Trobe Library in Melbourne in 1954.

Strutt's first painting exhibited with the Royal Academy in London was entitled *The Little Wanderers, or the Lost Track* (4). The adventures of three children who had been lost in the mallee scrub of Victoria and discovered alive by Aboriginal trackers after nine days was reported in the Melbourne newspapers in 1864 and, as well as Strutt's picture, inspired graphic works by S. T. Gill and Nicholas Chevalier.[37] The same events were the basis for a sentimental illustrated children's book, *The Australian babes in the wood—a true story told in rhyme for the young* (London, Griffith & Farran, 1866). Strutt's Academy picture of 1865, which is now known only by a watercolour copy in the National Library of Australia, Canberra, shows his continuing interest in the more

4 William Strutt, *The Little Wanderers*, watercolour, 14.5 x 19.2 cm, signed and dated l.l. 'W. Strutt 1865'. National Library of Australia, Canberra

melancholy aspects of colonial life and, although the theme had been previously treated in literature, indicates the beginning of an artistic trend for lost children subjects which was later developed in a series of paintings by Frederick McCubbin: *Gathering Mistletoe, The Lost Child* (1891), *Found* (1892) and *Lost* (1907).

Strutt himself returned to the theme in the 1870s with an illustrated story called 'Cooey; or, The Trackers of Glenferry', which deals in an imaginative way with the adventures of the lost children, the search for them, and their discovery by the Aboriginal trackers. Although the story was completed in 1901, Strutt's illustrations are charming, highly finished watercolours and tinted drawings which are still very much in the mid-Victorian narrative tradition. His title-page vignette for 'Cooey' is surrounded by a garland of Australian wild flowers, and the head-pieces for the seven chapters are decorated with Australian flora and fauna.

The story, interesting synthesis as it is of artistic and literary aspects of the theme, was sold to a periodical called *Our Animal Brothers* in 1906, but was never published.[38] The typescript and illustrations are now in the National Library of Australia in Canberra.

Based on the bushranging incident on the St Kilda Road in 1852, Strutt's *Bushrangers, Victoria, Australia, 1852* (5) has probably become his best-known Australian work. His preliminary studies for the picture, made between September and December 1886, are valuable evidence of his method of assembling figure compositions. These sketches and drawings range from a compositional sketch, showing the relative proportions and arrangement of the figures, to head studies, figure groupings, and details of hands bound with cords.[39]

Charles Brooke Crawshaw, a Yorkshire colliery owner and collector of paintings, bought the picture from the walls of the Academy in 1887, after some private negotiations

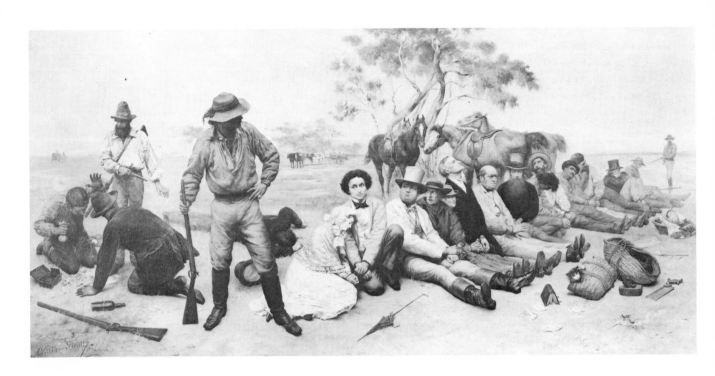

5 William Strutt,
*Bushrangers, Victoria,
Australia, 1852*, oil on
canvas, 73.5 x 154 cm,
signed l.l. 'William Strutt',
1887. University of
Melbourne (Russell
Grimwade Bequest)

with Strutt about the price. Strutt's letter to Crawshaw, written on 6 July 1887, throws further light on Strutt's conscientious approach to his work.

I am much obliged by your letter and frank statement of what you feel you could give for my picture of 'Bushrangers.' The price I asked—considering the time it took, nearly 6 months, and research necessary, and very expensive frame—was moderate, also I brought the costumes over from Australia and they are the very ones worn by the Colonists at that time . . . I am certain you will feel so pleased with the picture when you see it nearer as the various expressions are lost thro' its being hung so high . . .[40]

The painting remained with Crawshaw's family until 1955, when it was purchased by Sir Russell Grimwade of Melbourne. In 1973 it passed by the bequest of Sir Russell to the University of Melbourne.

The 'hero' of Strutt's painting, the red-shirted sentry who links the group of banditti to the left with the line of prisoners to the right, although his face is in shadow, is a monumental figure who dominates not only his captives but the landscape as well. By the 1860s the Australian illustrated press was beginning to depict the bushranger as something of a folk hero. By 1887 he was almost legendary, and the *Bushrangers* was as much a reconstruction of Australia's colonial past as Tom Roberts' *Bailed Up* (Art Gallery of New South Wales), which was commenced only eight years later.

In 1886 Dr William Gillbee, a Melbourne surgeon, bequeathed £1,000 to the trustees of the Public Library of Victoria for the purchase of an Australian historical picture, the subject to be selected from the Burke and Wills Expedition or Captain Cook's visit to Australia. The terms of the bequest were not carried out until 1901, when it was decided to give a commission for each subject. Although Strutt had 'obtained materials of every kind likely to be of use to me, with living portraits of the actors on the scene, and placed just as they stood on the occasion of the burial . . .'[41] he was unsuccessful in gaining the commission, which was given to John Longstaff in 1901. Longstaff forwarded his large painting of Burke, Wills and King at Cooper's Creek in 1907, and it now hangs in the National Gallery of Victoria, Melbourne.

Strutt, however, persevered with his own picture, for which his preparations had been most thorough, photographing men posing with a flag, and ordering a large canvas. Work on this painting was to be his major concern until the end of 1911.

In July 1911 he sent off invitations to view *The Burial of Burke* (6) at the rooms of the Royal Geographical Society in London. The Melbourne *Argus* of 14 August commented:

His latest work, which is hung in the Geographical Society's rooms, portrays the final scene in the desert; the explorer's remains, with the Union Jack as their shroud, are being reverentially committed to earth by the members of the Howitt expedition. Their features are life-like and authentic. A further touch of realism is added to the story by the introduction of the dust-covered cart in the backgound, with its unharnessed horses resting after their long journey.

The following year the *Windsor Magazine* (November 1912) noted that the painting was 'now on view in Melbourne'. Evidently it was in the possession of James Richardson, a Melbourne hotelier, for some years. It was placed on deposit in the Melbourne Public Library, and in 1944 was purchased privately and presented to the Library, where it now forms part of the La Trobe historical picture collection.

In the 1870s Strutt had painted two watercolours of The Death and Burial of Burke for the publishers Cassells to use in a book entitled *Heroes of Britain*.[42] The oil of 1911 is disappointing and lacks the sensitivity of the earlier watercolours, in spite of the monumentality of the figures. The clumsy brushwork, garish colouring and lack of finish make this the least successful of Strutt's Australian paintings.

As James Smith, the art critic on the *Argus,* noted on the day of Strutt's departure for England, the colony was losing 'an artist whose abilities have been scantily rewarded and imperfectly appreciated in Australia'. His lack of success in Melbourne was mainly

6 William Strutt, *The Burial of Burke*, oil on canvas, 122 x 207.5 cm, signed l.l. 'William Strutt, R.B.C.', 1911. La Trobe Collection, State Library of Victoria, Melbourne

connected with his thwarted ambitions to paint large historical pieces illustrating political events. Colonial taste was geared to portraits and views, and like many other artists in Australia at the time, Strutt had to supplement his income by teaching and illustration. He was extremely fortunate, however, in being on familiar terms with a number of influential citizens in Melbourne (especially John Pascoe Fawkner and Sir Edward Macarthur) through whom he secured private commissions.

It was probably his greatest misfortune to leave Australia at the time he did. Opportunities for an artist to exhibit his work had been limited, but by 1868 there were two shops in Melbourne specializing in the sale of pictures, and both Louis Buvelot and John Gully were finding a ready sale for their landscapes. In 1872 James Smith wrote:

I cannot help continually regretting your departure from Australia, as I think you did so just at the turn of the tides. Gully seems to meet with a ready sale for all his views of New Zealand scenery & has found purchasers in London for five large watercolour drawings at £60 each.[43]

Strutt came to regret having spent so much time and effort on *Black Thursday,* as he wrote to James Smith in 1870:

It was certainly a misfortune that I spent so much time upon a subject connected with the colonies, the more so that all my pictures (with one or two exceptions) of home subjects, have met with purchasers: my principal work last year, being sold to an eminent collector.[44]

Had Strutt remained in Australia, his established reputation might have secured him the commission for *The Burial of Burke*; as it was, he completed the painting with no financial assistance at an age when his artistic abilities were past their best. It is also probable that, with his sound academic training, he might have gained a position as a teacher at the National Gallery Art School in Melbourne.

Australian recognition of Strutt's significance, both as a colonial and a Victorian artist, has been retrospective. Most of his known colonial works are now in public collections in Australia and New Zealand, and since 1974 several of his 'Victorian' paintings have found their way to Australia. Five have been acquired by public galleries: *David's first Victory* (Sydney); *An Irish Obstructionist* (Melbourne); *Sentinels of Empire* (Hobart); *Cultivating an Acquaintance* and *A Warm Response* (Canberra).

Strutt's contribution to the development of Australian painting is an interesting one: at some times his depiction of themes of national interest foreshadows the work of the Heidelberg group and John Longstaff; and at others (for example the *Bushrangers* and *Bailed Up*), because of the time-lag between Strutt's original conception and the execution of the finished work, his treatment of such themes is almost contemporaneous. In particular, his work has an affinity with the melancholy themes of Frederick McCubbin.

Strutt selected 'typical' colonial figures—the digger, the native policeman, the bushranger and the explorer—and sought to elevate them to a heroic status. He also isolated themes that were to become commonplace in Australian art and literature—the bush fire, the bush hold-up and the lost child—and, by the use of compositional devices and gestures drawn from his classical training and wide pictorial knowledge, tried to invest them with the dignity appropriate to history painting. In *Black Thursday,* especially, he has left us a panoramic vision of apocalyptic horror unequalled in the art of Australia's colonial period.

PETER MORONEY Walter Vernon: A Change in
the Style of Government Architecture

Walter Vernon's appointment in 1890 as New South Wales Government Architect brought not only an administrative change but a change in the general stylistic approach to the design of public buildings: particularly noticeable in the smaller, less important ones. He established for buildings such as police stations, court houses, post offices, fire stations and, later, schools a style less grand, less imperial, more domestic and approachable than had been used by his predecessor, James Barnet. It was an eclectic style with more emphasis on Gothic than Classic elements, invoking the truth-to-materials aesthetics of Morris and the architectural forms and vocabulary of Shaw and Richardson, but attenuated and refined to suit the relative importance of the buildings and the economy of a government department; a style which persisted beyond the First World War.

If one looks at government architecture in New South Wales from the earliest days of the colony, it will be seen that stylistically, classicism in one form or another reigned almost supreme. Undoubtedly Greenway made excursions into Gothic but these were few and, apart from the stables for the proposed new Government House[1], quite insignificant. Mortimer Lewis made no concessions to Gothic in his official capacity as Colonial Architect[2], although he undertook certain domestic Gothic architecture in a private capacity: Richmond Villa being one example. Blacket's Gothic buildings were designed in his capacity as a private architect: even the University buildings were not at that time under the control of the Colonial Architect. And Barnet was a classicist through and through.

From the first Government House by James Bloodworth in 1788 to the late buildings by James Barnet, all had with very few exceptions been classical in concept: Georgian, Regency, Greek Revival, Victorian Classicism. One has only to think of buildings such as Greenway's St James Church and Hyde Park Barracks in Queens Square, Sydney; Mortimer Lewis' High Court Buildings in Taylor Square, or any of the numerous buildings by Barnet.

Even the commercial architecture of the colony had been principally based on the classical, from the simple early Georgian buildings through to the elaborately decorated stucco building of High Victorian—one notable exception being Horbury Hunt's fine Gothic arcaded facade on Farmers' building in Pitt Street of the seventies. However even this was never very popular, as Freeland remarks in his work on Hunt: 'While the Gothic (or 'Christian') style was accepted as being perfectly orthodox for churches, a Gothic shop front was entirely another matter'.[3]

In the mother country, however, a more stimulating situation prevailed; from the first quarter of the nineteenth century the most classical of architects were consciously experimenting in picturesque alternatives. Nash, Wilkins, Smirke and Blore had built in Gothic bekore 1825; the publications of Loudon, Hopkins, Pugin and Ruskin, supporting the picturesque point of view, provided further inspiration; and by the time the new Houses of Parliament were completed in the 1860s, G. E. Street, Gilbert Scott, Waterhouse and others were transforming whole skylines with their Gothic silhouettes. By this time too,

Webb, Shaw and Nesfield were introducing the embryo of a style derived from the architectural vocabularies of William and Mary, Queen Anne, Gothic and Tudor buildings, and embracing the artist craftsman truth-to-materials aesthetic of William Morris. This style, later to be developed by Shaw with a lightness and animation that gave him an immediate and widespread influence on the architectural profession of the time, was eventually to be called 'Queen Anne'.

It was amongst this ferment of changing concepts that Walter Vernon received his training as an architect. Born in High Wycombe in 1846, he received his early education at Windsor and in the early 1860s was articled to the architectural firm of Habershon and Pite in Bloomsbury Square, London. Recalling the type of training he received, in an address to the A.A.A.S.[4] in 1913, he said:

In my younger days in London we were taught that it was essential in mastering the subtle art of proportion, the disposition of enrichment and ornament, the effect of light and shade, construction and the analysis of the principles guiding a masterpiece of design, that the student should take his measuring rod and rule and set out the whole or parts again on paper from his actual observations, a method resulting in great advantage to his subsequent drafting efforts. I can remember nothing more enjoyable than our weekly occupation: office all day and long hours, academy on South Kensingston with lectures and classes in the evenings, with a bit of original designing at odd moments, and week-end excursions to some delightful old fane or old world village for sketching . . .[5]

Habershon and Pite had a very large practice which extended not only to most parts of the United Kingdom but embraced some continental work as well; and, as might be expected, this included a large amount of work both classical and picturesque in concept. Two convenient examples exist almost opposite one another in Marylebone Road, W.1.: respectively the old buildings of the Samaritan Hospital, and the Philological Society's building—now a school. So Vernon was exposed liberally to both tendencies in his working atmosphere as well as in the urban environment around him. It must have been an exciting period for a young architect beginning his training. The protracted building of the Houses of Parliament was drawing to a close with their Gothic detail, and picturesque towers rising to sublime heights above the banks of the Thames; the seeds of the later Shavian style were being sown, with Nesfield's picturesque lodges in Regent's Park and Kew Gardens being erected; houses such as Shaw's Glen Andred and Leyswood in Sussex were being built (Shaw's 'Architectural Sketches from the Continent' was also gaining credence); and the arts and crafts movement was kept to the fore by the increasing success of Morris' company.

When Vernon began practising in his own right in Hastings in the 1870s he used both styles. However it is not surprising to find him using the classical in his rather mundane stucco Victorian terraces and reserving a more picturesque style, where he had greater freedom of expression, for larger free-standing houses or public buildings, as in his house for Captain Brown in Dudley Road, Hastings (1), or the Brassey Institute in Claremont, Hastings (2): the former, with its steep gables, high ribbed chimneys and carved details, is early Shavian in character though lacking the lightness of Shaw; while the latter is quite Ruskinian in its presentation of a Venetian Gothic spirit—a truly 'honest' and 'Christian' architecture. There is also the spirit of Morris in these buildings, particularly in the Brassey Institute, where, in the truth-to-materials use of brick and stone, the artist-craftsman manner of its construction in the meticulously laid bricks and finely carved stone ornament, and the use of a mosaic frieze in the entrance porch, almost all that Morris was preaching is embodied. It is perhaps significant too that this building was erected the same year (1877) in which Morris began his famous public lectures.

Throughout his career Vernon seemed generally to favour a Gothic approach and remarked as late as 1909—when speaking of the architecture of old Fisher Library—that it was '. . . a type which admits much individuality and rich effects not obtainable in the colder and unbending lines of Pagan Classic'.[6] This predilection for picturesque elements combined with fine craftsmanlike building practice was later to become characteristic of much of his work as government architect in New South Wales. His preference for brick and stone was also to remain with him, and it is interesting to note that even large buildings such as the Mitchell Library and Registrar General's building in Sydney were originally designed by Vernon to be built in red brick with stone dressing.

When Vernon sold his practice in Hastings and came to New South Wales in 1883 for health reasons, his architectural preferences were mainly formed and to some extent set: he had been liberally exposed to the British scene, had travelled on the continent and practised his profession for more than ten years in Hastings; it was only left for Richardsonian influences and climatic conditions to modify his ideas. Vernon had visited America in 1887 and could hardly have avoided the numerous examples of Richardson's work. However, more important was the introduction to Sydney in 1890—the year of Vernon's appointment—of 'American Romanesque', with the erection of Edward Raht's Equitable Life Assurance building, which was to be the forerunner of a rash of Richardsonian-type business houses of all kinds, made conspicuous by their round arched, tripartite facades. Vernon was to use the round arch more modestly in many of his buildings later. By the time, therefore, that he was appointed Government Architect Vernon was imbued with ideas which were likely to predispose him to a change of style; however, apart from this possible predisposition, other forces were at work which must also have played a part.

In the commercial and domestic fields there had been a growing discontent with the

1 Walter Vernon, House in Dudley Road, Hastings. Steep gables, high ribbed chimneys, carved details

2 Walter Vernon, Brassey Institute, Hastings. Ruskinian in its Venetian Gothic spirit

general architectural incompetence and poor building practice: Victorian elaboration and pomposity—made even less valid by the covering of poor brickwork with stucco and the application of readily available moulded cement ornament—was losing its appeal. Pleas were being made for more colour and better craftsmanship. J.B. Barlow in a paper read before the Institute of Architects, after extolling the use of red brick in buildings such as Hunt's Farmers' Store, went on to decry the excessive use of cement:

Cement facades, gaunt and grey with never a touch of colour to relieve them; stores, arcades, hotels and offices all cemented . . . cement fronts painted and sanded, cement in its pristine ugliness . . . cement, monotonous, insipid and lifeless. Nothing but cement.

Architects of integrity like Horbury Hunt and John Sulman had been endeavouring for some time to improve not only the ethics of the profession but the quality of design and execution. Furthermore, with thoughts of Federation strongly to the fore in the public mind, a case for a more genuine Australian style was being put forward in the journals of the day. In an article in the *Builder* entitled 'An Australian Style of Architecture' James Green complains that:

Now-a-days in architecture . . . the acquisition of principles together with a solid grounding in design are too little insisted on; and publications which would be invaluable if rightly used, become a bane instead of a boon, affording an easy roseate road to the 'cheap and nasty' estimation of the public in matters of architecture[8]

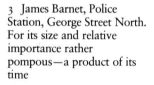

3 James Barnet, Police Station, George Street North. For its size and relative importance rather pompous—a product of its time

and later suggests—in a style hardly less florid than the architecture of the time—that:

If we could be induced to take style by style and subject it to a rigid analytical examination in the crucible of Australian needs, we should be in a better position than we are to estimate how much of each one consists of volatile gasses and foetid fumes and how much of solid valuable residue which one may employ in the synthetic building-up of a true Australian Style of Architecture.[9]

The criticisms levelled at commercial architecture could hardly apply to the government architecture of the day, for Barnet was certainly one of the most competent Colonial Architects who ever held the position. His forced resignation was the result of professional jealousy and political connivance. The charges were not professional incompetence but alleged administrative inefficiency. Vernon himself admired Barnet's work and was often reluctant to add to his existing buildings for fear of interfering with the original design: as, for example, when alterations to the General Post Office were being contemplated he had urged '. . . that if possible the existing building with its well known architectural lines should not be disturbed and in order to achieve this it was possible to resume additional land . . .'[10] So Vernon's abandonment of the general classical style of Barnet should not

4 Walter Vernon, Darlinghurst Police Station. Unpretentious, approachable, almost domestic

necessarily be taken as a criticism of Barnet the architect, but as a natural reaction against a style that had lost its earlier credence through changing circumstances, together with a desire for something new and yet untried in this type of building: something more akin to the prevailing socio-aesthetic-economic climate.

Whatever the reasons were, a change was made; but in order to appreciate the extent of this difference of concept it is necessary to examine some typical examples and, where possible, compare them to similar work done previously. First then, a police station built by Barnet in George Street North, Sydney: it has a tripartite stone facade, heavily rusticated and dominated by a central round arch supported by two Tuscan columns; the division of the facade is achieved by heavy stone pillars flanking the arch and rising to an entablature surmounted by a pediment and thus providing an aedicule for the central area; similar stone pillars define the limits of the building and support an entablature and balustrated parapet (3). It is heavy with the weight of authority, imperial and, for its size and relative importance, rather pompous—a product of its time. If a comparison is made with Vernon's police station at Darlinghurst, a building of approximately the same degree of importance, the difference of approach becomes immediately clear: built in brick with stone dressing it has a cylindrical corner section huddled against two cubic forms, with small, segmental single-storey masses nestling into the corners formed by the meeting of the larger masses; and a picturesque roof line is made possible by the merging of gable ends with the conical roof of the corner section (4). It is unpretentious, bearing little of the hallmark of authority apart from the royal arms, approachable, almost domestic.

It might be argued that Vernon was forced into a more relaxed style in this building because of its corner site; but apart from the fact that such a site is often used to make a

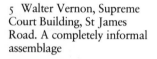

5 Walter Vernon, Supreme Court Building, St James Road. A completely informal assemblage

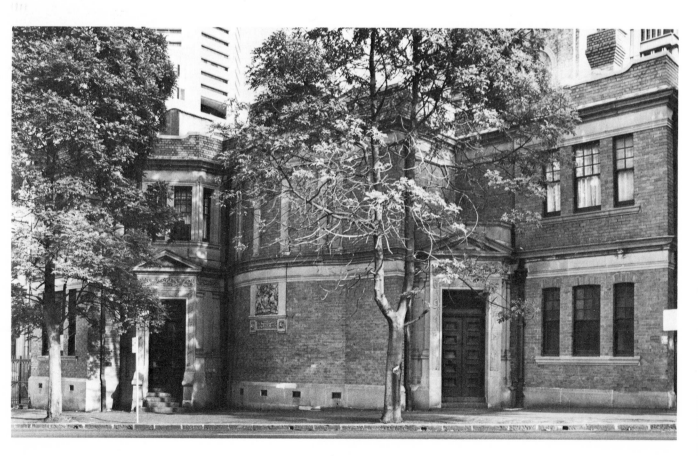

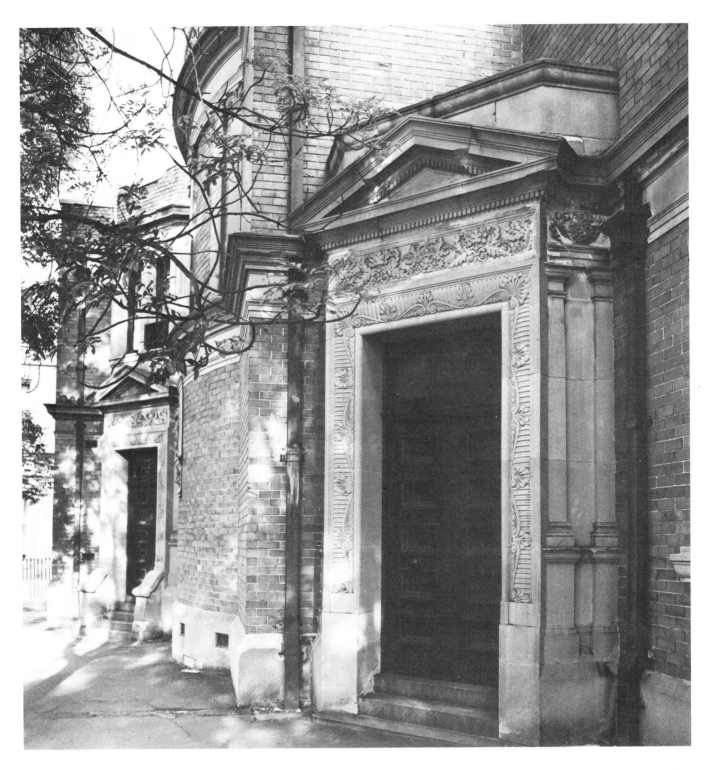

building more impressive, Vernon often used an assemblage of different geometrically shaped masses irregularly to give an informal feeling to a building: his extension of St James Road to Greenway's Supreme Courts in Sydney is a good example of this. Instead of building the facade in a straight line following the street alignment, he has assembled it by flanking a central bowed section with two rectilinear masses, one of which is receding from the central volume and the other protruding. Into the angle formed by the meeting of the sections, entrance doors have been placed at an oblique angle to the street alignment. The assemblage is completely informal, the only concession to formality being in the application of stone pilasters supporting an entablature and festooned parapet on the bow, and the royal arms below (5–6). This is a complete change of style in courthouse building and hardly needs comparison with any of those built previously, from Green-

6 Walter Vernon, Supreme Court Building, St James Road. Entrance doors placed at an oblique angle to the street alignment

way's in King Street through to the later ones of Barnet, where either symmetry or regularity was used to provide a formality and dignity appropriate to the law.

This same difference of approach is apparent in all other official buildings built in Vernon's time.[11] What could be more different from the facade of Barnet's fire station in Castlereagh Street, Sydney (7), than Vernon's Darlinghurst Road facade of the King's Cross Fire Station (8)? The one straightforward, with regular groupings of fenestration divided by rusticated stuccoed pillars and surmounted by a parapet unbroken in height. The other remarkable for a dramatic rise and fall of roof line; with its rounded and pointed gables competing for attention; with some sort of horizontal uniformity being restored by stone banding running along the facade at first floor level; and with a semicircular galleried section to accommodate the corner. It is hardly possible for two buildings serving the same purpose to be so different.

The few examples given here represent only the tip of the iceberg, and although it is impossible to illustrate in this study the scores of buildings by Vernon which exhibit the characteristics mentioned, it might be beneficial to name some which would allow readers to verify for themselves. A number of buildings in the Sydney University are distinctively Vernon: the old Peter Nicol Russell building, the old Union building, the Veterinary building, and the Agricultural building. They all have characteristics which immediately associate them with one another: they are built in the same materials, brick with stone dressing; they all have certain Gothic elements like pointed gables, an occasional trefoil arched window, gargoyles and buttress light features; and like most of his building after

7 James Barnet, Fire Station, Castlereagh Street. Regular grouping of fenestration divided by rusticated stuccoed pillars

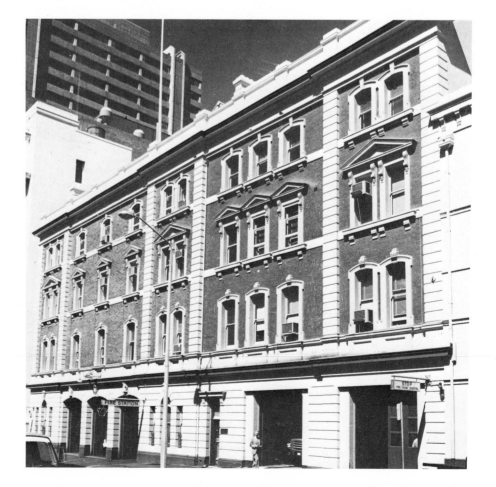

8 Walter Vernon, King's Cross Fire Station. Dramatic rise and fall of roof line, irregular fenestration

1908, they have art nouveau minor decorative elements. Although ornamentation is used, it is used sparingly with emphasis being rather on the manipulation of volumetric shapes to give interesting visual effects. There is also a general truth-to-materials air about these buildings, with the use of unpainted brick interiors and exposed structural elements—the reading room of the old Union building being a good example of this.

To sum up some of the characteristics of Vernon's style, emphasis must be placed on the use of brick and stone dressing as building media, gables rather than parapets, irregular massing of volumetric shapes, restricted use of ornamentation in most buildings[12] after the turn of the century, frequent use of the plain rounded arch and semicircular windows: all of these allied to a generally picturesque modest domestic air. Look at almost any of the Vernon suburban or New South Wales country post offices, police stations, court houses and (after 1904) schools, and some or all of these characteristics will be present.

Whether one approves or not of this new look to government building effected between 1890 and 1911 is a matter of personal preference, but it would be hard to deny that there was a need for change due to altering social circumstance and a demand generated by that need. Vernon responded to that demand with a style more appropriate to the modest beginnings of a new nation.

PETER QUARTERMAINE 'Speaking to the Eye': Painting, Photography and the Popular Illustrated Press in Australia, 1850-1900

... since we learned how to make the sun paint for us, attention has been directed to the subject in all the countries of Europe; and in no art have greater improvements been made than in the arts of engraving and printing engravings. The result is a facility of illustrating passing events truly and graphically, which makes the artist as much or more than the writer, the historian of our times.
— *Illustrated London News*, 24 May 1851

The reader will glean much from our pages to which he must otherwise have lived and died a stranger . . . He may see his fellow-colonists engaged in every branch of industry, and . . . be a spectator of every future important event of colonial history . . .
— *Illustrated Sydney News*, 16 June 1864

Over thirty years ago Bernard Smith observed of Australian art that 'the majority of important artists who began their work during the eighties and nineties of last century graduated through the illustrated periodical'. The Australian periodicals came into being largely as a result of a sudden demand for visual as well as written accounts of the new gold rushes, and they made the country 'in the second half of the nineteenth century one of the most important centres of black and white art in the world'.[1] Like the photographs upon which they were often based, the wood or steel engravings represented a flourishing popular art form for over a half a century, until technical advances made it possible for photographic reproductions to replace them and create the 'illustrated magazine' as we know it today. The role of the illustrated periodicals in the cultural history of Australia has been neglected, and I hope that the account which follows will help establish their importance as well as provoking discussion on the role of photography in the visual arts in the latter half of the nineteenth century.[2]

The *Melbourne Illustrated News* made clear in its first issue, for October 1853, the extent to which it was intended to provide a means by which the public could communicate to friends at home not only news but 'a more perfect picture in details of the country they have adopted than any description in words could furnish'.[3] The article also reveals a certain sensitivity as to where 'home' might be, and an intention to use illustrations to establish Australia as the place where its readers belonged:

Our arrangements will enable us to give a series of illustrations of *home* (Australian) subjects and scenes as they occur. We have secured the services of artists of ability, in every department connected with the pictorial department of the paper, which will enable us to present to our readers, in due succession, illustrations of the domestic architecture of the colony, public and private, scenes in the bush, at the goldfields . . .

That the editors had something more than simply anecdotal illustrations in mind is suggested by their defensive tone in anticipation of sneers at the very idea of an illustrated journal. Seeking to prove the seriousness of their undertaking, they drew a comparison (perhaps with more imagination than logic) with 'the aboriginal Peruvians or the more civilized Egyptians, whose genius and superior refinement taught them to record in

pictures, and transmit to posterity the annals of their history'.[4] Such appeals to antiquity were understandable but misguided, and the *Illustrated Melbourne News* argued the case some five years later in terms which leave no doubt of the primary importance of photography. The writer still invokes pictures as 'the oldest narratives extant' and invites comparison with 'the time of Chofo or Osirtesen', but his central and irrefutable claim is that:

since science has compelled the sun to limn the portraits of our contemporaries . . . there is no impugning the truth of the pictorial record, how much soever we may question the veracity of the human scribe.[5]

The Introductory Address to readers in the first issue of *The Melbourne Pictorial Times* in July 1855 was eloquent not only upon the general necessity for 'a good Pictorial Paper' at a time when 'civilization, with its constant attendant the Fine Arts, has risen to so high a pitch', but upon the importance of that paper depicting accurately and fully the typical features of Australian life:

Let us be understood distinctly to say that we are not about to emulate . . . the illustrated publications of England, France or Germany; what we intend to do is chiefly to display our 'personal appearance' . . . with a constant and graphic eye to all our progressive improvements and changes.[6]

The journal aimed to present a comprehensive visual picture of the colony, and the precise description of items which would feature in later issues coincides almost exactly with the range of subject-matter to be found in the albums issued by professional photographers in Australia during the period up to 1870:

. . . views of Public Buildings, Institutions, objects of local interest, new townships, new inventions of mining machinery, public works—completed, or in progress, Australian scenery, of course including the tent-life of the goldfields, and the camping-out in the Bush. We shall also give occasional portraits or sketches of well-known characters . . .[7]

References to the undeniable accuracy of the photographic image in captions to engravings which are acknowledged as being from photographs make it clear that landscape photography did not, like portrait work, suffer from any conflict between the literal quality of camera vision and what was thought to be attractive. The *News Letter of Australasia* for May 1860 remarked of its cover picture that it would:

recommend itself to all old colonists by its faithful portraiture of Kennedy's Punt, Campaspe River. To those who assert that this colony is deficient in the picturesque, it affords an unqualified denial, the original sketch being taken by the aid of that invaluable delineator, the photographic apparatus, it is free alike from the flattery of the artist or the adventitious charms of writing[8]

The illustration in question appears to fully justify these claims of authenticity, and hopefully satisfied the 'old colonists' the writer had in mind. The question of 'the picturesque' is more difficult, and in seeking to understand its relation to the quality of 'faithful portraiture' in landscape, it is useful to consider the opinions expressed in an earlier issue of the *News Letter*. In the 'Journal of Art and Literature' section for January 1857, a review of a Fine Art Exhibition describes paintings by von Guérard as being characterized by 'their general faithfulness to nature, and by skill and delicacy in execution', while photographs of Europe in the same exhibition are evaluated in almost identical terms:

Photographs are in abundance, and are all good. The large ones of views in Paris and Rome call for special notice; some of them are the largest we have ever seen, and their delicacy of detail is remarkable.[9]

This similarity of phrasing is not fortuitous. Von Guérard's paintings possess the quality of detailed particularity typical of the photograph, and in fact exemplify a tendency,

illustrated by English and American painting over a comparable period, for the growth of photography to stimulate an interest in accurately delineated detail in landscape work. In Australia this tendency is associated with the increasing interest shown by painters in the depiction of local life and scenery.[10]

In November 1863 the *Illustrated Melbourne Post* reproduced an engraving of *In the Valley of the Acheron* by von Guérard, and praised the original in terms which made quite clear the extent to which his talent was seen as that of depicting local Australian scenery accurately yet picturesquely. The article quotes with approval the opinion of 'the highest critical authority of the day' that 'every picture purporting to be a transcript of natural scenery, and professing claims upon our admiration as pure work of art, should combine fullness with finish'.[11] After reaffirming the opinion of the 'authority' that 'If nature carries out her minutiae over miles, he [the painter] has no excuse for generalizing in inches' (a remark attributed to von Guérard himself in other editions), the writer adduces as the final proof of the painting's artistic quality a comment by 'a well-known explorer' who remarked: 'I recognise the individual physiognomies of the trees and the brushwood in the foreground'.[12] Earlier in the year the same journal had reproduced a painting by Buvelot of *Scenery at Mount Macedon* (1), and in the accompanying article, 'With a few Remarks upon Art', had discussed the romantic and pictorial possibilities of the Australian landscape for the artist.[13] The writer comments upon the popular role of photography in connection with the illustrated journals, and reveals his attitude to painting as a blend of romantic idealization of the wild Australian landscape and keen interest in the accurate depiction of bush life and scenery. It is a seemingly self-contradictory position, which provides the key to many of the popular illustrations and photographs of the period, and which indicates clearly the dual role which photography was to play in Australia. The accuracy and delicacy of the camera image served both the romantic and the realistic school with impartiality, and this article illustrates how the two attitudes could be reconciled.

In his role as the surveyor and illustrator of new territory, the photographer is seen as having provided a new source of wild and remote landscape scenes to delight not only Australians but the academic critics in England:

By the skillful means of photography, and the more recent acquisition among our Australian selves of the engraver's art, we are enabled occasionally to present our readers with some of the choicest and most enviable bits of local scenery, such as we feel certain would gladden the enthusiastic student of the old world, could he be but momentarily transported to the spot.[14]

The writer argues, moreover, that Australian scenery offers the artist elements of the romantic and the exotic no longer discoverable in more settled lands. The interpretation of a skilful (English) artist would reveal to the eye the 'unique character' of the scenery, and lead to recognition of that 'primeval' quality of the landscape unnoticed by many Australians:

Hundreds of scenes and subjects which are common to us, and which our material eyes almost hesitate to notice, would, under the masterly handling of the English artist, glow forth with a magnificence and freshness unknown in the monotony of frequent repetition. For there is a unique character in our scenery, essentially Australian, and when among the untrodden park-like plains, the wooden wilds, or rocky heights—savoured with the kindred association of the quaint aboriginal—there is a sentiment almost Arcadian, something of a primeval element, that might induce the belief of having reached the other side of some thousand years gone by.[15]

While admitting that such 'retrogression' is 'at variance with modern economy', the writer concludes that:

1 *Scenery at Mount Macedon*, engraving after a painting by Louis Buvelot, *Illustrated Melbourne Post*, 25 April 1863, p.1. La Trobe Collection, State Library of Victoria, Melbourne

the poetry of retrospection is the legitimate hand-maiden of art . . . The mere portrayal of existing phases, wins only on the finer faculties of the mind as it approximates to this standard—the conception of original purity and beauty; and it is this very distinctiveness or opposition to the commercial phase of life, that gives and constitutes the properly balanced mind, by promoting the appreciation of the poetical and the beautiful.[16]

Australia, then, represents the last example of a primeval Arcadia and, far from lacking the picturesque qualities of the European landscape, offers in its strange and primitive nature the possibility of depicting from life certain aspects of the exotic:

There can be no doubt that in the present keenness of our civilised sensibilities there is infinite pleasure and relief in the contemplation of what is primeval. There are no more continents to be discovered, and in the possession of Australia we have perhaps the only remnant of that original uncommercial world which may be considered the poetry of Oriental times; and ere this is trodden down, or the original denizen depopulated, may our pencil labour in transcribing its beauties.[17]

In these comments the writer appears to align himself with earlier artists who had seen Australia as the land of the noble savage, but he goes on to distinguish between his own attitude and that of artists who are found to ignore the existence of Australian sentiment altogether:

in the rich and pellucid characteristics of Australian scenery . . . there is that which must eventually establish a school of art, of which, it is to be hoped, we need not be ashamed, and so let Art be considered as one of our household institutions . . .[18]

It is in this context of the proud recognition of what the writer sees as a truly Australian

school of art that he stresses the importance of the illustrated journal. It is to be hoped, he maintains, that the efforts are worthwhile:

in endeavouring to graft on our colonial journalism that important element of modern civilisation so successfuly embodied in the illustrated issues of England and America—the pictorial transcript of local characteristics—the popular theory of speaking to the eye in the wide dissemination of pictorial pages.[19]

The writer had begun by stressing in general terms the way in which the 'almost Arcadian' quality of Australian romantic scenery stands in contrast to 'the mere portrayal of existing phases'. But his conclusion is specific and local, concerned with the importance of 'pictorial pages' in the popular journals, and promising a special place for pictures of bush life and scenery:

Let the pen and pencil here, as elsewhere, go hand in hand . . . we shall continue to select subjects to the best of our judgement, and be always ready to give publicity to worthy sketches from our up-country friends.[20]

In its easy transition from stress upon the 'romantic . . . sylvan scenery' offered by the 'rocky passes' of Mount Macedon to discussion of the importance of 'local characteristics', the article illustrates how seemingly academic preoccupations with the 'unique character' of Australia lead to an interest in the specific, typical features of local life and scenery. Such an interest, whatever its antecedents, was essential before artists in Australia could paint local views for a local market.[21] The popular illustrated journal, with its 'wide dissemination of pictorial pages'—themselves based to a large extent upon photographs, played an important part in bringing this situation about, both through its illustrations and through critical arguments such as the one examined. The relevance of such discussions to von Guérard's paintings is clear, and it comes as no surprise to find that accounts of his work by contemporaries value both the romantic elements and those which show an almost scientific attention to detail.

Von Guérard's technique produced pictures of photographic accuracy and detail, and while many contemporary commentators recognized and admired this quality, some detected the lack of a romantic attitude in such meticulously faithful work. The *Illustrated Australian Mail* commented in 1862:

His vision comprehends the whole, and comprehends also the minutest part. The vastness of natural objects . . . Nothing is overlooked, nothing imperfectly recorded, nothing imperfectly introduced. What he sees he describes, with literal truth and admirable force. His interpretation is faithful to a fault, and faulty, by reason of its excessive fidelity . . . He is, it must be confessed, more intent upon conveying the form than the spirit . . .[22]

Some indication of the 'spirit' felt to be lacking is given by the account of *In the Valley of the Acheron* by von Guérard in the *Illustrated Melbourne Post* the following year. Yet even here his blending of 'scientific statement' with the 'fitful radiance' proper to romantic landscape painting does not escape comment:

The sharpness and crispness of outline, the aerial transparency, the melting softness of colour in the misty concavity of the mountain, the scientific statement of geological structure, the purity and delicacy of the shadows, the happy incidence of that pencil of rosy light, which streams through a fissure in the range, touching the jagged peaks with fitful radiance and crowning the solitary pinnacles with a momentary glory—these constitute the best testimony to the artist's genius as a landscape painter, and prove his rare capacity as an interpreter of nature.[23]

Such praise certainly recognizes an ability to convey 'the spirit' as well as 'the form', but the 'misty concavity' and the 'jagged peaks' are seen as no less accurate for being dramatically illuminated by a 'pencil of rosy light'. The overall effect of von Guérard's painting is

summed up by a writer as 'a growing sense of the absolute illusion'. This approach to von Guérard's work illustrates Bernard Smith's remark that by the middle of the nineteenth century:

the 'picturesque' had taken unto itself so much of the documentary discipline of science that the artist was able to publish a painting with an appeal both for the scientist and the man of taste.[24]

It is clear that von Guérard's paintings were seen as fulfilling a particular purpose through their Australian subject-matter and detailed treatment of it. An account of a new work by him, *A Landscape in the Daylesford District*, printed in the *Illustrated Melbourne Post* for 1864, displays an understandable pride in an artist who has devoted himself to the delineation of the local scenery with such success:

The art critic in Victoria seldom finds subjects for his pen. Occasional importations of works of art from Europe are welcomed by him as exceptional events. But it is with peculiar pleasure that he

2 *Fern Tree Gully, in the Australian Alps*, engraving after a sketch by Nicholas Chevalier, *Illustrated Australian Mail*, 18 January 1862, p.37. National Library of Australia, Canberra

examines any work of either sculptor or painter resident amongst us, who devotes himself to the study of colonial subjects, the illustration of Australian life, or the picturing of Victorian landscapes.[25]

Another artist whose work merits consideration in this connection is Nicholas Chevalier, who did a considerable amount of illustrating for the popular journals. Consequently he was accustomed to providing definite detail for the engraver to follow, and to depicting representative scenes of Australian life. A caption to a drawing by him in the *Illustrated Australian Mail* for 1862 of a *Fern Tree Gully in the Australian Alps* (2) gives an indication of the accuracy the journals sought to achieve, even in the illustration of such romantic scenery: 'The accompanying illustration, which represents with photographic fidelity some of the mountain scenery of Gipps Land, will serve to show the romantic characteristics of the Australian Highlands'.[26] Chevalier's picture of *The Buffalo Ranges* (1864) was described by the *Illustrated Melbourne Post* in 1865 in terms which stressed the extent to which he had established a reputation for delineating the specific, local qualities of the Australian landscape:

by continually painting the special features of the Australian landscape from nature, he has so thoroughly familiarised himself with characteristic forms and local effects, that he has in a manner got off by heart the practical rules necessary to be known in giving the quality of true resemblance to his subjects.[27]

The reviewer saw this quality of 'true resemblance' as being largely due to Chevalier's 'habit of copying with truthful exactness . . . the objects he transfers to his canvas'. It is clear that part of the pleasure the commentator derived from the picture was in seeing local details portrayed truthfully yet attractively:

Nor is this truthfulness less obvious in the special details scattered about in that part of the picture that comes nearest to the eye. The digger's hut is eminently picturesque, but it is of photographic accuracy . . .[28]

Two months later the journal reproduced an engraving of the painting, and commented that Chevalier had 'executed a work which does infinite credit to himself, and of which the colony ought to be proud'. It is a curious illustration of the extent to which admiration of photographic detail in painting went hand in hand with romantic attitudes, that it was this same painting which in 1874 inspired Marcus Clarke to write some of his oft-quoted remarks on the 'weird melancholy' of the Australian landscape.[29]

In an artistic climate which displayed such an interest in particular detail it was to be expected that the camera would exercise a considerable influence, and admiration for the delicate quality of photographic prints is more fully understood when it is realized what a revolution such prints were in Australia. Jack Cato has argued for the importance of the photograph at this period in Australia, and while he does not take full account of the impact of the camera upon the livelihood of the portrait and miniature painters, he rightly stresses the way in which photography stimulated visual awareness as well as making faithful original images of local life available to the general public for the first time:

Photography was born into a pictureless world. There were a few originals for the privileged rich but processes of reproduction were rare . . . Photography gradually made the whole world picture conscious, and rather than injuring the development of painting, was probably its greatest blessing.[30]

The poor quality of the engravings after European artists available for purchase in Australia was denounced by the *News Letter of Australasia* as early as 1856. The writer found that:

3 *Saturday Night in a Digger's Hut*, engraving after a drawing by Nicholas Chevalier, *Illustrated Australian News*, 23 February 1865, p.7. La Trobe Collection, State Library of Victoria, Melbourne

the engravings purchased . . . on the strength of the artists' names, and of a recognition of once familiar subjects, are but the impressions of plates long since worn out . . . defaced plates are bought up by the exporters of Houndsditch, and fudged up to produce cheap prints for the colonies.[31]

In a situation where imported engravings were of such poor quality, it was likely that photographs of local scenery would have a correspondingly greater impact.

It was natural that one of the main interests of the early illustrated journals should have been in depicting scenes of bush life, for these would have been recognized and appreciated by many of the readers. Thus the *Illustrated Australian News* could say in 1865 of its illustration *Saturday Night in a Digger's Hut* (3): 'The scene here depicted by our artist is one that must be familiar to every one acquainted with our goldfields . . . The picture speaks for itself'.[32] A readership with at least some knowledge of diggers' huts is clearly assumed, but that there was another section of the readership for whom such illustrations held a more remote romantic attraction is indicated by the text accompanying the illustration of *The Wood-Splitter's Hut in Fern-Tree Gully* in the same journal for December 1865.[33] Such a romantic attitude is by no means typical of all the features on bush life in the journals of the time. The previous year *The Australian News* illustrated *A Night Encampment of Bushmen*, and commented wryly:

The rough and ready style and the many delights which attend life in the bush, have been extolled by able pens to the restlessness of many condemned to the insipid conventionalities of civilization . . . The artist has contributed his share towards the representation of the sunny side of the scene.[34]

In the same year an article was published which emphasized the darker side of rustic life from the point of view of someone who understood the physical and financial hardship it entailed. Under an idyllic picture of a shepherd beneath a tree, his flocks grazing in the background, the *Illustrated Australian News* commented:

4 *Interior of a Shepherd's Hut*, engraving after a drawing by Cousins, and *Exterior of a Bushman's Hut on a Sunday Morning*, engraving after a photograph by Walter, *Illustrated Australian News*, 21 March 1870, p.13. National Library of Australia, Canberra

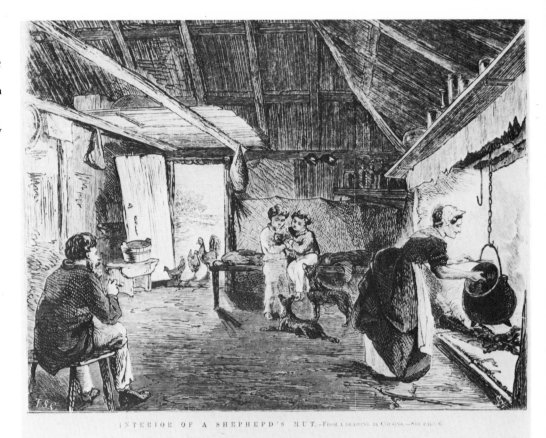

INTERIOR OF A SHEPHERD'S HUT.—From a drawing by Cousins.—See page 6.

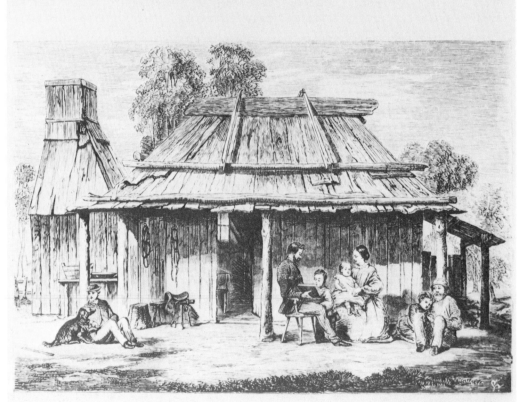

Pastoral life looks very pretty in the poetry of Theocritus, Virgil, and even of James Thomson, but has nothing very imaginative in it except for those who have never, on Grampian height or Australian plain, Norval like, fed their flocks—poor frugal swains . . .

In truth, the occupation of shepherding . . . is one of the most listless and monotonous that can be conceived . . . It is well for the pastoral interests that man is a strangely constituted and adaptable animal.[35]

By the 1860s the increasingly large proportion of the population living in the cities or travelling by public transport across country had rendered direct experience of bush life sufficiently rare to make its depiction an item of interest. The English economist, Stanley Jevons, had travelled by road to Melbourne from Sydney in 1859 and observed in a letter home to his sister Lucy: 'As steam communication with Melbourne is so convenient and rapid, it is an unknown thing to go overland, except when there is necessary business on the road'.[36] Throughout the latter half of the nineteenth century illustrated features on bush life were a regular feature of the journals (see 4 for example). *A Bush Cottage*, *Crossing the Creek with Cattle* ('A Real picture of Australian life and scenery . . .'), *A Selector's Hut on a Sunday Morning* ('a real scene . . . taken from a photograph') and *Incidents in the Life of a Selector* are typical titles of single illustrations or, as with the last example, of a page of vignettes showing bush tasks and scenery.[37] Of the *Incidents*, the *Illustrated Australian News* for November 1885 commented:

Very few people, with the exception of those who have been personally engaged in the task of opening up new country, can form any idea of the trouble and hardship that is undergone by the pioneer selector of forest land.[38]

The purpose of such engravings was to depict typical aspects of life in the bush rather than to illustrate items or events of particular interest. A scene entitled *View of an Australian Farm* in the *Illustrated Australian News* for 1869 had these accompanying comments:

We are not aware that the talented artist assigns any reason for having selected this particular farmyard as the subject of illustration beyond the fact that it is similar to others, and may be regarded as typical of the first stage of home-making in the bush.[39] [compare 5]

5 *View of an Australian Farm*, engraving after a sketch by J.H. Carse, *Illustrated Australian News*, 27 December 1869. National Library of Australia, Canberra

The illustrated journals came to rely increasingly upon photographs as the source for their engravings, and in terms of convenience and accuracy there were obvious advantages in this. The faithfulness of the photographic print was much appreciated, and it gave an amount of detail which was impossible for the sketcher to equal profitably (6 and 7). Even where the engraving reproduced essentially an outline sketch, the scene usually had a reality lacking in the usual stylized engravings. *The Pictorial Australian* for January 1887 published sketches of the Teetulpa goldfields, acknowledged as being from photographs by Tuttle and Co., which have exactly this quality of bare authenticity. The journal stresses the documentary value of the photographs, which the engravings presumably sought to capture:

We have been once more supplied with a most interesting lot of photographs illustrative of a digger's life at these promising fields. Any one who scans these pictures with care and thoughtfulness cannot fail to acknowledge that there is something instructive in such delineations which the pen of the scribe, be he ever so graphic in style, is unable satisfactorily to convey to his reader.[40]

In printing a series of landscape views from photographs in 1889, the *Australian Sketcher* still felt obliged to remark: 'For the items in this group of picturesque and striking subjects the artist is indebted to the perambulating photographer, and their variety is evidence of the extent of ground he covers . . .'[41] The 'perambulating photographer' had been providing a steady stream of material for some thirty years before this, and an idea of the range of subject-matter covered, and the considerable enterprise involved, may be gained from the exploits of Charles Walter. His advertisement in the *Illustrated Australian News* for January 1869 reads: 'Charles Walter. Landscape Photographic Artist. Colonial Scenery taken. A Great Variety at Moderate Prices. Letters addressed to The Age Office will be forwarded'.[42] An account of Walter's travels published in the journal for October 1866 gives some indication of why it was necessary for letters to be forwarded to him:

Mr. Walter . . . has devoted himself for years entirely to the landscape branch of photography and many of the views of Australian scenery which have appeared from time to time in our pages, have been the result of his labors.[43]

6 Stereoscopic photograph by Charles Walter, registered for copyright in Victoria 19 October 1870. La Trobe Collection, State Library of Victoria, Melbourne

7 *Black Camp, Lake Tyers Mission Station, Gipps Land*, engraving from a photograph by Charles Walter, *Illustrated Australian News*, 7 August 1869, p.160. National Library of Australia, Canberra

The labours involved would seem to have been considerable to judge from the journal's account. Walter apparently travelled alone on his photographing trips, 'with his apparatus and tent upon his back—the whole weighing fifty pounds', and 'penetrated to places inaccessible to vehicle or horse . . . after considerable clearances had been effected by means of a tomahawk'. He surely earned the generous tribute that the journal published on his activities for the promotion of the picturesque:

Mr. Walter deserves the highest praise for his exertions in so ably illustrating the romantic and the picturesque which nature has scattered so lavishly around us, and not the least important result of the publication of the views which he has so successfully taken, will be to direct the lovers of nature to places hitherto unknown . . .[44]

The *Illustrated Australian News* refers to Walter in 1869 as 'our photographic artist', and in 1873 published a lengthy account of a journey in the bush taken by 'our artist' which showed him with a large box and a tent on his back, and a 'tomahawk' in his right hand.[45](8) That this is a picture of Walter is confirmed by the text in which the artist gives an account of his motives which tallies closely with the earlier remarks of the journal:

In giving the following minute description of the track, I have been prompted by a desire to assist any tourists in search of the picturesque that they may find their way through a rather difficult but nevertheless most interesting part of our colony.[46]

Walter presumably had a commission from the journal to supply suitable illustrations, and in ability (and constitution) he was apparently well fitted for the task. That he should have succeeded in exposing and processing his wet-plate negatives under the conditions described is perhaps the greatest achievement of all, even if there was the added attraction of adding to his own 'great variety' of Australian views in the course of taking scenes for the journal.

It would seem that Walter often worked alone, but an account of his movements in 1869 indicates that he sometimes chose to work alongside other pioneering recorders of

8 *Our Artist*, engraving
Illustrated Australian News,
31 December 1873, p.212.
National Library of
Australia, Canberra

the landscape. The issue of the journal for June carried an illustration of *The Mouth of the Snowy River, Gipps Land* credited as being 'from a photograph by Charles Walter', together with a long article describing how it came to be taken:

Two geodetic survey parties have been for some time past engaged in extending the triangulation towards the two termini . . . [for] . . . the demarcation of the boundary line . . . Mr Walter . . . made his home with this survey party for two months last year, thoroughly enjoying it . . . He accompanied the survey party to the different mountain peaks . . . taking photographs whenever he had the opportunity. Mr. Walter, after a short stay in Melbourne, has left with the view of returning to his bush life, and photographing in Gipps Land . . .[47]

By comparison with his lone excursions into the bush, Walter must have found working in co-operation with a surveying party a relatively easy method of obtaining photographs of unexplored territory. In November of the same year the journal informed its readers:

Our photographer, Mr. C. Walter, is at present in the neighbourhood of Cape Howe, exploring the coast scenery in company with the geodetic survey party . . . Mr Walter has sent us several sketches, from which we have selected the four which form the pretty vignettes. Accompanying the sketches we received verbal descriptions of the several localities.[48]

The four photographic 'sketches' referred to show *Scenery near Cape Howe* (9), and it is interesting to note that the descriptive text written by Walter contains a good deal of precise geological information. It would have been natural for him to seek the advice of his surveyor companions when writing the text to send off to Melbourne, and this perhaps explains the geological emphasis. The result is that not only are the illustrations precise,

Our photographer, Mr C. Walter, is at present in the neighborhood of Cape Howe, exploring the coast scenery in company with the geodetic survey party. Their quarters seem at present to be at a point midway between Cape Howe and Ram Head. Mr Walter has sent us several sketches, from which we have selected the four which form the pretty vignettes. Accompanying the sketches we received verbal descriptions of the several localities.

Wingan Inlet is situated about two miles east of the Ram Head, and runs into the interior about three miles. At the head of it, a river of the same name empties itself. I found on the banks of this river Cypresses (Callitris cupressiformis) and Peppertrees (Drimys aromatica), the latter very large of its kind, some of the trees being two feet in diameter. Wingan Inlet, I think, never closes; as the eastern shore near the entrance is rocky, the tide runs in and out with great velocity. It abounds in oysters. The geological formation of Ram Head, Wingan Inlet, and extending as far east as Sandpatch Point, is a coarse crystalline granite intermixed with patches of red syenite, and from Sandpatch Point eastward the cliffs are formed principally of argillaceous slate, in some places much contorted, in others intersected with well defined quartz reefs; a fine specimen of the latter occurs at Bastion Point near Mallagota. At little Ram Head there is a singular conglomeration of rocks, showing evident signs of some violent convulsion, the different strata, trap, slate and immense masses of quartz being thrown up in the greatest confusion, and some of the rocks are so twisted as to present the appearance of having been wrung. Between Wingan Inlet and Mallagota Inlet there is little difficulty in crossing the small rivulets and inlets. There is only one deep inlet, about

SCENERY NEAR CAPE HOWE.

CLIFFS AT THE LITTLE RAM HEAD.

Twofold Bay, accompanying him along the coast, and landing every night. On arriving at the scene of the wreck, the crew made free with the flotsam and jetsam, became oblivious, and lost the boat with all the stores. Mr Morris, however, was determined to persevere and succeeded in reaching the Snowy River. In endeavoring to cross it some of the cattle were drowned; the natives, who were then very numerous, mustered in great force, and speared many of the cattle; and Mr Morris saved the lives of himself and party only by abandoning the whole of the cattle, and getting back to Twofold Bay on foot, in a sorry plight. Wreck Creek, as it is called on account of the events just narrated is seven miles west of Mallagota Inlet, and sixteen from Cape Howe.

Cape Everard, one of the prominent points on the Victorian coast, is situated about eight miles east of the Tamboon River. Its geological formation is exclusively granite. The same feature extends to the west as far back as the Tamboon River. On the eastern side from the Toolaway River, which is about three miles from Cape Everard, silurian crops out for about three miles, then granite again to Ram Head, and as far as Wingan Inlet. Half a mile east of the Toolaway, two streams unnamed and not marked on the maps, having their junctions a quarter of a mile inland also run into the sea. One of these streams comes from the northeast and the other from the north, and both flow east of West Hill. These two rivers and also the Toolaway are difficult to cross, being full of quicksands. The geodetic party had to build a raft for each of them, and a boat for Wingan Inlet. The topographical feature of Cape Everard is a series of sand hummocks, extending three miles back from the creek. Beyond the hummocks are wet boggy flats covered with heath and bayonet-grass for several miles; these flats gradually rise and form into low ranges, which run into the coast dividing range—a wretched barren

9 *Scenery near Cape Howe*, engravings from photographs by Charles Walter, *Illustrated Australian News*, 4 November 1869, p.187. National Library of Australia, Canberra.

RIVER SCENE, NEAR CAPE HOWE.

THE SKERRIES, WINGAN, INLET

1½ miles west from Mallagota. The country along the coast here is chiefly open bayonet-grass flats and heathy downs bordering the cliffs that form the sea shore. The coast line from Mallagota Inlet to Cape Howe is low and sandy; but Howe Hill, about 5 miles N. W. from the Cape, is a fine bold peak. From Mallagota Inlet is a bush road to Twofold Bay, distance about 60 miles. There are several stations on the Genoa River and one at Mallagota Inlet.

The view of Wreck Creek was taken from a position which formed the scene of a sad catastrophe in the early days of the colony. About thirty five years ago, a schooner bound from Hobart Town to Sydney with a company of actors as passengers, was seen by the master of one of the cattle vessels trading between Twofold Bay and Hobart Town, drifting helplessly about in the offing. He passed close to the schooner and hailed, but all hands of the ill-fated vessel appeared to be drunk, and receiving nothing but abuse, he went on his way, though with many misgivings as to the fate of the vessel and her infatuated crew. That night the vessel went ashore, and nine out of eighteen of these misguided people paid the penalty of their folly with their lives. The unfortunate actors became the *dramatis personæ* in a play which to them proved an unexpected tragedy. The survivors were found and succoured by Mr Allan, one of the early settlers in that region. Unfortunately the mischief did not end with the loss of the vessel. Being laden principally with spirits, the beach was strewn with casks and cases, and the demon of drink had soon other victims. Mr Morris, a squatter, was at the time trying to penetrate with five hundred head of cattle into Gipps Land, then a *terra incognita*. To facilitate his movements he had a whale-boat laden with supplies from

VIEW ON THE WINGAN RIVER.

country, with no animals but wild dogs. Cape Everard is about 15 miles east of Sydenham Inlet, and 15 miles west from Wingan Inlet.

NEW ZEALAND.

In the Resident Magistrates' Court, Port Chalmers, on the 10th, James Robertson, chief officer of the ship Asterope, was charged by Captain Ingliis with wilful neglect of duty while on the passage from London to Otago. The case was remanded till Tuesday next, bail being accepted.

The Auckland papers report that, owing to the great rush to Coromandel, labor is beginning to be very scarce at the Thames, and it will be utterly impossible soon, when fine weather sets in, for many companies to obtain as many men as they will need for the different workings of the ground.

An Auckland paper mentions, as a proof of the rising prosperity of that province, and of the increased value of land in the neighborhood of Auckland, that a Mr Wallace purchased a small piece of land near Mount Eden about eighteen months ago for £480, the half of which he sold a few days ago for £1500.

Dorrington, the watchmaker at Parnell, who was arrested on two charges of selling arms and ammunition to the natives, has been acquitted on both charges. Considerable surprise is expressed in Auckland at the verdict. The judge made particular reference to the fact of a juryman having conversed with a stranger during their adjournment. His remarks referred to the foreman, who conversed with Dorrington's son. The three natives implicated in the same case pleaded guilty, and were sentenced to three years' imprisonment, together with a fine of £5 each.

WANGANUI, September 9th.—Intelligence was received that Te Kooti had returned to

but they are accompanied by a scientifically exact text which conveys specific information on the characteristics of the local scenery. Whether Walter also assisted the surveying party with photographic work is not known, but it is unlikely that he could have lived with them for so long without having been asked to make practical use of his talents.

The nature of Walter's photographic activity demonstrates the impossibility of making simple distinctions between the various kinds of photography which were practised in Australia during the latter half of the nineteenth century. Much of his effort was devoted to capturing views of remote romantic scenery, but equally his way of proceeding and the detail inherent in his pictures link him with the surveyors, with whom he also worked. The records of his work which exist are important for the light they shed upon a hitherto unnoticed aspect of the camera's contribution to the depiction of Australia. They reveal a role of great variety, but tending always towards faithful representation of scenery and to the exploration of new ground, even in the search for the picturesque. Such tendencies of documentary exploration are confirmed by other photographic work of the time.

If Charles Walter combined an interest in the photographic depiction of the picturesque with the ability to work with surveyors in the literal and visual exploration of the landscape, so too painters who specialized in romantic pictures of 'fearful storms upon high crags', in the manner sanctioned by the academies, found value in the camera's faithful image. The paintings of von Guérard were seen by contemporary commentators as combining the details of scientific statement with romantic grandeur. It is not strange, then, to find that one of the popular painters of the 1870s was by training a surveyor, nor that his hobby was photography.

William Charles Piguenit (1836-1914) was a native-born Tasmanian who began life as a surveyor but in 1872 turned his hand to landscape painting. In 1870 he is said to have won the highest award for photography at the Sydney Exhibition, while his painting, *Mnt Olympus, Lake St. Clair, Tasmania,* much admired at the 1875 Exhibition, was the first Australian painting acquired by the Art Gallery of New South Wales.[49] Piguenit is an interesting example of a painter of romantic landscapes who was successful as a photographer, and who used photography to help him in 'prospecting' for views, rather as he may have used it in his earlier work as a surveyor.

A notebook kept by Piguenit contains occasional entries for the period between February 1871 and October 1875, in particular during a visit to the Valley of the Grose, New South Wales, in 1875.[50] It is clear from Piguenit's entries that on each trip he used the camera and the pen with equal freedom to record details for later paintings, a procedure which may account for the 'flat' yet detailed quality of his work. His practice seems to have been to use the camera to record the general scene, and then to sketch general views and also particular items to be used later in foreground compositions. Thus an entry for 2 February 1873 reads 'Sketched Olympus (North End) from the banks of the river running into lake', and for the following day, 'Sketched a few foreground subjects', while on 1 March he records, 'Took three photographs from South end of Lake . . . Day fine'. Three days later entries read, 'Took photographs of "party on the tramp" and of "Camp Bay". Sketched tree for foreground', while on the eighth he 'took photographs of fine valley' and the next day again 'took photographs'. A later tabulated entry notes subject details and exposure times for thirteen shots around Lake St Clair, including several of those mentioned above.

Late in 1875 the New South Wales Academy of Art arranged for the formation of some sketching camps, 'with the view of enabling its members to form acquaintance with some of the picturesque scenery of the colony'.[51] *The Australasian Sketcher* for April 1876 contained an account of this event, and also published an engraving of *The Valley of the*

10 *In the Grose Valley,
Blue Mountains*, engraving
after a painting by E.L.
Montefiore, *Illustrated
Australian News*, 1
December 1875, p.192.
National Library of
Australia, Canberra

Grose, explaining that 'A photographer accompanied the expedition, and took fifty or sixty photographs of the most striking scenes, and it is from one of these . . . that our engraving is prepared'.[52] According to the journal, 'fifteen large plates, 12 x 14, and about twelve smaller, 10 x 12, were taken', but apart from this official photographer, there was probably other photographic activity. The *Illustrated Australian News* for December 1875 also carried an engraving of the Grose Valley (10), 'from a painting by E. L. Montefeore, Esq.', and attributed the planning of the camps to Mr Du Faur, the Secretary of the Academy of Art, who had spent 'a good deal of time and money over the under-taking':

Under his supervision a camp was formed in the Grose Valley, for the purpose of making sketches and taking photographs of the surrounding scenery, which he intends . . . to transmit to the Philadelphia Exhibition.

Among those at the camps was Piguenit:

Mr. W. C. Piguenit, the Tasmanian artist, was invited to join the photographic camps, and spent four or five weeks in the gorge. It is expected that his portfolio will furnish several subjects at the approaching Sydney and Melbourne Exhibitions, which will do more justice to its grand scenery than can be expected from photography.[53]

Piguenit left Hobart for New South Wales in September 1875, arriving at Mount Victoria via Sydney on the eleventh and on the following day he records that 'Mr. Bischoff arrived (photographer)'. On 26 September he 'completed sketch of Mount George from upstream', while the final entry for 2 October reads, 'Met Bischoff and got him to take two or three photographs of nearly completed sketch of Mount George during after-noon'. Why Bischoff should have been requested to photograph Piguenit's sketch is not clear (perhaps as a record for the Academy of Art of work done during the camp) but in the realm of art and photography their meeting is of interest, for Bischoff's prints have much in common with Piguenit's paintings. An album of photographs now in the La Trobe Library historical collection contains several taken in the area below Mount

George, some impressed with Bischoff's name and a number unmarked but in the same pictorial style. It is possible that these prints were taken in 1875, when Piguenit records Bischoff as having been in this area, and a comparison of the photographs with Piguenit's paintings suggests that the two men would have found much to discuss on the composition and execution of landscape views.[54]

In the case of Piguenit, then, we can be sure that the limpid clarity of his lake scenes and the delicate detail of his cloud-topped crags owe a good deal to the fine definition of his glass-plate negatives. Bernard Smith has noted that Piguenit 'sought dramatic and exciting subjects which would be typical of the country at large', and that he had 'an eye for the typical'. His interest in photography, which was clearly well known at the time, has been overlooked by recent critics, but a recognition of it may help to a fuller understanding of his paintings, and of that taste which ensured their popularity as 'faithful and expressive' works, 'pleasing to the eye and affording food to the imagination'.[55]

Piguenit's works, like those of von Guérard and Chevalier, were often reproduced as engravings in the illustrated periodicals. An exploration of the role played by the illustrated press in forming popular taste, together with the attitude to (and use of) photography by 'high art', could yield valuable insights into the period leading up to 'the nineties'.

NIGEL LENDON Ashton, Roberts and
Bayliss: Some Relationships between
Illustration, Painting and Photography in
the Late Nineteenth Century

At first glance this famous painting (*Shearing the Rams*) appears to be almost photographic. Yet in spite of the artist's concentration on detail, the carefully studied portrait heads and the meticulous drawing of the interior, the picture hangs together extremely well.[1]
— Robert Campbell, *The Paintings of Tom Roberts*, 1962

The traditional assumption of a hierarchy of forms—where the superiority of painting over all other forms of visual imagery is taken for granted—is reflected in the quotation above, and is implicit in most writing on the relationship between painting and photography. The task of this paper is to find a critical method whereby this relationship can be re-evaluated in the light of material factors in the various productive processes, which are not taken into account in the orthodox approach to the subject.[2]

A common problem which is characteristic of an orthodox method of analysis emerges when the 'effects' of the invention of photography are considered within a given and persisting framework of forms, conventions and styles. While one would expect that the intervention of a new form like photography would have inevitably caused some disruption to established assumptions, values and modes of practice, it must be remembered that painters and photographers were themselves subject to the inhibiting influence of the contemporaneous orthodoxies (beliefs about the superiority of painting). Hence the persistence of the problem. It is a constant factor in the various debates on the interaction between painting and photography that a hierarchical viewpoint tends to act as a self-validating mechanism for dominant interests and values, disguised in a 'logic' of formal consistency.

I

In the second half of the nineteenth century there occurred an extraordinary penetration of photographs (and photographically derived images) into the lives of people whose social and economic status had previously restricted their access to visual forms of communication. This coincided with a marked increase in the proportion of the population living in urban centres, and a rise in literacy associated with the growth of the middle classes.

The invention of photography resulted in the virtual demise of certain forms (e.g., miniature portraiture), and in modified modes of practice of others (e.g., naturalistic painting). Even more significantly, the invention of photography and the development of photo-mechanical processes of reproduction made possible the development of the forms of 'mass culture' by which our lives are ordered today.

To a large extent, it was the much-vaunted 'objectivity' of the photographically derived

illustration which helped to establish the form of the late-nineteenth century popular press, which was to emerge in the early twentieth century (in conjunction with the organization of mass production and patterns of mass consumption) as the 'mass media'. Yet this 'authority of the camera', as perceived by the audience of the popular press, is not some abstraction of a scientific understanding of the technology.[3] It derives from a much simpler process of verification, the photographic portrait. All but the most impoverished sections of society could now afford to commission and possess an image of themselves in the form of a photograph. In 1847 half a million daguerreotype plates were sold in Paris, and by 1862 it is estimated that in Great Britain more than one hundred million photographs were produced annually.[4] The great majority of these photographs were portraits. Would a member of the audience addressed by the print media be willing to 'believe' in, say, the might of the British Empire, on the basis of Roger Fenton's photographs of the Crimean War, if the 'objectivity' of the photographic process had not already been confirmed by the making of his *own* photographic portrait? Illustrations in the press, or naturalistic paintings, became more or less credible, or powerful, according to the degree to which they were seen to approximate 'photographic' reality. It was through the establishment of this complex relationship between the forms of representation and their social application (and reception) that photography caused a fundamental disruption to the traditional hierarchical understanding of the visual arts.

What, then, are the bases for the continuing controversies surrounding the relationship between photography and painting? How might a methodology be developed which adequately accounts for the dynamic interrelationship of the forms of visual representation since the mid-nineteenth century?

We need to consider these questions from two angles: we need to account for *both* the 'aesthetic' *and* the material consequences of the invention and development of photography in relation to the practices of production of all forms of visual imagery. The 'aesthetic' approach is the raw material of orthodox photographic criticism, which has produced its own body of literature.[5] The primary purpose of this paper is to explore the *connections* between aesthetic and material considerations in circumstances where we have become accustomed to their *separation* as the norm in the literature of photography.

In formal terms the development of photography through its early stages can be seen to have exerted an influence on painters in a number of ways, both through a conscious use of the new medium and (unconsciously) through conventions derived from its use in other forms of visual representation. In the former, photography was used by painters as a substitute for sketching, as an *aide mémoire* to assist with the depiction of precise details or topography. Early instances of painters' use of the camera in Europe (both in the photographic process and its antecedent, the *camera obscura)* are numerous and well documented.[6] Its use in this sense might be seen to extend from the study of form *per se* to the early photographic studies of form *in motion* which were of intense interest as much to painters of an academic following as they were to the Impressionists.[7]

In Australia it seems likely that the first artist to make use of the camera was S. T. Gill, who in 1845 imported the first daguerreotype apparatus to Adelaide.[8] Both Conrad Martens and C. W. Piguenit made early use of the camera as an integral part of their practice as painters.[9]

The consequences of the use of the camera on the prevailing conventions of pictorial composition are more complex: consciously used, the frame of the photographic image and the spatial distortions induced by contemporaneous lenses resulted in outstanding innovations, as well as some extremely uncomfortable attempts to interpret these new conventions.[10] Unconsciously perhaps, the attention given to 'the frame' may have re-

sulted from its coincidence with the typographical requirements of book and magazine illustration.

Aaron Scharf makes the further point that the various means of photographic production encouraged an emphasis on tonal rather than linear structure in drawing and painting; similarly, he investigates the attention given by artists to the blurred figures of early instantaneous photography, or the indistinct forms of foliage on a windy day. Such aspects coincided with a scientific interest on the part of some painters in the properties of light and the perception of colour.[11]

On another level, there occurred a kind of inversion (or 'reversion', if understood in relation to the innovations which derived from photography) when the 'standards' of painting assert their hierarchical authority over the modes of practice of those photographers whose aspirations were to join the ranks of the Fine Arts.

The strength of this concurrence with the prevailing taste in the criticism of painting can be seen by comparing the precision and detail of British photography with the soft focus and atmospheric effects of its French equivalents.[12] The aspirations of most professional photographers towards their 'proper' place in the hierarchy of the Fine Arts can be seen in the subjects which they chose to exhibit in the Intercolonial and International exhibitions of the 1860s, 1870s and 1880s. Their search for the exotic or the picturesque scene reflected the dominant aesthetic interests of their European counterparts.[13]

Given the above, to what extent it is meaningful to refer to a painting like *Shearing the Rams* as 'almost photographic'? Any contextual examination of the relation between photography and painting reveals that at least *some* of the interrelationships would have been familiar to any realist or naturalist painter in the late nineteenth century. We can safely assume that such artists would have been well aware of the aesthetic controversy, irrespective of whether their work implied a relationship of a more utilitarian nature. From the remarks of Charles Conder in 1891 in a letter to Tom Roberts (when he was working on *The Breakaway)*, we can see that the use of photography was for these painters *anything but* controversial:

The difficulties of sheep in motion must be tremendous and need a deuce of a lot of study and memory (wouldn't photographs help you somewhat? That's the way the sheep and cattle painters work here, they say, but after all they show it a bit too much after). However, it doesn't matter too much how it's done does it? So long as you get what's wanted.[14]

That the sheep and cattle painters of Europe 'show it a bit too much after' hardly compares with the nature of the debate of earlier years. Of Courbet's *Burial at Ornans* (1849), the critic Étienne-Jean Delécluze wrote:

In the picture, which might easily be taken for a badly developed daguerreotype, there is the natural crudity which is always the result of taking Nature at first hand . . . In spite of the gross defects which spoil M. Courbet's huge picture, there are certain very solid qualities in it, and parts of it are too well painted for anyone to believe in the ignorance and rawness affected by this artist.[15]

With regard to naturalistic painting, the use of the term 'photographic' as a derogatory epithet (rather than an objective description) emerges in criticism of turn-of-the-century Salon and Royal Academy painting. An indication of how this was received by painters of the Heidelberg school can be deduced from McCubbin's reading of an essay by Walter Sickert on the work of Bastien-Lepage:

Sickert writes about Lepage in a spirit of detraction, saying that he was no artist at all but only a clever workman, whose main object in life was to produce a big photograph. Entering for the Salon every year, he never got beyond slavish copying of the model, and had no sense of movement in his work . . . For myself I think Sickert is a fool; he is incapable of any catholicity of judgement.[16]

Continuing references to 'photographic' realism must, therefore, be located in relation to the state of the controversies of the time. Campbell, quoted at the beginning of this paper, characteristically fails on another score: *Shearing the Rams*, in both the academic character of its composition and in the way it is painted, is demonstrably *non*-photographic.[17]

We must also consider, however, a question which may be particularly relevant to Tom Roberts, given the variety of means by which he sought to achieve the naturalism he desired. To what extent were painters, while consciously making use of photography as an aid to their paintings, subject unconsciously to the indirect influences of the invention and development of photography? While painters may have taken advantage of the controversies surrounding 'photographic' naturalism or realism, they were themselves subject, at the same time, to the ideological role of photography in the form of the illustrated popular press.

To follow this line of speculation beyond the realm of aesthetic controversy it is necessary to make a comparative study of the practices of the professional photographer at the time when real competition (in an economic sense) existed between the photographer and the painter/illustrator.

II

On 26 June 1880 the news reached Melbourne that the Kelly gang had killed the informer, Aaron Sherritt, near Beechworth in north-eastern Victoria. Immediately a train with a small detachment of police and trackers was despatched to the scene, and four 'representatives of the Press' were invited to accompany them. The journey there was newsworthy in itself, and was reported in the most minute detail by those aboard. Travelling at high speed in the early hours of the morning, the train first survived crashing through a gate across the track, damaging its braking system. Later, near Glenrowan, with the news that the track had been torn up by the Kellys, the train was forced to proceed at walking pace, its passengers in constant fear of ambush.

On arrival at Glenrowan, the police found that the gang had retired to the hotel, holding the whole population there at gunpoint. The siege of the hotel, the arrest of Kelly himself (wounded despite the protection of his suit of armour), and the killing of the three other members of the gang by police and volunteers, has become a legend, part of Australia's folk-history. This found its first form in the extensive coverage in words and images in the illustrated press, a climax to the press coverage throughout the gang's notorious history.

The second and later trains to arrive at the scene brought the artists and photographers from the competing newspapers, anxious to provide the most dramatic and authentic coverage of the event. One of these, Julian Ashton, was an artist who had come to Australia in 1878 to work on the staff of the Syme newspaper, the *Illustrated Australian News*, for a salary of £300 per annum. He was characteristic of a new generation of immigrant artists whose need to earn their living working as press illustrators was not inconsistent with their advocacy of painting *en plein air*, or with their emerging interest in a distinctively Australian range of subject matter.[18]

Illustration 1 (*The Capture of Ned Kelly*) is more than simply characteristic of this kind of work; it marks the end of one mode of illustration—the work of the painter-illustrator—and the beginning of another, the era of 'news' photography, the precursors of which can be seen in illustrations 3 and 4. The conflict between dramatic effect and authenticity in newspaper illustrations was not yet resolved in 1880. It is accentuated in illustration 1 by a 'subterfuge', which in a relatively short time would prove unacceptable

1 Julian Ashton, *The Capture of Ned Kelly*, *Illustrated Australian News*, no. 291, July 1880, woodblock illustration. Mitchell Library, Sydney

to a public wishing to read and believe in the news media. The 'subterfuge' in illustration 1 is that Julian Ashton arrived too late to witness the incident he portrayed:

One afternoon I received a message from Mr. Syme to meet him. He informed me that a train was leaving Spencer Street at seven o'clock with police and Press *en route* to Glenrowan, and asked me to go and get material for drawings for the *Illustrated Australian News*. I travelled with Captain Standish, head of the Victorian Police, and reached Glenrowan in the early hours of a wintry morning. As I walked towards the rear of the train I noticed advancing towards me a tall dark-bearded man, limping slightly, with a policeman on either side of him. He had been handcuffed, and his fierce dark eyes rolled suspiciously around. He was made fast to the rail running around the luggage van, a policeman being left in charge.[19]

It is arguable that to refer to an established convention as a 'subterfuge' is a misrepresentation in the absence of any alternative convention. In a real sense, the 'division of labour' which was already occurring between the photographer and the illustrator was limited only by the technological stages through which photography passed.[20] By 1880 the photographer was at the point of being able to 'stop action', to take what we now refer to as 'candid' photograph, a photograph of the event *as it occurs* (4). This 'division of labour' is further evident in the drawing made by Ashton of Joe Byrne's body (2). Here the dramatic reconstruction of an event is less artificially conceived and executed:

Byrne's body was taken to the next township where there was a police station and placed in a cell. As my work was to get some illustrations for the paper I was allowed in the cell which was about eight by six feet. Here I sat on the cold cement floor and, by the light of a candle stuck in a bottle, made a drawing of the dead man. I was glad when I got out in the sunlight again.[21]

Clearly, the artist-illustrator fulfilled a need for the imaginative, evocative, dramatic and even romantic image which the photographer was unable to provide. On the other

2 Julian Ashton, *Finding Byrne's Body—A Study*, *Illustrated Australian News*, no. 291, July 1880, woodblock illustration. Mitchell Library, Sydney

3 Burman, *Byrne, The Outlaw, After Death*, *Bulletin*, 10 July 1880, woodblock illustration. Mitchell Library, Sydney

hand, the photographer excelled in the depiction of topography and landscape, of botany and technology, and in this case *nature morte* (3 and 4).

By comparison with Ashton's drawing, the illustration from the *Bulletin* (3) appears somewhat prosaic to our eyes. In its own time, however, the caption, 'From a picture taken at Benalla by Mr. Burman, Victorian Government Photographer' *proved* its authenticity, in direct contrast to that produced by Ashton.

Perhaps the photographer J.W. Lindt saw what was happening in a much more perceptive way when he set up his camera to show more than the body of Joe Byrne. He chose to include both Julian Ashton (on the left, with a sketch-book under his arm) and another photographer, possibly Mr Burman himself (4). It is perhaps also a reflection of Lindt's extraordinary prescience that it was not itself used as a 'news' photograph, and was not published until 1941 in Ashton's autobiography. The arresting qualities of this photograph derive as much from the significance of the historical event and its macabre aftermath as from another level of meaning altogether. This latter significance is that a relationship between working artist and working photographer has been seen and recorded, fixed forever by the action of another photographer.[22] The historical moment at which such relationships could be recorded by photographic means had arrived and in the literal way which is particular only to photography the developing nature of that relationship was demonstrated to be irreversible.

III

In the first part of this paper I referred to the 'dynamic' interrelationship between the forms and conventions of painting and photography, and other forms of visual representation. To pursue the subject further it will be necessary to consider the practice of the photographer on formal, material and ideological grounds, and compare it with that of the painter in similar circumstances.

Charles Bayliss was the foremost topographical and landscape photographer in Sydney during the late 1870s and 1880s. He began his career in 1869 as assistant to Beaufoy

Merlin, with whom he travelled widely through Victoria and New South Wales.[23] In Hill End in 1870, Bernard Otto Holtermann engaged Merlin to begin the project of celebrating in photographs the characteristics and virtues of the land in which Holtermann had found his fortune.[24] When Merlin died in 1873, Bayliss took over the ambitious project, to be known as Holtermann's Exposition. It was planned for exhibition at the 1876 Philadelphia Centennial Exhibition and the Paris *Exposition Universelle Internationale* of 1878, to name only the most prominent exhibitions in its overseas itinerary. The quality and achievement of the project can be understood both by its scale and by its successful reception by the judges.[25] Part of the attention Holtermann's Exposition attracted was due to the inclusion of a three-panel panorama of Sydney—the largest photographs ever produced, taken on plates 96 x 160cm, made in a camera especially constructed in the tower of Holtermann's mansion at North Sydney. Other panoramas produced by Bayliss measured up to 10 metres in length. The sections of these panoramas were joined together on a canvas scroll, or mounted sequentially in specially prepared albums, or sold individually to be included in the travel albums which were then popular.

In 1876 Bayliss established himself independently as a 'Landscape Photographer', and maintained studios at various addresses in George Street until his death in 1897.[26] While continuing the production of panoramic views, for which he became well-known, he also travelled widely in New South Wales and Victoria, using first wet-plate and then dry-plate technology. His stock-in-trade ranged from the panorama and street scene to scenic photographs which accentuate both the dramatic and picturesque character of the Australian bush. In the latter category his work compares favourably with that of Charles Nettleton, of Melbourne, and with the series published by the Scottish photographer George Washington Wilson.

Illustration 5 is a gold-toned albumen print identified in the lower left corner by the blindstamp 'C. Bayliss Photo. Sydney'. Although we do not know the exact date of its execution, indications given by the length of exposure of this and others in the series

4 J.W. Lindt, 1880, original print not known. Copy from the La Trobe Collection, State Library of Victoria, Melbourne

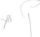

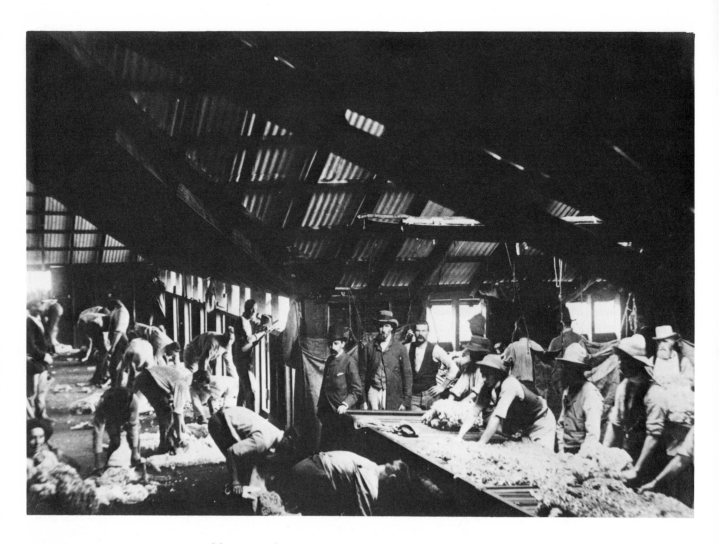

5 Charles Bayliss, albumen print, 14 x 19.5 cm, c.1880. Private collection

would suggest the early 1880s. In itself it is a *deceptive* photograph, which is, in relation to the expectations of the period, a measure of its success. By deceptive, I mean that Bayliss has *disguised* the necessary conditions of its production: apart from the rigid pose of the central figures, the photograph achieves a remarkable illusion of activity. This is despite the long exposure necessary in the dim conditions of the shed, which means that the 'action' had been carefully staged for the camera.

Again, in itself the photograph is remarkably descriptive of the shearing process, from the actual line of shearers on the left to the sorting tables on the right. Some of the details show an engaging animation. The tar-boy at the extreme lower left is smiling at the novelty of the occasion, bearing a marked resemblance to his counterpart in *Shearing the Rams*. The two men at centre left watch the camera, the one to be told when he can release the sheep down the chute, the other stopped in the act of sharpening his shears with a whetstone.

In formal terms, a comparison with Tom Roberts' *The Golden Fleece: Shearing at Newstead* (1894) (6) reveals many similarities: on the right there is the shearer pausing to sharpen his shears, and again the tar-boy smiles out at the spectator. Like Bayliss, Roberts has set out to show the whole process, but in a form of pictorial organization which avoids the central, idealized figure of the shearer in the earlier *Shearing the Rams* (as well as the symbolic implication of it being the rams which are being shorn). In the later painting we

see *the gang* of shearers in action. The paintings are contrasted in their formal organization, from a central figure who is the embodiment of 'strong masculine labour' to a central void, with the workers arranged to left and right, in the later painting. There is a further contrast between these two paintings in the way Roberts has used his colours: in *Shearing the Rams* the central figures are more vibrantly coloured and in a higher key than the others of the gang; in *Shearing at Newstead* the whole interior is bathed with the same warm light, and a uniform tonality.

The central figures in the Bayliss photograph (5) reveal it to be both a portrait and an image of a productive process. The central figure is the owner of the property; next to him stand his overseer and foreman. Their social rank is reflected not only in their clothing but by the formal organization of the photograph. The photograph is being taken for the owner of the property, just as the sheep are being shorn for him. The twenty-six other people in the photograph have been stopped in their work so that the photographer can make the image he has been commissioned to make.

The nature of the photographer's task can also be seen in illustrations 7 and 8, taken from the same album as illustration 5. Each shows the owner of the property literally declaring his ownership; not only of fine horses, or of a newly planted formal garden, but of the whole valley beyond. The gardener, as employee, stands awkwardly in the artificial environment he has created, turning his head as the exposure is made, thus blurring his image. But it is not *his* image that matters, for it is the figures on the lawn who are to be remembered. These photographs are a celebration of class privilege.

6 Tom Roberts, *The Golden Fleece: Shearing at Newstead*, oil on canvas, 104.1 x 158.8 cm, 1894. Art Gallery of New South Wales, Sydney

7 Charles Bayliss, c. 1880, albumen print, 21.5 x 29.4 cm. Private collection

How then do Roberts' paintings escape the stigma of such a charge, and become validated by succeeding generations as more than stereotypes, as if revealing some greater 'truth' about the nature of rural life in the early 1890s? The photographs show the social relationship between photographer and client in their content and in the formal organization of the image itself. Similarly, they show social relationships which are the consequence of the client's ownership of productive wealth. In the paintings such formal or social relationships are absent. The few figures who could be thought to be owners, or bosses, or foremen are formally marginalized: they squat out of the way of the activity, lean on the windowsill in the background, or peer from the edge of the picture. They are not portraits. They do not need to be. The nature of the form is such that the class of owners of productive wealth stand *in front* of pictures of this kind. The ownership of paintings confirms what the photographer records in unavoidable detail.

But this is too generalized. It does not take into account the different ideological tasks of the painter or photographer, or their different class positions or aspirations. The complex relations of class interests which existed at that time between the city and the country further complicate their respective meanings.

IV

While it is highly likely that Roberts would have been familiar with Bayliss' work, this is not in itself particularly significant. Roberts' familiarity with photography is an intrinsic part of his whole career. His early training was in portrait photography, when he was apprenticed to Richard Stewart in Melbourne from 1870 to 1881. While he eventually became senior operator with this firm, from all accounts it appears that he was never particularly proficient.[27] His skills lay more with the imaginative pose of the subject, which he often embellished with displays of native flora. On his return to Australia in

8 Charles Bayliss, c. 1880, albumen print, 21.5 x 29.4 cm. Private collection

1885, he was employed by the photographer Andrew Barrie to 'reorganise the posing, lightings and backgrounds' of the photographic studios.[28] His acceptance of the utilitarian value of photography may however date from the earlier influence of his painting master, Louis Buvelot, who had been a successful portrait and landscape photographer in Brazil from 1845 to 1885, and on his arrival in Melbourne in 1865.[29]

It should come as no surprise, therefore, that Charles Conder should make the casual suggestion that Roberts should use photographs to assist in painting *The Breakaway*, and it also suggests that neither artist sought to actively involve themselves in the aesthetic controversy of so-called 'photographic' realism.

Roberts' contact with photography occurred also on the more mundane level of his occasional work as a newspaper illustrator[30], that is, as a result of the *de facto* 'division of labour' between photographer and painter/illustrator referred to earlier. In the four years Roberts spent in London studying at the Royal Academy, he supported himself by working for *The Graphic* and other illustrated newspapers. With the technological advances made by photography and the various photomechanical means of reproduction in that period, Roberts would have been acutely aware of the inroads being made on the traditional domain of the painter/illustrator.

It is normal to expect of artists a more keenly developed awareness of basic changes in their visual culture. One might also expect that, as artists, they would be in a unique position to exploit potential changes, or to consciously reject their potential influence. Artists, however, are social beings, and with the rest of the audience to whom the illustrated popular press addressed its messages of word and image, the artists of the time were themselves subject to its effects. In the period under study, the means of transmitting photographically derived visual images had reached a crucial stage in a process leading towards its formal domination of what was to become the 'mass media'. This had inevitably influenced the modes of practice of all visual imagery. The novelty of the

photographic image had carried with it the dual cliché of objectivity and impartiality, which perfectly suited the class-interest and partiality of the owners of the Press.

The question of the ideological character of a painting or a photograph can be approached by considering one form in relation to the other, bearing in mind their relative contexts of use and the traditions in which each is located. A further basis for consideration is the nature of the complementary and competitive tasks performed by painters and photographers for the illustrated press. In this respect the changes in the nature of their tasks in the late nineteenth century indicate the gradual decline to a peripheral importance of the role of the painter-as-illustrator, and a corresponding domination of the illustrated press by the photographer. This development on the economic level had consequences in relation to the modes of practice of both forms. In conjunction with the depressed economic conditions of the 1890s, this made the life of the painter considerably more difficult.

The painter of subject-paintings like *Shearing at Newstead* relied almost entirely on the public patronage of the trustees of the colonial galleries. It can be argued that from the outset the painter of this kind of painting had in mind an audience much broader than that class of people wealthy enough to *own* such pictures in the first place.[31] Yet an earlier point still holds: the painter intends by such a picture that its meaning transcends the particularity of time, place and, more importantly, of the private ownership of the productive processes depicted. Social relationships are abstracted: for the audience of such a painting the question of ownership is obscured.

Roberts wrote in defence of *Shearing the Rams* 'that by making art the perfect expression of one time and one place, it becomes art for all time and all places'.[32] For the photographer the consequences of the changes in the period under study corresponds closely to the development of the ideological function of the illustrated popular press. Like the newspaper, the photograph, including those discussed in the latter part of this paper and despite their partial function as portraits, is from the outset the product of a publishing venture. The photographic image in this period is not unique, and is therefore not confined to any one context of use. The photographer prints and sells as many copies of an image as the market will take, as is the case with the Bayliss photographs. We can only say in broad terms what happens to any *particular* image, but we can deduce a certain amount of information concerning the photographer's audience and market if we consider the range of categories within which the photographer characteristically produced. We find that images of labour are far less common than, say, photographs which have a novelty value (disasters, freaks, famous personalities, etc.) or those of a general topographical nature (the travel album), or of a scientific or technological interest.[33]

Photographs of labour processes are related to the last-mentioned category, as images which typify the subject-matter from the point of view of the buyer. Images which contradict or challenge the viewpoint of a prospective customer did not sell! Photographs which might be thought to be exceptions to this rule (e.g., the Lindt photograph) were produced under atypical circumstances, or for motives which contradicted normal practice. In contrast, the photographer's stock-in-trade in this category were those images which reinforced (or celebrated) the buyer's social relationship to those productive processes. In this respect the mode of practice of the professional photographer corresponded closely to the needs of the illustrated popular press. If this correspondence is true, we have established two things: the material basis for the intervention of photography in the other forms of nineteenth century visual culture, and a basis on which the investigation of the ideological character of the photograph in the nineteenth century should proceed.

IAN BURN Beating About the Bush:
The Landscapes of the Heidelberg School[1]

The image of the Australian bush produced in the late nineteenth century by the artists of the Heidelberg school has mediated the relation to the bush of most people growing up in Australia during the past fifty or so years. Perhaps no other local imagery is so much a part of an Australian consciousness and ideological make-up.

Paintings by the artists of this school have been frequently reproduced and discussed at great length. Yet all this effort has yielded few insights into the ideological nature of the imagery or its enduring impact throughout most of this century. Moreover, one senses that not much more can be said with the current orthodox interpretations of the pictures. I want to outline below a basis for a reinterpretation which can begin to take account of these factors.

The key early examples among the landscape pictures of the Heidelberg school are Tom Roberts' *The Artists' Camp* and Frederick McCubbin's *The Lost Child* (illustrations 1 and 2). Both pictures were painted about 1886 at the artists' camp in the suburban bush at Box Hill and portray a very similar bush landscape. The pictures also record very similar attitudes about what to include and what to omit, in terms of how the bush is depicted. Both pictures present only a foreground and a close middle-ground; thick bush cuts off any sense of distance but for a few glimpses of sky. The horizon is placed high, so that each picture is mostly landscape and the viewer is located within it. Each contains a 'narrative' incident: the two artists cooking over their camp-fire, a young girl lost in the bush. Each incident is placed slightly awkwardly a little way in front of the middle-ground. The middle-ground is cut off and becomes an out-of-focus 'backcloth' of foliage and bush haze, with slender tree-trunks picked out by lighter or darker tones. The foreground is declared by the slender trunks of tall gums, which also serve to break up the picture space, framing the narrative incident and pushing it back into the picture, so making the viewer conscious of looking past or through the trees towards the incident. In each picture there are a number of sharply defined details—tufts of grass, foliage of spindly new growth, peeling bark—which attract our notice as we 'witness' the incident.[1]

While other kinds of bush landscape were subsequently depicted by these and other artists, especially Arthur Streeton, I want to argue that the *attitudes* which underlie these two pictures by Roberts and McCubbin are not violated but merely extended to encompass other types. So the first task is to analyse the attitudes reflected in these two pictures.

What are these attitudes? What do they tell us of the artists' *social relationship* to the bush landscape?

The first thing to notice is that any elements which might associate the image with the harshness of life in the bush, the hard labour of working the bush, the threat to farmers of bushfire and drought, or the original owners of the bush—the Aboriginals—are all omitted.[2] No hint of these remains. The bush is not seen through a 'worked' or 'lived' experience. It is not a thick forest to be cleared, sown with crops or turned into grazing land; it is not a rich resource for logging; nor does it appear as an obstacle to cross by foot

or horse. If we look at old photographs of bush workers and their families posing in front of their huts, it is hard to imagine that any part of *their* understanding is being represented. Not only is the idea of the harshness of bush life excluded, but there is no hint of the more pleasant sides of bush living, the sorts of fun and pastimes which can be enjoyed only by country people. No—this view of the bush does not accord with the reality of the bush as experienced by the small selector or bush worker.

But neither is it the reality of the bush as understood by the squatters or pastoralists, that is, its significance as economic value. The bush landscape as depicted by Roberts and McCubbin conveys no sense of itself as landed property.[3]

The people depicted in the pictures are *visitors* to the bush, very much like Roberts and McCubbin themselves were. The pictures reveal only those aspects of the bush which would be pleasurable to someone from the city having a day out or a brief holiday in the country. The bush is 'nice and cosy', fresh, clean and tamed; it displays its attractive and recreative qualities for people who do not live there.

Yet there is a note of threat in the McCubbin picture. What kind of threat? The threat of a child becoming lost in the bush. What kind of child? A young girl, well-dressed in clothes suitable for a picnic in the bush or a leisurely stroll along a well-worn track through part of

1 Tom Roberts, *The Artists' Camp*, oil on canvas, 45.7 x 60.8 cm, 1886. National Gallery of Victoria, Melbourne

2 Frederick McCubbin, *The Lost Child*, oil on canvas, 114.3 x 72.4 cm, 1886. National Gallery of Victoria, Melbourne

the bush. She has strayed away and, with little practical experience of the bush, she does not know what to do. The threat which is depicted is not addressed to families who live in or nearby the bush and are familiar with it. It is addressed to those *visiting* the bush. It is a fear appropriate to city people.[4]

The people in the pictures are city folk and the incidents narrated are part of the social relationship to the bush of an urban class. The perception of the bush which the artists have portrayed conforms to *their* social relationship.

The next question must be more specific—to *what class* of city folk does this perception of the bush belong? An indication is given in illustration 3. The photograph shows a camp in the bush, not unlike that depicted in the picture by Roberts. The text under the photograph describes the scene in this way:

Australian professional men frequently spend their summer vacation in camping in the bush. It is such a camp which is depicted here, its arcadian simplicity is evident. The campers live out their holidays in the open air . . . sketching, photographing, botanizing, fishing, till on their return to town they are bronzed and hearty specimens of humanity ready to face the toils and the stress of the cities with new vigour.

Analysing the whole text we get the following: (i) the bush described in terms of 'familiar', 'beautiful scenery', 'arcadian simplicity', 'tempting spots', 'abundance'; (ii) the relation-

A BUSH CAMP, Tasmania.—This delightful scene represents a familiar aspect of the summer life of Tasmania. Walking tours are exceedingly popular on the island, the beautiful scenery of which annually attracts large numbers of tourists. Australian professional men frequently spend their summer vacation in camping in the Tasmanian bush. It is such a camp that is depicted here, and its arcadian simplicity is evident. The camp is on the river Levin, a beautiful stream on the north-west coast. The river abounds with fish, and all along its banks are to be found tempting spots for the tent, sheltered from both sun and wind, and with wood and water in abundance at hand. The campers live out their holiday in the open air, taking their turn to cook the meals of the party, sketching, photographing, botanising, fishing, till on their return to town they are bronzed and hearty specimens of humanity ready to face the toils and the stress of the cities with new vigour. Outside the tent with its calico fly is the familiar tripod from which is suspended the inevitable billy. A couple of slabs serve as tables, and the equipment is of the simplest.

3 From *Federated Australia—its Sceneries and Splendours*, published by Charles Taylor, London, n.d.

ship to the bush being one of 'walking tours', 'tourists', 'camping', 'summer vacation', 'holiday'; (iii) this relationship existed for 'Australian professional men' from the city, 'sketching, photographing, botanizing, fishing'; (iv) they did this for the 'open air' and the amazing recuperative powers of the bush.

This example suggests that there existed a very well-formed and conventionally held idea of what constituted 'the bush' and what did not. It spells out a particular *social relationship* to the bush. It also makes clear *for whom this relationship existed:* the urban educated upper-middle class. A sensitivity to the recuperative or health-restoring qualities of the bush was apparently available only to those who could take a certain *intellectual* pleasure in it. The suggestion is that this relationship is the domain of the urban bourgeoisie.

The text quoted above is from a book published to celebrate Federation at the turn of the century. But was that relationship to the bush as well formed in Australia in 1885 when Roberts and McCubbin began their bush pictures? There are many examples to indicate that it was. If we look through the numerous illustrated publications which appeared during the 1880s we can find many illustrations showing the urban bourgeoisie 'taking in nature', as well as illustrations highlighting the aspects of nature they would most appreciate (for examples, see illustrations 4 and 5). Or take the example of the National Park (unfortunately now called the Royal National Park) just south of Sydney, which contains a variety of natural bushland. It was established in 1879. It was the second national park in the world—Yellowstone National Park in the United States was established in 1872. While both were decreed to preserve areas in their 'natural' state, Yellowstone has a claim to uniqueness in geological terms. In contrast, what were considered here to be worthy of national park status were not spectacular areas like Ku-ring-gai Chase or the Blue Mountains, but instead luxurious but intimate bush areas and beaches, which incorporated examples of 'the most characteristic and beautiful features' within this 'bit of original Australia'. Quoting further from the *Picturesque Atlas of Australasia*, volume 1, published in 1886, the Park is described as 'the largest of all the metropolitan pleasure grounds' and contains an

4 From *The Picturesque Atlas of Australasia*, vol. 1, The Picturesque Atlas Publishing Co., 1886

5 George Ashton, 'Easter pedestrian tourists; noonday halt at the Black Spur', engraving from the *Australasian Sketcher*, 23 April 1881

NATIONAL PARK.

abundance of those situations experienced picnickers seek out . . . a wilderness for those who like the change from hot and dusty streets . . . a place where the labours and worries of town may be temporarily forgotten, and where on holidays the multitude may get out and find scope for the free enjoyment of all innocent natural propensities.[5]

The concept of a national park institutionalizes one form of the 'visiting' relation to the bush, as well as providing an ostensive definition of the bush or wilderness. In the quoted passage, two importantly *different* types of visitors and relations to the bush are noted. On the one hand is 'the multitude' — on the other are 'experienced picnickers', 'those who like the change from hot and dusty streets' and who need to forget 'the labours and worries of town'. On visiting the Park, the multitude return to a state of innocence and naturalness, like children at play. But the others visit the Park for quiet leisure and recuperation, for the uplifting experience of an unhurried carriage drive or stroll through some of the more 'pure bush' spots, maybe even doing some sketching, photographing or botanizing.

This description, written at the same time that Roberts and McCubbin were beginning their bush pictures, implies two different *social classes* of visitors, urban bourgeois and urban working class (including in this group the small business section of the petty bourgeoisie), and further implies a different *social relationship* appropriate to each class. The image of the bush that Roberts and McCubbin provided connects rather more readily to a relationship of contemplation and educated appreciation than it does to a likely site to romp around in like children. This is nowhere more clearly stated than by Roberts himself, when he writes that they had tried:

to look into the deep, quiet face of nature; lingering where the wandering almost silent river bathes the feathery wattle branches; sometimes on a hillside watching the sun setting over range and valley, the cool shadows rising on the soft pile of the hills go distant, more distant in the grey dusk until the moon rises in the quiet east; finding beauty in odd corners of some country shanty, or by some lagoon . . . all bathed in a great shimmer of trembling, brilliant sunlight . . .[6]

The social relationship which is dominant in the bush pictures by Roberts and McCubbin is *specific* to the educated urban upper-middle class of the period. That is to say, *inherent* in the way the artists saw and related to the bush are the values and relations of *their* class ideology. While it has been long established that the artists associated most closely with the bourgeois intelligentsia and professionals, and that this section was looked upon as both audience and prospective market for their pictures, the point that is being stressed here is that *the way of looking and depicting* the bush landscape is also specific to that class or class section. That is, the way of seeing inherent in these pictures *corresponds* to the way the urban bourgeoisie 'saw' the world and itself.

That is a very general point, but it carries significant implications for interpretation of the whole range of imagery of the period. For example, given the argument put forward above, what is the relationship of the bush image of the Heidelberg painters to the image of the bush produced by writers like Lawson, Paterson, Furphy, and others associated with the *Bulletin*? The painters' perception of the bush seems *contradictory* to the perception of the writers. The latter's vision is not a rural arcady, but more an environment of material hardship which brings out ideal and admirable qualities in people. For the *Bulletin* writers the cultivation of a bush ideal was not 'the transmission to the city of values nurtured on the bush frontier, so much as the projection onto the outback of values revered by an *alienated* urban intelligentsia. How far itinerant bush workers absorbed these values, or shared them already, remains an open question'.[7] (emphasis added)

Our discussion so far of the bush pictures of Roberts and McCubbin makes the case that they too are a projection from the city, but not of values of an *alienated* urban intelligentsia. The contradictoriness is perhaps more apparent in the opposing attitudes

towards the city. The artists applied the same way of looking to their views of the city, but only to certain types of urban-scapes. They saw no 'dusty, dirty city' whose 'foetid air . . . spreads its foulness over all'; they heard no 'fiendish rattle of the tramways and the buses'.[8] The view of the city was 'laundered' in much the same way as was the bush—with the additional point that there are few, if any, signs of urban progress. Perhaps that is not surprising, since all sense of rural progress has been excluded from the bush pictures. The idea of a rural arcady is strongly fixed within a nostalgic sentiment; thus it is possible that the views of the city were also shaped by nostalgia.[9] On the other hand, Lawson, Paterson, and most of the other writers associated with the *Bulletin*, were addicted to the city but railed against its vices and squalor, including much that is linked with urban progress. Their vision of the bush, which emerged in the late 1880s, was an *anti-type* of the city. Thus the writers' increasingly dismal view of the city is connected to the emergence of the bush ideal, the tendency to describe the bush in mythic or legendary proportions.[10]

Indeed, Russel Ward recently argued that the 'legendary view of Australia . . . can be said to have been conditioned by the English vision of rural arcady [an important influence on Roberts' and McCubbin's vision] only in the sense that it was *a total negation* of the latter'[11] (emphasis added). While this idea of total negation serves the kind of argument that Ward is making, at the same time the vision of rural arcady and the legendary view reflect very different and conflicting kinds of social and political consciousness.

If this is so, then the following appears to be the case. Only a short time after the painters developed the means of representing rural arcady in the form of the Australian landscape, their ideas began to be invaded by the same vision which was inspiring the writers. The painters began to rethink the bush as 'the Bush with a capital B'. However this entailed an attempt to integrate two strongly conflicting ways of looking at the bush. This contradiction was never really resolved by the artists, so most of the pictures of bushrangers and workers can be 'read' as various degrees of imposition of one way of seeing onto another. Or—put another way—what resulted was an imposition of a social ideology which contradicted the social content inherent in the aesthetic ideology of the artists' work.

The contradiction is least able to be disguised in pictures like Streeton's *'Fire's On'*, *Lapstone Tunnel* (1891), which includes a scene showing the body of a worker killed by an explosion being carried out on a stretcher, but in which the potential for a mythic idealization of the event is negated by the way of seeing the landscape itself. Admittedly, the contradiction obtains an illusion of resolution in some instances, but this is only when the subject-matter itself embodies or *symbolizes* the mystique of the bush ideal (e.g., in Roberts' *Bailed Up*, *The Breakaway*, and to some extent his shearing pictures). In these cases the way of perceiving the landscape dominates, and the artists' major concern appears to be the discovery of a similar intellectual and aesthetic beauty in the subject-matter of the bush legends.

In order to take this discussion further, we now need a precise analysis of the pictures themselves. The first step, as a prerequisite, has been to establish the class specificity of the imagery. However *interpretation of that imagery cannot be deduced from any general class ideology*. Images themselves are not determined by class values, however it is the class values which set the limits within which a range of possible imagery can occur. What then were the limits of the Heidelberg imagery?

A striking feature of the story of the Heidelberg school is the *rapidity* with which a definitive range of imagery was developed. The first examples seem to embody a fairly complete definition. While the reference of the definition is extended, the definition is not

altered in any substantial fashion. This suggests two things. One is that the definition had to be 'possible', i.e. technically and iconographically there had to be enough sources to draw on to suggest the rapid innovation of the imagery. These are not only the European traditions (which have been well accounted for by Bernard Smith and Virginia Spate[12]), but also sources in the popular press of the day, the black-and-white engravings[13], as well as in the ongoing work of 'minor' illustrative artists in Australia. The second point it suggests is that this way of seeing the bush had to 'feel right' for the artists. That is, there had to be some sense of a visual match between the picture and the social relationship to the bush, and this match had to be recognizable by the artists when they had achieved it. In other words, the class specificity of the imagery had to be shared by the artists.[14]

Given this, what are the pictorial characteristics of the bush imagery? A fleeting impressionistic (not Impressionist) view of the bush was adopted. This view was then filled in with selected details which were sharply delineated. Virginia Spate, in her book on Tom Roberts, discusses Roberts' uncertainty about representation of space. Having abandoned the traditional use of tonal contrasts to create a sense of space, Roberts tried 'to provide new space indicators by unobtrusive framing devices like the trees, tufts of grass and leaves in the foreground and middleground'. The attempt to use elements of the bush as space markers characterizes various of Roberts' paintings during this period, as well as works by McCubbin and Streeton.[15] Spate argues that in observing a landscape Roberts 'seemed to focus separately on different aspects of the view and he incorporated these separate observations in the painting'. Elsewhere Spate speaks of Roberts' habit of composing by 'successive observations', so that the viewer has difficulty in getting a sense of the whole and instead, is forced 'to look at the painting focus by focus, detail by detail . . .'[16]

To a greater or lesser extent this feature is characteristic of how we look at all the pictures by the artists of the Heidelberg school during its early phase. Its significance is this: the way of 'reading' the picture is consistent with the way someone visiting the bush notices details; it is a leisurely and contemplative gaze not tempered by any organized or practical experience of the bush. Sitting quietly or strolling slowly, one's gaze follows random patterns, one detail attracting attention and then another.

This differs greatly from the pictorial conventions (and thus the way of seeing) of Buvelot and other artists working earlier in Australia. Before everything else, Buvelot presents us with an organized, well-constructed, distanced 'whole' landscape, which we 'enter' through an invitational figure (or a cow, a fence, or some other 'note of civilization'). We relate to the landscape largely through that figure; and once 'inside' a Buvelot landscape we notice and pick out in a varying sequence details which interest us. But this process is dominated by a sense of the whole. In contrast, what a viewer can pick out in the Heidelberg pictures is restricted to a far greater extent by the artist and the sense of *predetermination* of the significance of details is far stronger. So the Heidelberg pictures advance a much more precise and specific *definition* of what is 'the bush'.

The Barbizon-type landscapes of Buvelot do not confront us with a definition of the bush in this way, and the range of bush details which might stand as constituents of a definition of the bush is far broader. Thus the implication is that, in the Heidelberg pictures, the range of possible ways of seeing the bush is being circumscribed, so that not just the 'look' of a particular landscape is being presented within a set of pictorial conventions, but a set of pictorial conventions is being used to *advance* a definition of the bush landscape. The effect is to impose onto the viewer a *singular* way of seeing and relating to the bush.

A brief comment is required here about the assumptions on which I am proceeding.

6 Tom Roberts, *A Summer Morning's Tiff*, oil on canvas, 74.2 x 50.1 cm, 1887. Ballarat Art Gallery

This is an ideological interpretation of a particular range of imagery; it does not pretend to deal with the entire range of any artist's work. My aim is to focus on *the most frequently reproduced* landscape pictures, the images most frequently used to imply (in symbolic form) a sense of Australian-ness or national identity. While there are many hazards in such an approach, at the same time it reflects a crucial form in which the images have come down to us through the twentieth century and so is central to any discussion of its ideological nature. The main works under consideration in this section are as follows: McCubbin: *The Lost Child* (1886) (2), *A Bush Burial* (1890); Roberts: *The Artists' Camp* (1886) (1), *A Summer Morning's Tiff* (1887) (6), *Holiday Sketch at Coogee* (1888); Streeton: *Golden Summer* (1889), *Twilight Pastoral* (1889), *Still Glides the Stream and Shall Forever Glide* (1890), *The Selector's Hut* (1890) (7), *Near Heidelberg* (1890) (8), *'Fire's On', Lapstone Tunnel* (1891), *Purple Noon's Transparent Might* (1896). Some of the genre pictures are also being considered, since there is a predominance of landscape in many of them. These include Roberts' *The Breakaway* (1891), *Bailed Up* (1895) and *The Splitters* (c. 1886).[17]

Listed earlier were some of the social aspects which were excluded from the Heidelberg

7 Arthur Streeton, *The
Selector's Hut*, oil on canvas,
66 x 35.5 cm, 1890.
Australian National Gallery,
Canberra

painters' definition of the bush. But what characteristics of the bush were selected to carry the definition? And why? Recurring through the above range of bush pictures are a set of *motifs* which occur in different combinations and arrangements. There are four or five which recur with considerable frequency (though there may be others). These are not the elements of personal style to which every artist has recourse; these motifs play a more directly *social* role. The definition of the bush is achieved largely through the presence and arrangement of these motifs. Where once the artists needed the presence of a narrative specific to the urban bourgeoisie, e.g., a finely dressed young lady visiting the bush, the same social meaning can be produced by the landscape motifs. The social (and ideological) meaning of the pictures resides in the common 'language' of the motifs. The imprint of one of the motifs on a related type of landscape is enough to extend the definition to include that type.

The following are the main motifs:

(i) *A tall, slender variety of gum tree, generally solitary and silhouetted*

This motif occurs in all the above mentioned works. Its evolution begins in close-up in the two pictures of Roberts and McCubbin discussed earlier; it then is used to impress an 'Australian-ness' onto pictures like Roberts' *Coogee* (which otherwise might look like any

place), and is adopted and repeated by Streeton in an often exaggerated form through pictures like his *Twilight Pastoral, The Selector's Hut* and *Near Heidelberg* (8).

This motif is not merely a decorative framing device, though it often serves that end as well. Moreover, it is of some consequence that this is the first time the gum tree is used so directly for its decorative qualities in a 'high' art tradition. But of more concern to this discussion is that in the context in which these painters worked the motif is used to generate a social-symbolic meaning. A clear example of this is in Streeton's *The Selector's Hut* (1890) (7). The solitary gum tree becomes a symbol for the solitary life of the selector, as well as a symbol of his resilience. However by comparing Streeton's painting to Conder's of the same scene, *Under a Southern Sky*, we can notice how the selectivity, arrangement and emphasis build up the social symbolism and meaning. Conder's picture informs us that the selector is not alone but has his family and child with him, while the background landscape suggests that the locale is not nearly as lonely and isolated as Streeton would have us believe.

Today there can be no question that these gum tree symbols carry a heavy ideological load. To accept that they could be used in the late 1880s to produce meaning in these

8 Arthur Streeton, *Near Heidelberg*, oil on canvas, 52.1 x 39.5 cm, 1890. National Gallery of Victoria, Melbourne

terms depends to a large extent on the acceptance of the argument made in the first part of this essay. What might a young or slender gum tree have symbolized to an urban 'professional man' of the period? A list might run something like this . . . youthful, growing, expanding, optimistic, new, striving, unconstrained, uncluttered by old or dead wood, fresh, free, independent. Furthermore, with a number of the pictures, the tree acts as the 'point-of-entry' into the landscape, so that a viewer frequently identifies with the tree before anything else. This is not just an empathy with aspects of the bush, since such empathy is fundamental to the relationship to the bush which is being depicted (and presupposed). Moreover, what is being projected by the viewer is self-reinforcing. What is achieved is a virtual state of symbiosis. In contrast to this, the viewer is left with a *voyeuristic* feeling towards people depicted in the landscape. This is consistent with the argument made earlier about the point-of-view being that of a *visitor* to the bush: either you see bush workers from within the context of your leisure time and place, or you see other visitors as interlopers onto your leisure-time territory.

(ii) *Spindly new (eucalyptus) growth in the immediate foreground* often with wildflowers and tussocks of grass picked out in sharp detail. This kind of detailing seems almost to grow out of the bottom edge of the picture, and again the viewer is made conscious of peering over and through these bush details. With a number of the bush pictures the viewer feels 'unnaturally' close to these foreground details, as if the viewer is crouching — this is particularly the case with *The Artist's Camp, The Lost Child, The Selector's Hut* and others. The effect is to heighten the voyeuristic feeling towards the people depicted, while reinforcing the viewer's feeling of the sanctuary of the bush. While this effect may be partly the result of the artist sitting or squatting while painting the picture, the detailing is too pronounced for that to be accepted as the sole explanation.

This motif is also important in the 'space marker' sense and is commonly used to define the space in the foreground of the picture. When this kind of definition is omitted, the resulting picture tends to lose any strong sense of depth. While it is a common device of painters to use objects or details in the immediate foreground in order to create depth, it is the *luxuriance* of these details that is being commented on here; one's eye is led into the picture by a sequence of *arcadian* details.

(iii) *Close tonal relationship between the sky and the distant or horizon landscape*

This device establishes an effect of strong sunlight flooding down into the foreground bush (as, for example, in all the Streetons mentioned above), or of hazy light suffusing the bush landscape (as in the two McCubbins and Roberts' *The Artists' Camp* and *A Summer Morning's Tiff*). The tendency is to reduce the landscape to a sequence of close-toned horizontal bands, against which other motifs and details are picked out. This motif achieves its most reduced symbolic form in the opening at the back of the shed in Roberts' *Shearing the Rams*; the three close tones with mild changes in hue represent paddock, trees and sky, and form a discrete tricolour 'flag', which announces the 'Australian-ness' of the shearing scene and provides a 'psychological' focus for all the activity in the shed. This motif depends on the landscape being high-keyed, with no great tonal contrasts occurring within it. Often the sense of sunlight flooding downwards is reinforced by the strong vertical stripe of a gum tree. This presence of sunlight, either direct or suffused, as a recurring theme emerges as part of the bush symbolism.

(iv) *An exaggerated blue sky*

This appears in the early 1890s and is used frequently by Streeton (e.g., *The Selector's Hut* and *Fire's On*, and many of his Sydney Harbour views) and occasionally by Roberts (e.g., *The Breakaway*). It creates the effect of a landscape *bleached out* by sunlight and

dominated by sky. In order to sustain this effect the artist is obliged to treat the landscape in special ways, gently modulating to bring out form rather than building up contrasts, defining shapes almost in drawn outline, while the dominating hue of the sky 'pushes' the landscape back from our gaze. In some of his Harbour views Streeton 'inverts' this motif, exaggerating the blue of the water while giving a close tonal relationship between the sky and horizon landscape. A similar effect is achieved nonetheless, the area of blue 'keys' the colour range and determines the light and space of the picture. (It reminds one of the device sometimes used by the French Impressionists of inserting a patch of pure red in their pictures as a way of keying up the colour.)

While not a motif in quite the same sense, Streeton's treatment of the distance and middle-distance should be mentioned here. In a picture like Streeton's *Golden Summer*, the 'veil' of thick bush has been lifted, and the distance depicted without it appearing as an enormous expanse which is both mysterious and vaguely threatening, a vast unknown. Such a feeling about distance tends to pervade the landscapes of Chevalier, von Guérard, and (to a slightly lesser extent) Buvelot. In contrast, Streeton's depiction of distance sustains the same harmony and arcadian evocation as the foregrounds and middle-grounds of the other pictures.

During the period of the works under discussion, for about the first ten years, the artists kept returning to one or other combination of these motifs. They relied on the motifs to give compositional structure to the pictures, as well as to establish meaning. The strength and clarity of the meaning conveyed depends on the selectivity and arrangement of the motifs, and on their ability to exclude other meanings.

But what about all the bush motifs and details which may be seen as no less characteristic but which never appear in the Heidelberg pictures? If one relies on a set of motifs to carry an effect, then it is plain that only a *limited* type of bush landscape can be depicted. Why such a narrow range of types of urbanscapes and of bush landscapes, and nothing in between? Why, for example, was there reticence about representing aspects of country towns, places which played such an important role in rural life? Why are these and many others excluded from the Heidelberg imagery? It is hard to believe it was because the artists were seeking the 'typical' or 'essence' of the Australian landscape. It seems more likely the case that a certain *type* of bush, and a certain way of assembling the type via a set of motifs, achieved the most direct expression of the social (class) relationship. That is, the 'essence' which is depicted is a specific 'essence' of the urban bourgeoisie.

What is happening when a person sees the landscape in terms of *types* of bush? If a thing is seen as a type, then it is looked at in terms of type characteristics, or motifs which can stand for the type, rather than seeing and examining what it is. Consider for a moment the way the Heidelberg artists depicted workers in the bush setting. Workers appear not just as incidents in the bush, but as incidents *of* the bush (and a viewer sees and relates to them in that way too). The artists have seen and depicted the workers within the context of a leisure time and place. The workers have no lives of their own, no pasts or futures, no conflicts or struggles, no joy or emotions.[18] We observe them with detachment, while they are already detached from their real lives. Why is this? Isn't it because the artists are not really interested in the workers as people, but only as *bush types*, the 'human spirit' of the bush? Could the artists be as interested in the urban proletariat? No—the artists are not interested in the social reality of the workers *as a class* or as *individual members* of a class. The artists are creating an idealization of the workers' role, their characteristic activity. This need not exclude sympathetic feelings towards the workers. There may be sympathy, even respect (and even a feeling on the part of the artists of being 'fellow-workers')—but the relationship within which that may occur is prescribed. The sympathy or respect is

towards the worker via the worker's work-type. *Who* he is, is determined by *what* he does.[19]

That point is important to make, because the social relationship which is perhaps more clearly discernible in the depiction of bush workers is the *same* relationship which shaped how artists saw the bush landscape. The depiction of a landscape is no less ideological, thus no less 'political', than the depiction of themes of work. Indeed its ideological impact can be and has been far greater due to the apparent absence of 'workerist' themes. To perceive workers as types, not individuals, not members of a class, is a reflection of how the urban bourgeoisie sees the world and itself. To perceive the bush (i.e., to define it as so) as a restricted and exclusive set of types of bush establishes one class relationship to the bush and denies the possibility of other class relationships. Accept this definition of the bush, learn to love the bush in this and only this way, and *you identify yourself* within a set of social relations of the class which dominates our lives.

To summarize the argument so far: the relationship to the bush which is depicted resides with the educated urban capitalist class of the period. The type of bush landscape selected conforms to an expression of a social relationship of that class. Searching for a 'self-symbolism', it discovered that symbolism in a 'way of seeing' the bush. The portrayal of the landscape in a positive class-specific manner conveyed the idea that the *existing order* of society was also positive, timeless and unassailable. In other words, our middle-class visitor identifies himself (perhaps herself?) in this youthful, expansive, unconstrained arcadian image. He is at one with nature. He exists in the image of nature. He *is* nature.

Such an interpretation is far from out of the question. As outlined here it still contains a few intuitive leaps. With a little more painstaking research these could be reconstructed in a persuasive fashion. We would then have the basis of a reinterpretation of the bush imagery of the Heidelberg school which *locates it within a history of the development of visual culture and ideology in Australia*. The history of this imagery then becomes a history which includes the following account.

In its initial development the imagery entailed particular ideological characteristics. These are what have been outlined in this essay so far. During the 1890s the images underwent a partial re-evaluation. Then again, after the First World War, the 1890s were reinterpreted—and by and large this appears as the ideological form in which it reaches us today. This history can be elaborated as follows.

The first 'layer' of interpretation which must be negotiated in trying to understand the bush imagery within a current perspective is that of the post First World War period. What happened then? During the 1920s the bush imagery was widely popularized; the images acquired a 'national' emphasis and it was claimed for the artists that they had been concerned with producing images of 'the national life of Australia'. Following the first War, the feeling was strong in Australia that the horror and chaos which Europe had just experienced was the logical outcome of the development of urban industrialized societies. It was believed by many that Australia could escape a similar fate only by 'a return to the soil', by maintaining itself as a non-industrial, rural society, the sort of 'natural' society symbolized by the arcadian imagery of the Heidelberg school. Thus the influential critic, J.S. MacDonald, could write of the paintings of Arthur Streeton: 'They point to the way in which life should be lived in Australia, with the maximum of flocks and the minimum of factories . . . If we so choose we can yet be the elect of the world, the last of the pastoralists, the thoroughbred Aryans in all their nobility'.[20] The artists and writers of the 1880s and 1890s were re-cast as giants, the like of whom we would be lucky to see again.[21] Among the artists Streeton was singled out (partly through his own efforts) as the leading figure—and his late formula-ridden landscapes achieved a peak of popularity. Only later

was Roberts' leadership in the Heidelberg group appreciated again.[22] Today it is conventional to speak of Roberts, McCubbin, Streeton and Conder as 'the first to capture the true vision of the country, to break away from the idealized interpretations that went before'[23] — and all that follows must be built on this foundation. The late 1880s and 1890s were heralded as *the* beginning, everything preceding that period had been incapable of grasping the essence of the 'true Australia'. Vague concepts of egalitarianism or mateship, of democracy and nationalism, all deriving their stimulus from life in the bush, were crudely overlaid the images of the bush. Aspects of the pictures were singled out for a significance they never really had, while other aspects, and indeed the diversity of the work as a whole, were ignored. It has been argued that this interpretation of the period 'has been a potent force for the conservatism in Australian literature and culture generally'.[24] In this sense, the bush pictures of the Heidelberg school have perhaps served the conservatism of the ruling economic and political interests too well.

The strong rural, anti-industrial sentiment emerged at a time when Australian capitalists were being forced into increased industrialization.[25] The economy was being restructured increasingly around manufacturing, and a new emphasis on 'Australian-made' products was being sold to the buying public. If the 1920s was the period when the bush imagery was lodged within our ideological make-up in roughly the form in which it still occurs, then it is necessary to examine the role that the imagery played *both* in the generation of nostalgia for a pastoral way of life *and*, symbolically, in support of a gearing up of the economy towards a more highly industrialized society. It is important to note that a bush arcady is neither competitive with nor antagonistic towards an industrialized way of life. So was there at that time a transformation wrought upon our relation to the bush image? Given the class specificity of the imagery, and despite its appropriation by anti-industrial protagonists, it could not be antagonistic towards an industrialized urban way of life. In other words, such an ideological function was *implicit* in the imagery from the beginnings of its development.

What then do we make of the re-evaluation which was placed on the bush imagery during the 1890s? While the writers and, in a contradictory form, the painters projected bush life in legendary proportions, the period seems to contain little awareness of *itself* in any mythic scale.[26] It was a time of severe depression and high unemployment, a time when our dependent links with British capital were being seriously questioned again. There surfaced a renewed desire for a more independent economy. It has been argued by some writers that this automatically led to a great national culture. But such accounts obscure the real complexities of the period. The difficulty with nationalisms, besides the elusive nature of their 'contents', is that they tend to gloss over class lines, so an account which gives priority to the idea of a nationalist ethos cannot adequately explain class-derived characteristics. The contradictory perceptions of the painters and writers need to be accounted for against a background of the internal conflicts within the class structure of the period. Against this background the contradictory 'ways of seeing' can be interpreted in some instances as contradictions between and within social classes. I will outline one area in which this contradiction is clear in class terms. The question of land probably recurs as the major political question during the nineteenth century in Australia. The key struggle during the latter half of the century was not between an emerging bourgeoisie and a developing working class, but rather between the urban bourgeoisie and the old squattocracy or pastoralists. The rural and urban working classes saw some of their interests allied to the urban middle class in their efforts to 'unlock the land', to open up the land for small selectors. The growth of militant rural-based unions, with their conflicts with the pastoral land-owners, indirectly served the interests of the urban capitalists. As the

economic crisis approached and unemployment rose through the late 1880s, the demand to open up the land became strident again. A theme which surfaces through some of the writers' work is support for land reform, something which is markedly absent in the work of the painters. The perception of the bush as depicted by the painters reflects a social relation to the landscape which seems exclusive of the idea of land reform. So the re-evaluation placed on the bush imagery during the 1890s (in part imposed by the artists themselves) is the initial conflation of the contradictory ideologies, their 'unification' into a populist national identity.

In this essay a different interpretation of the bush images has been outlined, one which reveals their ideological nature, and some of the significant social and political contexts in which that ideology became specific have been sketched in also. A further comment is now possible. In the late nineteenth century the bush imagery was associated with a section of the local bourgeoisie which can be seen to have had progressive tendencies. It was a class section which was prepared to accept European models reinterpreted (rein-vented?) in terms of local landscape types and motifs, a section which appreciated the need for an independent cultural identity, as well as some of the political and economic preconditions for that. The nature of the bush imagery is complex, and not free from contradictions. In the political climate in which it developed, the imagery corresponded to a progressive element in the urban bourgeoisie, an element not free from contradictions itself.

During the later period, between the two World Wars, the imagery again obliquely served a progressive end in the context of building up the local manufacturing base and a concomitant pride in locally made products. However its progressiveness during this period was of a distinctly different kind to its earlier form, and might be regarded as almost exploitative of it. The pictures are no longer upheld as expressions of the 'cultural independence' of a specific section of the urban bourgeoisie, but serve to symbolize a national cultural independence and nationalist pride. In the latter case, however, the imagery supports not a progressive section of the bourgeoisie but a rather conservative section, a section which built up the manufacturing sector under threat, in order to survive. The difficulty of drawing stronger conclusions at this point is due to the lack of a detailed class analysis of the entire period, one which allows special reference to 'cultured' sections and which reveals correspondences to ideological points-of-view. This and other essays in this volume are contributing towards such an analysis.

The Heidelberg painters taught us to *see* our bush environment in a new way, but at the same time *distorted* our comprehension of that environment. The pictures allude to a reality of the bush, but embody the illusions of a class 'way of seeing'. In the context of the late nineteenth century, that class perception had progressive elements within it. During the twentieth century, the bush imagery has been used increasingly to serve the ends of the most conservative sections in this society. Thus the continuing pre-eminence of the Heidelberg imagery as *the* definition of the Australian landscape reflects the continuing domination of our society by the same class interests.

TERRY SMITH The Divided Meaning of
Shearing the Rams: Artists and Nationalism,
1888-1891

Ah! We read about the drovers and the shearers and the like
Till we wonder why such happy and romantic fellows 'strike'.
> — Henry Lawson, *The City Bushman*, 1892

Shearing the Rams (1) was painted by Tom Roberts between 1888 and 1890. It is not only one of the best-known Australian paintings, it is one of the most widely known Australian *images*. It is regarded as an outstanding painting within a period usually heralded as the 'Golden Age' of Australian art *and* it is one of the first images to which Australians turn when wishing to illustrate the 'characteristically Australian'. How did *Shearing the Rams* become a cultural artefact? A study of the different ways in which it has been interpreted, of the different ideologies to which it has been related, will be important to the study of cultural formation in this country. But first it is necessary to see the painting in the original contexts of its production. This essay aims to do just that. It will be primarily an essay in reinterpretation, drawing on the scholarly work and example of many writers, especially Bernard Smith and Virginia Spate.

Shearing the Rams was both a personal response and a public statement. It was recognized as such from the moment it was placed on exhibition in Roberts' studio in Melbourne in May 1890. It attracted more press commentary at the time than any other Australian painting. All commentary, including a letter by Roberts to the *Argus*, assumed that the artist's feelings, observations, skills and beliefs should be used to project a picture of contemporary life.[1] But to whom? We need to be quite specific about the painting's audiences, because it is in exchange with them that the artist's search for meaning is realized and the painting's content is established.

From this perspective, most accounts of the motivation and meaning of *Shearing the Rams* and related paintings stop short at crucial points. It is inadequate to characterize Roberts' choice of subject as if it were a substitution of local bushworkers for the peasants of Millet, Bastien-Lepage and van Gogh. Those who draw this parallel without developing the implications of the subject itself tend to confine Roberts' perceptions and the painting's significance to a purely aesthetic realm. They siphon off the social meaning of the work of these artists and of others tackling similar subjects. Further, Roberts' earlier landscapes at Box Hill, Mentone and Heidelberg express a visiting, recuperative response to the suburban bush, so we might expect his view of labour in the deeper bush to be similarly city-based. Of course it was, but it is insufficient to merely point this out. Most Australians lived in cities and towns, but they were not unified socially, ideologically or politically by that fact. We need to ask: which urban class or classes viewed bush work in the way Roberts did? and: what are the implications of our answer to this question for the meaning of *Shearing the Rams* and its subsequent ideological role? Similarly, it has become almost automatic to credit the Heidelberg School in general, and *Shearing the*

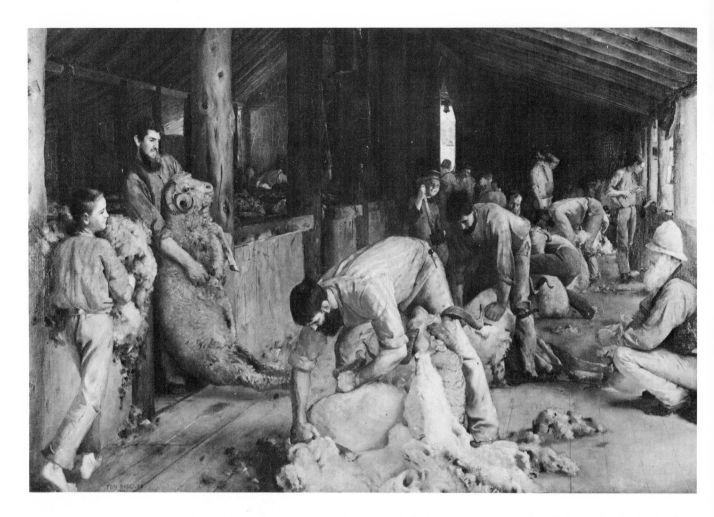

1 Tom Roberts, *Shearing the Rams*, oil on canvas board, 121.9 x 182.6 cm, 1890. National Gallery of Victoria, Melbourne (Felton Bequest 1932)

Rams in particular, with a formative role in the creation and diffusion of 'The Australian Legend', the 'national myth' of the centrality to Australian experience of the independence and egalitarianism of 'the bushman'. But the relationships here are both tentative and complex. In the 1880s and 1890s different views of Australia were advanced and different kinds of nationalism competed. To which were the Heidelberg School paintings related? Was the overriding intention of these artists to create a distinctive form of English-European high art *in* Australia, or was it to create a distinctively Australian art *for* Australians?[2]

In order to tackle these questions I shall examine *Shearing the Rams* and related images of work in three different ways. I shall first isolate the painting, seeking its specific conditions of production, and explore Roberts' immediate response to his subject. I shall then restore the painting to its contemporary artworld, showing how Roberts' style relates to developments within that world as well as to other tendencies within the visual culture. The main body of the article will examine *Shearing the Rams* as a response within the conjuncture of the competing class ideologies which marked the period. Division of the article into sections is, of course, made for purposes of exposition only.

INSIDE *SHEARING THE RAMS*

The painting is not large but its internal scale is such that it appears to be so. Compositionally, it is organized into diagonal zones of light and a perspectival space down which the

figures are dispersed, except for the grouping across the front. While at first glance each of these elements coheres into a single image, there is a slight tension between this coherence and its elements, which emerges when we inspect them more closely. The perspectival recession does not coincide with the disposition of the light; the vanishing point is off to the right and above the centre line; the foreground figures are given greater definition than those behind, indicating differences between observations made in the studio and in the shed; light, colour and stance differ between foreground and background, with the result that middleground is reduced, almost denied. Some, or all, of these might have been deliberate choices aimed at increasing the expressive power of the image. But equally they may be symptoms at the level of form which indicate stress at the more fundamental level of content.

In preparing *Shearing the Rams* Roberts visited Brocklesby station in the New South Wales Riverina during the shearing seasons of 1888 and 1889 (September to December).[3] One of the many sketches which he is reported to have made has recently become available (2).[4] A black, white and grey gouache, it is inscribed by Roberts 'First Sketch for "Shearing" . . . Brocklesby', a dedication and a date, 1890.[5] In the absence of other studies it is difficult to assess the relationship of this sketch to the final painting, but it might record the moment when he arrived at the idea, the basic composition of the painting. He seems to have begun the sketch as a study of the light-dark contrasts at the back of the shed and of the tonal variations down the right side. The foreground is not at all resolved, but he has already arrived at the solution to the problem of representing a row of shearers: a nearly abstract knitting of alternating backs. Significantly, he does not yet give any sense of the 'dignity of labour', the 'ennobling of the bushworker'. Only the shearer entering left is drawn animatedly: all the other workers, especially the row of shearers, are simply

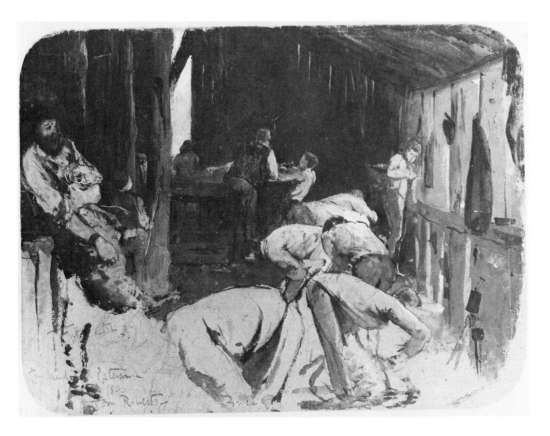

2 Tom Roberts, *First Sketch for Shearing . . . Brocklesby*, gouache on paper, 1889-90. National Gallery of Victoria, Melbourne

abstract shapes. The sketch emphasizes the importance of the foreground figures to the meaning of the final painting: it shows anonymous, hard slogging, while the painting stresses simple strength and skill.

A journalist's account of the genesis of *Shearing the Rams*—seemingly based on an interview with Roberts—throws further light on this aspect of the painting. It lists his studies in this order: 'the light, the atmosphere, the shed, the sheep, the men and the work', and stresses that he took pains to choose the 'most characteristic and picturesque of the shearers, the rouseabouts and the boys'.[6] The painting bears out these remarks: the foreground figures are individualized, while those at the back are not; yet differentiation between all of the figures is based primarily on their roles within the shearing process. A later shearing picture, George Lambert's *Weighing the Fleece* (1921) (3), focusses attention on the owner, his wife, the prize ram, the fleece and the shorn ram. The class-based nature of Lambert's seeing is evident in the fact that the other four people are less and less clearly individualized as they descend the social scale![7] Roberts does not go this far, but his seeing in terms of types tends in the same direction.

Thus two contradictory tendencies seem apparent in Roberts' response to his subject: a recognition of the specificity of the work depicted and, at the same time, a distancing, a withdrawal which enables him to generalize and typify it. These tendencies interact in his letter to the editor of the *Argus* (2 July 1890), written 'to justify myself as an artist in taking up my subject':

It seems to me that one of the best words spoken to an artist is, 'Paint what you love, and love what you paint', and on that I have worked; and so it came that being in the bush and feeling the delight and fascination of the great pastoral life and work I have tried to express it. If I had been a poet instead of a worker with the brush, I should have described the scattered flocks on sunlit plains and gum-covered ranges, the coming of spring, the gradual massing of the sheep towards that one centre, the woolshed, through which the accumulated growth and wealth of the year is carried; the shouts of the men, the galloping of horses and the barking of dogs as the thousands are driven, half seen, through the hot dust cloud, to the yards; then the final act, and the dispersion of the denuded sheep; but being circumscribed by my art it was only possible to take one view, to give expression to one portion of all this. So, lying on piled up wool-bales, and hearing and seeing the troops come pattering into their pens, the quick running of the wool-carriers, the screwing of the presses, the subdued hum of hard fast working, and the rhythmic click of the shears, the whole lit warm with the reflection of Australian sunlight, it seemed that I had there the best expression of my subject, a subject noble enough and worthy enough if I could express the meaning and spirit—of strong masculine labour, the patience of the animals whose year's growth is being stripped from them for man's use, and the great human interest of the whole scene.

The basic components are 'the great pastoral life and work' and 'a subject noble enough and worthy enough', that is, 'strong masculine labour' and 'the patience of the animals'. What does the letter tell us about Roberts' relationship to each of these?

The pastoral industry gives him feelings of 'delight and fascination', feelings at most only partially descriptive of ways in which squatters, selectors, shearers and other bushworkers would relate to the bush. The sentence beginning 'If I had been a poet . . .' is a romantic evocation of a mood, a scene-setting which treats the organization of rural production as a spectacle. This is explicit in the next long sentence, which begins with Roberts picturing himself as a spectator: 'So, lying on piled up wool bales . . .' Shearing itself becomes curiously empty: it is reduced to 'the final act', 'the subdued hum', 'the rhythmic click'. Nor does Roberts spell out his own 'hard labour' on the painting as it was described by the journalist; he does not allude to the fact that he paid the shearers to pose.[8] He was replying to criticism of his choice of subject by a writer, who, implying that it was 'unworthy', had asserted: 'The object of art is not to copy a fact, the object of art is to be

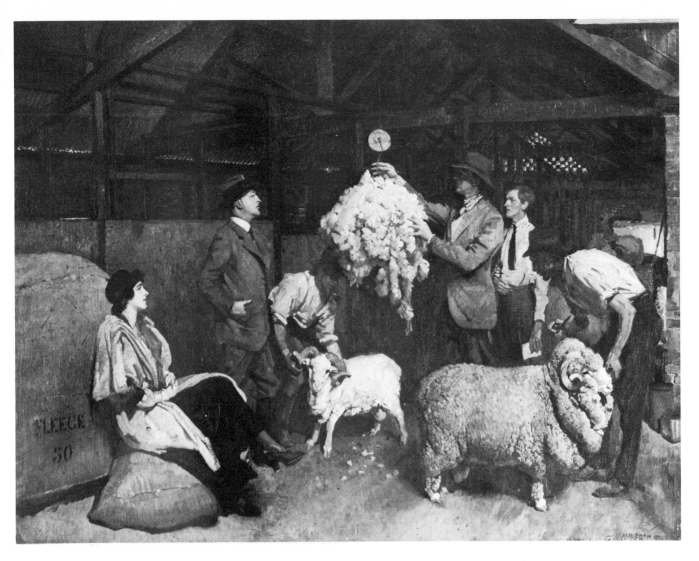

3 George Lambert,
Weighing the Fleece, oil on
canvas, 71.7 x 92.2 cm,
1921. Australian National
Gallery, Canberra

artistic and to be artistic is to represent something beautiful or elevating or instructive'.[9]
Roberts' letter is primarily an attempt to argue the worthiness of his subject according to
these academic criteria. On the other hand, work is mentioned twice in the letter, 'the
subdued hum of hard fast working' and as the declared subject, 'strong masculine labour'.
This is associated with 'the patience of the animals' and recognizes, as does the painting,
the sheer hard work of shearing, the basic material fact of men working to transform
nature in order to produce 'the wealth of the year' for 'man's use'.

The conflict and conflation of the demands of art (romantic and academic) and the
demands of the 'subject' mark much of the thinking of the Heidelberg School painters —
including those, like Arthur Streeton and Charles Conder, who were inclined towards
Aestheticism. Streeton's letters to Roberts and McCubbin from Glenbrook in 1891 are
full of references both to inspiring views and to 'big, stalwart men'. He senses them to be
class-distinct, but gradually comes to write about them in close personal terms, recogniz-
ing the danger of their work as tunnel-builders.[10] But the resultant painting, *'Fire's On'*,
Lapstone Tunnel (1891) displaces these men as a subject: the miner being carried on a
stretcher and the workers and their families rushing to the tunnel-mouth become indis-
tinct blurs, counting for little amidst the overwhelming presence of the rugged landscape.
Male presence has been generalized to the landscape as a whole. The left/right division of
the painting opposes Nature to the transformation wrought upon it by Man. But railway
and mining engineers, fettlers and miners, carpenters and tunnel-builders are given no
specific identity — a romantic landscape has taken over from people working and from
relations between people.

Despite ample precedents amongst his artistic sources, women appear in none of

Roberts' known images of work—rather, they remain the subject of portraits, interior scenes, the first Box Hill landscapes and scenes of leisure. The same is true for other members of the Heidelberg School, with the exception of Frederick McCubbin, who gives women a central place in his series on the struggles of squatters and selectors that culminates in *The Pioneer* (1904).[11] McCubbin may have been responding to the movement towards the emancipation of women in the 1890s—his fellow artists simply did not. Indeed, in *Shearing the Rams* Roberts chose to celebrate, not the 'general' shearing of ewes and wethers, but the special session during which only rams were shorn.

THE ARTISTIC CONTEXT OF *SHEARING THE RAMS*

Bernard Smith has observed: 'If in such a painting as *Shearing the Rams* Roberts sought to hold up the mirror to Australian life, it must not be forgotten that he was also in one sense the Australian champion of *l'art pour l'art*'.[12] What role did predominantly artistic methods and meanings play in *Shearing the Rams*? On what imagery did it draw? Which were its intended audiences?

The main artistic tendencies in Europe and its colonies in the later nineteenth century were Realism, English subject painting, French Avant-gardism and the Aesthetic movement. Each of these styles had evolved its own particular set of practices, values and beliefs, a set of favourite subjects, methods, masters, models and motifs, as well as views about the nature of art and its social role. In short, each style entailed an *aesthetic ideology*, expressed not only in the artworks made by those who subscribed to it but by their role within institutions of art and culture. Furthermore, each style had evolved special relationships to the competing *social ideologies* of the different classes and sections of classes of the period. This is no simple matter: an aesthetic ideology does not mirror a social ideology directly, nor, perhaps, even in a refracted way. Rather, a style in art, whether personal or shared, evolves as a series of changing responses, within the conventions of artistic practice, to the conjuncture, itself always changing, of competing social ideologies and social practices of the time. So when we locate *Shearing the Rams* in its artistic context we need to go beyond its iconographic precedents to an understanding of the ideological acceptances and rejections entailed in Roberts' artistic decisions.[13]

Shearing the Rams is clearly part of a tendency shaped by Realism and the English subject picture, by such major paintings as Courbet's *The Stonebreakers* (1849) and Ford Madox Brown's *Work* (1852-65). Without suggesting the direct influence of these two paintings, which Roberts may not have known, it is instructive to compare *Shearing the Rams* to them in order to point up Roberts' specific relationship to similar subjects. The wool boy at left in *Shearing the Rams* and the boy in *The Stonebreakers* may both be drawn from the same iconographic convention, but the pleasant, joyful face and graceful step of the wool boy could hardly contrast more with Courbet's burdened young man, destined to end up like the broken old man next to him.[14] When Courbet describes his painting he uses an exact, staccato, direct language, quite unlike the evocative rhetoric of Roberts' letter.[15] Courbet gives priority to the human and social reality of *exploited* work, to the degradation of these workers implied in the way they are seen: as faceless things, glimpsed at the roadside from a quickly passing carriage. This nascent class analysis, and the politically interventionist nature of Courbet's work 1849-51, is not present in any Heidelberg School work. Realism is relevant to *Shearing the Rams* only as the style which stressed truth to appearances, which introduced work and working-class life as subjects fit for major art. In his *Work*, Brown carefully distinguishes different types of worker according to the degree to which they deserve the pity of the humanitarian bourgeoisie,

measuring them all against the ideal navvy, on the one hand, and the intellectual, on the other. Despite the hard, precise rendering of the figures, *Work* is extraordinarily abstract in its conception.[16] Yet, precisely because a range of work (and idleness, and unemployment) is carefully presented, *Work* goes further than *Shearing the Rams*, which depicts only one type of worker and thus cannot show the social and class relations of work.

The stylistic tendency to which *Shearing the Rams* relates most is the diluted Realism of Naturalism—specifically that of Bastien-Lepage and his English followers, such as George Clausen and Stanhope Forbes.[17] Artists working within this style documented moments in the lives of all classes all over Europe, presenting their precise vignettes in the Salon and Academy exhibitions. A significant proportion painted scenes of petty bourgeois and working-class life in both the city and the country. Their approach was one of idealized sympathy, often sentimental, matching careful observation with psychological and social withdrawal. The eyewitness character of Naturalism served to present these scenes as isolated instances of individual failure rather than as structural victimization. Ignoring the growing socialist movement, these artists put their faith in parliamentary reformism and individual acts of charity. Victims of an exploitative and oppressive social system become poor, suffering, fellow human beings, looking out of the painting appealingly at the bourgeois spectator. The institutional structure of the artworld tied artists into this ideology.

In *Shearing the Rams* Roberts clearly accepted the aesthetic ideology of Naturalism: the 'worker/peasants' are its overt subject; they and their work are rendered with carefully detailed attention; they are joined together into a balanced composition which attempts to follow academic rules of colour, light and perspective; and they form part of a scene which could be observed, but has meaning beyond mere appearance. The painting also shares much of the same relationship to social ideologies in what I shall argue to be its abstract sympathy, its mystification of social relationships and its idealization of work. But it does not fully subscribe to the sentimentality, the pathetic condescension of the main tendency of Naturalism, seen most typically in the work of Bastien-Lepage. Roberts did paint in this way in *The Flower Sellers* (1893-96) and in *The End of a Career: the Old Scrub-Cutter*, done in 1888 immediately before *Shearing the Rams*.[18] However the bustling confidence of *Shearing the Rams* rejects the sentimentality of Naturalism as firmly as its rejects the critical, questioning edge of Realism. Why? What factors within the painting's artistic context permitted this difference of approach?

Shearing the Rams was aimed at two different audiences on two different continents. There was discussion at the time about the desirability of sending paintings with Australian subjects to London, and it is likely that Roberts intended to submit *Shearing the Rams* to the Royal Academy exhibition of 1890.[19] In official exhibitions in England and Europe scenes of work were not common, but they were painted; in ways ranging from the Realism of Max Liebermann and Belgian artists such as Larock to the bland reportage of Melton-Fisher. Strong, positive images of work were, however, rare: Arnaldo Ferraguti's *Digging*, Adolf von Menzel's *The Steelworks* (1875) and Ulrich's *Making Lampbulbs* (1883) are European examples unmatched by English artists. The closest would have been George Clausen's *Labourers: After Dinner*, a relatively direct and unsentimentalized image of rural workers but in a Bastien-Lepage manner, which caused much comment when exhibited at the Royal Academy in 1884, the year before Roberts' return to Australia.[20] Similarly, English audiences may have been aware of the popularity of scenes of rural life in official exhibitions in Europe, especially those set in exotic places and in residual cultural pockets such as Brittany and the Alps.

Shearing the Rams was not completed in time for submission to the 1890 Academy

exhibition and was sold before the next one, so we may only speculate as to the responses of English audiences to it. In presenting a positive image of work, Roberts may well have risked a negative reaction, but this would have receded before the familiar academic style of the painting and the unfamiliarity of its subject: the Australian wool industry. It would have been interesting as a document of the way in which shearing was organized in Australia, on a scale unmatched elsewhere in the world, and as a symbol of the production of a raw material which was crucial to British industry. And it would have been satisfying, positively reassuring, in that it shows Australian colonials happy to serve Britain's needs. Exhibited in 1890 or 1891 it would have had the extra advantage of news value: political and financial upheaval in Argentina, a financial colony of Britain and another major source of wool, had led in 1890 to the collapse of a leading London finance house, Baring's. This placed extra emphasis on Australia's role but, as we will see, this was less secure than it had been: local finance was in a precarious state, wool prices were falling, shearers were striking—all of which led to a large-scale withdrawal of British capital in 1891.

Success at, or even acceptance into, the Academy exhibition would have enhanced the local prestige of both painter and painting. This is part of the same strategy, and *Shearing the Rams* had a key role within it. After his return to Australia in 1885 Roberts was a leading figure in local art politics. He strongly reinforced the tendency towards painting *en plein-air* and actively promoted professional practices amongst artists. He led opposition to the Victorian Academy of Art, was a founding member of the Australian Artists' Association (1886), the Victorian Artists' Society (1888) and the Society of Artists (Sydney, 1895), being president of the latter two groups. His major paintings, such as *Shearing the Rams*, are statements about the directions in which he thought Australian art should develop. So the *local* artistic context is (at least) as important to the particular character of *Shearing the Rams* as are the international factors we have been considering. But what sort of art was Roberts promoting, and for whom?

Roberts did not commit himself exclusively to one style, nor to one view of the role of art. Indeed, his work at all times tends in many directions. He certainly did believe in the priority of the subject, that once it was decided upon the appropriate style should be found. He sought constantly to challenge himself as an artist, to set himself complex and contradictory problems of subject and form. But these remarks do not explain why he chose certain subjects at particular times. What were the local acceptances and rejections entailed in painting *Shearing the Rams*?

Aestheticism had been one amongst the many tendencies in Roberts' art since the Thames studies of 1884, but he was never as interested in it as Streeton nor as committed to it as Conder. Landscapes such as *Bourke Street* (c 1886) and *Evening, When the Quiet East Flushes Faint at the Sun's Last Look* (1887-88) are attempts at pictorial equivalents of moods experienced by the sensitive observer. Portraits such as *Mrs L.A. Abrahams in a Black Dress* (1888) and subject-paintings such as *Jealousy* (1888-89) use Whistlerian arrangements and objects favoured by those with Aesthetic tastes in order to help define the character of the sitter or elaborate the narrative, but they are painted naturalistically. Roberts' 'impressions' come closest to Aestheticism as a style, and sixty-two of them were shown in the '9 x 5 Exhibition of Impressions', August 1889. The interrelationship between the Aesthetic Movement in art and as a developed, fashionable and perhaps even *passé* taste is evident in the way the works were displayed and in the immediate financial and critical success of the exhibition.[21] Roberts was painting in these ways throughout the period during which he was working on *Shearing the Rams*, but while Aestheticist ideology might have influenced the way he wrote about the painting, it is not evident in the

painting itself. Furthermore, with McCubbin in 1886 Roberts had assembled the motifs which, when the central figure was dropped, became the typical Heidelberg School landscapes, so quickly elaborated by Streeton, Conder, Davies, Withers and others. In *Shearing the Rams* this new landscape has been drastically reduced to the glimpse through a section of the open door at the back of the shed. It functions as a visual exclamation mark, declaring the country outside to be unequivocally Australia. This was possible only because the preceding five years' work had established the uniquely Australian character of a sun-drenched landscape painted in continuous high-key tone.

Clearly, the stylistic devices, the ideology and the social implications of Aestheticism are absurdly misplaced for the depiction of work, viz. Conder's *Yarding Sheep* (1890). Impressionism, similarly, tends to obscure the actuality of labour: for example, Monet's *Unloading Coal* (1872). Nor could the techniques developed at Box Hill and Heidelberg fit the subject: the workers in *The Splitters* (c 1886) are prominent but not individualized, and the details of their job are obscured.[22] So Roberts turned to an academic Naturalism, the style in which scenes of work and rural life were painted in Europe, England and—at the end of the 1880s—in Australia. Great public attention focussed on entries for the newly established National Gallery School Travelling Scholarship: the first, in 1887, was won by John Longstaff's *Breaking the News*; David Davies exhibited *From a Distant Land* in 1888; and Aby Alston won in 1890 with his *Flood Sufferings*.[23] All show typically Australian hardships from contemporary life or the recent past; all are academically composed interior scenes, with the narrative completed by what is depicted through an open door at the back. McCubbin had initiated this 'homely pathos' with his *The Lost Child* (1886) (Burn [2]), but he returned to it in 1889 in *Down on his Luck* and *A Bush Burial: The Last of the Pioneers*, presumably under the impetus of the success of his students. These developments may have influenced Roberts in both *The End of a Career: The Old Scrub Cutter* and *Shearing the Rams*.

The need for specifically Australian subjects in local painting had been discussed and urged throughout the centenary decade in ways which presume that both historical and contemporary themes would be depicted both naturalistically and according to academic conventions. Sidney Dickinson went further, proposing that 'our artists' should present 'the earnestness, vigour, pathos and heroism of life around them'.[24] In their work as illustrators, local artists were increasingly called upon to produce images of a great variety of aspects of Australian life, both past and present. *The Picturesque Atlas of Australasia* (1886-88) and *Victoria and Its Metropolis* (1888) are but two examples among many. Some of these artists, especially in Sydney, quickly turned to the same themes in paintings, mostly in landscapes but sometimes in scenes of rural work: Frank Mahony's *Rounding Up a Straggler* (1888-89), Julian Ashton's *The Prospector* (1889). Roberts, also an illustrator, reacted similarly.

These facts attest not only to the continuing influence of Naturalism amongst Australian artists, but perhaps to an increase in its use because it seemed the most appropriate framework within which to paint scenes of Australian life. The 1888 centenary celebrations certainly promoted an interest in images of Australia. But *Shearing the Rams* is a painting of work, and was offered for sale at £350. In embarking on his project Roberts must have hoped that, short of success in the Royal Academy, a local market existed for such a painting. In this regard the centenary celebrations are suggestive: following the model established at Manchester in 1857, the International Exhibition of 1880 and the Centennial International Exhibition of 1888, both in Melbourne, featured loans from local private collections. Amongst these, English and German Naturalism was prominent and scenes of work were to be found.[25] More generally, the huge scale and ostentatious

display of these exhibitions remind us that the 1880s was the 'boom' period in Melbourne's history. Ada Cambridge begins her account of the 1888 Exhibition with:

All in their degree were rich and lived lavishly; the upper classes seemed wholly given over to pleasure-making, and their appetite for social diversion was catered for as it never was before or since.[26]

Local artists might reasonably hope that some of this largesse would come in their direction.

The International Exhibitions were not only prestigious affairs, they were also enormously *popular*. Roberts is reported to have hoped that the National Gallery of Victoria would buy *Shearing the Rams*, which implies a degree of open access to the painting. However it is uncertain how many people, and which classes, habitually visited the Gallery.[27] But the best evidence for what I would claim to be Roberts' wish to produce a popular image is the painting itself. We have discussed the academic conventions which he employs: these situate the painting within the visual language of those in the habit of looking at art. The 'cultivated' bourgeoisie, and professionals interested in the arts, would register these first. But the imagery of *Shearing the Rams* is also embedded in a far more widespread visual language, in the habits of seeing of the 'uncultivated' bourgeoisie and professionals, and of the working class. This was vividly described by Richard Twopeny:

4 'In the Shearing Shed', *Sydney Mail*, 15 December 1883. National Library of Australia, Canberra

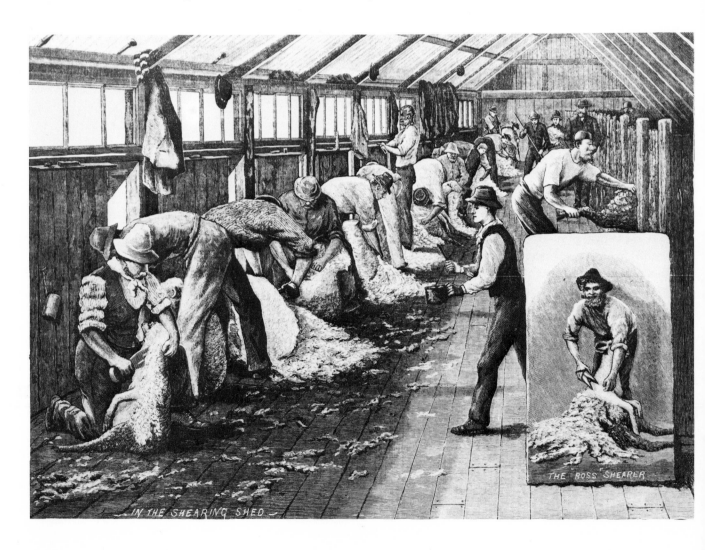

Can you imagine a man worth £5,000 a year? (or £500 for that matter) covering his walls with chromos? The inferior kinds of these 'popularizers of art', as the papers call them, have an immense sale here . . . Muttonwool can see no difference between a proof before letters and an illustration from the newspapers, which may be seen pasted up on the walls of every small shop and working-man's cottage . . .

It is only fair to mention as a tribute to the laudable desire of the people to see good works of art, that no parts of the International Exhibitions were so well attended as the Art Galleries . . . there is hardly a hut in the bush where you will not see woodcuts from the *Illustrated* and the *Graphic* pasted up, and that the pictures most admired at the exhibitions were those which were most dramatic . . .[28]

Two types of reproduction are referred to here: prints of high art and graphics from the illustrated newspapers, of which there were many, both English and Australian, circulating throughout the country. Prints of paintings were enclosed within copies of newspapers such as the *Illustrated London News* and *The Graphic*, and in their local equivalents. They were also sold separately, as were prints of *Shearing the Rams* in 1900.[29]

But the newspapers, especially the illustrated weeklies, also constantly featured prints based on drawings and photographs of a great variety of aspects of life in Australia, including rural work. Images of shearing sheds were quite common (4, 5 and 6). Furthermore, such images occurred frequently in the plethora of illustrated histories, encyclopaedias, travel books and other miscellania about Australia which were published in the 1880s and earlier. Altogether, these images indicate the existence of a well-known visual code upon which *Shearing the Rams* could draw and into which it could be inserted. Despite its academic characteristics, its subject and the descriptiveness of the treatment would make it immediately familiar to audiences not in the habit of looking at art.

The illustration in the *Sydney Mail* of 15 December 1883 (4) is typical in that it shows a standard shed, with rows of shearers on one side, the pens on the other. It omits the wool-sorting, but shows all the other subsidiary activity. Compared to Roberts' version it is roughly drawn and crudely observed but, interestingly, solves a problem which confronted Roberts: where he swings the line of shearers towards front centre, the *Sydney Mail* artist draws on a convention of illustration to isolate the 'Boss Shearer' in a floating insert, albeit at the expense of shrinking this figure. This image is plain and descriptive; others contain elements of humour, delight in displaying 'typical' bush 'characters'. In *The Australasian Sketcher*, in particular, these occur under the very city-based heading: 'Life in the Bush'.[30]

The relationship of *Shearing the Rams* to the other form of popular imagery, photography, is a little more problematic. Roberts' own photograph of the Brocklesby woolshed is a descriptive record, differing from the more spectacular or 'typical' bush scenes marketed by professional photographers (5).[31] But it does show him using a camera on the site and implies that he may have used photographs in preparing his painting. However, indoor scenes other than in studios were, for technical reasons, relatively rare at the time. More generally, like many painters and painter-illustrators of the period, Roberts was reacting to photography's claim to record the 'life-like actuality' of a scene, both in the exhaustive and detailed studies which he made and in a composition which gives the sense of being able to be taken in at a glance. In these respects the conventions of academic painting coincide with those being developed by the new medium.

Shearing the Rams was a major attempt to produce an image which would be of relevance to two different and distinct audiences. Its academic Naturalism linked it with the leading tendency of educated bourgeois taste in both Britain and Australia. At the same time, its relationship to the popular imagery of 'life in the bush' made it accessible to 'uncultivated' bourgeois, middle and working class ways of seeing. This implies a populist

outlook, an understanding of society as consisting of two 'classes': 'the wealthy' and 'the people'. However there is little sense of antagonism; rather, each way of seeing complements and reinforces the other: the academic treatment 'elevates' a popular subject to the status of high art, and the use of popular imagery opens an academic painting to wider audiences. This consensual approach seems to be widespread amongst artists of the period, indicating perhaps the kind of audience which they desired. But it was an ideal. *Shearing the Rams*, like much other art of the time, could be read in different, mutually exclusive ways by its different audiences. To understand why, we need to look beyond its artistic context to the political and social context from which it emerged.

THE SOCIAL CONTEXT OF *SHEARING THE RAMS*

The years around 1890 are usually considered transitional between two great periods in Australia's history: the Long Boom and the decline which persisted until the First World War.[32] Initiated by the mineral discoveries, the Long Boom (1861-91) was founded in massive British capital investment, mostly into the pastoral industry, which enabled exports of wool to grow so quickly that, by the 1870s, Australian exports dominated the world wool market. Spin-offs from this growth were evident in expanding cities and towns, railways, services, manufacturing, local capital formation and a decrease in the importation of labour. By the 1890s most people lived in cities and towns, and most were Australian-born. The main beneficiaries of the Boom were the 'comprador' bourgeoisie, serving British capital and servicing local industry, and the 'national' or domestic bourgeoisie, both in the cities *and* the country. But the gains spread slowly down, creating a relatively large petty bourgeoisie and promoting aspirations towards small self-reliant ownership amongst many members of the working class. Gains made by the trade unions reinforced these hopes. Nonetheless, conditions for most workers were exploitative. Class differences are recognized in the imagery, the literature, the press and the language of the period, although the usages vary from reluctant acknowledgement, through mere sectionalist description to the populist distinction (here antagonistic) between 'money power' and 'the people', and, sometimes, a frank acknowledgement that classes had formed in Australia because of people's different relationships to the ownership of the productive forces.[33]

The English journalist and poet, Francis Adams, saw much of this in his *The Australians: A Social Sketch* (1893). Two years earlier, in a preparatory article, he distinguished four types: '. . . the Anglo-Australian capitalist, the Englishman who has "risen", and remained an Englishman still to his finger-tips'; the 'upper class', which 'would be absolutely beneath contempt were it not for a handful of the better sort of capitalists, men liberal and progressive up to a certain point, but past that point resolutely conservative'; 'the workman of the Pacific slope', 'a petty suburban proprietor . . . feverishly "cocksure" of his possession of power and place'; and 'the workman of the Eastern Interior', typically a 'small unionist selector' from the bush which is 'the heart of the country, the real Australian Australia, and it is with the Bushman that the final fate of the nation and race will lie'.[34] Adams alludes only in passing to the squattocracy and to the rural and urban proletariat, and omits reference to his own section, but his account has great value because he located his types, especially the 'workmen', in their historical development during the Boom period, focussing on major changes during the years around 1890. These included the threats posed by the mid-1880s droughts and the predatory activities of local finance capital to workmen's 'suburban' properties and 'selections'; the efforts to combine both types of workmen into a labour movement; and the capitalists' response: the Great

Maritime Strike of 1890. During the later 1880s the language of class became less descriptive and more antagonistic: nearly all contemporaries seem to have seen the 1890 Strike as a class battle, a confrontation between Capital and Labour.[35]

Tom Roberts' own political and social views before 1891 cannot be established with certainty.[36] During the 1890s they seem to have been a mix of petty bourgeois ideology and the liberalism of the professional intelligentsia with whom he mostly associated, and to have become gradually more conservative as his career progressed.[37] At no stage do they seem sympathetic to the labour movement: there is no evidence that he intended, in *Shearing the Rams* or in any of his other images of rural work, to contribute towards the social or political goals of the movement. Despite the contradictions of his own life, and of the period, he seems never to have seen poverty, repression, exploitation, racism and war as *social* contradictions. Like most of his fellow artists he deliberately avoided such subjects in his painting.[38] This does not, of course, exclude such factors from entering the paintings as unintentional content, and from thereby contributing towards their meaning and significance.

Most importantly, the meaning(s) and significance(s) of *Shearing the Rams* are determined not only by what is given in the painting, but by relevant and conspicuous *absences* from it.[39] These guide us in our efforts to understand the painting, and others like it, as a response to the conjuncture of competing social ideologies of the time. They also help us to see more accurately just how this public statement became a reference point within the ideological debates of its time and of subsequent periods. To establish the relevance of these absences we need to measure the painting against the realities of the situation in which it was produced and to which it relates. Although *Shearing the Rams* conveys a sense of appearances closely observed, and alludes to Realism in its very subject, it is, nonetheless, a transformation of its subject according to the precepts of Academic art and the conventions of popular illustration. We should not expect it to be anything other than this, but we should continue to ask why is it as it is.

THE RIVERINA 1888-90

In the second half of the 1880s the Australian pastoral industry was in severe difficulties. Falling international wool prices, over-borrowing, expansion into marginal areas, and droughts all combined to cause a slowdown in squatters' growth, a halt to selection, and failure on the part of many smaller squatters and selectors.[40] Roberts, however, went to the south-central Riverina in the Hume district which, along with the neighbouring Murray and Murrumbidgee electorates, was the outstanding exception to this nation-wide tendency. There 'the struggle between the squatter and the selector has been fiercest, and . . . the most remarkable increase of agricultural settlement as regards wool growing and agriculture generally has been exhibited'.[41]

Brocklesby station was typical: begun in 1839, owned by a relative of Hamilton Hume in the 1840s, defined in 1866 as consisting of 51,000 acres, bought in the following year by 'Messrs Anderson and King'. Alexander Augustus Anderson was gazetted as lessee in 1874, after which 'Selection, in a few years, practically covered the area — a small proportion remaining in Mr Anderson's hands'.[42] Brocklesby was, however, unusual in that part of it was alienated for the establishment of Corowa, the fastest-growing town in the state between 1871 and 1888, with all the expected institutions from a School of Arts to the Border Brass Band.[43] Anderson strenuously resisted the town's eating up his remaining land: less than 2,000 acres by 1901. Brocklesby homestead was not large, and the woolshed was of moderate size (5).[44]

While the sketch suggests that the shed was quite small, the painting does not: it implies that we have stepped into the line of stands in a larger shed. Roberts' scaling up from reality may be a further reason for the awkwardness between foreground and background noted earlier. The decimation of Brocklesby itself is not indicated, nor is there any hint of the squatter-selector struggles which marked the period, particularly in the Riverina. The prosperity of this area is implied—indeed, it is generalized into an entirely positive image of a booming industry. But, as we have seen, the 'great pastoral life and work' was under severe stress; *Shearing the Rams* is unrepresentative of the contemporary state of the industry. In this sense it is a retrospective creation, celebrating a phase which was passing. And, in this same sense, it is city-based: it imposes the over-confident optimism of 'Marvellous Melbourne' onto a declining rural industry.

The retrospectivity of Roberts' vision in his major works on Australian subjects is striking. *Bailed Up* (1895) is deliberately based on an incident which occurred in the 1860s, and *Bushranging—Thunderbolt in an Encounter with the Police at Paradise Creek* (c 1895-98) similarly, on an incident before 1870.[45] *Bourke Street* (c 1886) does not show the cable tram system being installed in Melbourne at the time, and *The Breakaway* (1891) is an image of the recent past, of the sort of drought conquered by irrigation.[46] *Shearing the Rams* and *The Golden Fleece: Shearing at Newstead* (1895) likewise omit reference to a major contemporary technological change: mechanical shearing was being introduced into the Riverina during the 1888 and 1889 seasons. Its use was sufficiently widespread by August 1890 for it to become a strike-breaking device, since it required only two days for a novice to become an adequate shearer as opposed to the two-year apprenticeship for blade-shearers normal at the time.[47] There is no suggestion here that Roberts is deliberately misrepresenting the situations he is painting: all of them, with the exception of the bushranging subjects, could be witnessed in places throughout Australia. Rather, interest lies in the fact that, unlike much of the popular illustration and public rhetoric of the time, he elects *not* to show the most progressive aspect of the situation.

Shearing the Rams is also retrospective in its depiction of its ostensible subject: the shearers. Roberts' visits to Brocklesby coincided with the period of the most militant confrontation between station owners and shearers which ever occurred in the district. Wagga Wagga, less than a hundred miles north-east of Brocklesby, was the national headquarters of the Amalgamated Shearers' Union, whose leaders, such as W.G. Spence, Arthur Rae and W.W. Head, had been co-ordinating recruitment drives in the district since 1886. They subsequently published newspapers, managed the A.S.U.'s key role in the 1890 Strike, and became the major force in the N.S.W. Labor Electoral Leagues and, later, the Labour Party, standing successfully for state and, eventually, federal seats in the district. In August 1888, on Brookong station, thirty-five miles east of Brocklesby's northern border, a major confrontation occurred between striking shearers, members of the A.S.U. and the police. They had been called in by the owner, the Hon. William Halliday, M.L.A., to prevent the unionists picketing against the scab shearers whom he had hired. The resultant 'riot' led to the arrest, trial and imprisonment of nine men, who were sentenced to terms of hard labour ranging from one to three years.[48] Brocklesby station, although now small, could hardly have remained untouched by tensions such as these. But there is no indication of their existence in *Shearing the Rams*.

If Roberts ignored the possible union membership of the shearers, he also glossed over the realities of their working conditions. The majority of shearers throughout Australia at the time were itinerant, part-time workers, shearing for a maximum of five or six months in the year, if they were able to travel from north to south following the seasons. At other times they could take part-time labouring jobs in the city or remain unemployed 'on the

wallaby track'. Something of their conditions is reported by Flora Shaw, writing in 1891:

It was hugger-mugger of food on dirty boards, just one step removed from the well-filled troughs of swash and potatoes round which I have seen pigs crowd at home . . . They are readers of George and Hyndman; Bellamy's 'Looking Backward' is to be found in every shed . . .

Men hardly count upon getting more than four or five months employment in the year . . . the roughness of the existence in the intervals of work is unknown and probably unimagined by anyone who has not endured it . . . ninety percent of the wandering population is unmarried, and they may die hungry, thirsty, and homeless in the bush without greatly affecting any other human lives . . . You learn in this country what dying like sheep may really mean, and more men probably do die than are entered upon any district register.[49]

It is not just that shearing was hard, physically demanding work; it was also relentlessly exploitative. *Shearing the Rams* shows little of the former, none of the latter. Flora Shaw was describing the situation in Queensland, still a 'company state', dependent for capital and labour on the southern states and thus experiencing exaggerated forms of the conflicts inherent in the social organization of those states.[50] Yet as Buxton has noted, apropos the class-conscious rhetoric of the A.S.U. organizers and their reasons for accepting the 1890 strike as a trial of strength: 'It was not that the workers needed to be told their position on the social and economic scale. In Riverina society the reminders were continual, with the Masters and Servants Act to jog the memories of the forgetful'.[51] This Act governed relations between station owners or their manager and the permanent station

5 Tom Roberts, 'Brocklesby Woolshed', 1888 or 1889, sepia photograph. Private collection, Victoria

hands, as well as those between owners and shearers, unionized or not. A clause requiring the men to 'faithfully serve' the owner was included among the detailed rules as to the treatment of shed, shed behaviour, amounts to be shorn, rates, and other controls which were written into contracts.[52]

Social relations on sheep stations attracted the comments of many writers. In 1871 Trollope described, with obvious fascination, aspects of the squatter's life, particularly the fine distinctions between 'the house', 'the cottage' and 'the hut'. Furphy does the same in *Such Is Life*, writing of a Riverina cattle station in the 1880s. Trollope seems to marvel that English class distinctions can be maintained in such a 'rough' environment; Furphy treats them more pragmatically, sees their fragility.[53] Conflicts between squatters and selectors, then between both and the shearers, exerted great pressure on this set of distinctions. Again, nothing of such tensions, typical of 'the great pastoral life and work', is reflected in *Shearing the Rams*.

Both the academic Naturalist tradition and local popular illustrations tend to at least record class differences as a matter of observation. Many engravings of sheds in newspapers and books include the owner, manager and/or overseer, clearly distinguished by their different dress and by the fact that they are not doing physical work (4, 6 & 7). They are usually the focal point of the men working around them, our visual entry into the image. These social relations of production are rarely more clearly seen than in the photograph by Charles Bayliss from *c* 1880 (see Lendon [5]). Here the artist seems less to be creating an image of 'Life in the Bush' for a city audience than to be responding directly to a commission from the owner for a portrait posed in the midst of his property. The photograph is one from an album which shows him posed in front of his house, his yards, his horses and his land. The shearers and woolsorters are, from this class perspective, no different: they are just part of the resources which he owns.[54]

6 *Illustrated Sydney News*, 15 October 1864. National Library of Australia, Canberra

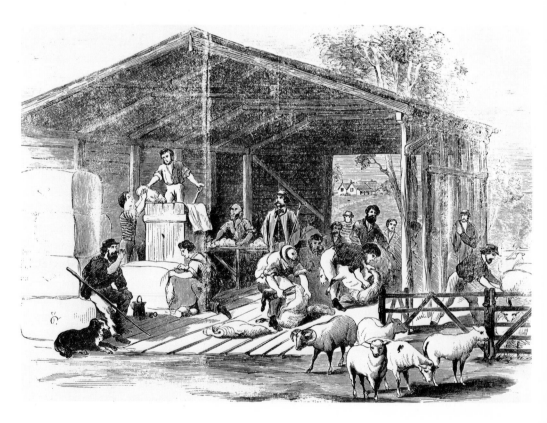

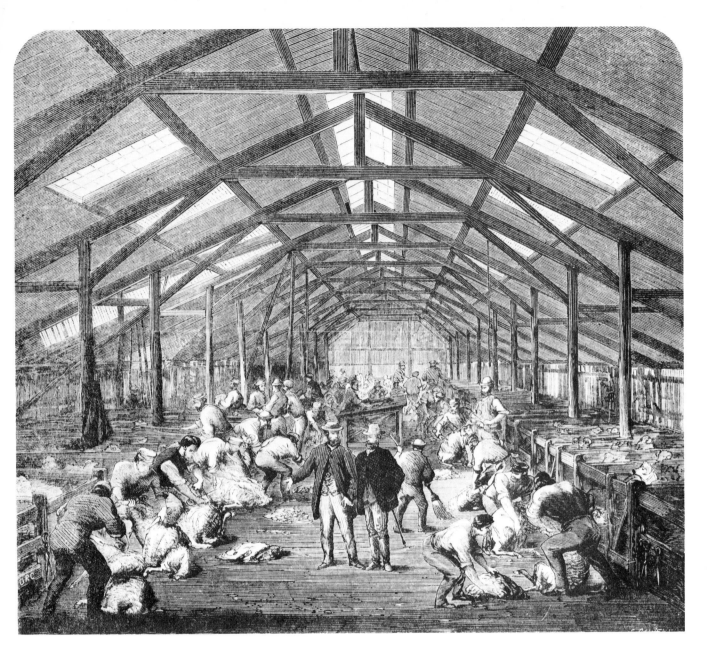

7 'Sheep shearing at the Yanco', *Illustrated Sydney News*, 18 February 1869. National Library of Australia, Canberra

Is this Roberts' view? Is he treating the shearers in the way that the owners of their labour might see them: as 'abstract' labour power, the power which transforms their sheep into profits? We saw earlier Roberts' evident fascination with shearing itself, as a process. In these two senses he does *idealize* the workers whom he is depicting: he abstracts their work beyond its physical and social reality. *Shearing the Rams* is a painting which any squatter might wish to hang on his wall.

But this will not quite do. The earlier illustrations and the Bayliss photograph show the owner standing centrally in the midst of the productive forces which he controls. Roberts does not do this. Is this because he need not, because the viewpoint—the very way the shearers are seen—is that of an owner? Is the squatter standing *here*, where we spectators stand, looking possessively at an image of what he owns? Not quite. There are elements within the painting, as well as many other relevant contextual factors, which oblige us to modify aspects of this interpretation.

It is possible to be more specific about the actual situation at Brocklesby on which Roberts drew for his painting. The station's early history has been described, and its owner introduced. Not enough is known about Alexander Anderson's early history or family to establish whether he was a squatter or a selector. He took up Brocklesby in 1867, when the Robertson Land Act had just opened up large properties to selection, but

he took it whole, and subsequently seemed unable to resist its being reduced by selection. Roberts' relationship with him is not as fully recorded as is his close friendship with Duncan Anderson, owner of Newstead where Roberts painted *The Golden Fleece* in 1894 (8).[55] The journalist writing in 1890 reported that at Brocklesby '... with much courtesy and kindness the proprietor arranged all matters to suit, as far as possible, the artist's convenience'. [56] Roberts visited three times at least, the third in the summer of 1890-91 to paint *The Breakaway*. There is no evidence that he was commissioned to paint *Shearing the Rams*, although he painted the house, a lagoon and tree nearby, and portraits of Anderson and the Hay family from a neighbouring property, Collendina.[57] So it cannot be definitely established that Roberts' relationship with Anderson was close, nor that his relationship to 'the men' was that of 'a gentleman' staying at 'the house', but such relationships are a reasonable inference.[58]

A report in the *Corowa Free Press* of 29 November 1890 stated that Alexander Anderson and his brother Charles were included in *Shearing the Rams*, as the two men sorting wool at the back of the shed.[59] If so, they are barely distinguishable as individuals and certainly do not occupy anything approaching the centrality of the owners in other images we have been considering. Furthermore, they are sharing in the work, as did many station owners and their families. This modifies any simplistic account of class distinction in terms of work done. This also counts against such an idealized, abstracted image of labour power being painted for them to own, precisely because their relationship to the work of the station, to the land and its resources, is *not* entirely abstract or distanced: they do contribute towards the productive process. The point would hold whether or not the Andersons were represented: it is only the absentee squatter, or the squatter seeking to present himself to an audience unfamiliar with farm work, who could be wholly satisfied with Roberts' idealization of what is, for both owner and shearer, a work site.

The *Corowa Free Press* report enables us to be almost as specific about the other figures in the painting. The white-bearded 'overseer' may be Francis Barnes, who was a member of the Corowa Progress Committee at the time. This committee acted, in effect, as a town council before Corowa's incorporation.[60] At this stage, moves towards incorporation were not attracting much support, so he would not necessarily be in conflict with Anderson over the issue. Nevertheless, this reminds us that the proximity of Brocklesby to a fast-growing town, and the general town-country conflict of the period, is yet another social factor absent from *Shearing the Rams*. The identities of the shearers and of the wool and tar 'boys' are also given in the report and in local oral tradition, although little is known of their histories.[61]

But, however interesting, these points are not necessarily relevant to the painting. While certainly influenced by the 'one view' and the verisimilitude of the photographic image, *Shearing the Rams* is not a documentary photograph. It draws, for part of its effectiveness, on associations with the presumed veracity of the photograph, but its actuality is not a precondition of its claims for authenticity. Nonetheless, the possible representation of Brocklesby's owner led us to modify our conception of the painting's intended audience, and the figure of Francis Barnes should lead us to a further modification.

Mr Barnes' membership of the Progress Committee would not have precluded him from being, or having been, a shearer. Indeed it makes it possible that he may have been an agent through whom shearers sought employment in the district. Neither of these roles preclude him from also being a member of the A.S.U. Further, he could have been all of these things and, at the same time, a selector. Because shearing was a seasonal occupation, local shopkeepers, stock agents or other permanent residents of towns in the shearing districts were often not merely members of the A.S.U. but local representatives of the

union. In the first issue of *The Worker*, William Lane addressed 'one of the first questions . . . Should shopkeepers and small employers of labour be admitted to Labour unions?'. He answered in the negative, except that 'some unions, such as the Shearers, Seamen, Carriers, and other floating workers, have been greatly indebted to non-wage earners whose sympathies have been with them, and whose services have been great'.[62] The picture of total class conflict also needs modification in view of the estimation that up to one third of shearers were also selectors—either selectors and their sons shearing in the locality when the season came round or, more often, shearers who followed the season but maintained a small selection as their home base.[63] Francis Adams' 'workman of the Eastern Interior' was the latter. Indeed the closer to the Eastern seaboard, the more likely it was that a shearer was also a selector. His selection did not prohibit him from membership of the A.S.U., the main branches of which were mostly in the East. Furthermore, the developing electoral role of the labour movement depended on the selector, because residency requirements effectively disenfranchised the itinerant worker until 1900 and labour's greatest number of seats were country ones.[64]

These factors not only indicate the disproportionate practical and ideological influence of selector-shearers in the A.S.U., they also suggest the prevalence in the shearing districts of a petty bourgeois ideology, in the form of a belief that small-scale self-sufficiency was the natural right of any man who worked hard enough for it. Examples of such success were known to all, and held out as a reasonable hope by union and non-union shearers

8 Tom Roberts with Duncan Anderson and Family, 1895, sepia stereograph, photographer unknown. Private collection, Victoria.

alike.[65] Selectors were clearly the most progressive class section in the Riverina during the 1870s and the first half of the 1880s, the larger ones displacing the squatters and even joining their ranks.

Given these circumstances, and the previous characterization of Roberts' personal ideology as in tension between its petty bourgeois and its bourgeois intellectual elements, is it not possible to claim that one aspect of the 'meaning and spirit' of 'strong masculine labour' in *Shearing the Rams* might be that such labour gives you a chance to improve yourself, to 'get on' in society? Is the evident strength of Roberts' figures a response to their actual models as embodiments of 'the dignity of labour'; or is it that they embody a labour force capable of owning itself, of being exerted in these peoples' own interests, on their own small selections? Does Roberts identify in this way with some of the shearers, projecting onto them or recognizing within them a set of aspirations: commitment to hard work and pride equivalent to those which marked his determined pursuit of an artistic career? There are, from this perspective, notable differences in the ways each figure is represented, so that there is an increase in detailed observation and in apparent command over the job from the background to the foreground.

9 'The Real Anarchist—The Squatter', *The Worker* (Brisbane), 21 July 1894

But, while a third of shearers were also selectors, two-thirds were not. While many shearer-selectors were in the A.S.U., many were not. While some non-selector shearers were scabs, most were in the union. And while petty bourgeois ideology was ascendant amongst selectors, most townspeople and urban dwellers at the time, it did not always override ideologies formed on the basis of working-class experience. There were more strikes in the pastoral industry between 1886 and 1891 than in all other Australian industries. If the dream of owning one's own land was prominent in the early and mid-1880s, by the end of the decade it was becoming increasingly a fantasy. By the early 1890s it was an obvious impossibility. These years broke the petty bourgeois hopes of many workers, throwing them back into the entrapped reality of the class to which they belonged. Historians are recently coming to see that some unions welcomed the 1890 Strike as, above all, a potentially educative experience, one which would demonstrate to the rural and urban working class that the benefits which some of them had had from the Long Boom were not 'natural' results of inevitable progress but were temporary achievements requiring union organization to defend and maintain. The complexity of this analysis is necessary because we are witnessing a class in itself becoming—slowly, reactively, with much backsliding and collapses into bourgeois ideology—a class for itself.[66] Conflict within and between shearers is, then, a major factor which *Shearing the Rams* obscures by proposing the false resolution of petty bourgeois individualism.

It was possible to produce images of this period of strained social relationships, and to do so well, with a sharp critical eye. Thus the illustrators for the labour movement publications, especially newspapers such as the *Hummer* (Wagga Wagga 1891-92), the *Worker* (Sydney 1892-) and the *Worker* (Brisbane 1890-). 'The Real Anarchist—the Squatter' (9) is from the *Worker* (Brisbane 21 July 1894).

MELBOURNE 1888-90

There is yet one further level of complexity to be discussed before the ideological conjuncture within which *Shearing the Rams* was lodged can be regarded as fully sketched. It is one which returns us to Melbourne, to the bourgeois intelligentsia with whom Roberts associated and to the bourgeoisie whom high art primarily served.

What relevance would a painting of pastoral life and work have to the city bourgeoisie? We must not forget that, although the spectacular fortunes of the 1880s were made from the explosive growth of Melbourne itself, the basis of the city's economy was, as it had always been, its function as a port, distribution centre and supplier of services to the country industries, especially mining and pastoral. Many of the newer banking, credit and insurance houses of the 1880s were linked to the pastoral industry through the supply of capital, mostly British but also local, to squatters and selectors. Many Melbourne businessmen owned pastoral properties all over Australia. Their relationship to pastoral work was not directly productive, being mediated through managers, accountants, brokers and agents. They did not often live for long periods on their properties: rather, they tended to visit them on tours of inspection. Throughout the 1880s and 1890s ownership of pastoral properties passed increasingly into the hands of banks, credit houses and societies and other finance companies, further removing individual commitment to them.[67] These remarks are, of course, generalizations aimed at suggesting a picture of the important, but distanced, relationship to rural life and work of one section of the Melbourne bourgeoisie.

We should not, however, expect Melbourne intellectuals and professionals to exactly reproduce this relationship in their view of the country. They were removed still further,

since they neither owned country stations nor serviced rural life and industry. Mostly British, although certainly open to European bourgeois culture in general, they set about quickly to staff and build the ideological apparatuses of bourgeois culture on British models. They did so according to predominantly British tastes, standards, and the ideology of gradual progress for everybody within a kind of social organization remaining pretty much as it was. We have seen that Aestheticism was, or had been, a prevailing fashion, that academic Naturalism was taken as the given framework for artistic practice, and that in the later 1880s there was a quickening of interest in local subjects within these two tendencies. In terms of social theory, the benevolent, trusting gradualism of the educator, Charles Henry Pearson, would perhaps have been typical[68], however the outrageous exaggerations of Marcus Clarke were well known, and were matched by 'Rolf Boldrewood's' sobriety. All three writers asked the same question: what sort of society could the British build in the face of the modifying influences of the climate and geography of Australia? The bush enters in at this level, as the one element which is obviously distinct and specific to Australia. Boldrewood writes of the outback air producing 'the hardy brood of the farmer, the stockrider, the shepherd. Stalwart men and wholesome, stirring lasses do they make'; of the abundant diet, hard work and the necessity of long travel, which produced 'The ordinary bush-labourer, reared on a farm or station, is generally a tall, graceful personage'. But all the rest is variety. 'There is *no* generic Australian definition', although the Australian 'more nearly resembles the Briton, from whom he is chiefly sprung'.[69]

This is the view, I submit, which accords most closely to Roberts' own experience and which echoes his artistic decisions in *Shearing the Rams*: the English-European academic Naturalism and the popular illustration imagery—itself often derived from English models; the desire to exhibit the painting in the Royal Academy and the response to developments in local high art. In this context 'Australian' does not imply any diminution of the overriding British framework. The peculiarly Australian character of the woolshed is interesting, even fascinating to artist and audiences, but it is not a threat to the 'golden link' binding Australia to the Empire.[70] Boldrewood's description of 'the ordinary bush-labourer' is as much a pen-portrait of Roberts' shearers as Adams' 'workman of the Eastern Interior'—perhaps even more so.

This connection suggests that Roberts and his audiences, at least in 1890, did *not* see the shearers he depicted as so transformed by Australian experience that they had become distinct *national* types. They clearly symbolize something unique to the colony (i.e., the huge scale of the wool industry), but do not quite suggest the model on which an *independent* nation might be built. Roberts was no republican, and republicanism, while often discussed, was not the leading political notion amongst Melbourne's intelligentsia. It was, for them as others, eclipsed by the idea of the federation of the colonies into a Commonwealth within the Empire. In their letter to the *Argus* of 30 August 1889, in defence of the 9 x 5 Exhibition, Conder, Streeton and Roberts hope that their 'impressions' have contributed towards 'the development of what we believe will be a great school of painting in Australia'.[71] They do *not* say 'a great Australian school', nor 'a great school of Australian painting', nor even 'a great school of paintings of Australia'. Nonetheless, the journalist's report of 1890 states that Roberts' subject 'seemed to him most really and absolutely Australian, and then he went out to the great Australian river to learn it'.[72]

Is this a further tension within *Shearing the Rams*, the dawning realization that these shearers were not exotic equivalents of Millet's peasants, were not just fascinating examples of what the demands of colonial life could effect upon good English stock, were not

local variants of typical workers from any country, but were men whose personal experiences and relationships to others made them the source of a different, radical conception of an independent nation? Nationalist views had been forcefully put, especially in 'the bushman's Bible', the *Bulletin*. Here is its editorial of 2 July 1887:

By the term Australian we mean not only those who have been merely born in Australia. All white men who come to these shores—with a clean record—and who leave behind them the memory of the class-distinctions and the religious differences of the old world; all men who place the happiness, the prosperity, the advancement of their adopted country before the interests of Imperialism, are Australian . . . In this regard all men who leave the tyrant-ridden lands of Europe for freedom of speech and right of personal liberty are Australians . . . who leave their fatherland because they cannot swallow the worm-eaten lie of the divine right of kings to murder peasants, are Australians by instinct—Australian and Republican are synonymous . . . No nigger, no Chinaman, no lascar, no Kanaka, no purveyor of cheap coloured labour, is an Australian.

But nationalism is not an ideology: it is an appeal to social unity made specific by the class ideologies and interests which call on it at particular times. The *Bulletin's* statement is, above all, one of petty bourgeois progressive individualism. Elements of it could be cited by all classes in Australian society, except the 'comprador' bourgeoisie. Its racism might have disturbed some liberals, but few others at the time. With suitable modifications, its implied image of a nation would be as acceptable to the domestic bourgeoisie as to the utopian socialism influential in the labour movement. Its elements were as present in the protectionist and exclusionist legislation enacted by the first federal parliament as in the first objective of the Australian Labour Party of 1905: 'The cultivation of an Australian sentiment based on the maintenance of racial purity and the development in Australia of an enlightened and self-reliant community'.

But my argument is less about the general question than the linking of nationalism with the bush worker. Was Roberts among the first of those intellectuals who saw the bush worker as having 'a specifically Australian outlook'—'a comradely independence' (mateship), a capacity for 'rough and ready' improvisation, to laugh at respectability and 'conventional manners', a 'reckless improvidence' and a sense of themselves as 'true Australians'?[73] I have established that he found the work of the shearers impressive, but he abstracted it; that he found the shearers themselves impressive, but he idealized them. We have further established that the painting's primary level of address is as an image of the wool industry, rather than shearers; of work in the bush, rather than bush workers. This is what he meant by the phrase: 'the great pastoral life and work'. Was Roberts responding to the uniquely Australian culture of the bush worker, or was he imposing onto work in the bush the same qualities as are revealed in the Heidelberg landscapes: health, regeneration, simplicity, growth and sunny optimism?

These qualities are marked, not in themselves, but in contrast to life and work in the cities. The shearers become ideal representatives: Arcadians in moleskin. This is an idealization by a city intellectual, akin to Paterson's *Clancy of the Overflow* (1889). But the Melbourne intelligentsia were less prone to link their view of the bush with nationalist sentiments than their Sydney counterparts. It is doubtful whether Roberts, even after he moved up to Sydney in 1891 and associated with the *Bulletin* writers, ever shared the preoccupations with secularism, republicanism, land reform and anti-Chinese feeling which led them to seek in 'the Bush' alternatives to their failure to realize a society based on these views in 'the City'.[74] Despite the fact that he was probably more familiar with the bush than most of the *Bulletin* writers, he never sought to project the relentless alienation of, especially, the selector and the bush worker's experience as did, for example, Lawson in 'The Drover's Wife' and Baynton in 'Squeaker's Mate'.[75] He never made explicit the

contradictions of their Bush-City views, as did Lawson in 'The City Bushman'. Whereas Lawson was devastated by his one long visit to the bush, Roberts maintained his optimism over many years of bush visits. Is this attributable to their different class perspectives? Unlike Lawson, Roberts does not go on to claim, in Francis Adams' words: 'Yet the bush is the heart of the country, the real Australian Australia, and it is with the Bushman that the final fate of the race and nation will lie'[76] (1891). Instead, in his letter to the *Argus* of 2 July 1890, he concludes the previously cited description of the spectacle of the woolshed with a classic statement of supranational ideological transcendence: '. . . by making art the perfect expression of one time and one place, it becomes art for all time and all places'. I hope that this essay demonstrates that this is just not the case, and that such appeals are ahistorical attempts at 'universal' resolutions of conjunctures of problems which are threatening in the present.

Finally, *Shearing the Rams* is a view from the city, above all, in that it shows the labour power at the heart of the pastoral industry from the viewpoint of the city bourgeoisie, especially that fraction of the class (described at the beginning of this section) which knows its dependence on such work as a fact of experience, but whose relationship to it is more abstract and mediated than that of the squatter. In order to confirm this point, and by way of a summary of the argument, we might consider the variety of approaches which Roberts could have taken, once he had decided on his 'subject'. He could have painted a threatened pastoral industry, the struggles between squatters and selectors, between owners and unionized shearers, between union and non-union shearers. He could have emphasized the sweat and grime of the work, or its exploitative, rule-bound nature. He could have depicted the lives of the shearers off-season, or a moment in the life of the station-owner, including an image of the latter in the midst of the labour power which he owned. He could have conveyed these through a narrative arrangement of figures, gestures and background information, as did Longstaff in *Breaking the News* (1887); or by focussing on their psychological effects upon an individual, as did Herkomer in *On Strike* (1891) and, to a lesser extent, Ashton in *The Prospector* (1889). But he did none of these things, although all were artistically possible and present in the social reality of the time.

Instead he presented a celebration of rural work, based on observed appearances and respectful of the job of shearing, but nonetheless abstracted from all those engaged in it, except those engaged at a distance. In this sense the primary spectator is the city bourgeois, in Australia or in England, with an investment in the pastoral industry. To him *Shearing the Rams* comes as an affirmation of his relationship to rural work, an image of an investment at the heights of its productive, and profit-producing, power. *Shearing the Rams* was not bought by the National Gallery of Victoria. It was not bought by a member of the intelligentsia, by one of the professionals who otherwise supported Roberts' work. It was not bought by a finance capitalist nor by a squatter. It was bought by Edward Trenchard, of Edward Trenchard & Co., leading stock and station agents, of Collins Street, Melbourne.[77]

In this context *Shearing the Rams* becomes less a picturing of men at work, more an image of the productive force of Nature itself. As a painting, its level of meaning becomes less that typical of a figure study and more that typical of a landscape. Its ideological function, for the city bourgeoisie, is to disguise the fact that the basis of their wealth, the source of their social control, was threatened by economic instability and organized labour. To them it can be read in a profoundly conservative way, as depicting a world which might have been, a world which might return, if only the thick-fleeced sheep keep coming in and strong, healthy, happy workers continue to shear them.

CONCLUSION

The reading just given of *Shearing the Rams* is, I submit, its major level of meaning at the time of its painting and subsequently. I make no claim that Roberts fully and consciously intended this to be so—rather, that as a response to the competing aesthetic and social ideologies of the time, it attempts a resolution most obviously, overtly and strongly on this level. Its proposal of this resolution has been its ideological function, as an important reference point within bourgeois institutionalized nationalism since Federation. However—and again irrespective of Roberts' intentions—the painting has elements within it which open it to association with at least two other class ideologies, enabling thereby changed levels of meaning. We have noted that the painting idealizes the independent strength of each shearer, implying the shearer-selector, the petty bourgeois ideal of small-scale self-reliance achieved and maintained through individual hard work. And we have noted throughout the essay the recording of the sheer hard work of shearing—a material fact which, if associated with other readings (such as a presumed communality of labour within the shed), opens the painting to working-class and socialist use.

Roberts aimed to produce an image which would be impressive in the company of the highest academic art of the period but which would also be popular. His sense of audiences was probably no more specific than that. However the class ideologies influencing him during the painting of *Shearing the Rams* were those of the city bourgeoisie and of the classes dependent on it: the liberal intelligentsia and the petty bourgeoisie. His image reveals no sense of the working class as a class: his figures are bushworkers idealized into elements within a scene of the pastoral industry, typically Australian but not nationalist. *Shearing the Rams* was not an icon of the Australian Legend at the time of its making, but this does not preclude it from becoming so subsequently. To take these conclusions further, it will be necessary to examine other images of work by Roberts and members of the Heidelberg School in the original contexts of their production, during the 1920s revaluation of the Australian landscape and since. In this way we shall learn more about the paintings, the artists, and about the ways in which culture and ideology are produced and reproduced in Australia than is usually accessible to art historical method.

ANN GALBALLY Aestheticism in Australia

Aestheticism in Australia has received little attention from art historians. Glossed over as a received fashion mishmash of afterglows, nostalgia and decorative fantasies, it has been placed as the rather uncertain forerunner to the 1890s vogue for Symbolism and Art Nouveau. Historians have usually identified with Aestheticism the more avant-garde tendencies of Tom Roberts, in the years after he returned from Europe, and the self-cultivation of Charles Conder, both as a member of the Sydney circle of Madame Constance Roth and later in Melbourne with his dandy attitudes and love of scene setting.

But were such attitudes really advanced for their time? A closer investigation into the reception of Aestheticism in Australia points not so much to its being the preserve of the radical artistic fringe, but the opposite. And a knowledge of the local popularity of Aesthetic fashions amongst the Melbourne middle classes suggests very different motives for Roberts, Conder and Streeton's 9 x 5 Exhibition, in which they identify themselves and their art with the fashion, from those generally held. What used to look like another bohemian jest amongst the group, a local example of *épater les bourgeois*, starts, under investigation, to look much more like a conscious effort of the group to actually *identify* with the tastes of the local middle classes.

Earlier accounts of Aestheticism in relation to Australia have been characterized by a lack of precise definition. Too often writers have simply taken the attitude that Aestheticism was a rather weak and effete link between Pre-Raphaelitism and Symbolism with little in the way of positive characteristics. The tendency to blend Aestheticism with Symbolism in accounts particularly of Charles Conder in the late 1880s confuse Conder's position by taking no account of his well-documented love of an audience.

For, unlike Symbolism, Aestheticism never aimed at secrecy, nor at being the preserve of chosen initiates. Aestheticism had a mass following, a middle-class base and distinct characteristics. It did, of course, aim at exclusivity. Its followers felt themselves to be innately superior by virtue of their recognition of and elevation to a new plateau of taste. But this exclusivity depended upon being recognized. Unlike the Symbolists, the aesthetes did not exist in separate, jealously guarded enclaves, but recognizably, in the midst of society. Their exclusivity depended upon society's recognizing their difference. Publicity was as much a cornerstone of the movement as was their own mutual and public recognition of each other, and their group contempt for those unaware of or indifferent to their superiority.

Aestheticism in Australia, as elsewhere, depended upon a class who were coming into money and who sought to distinguish themselves from the older moneyed classes. Socially they were upwardly mobile, usually political liberals who developed their domestic settings as a background for their own attitudes. These they wanted to be seen as distinctly different from their early Victorian forebears, whom they regarded as ruthless and insensitive. Art and music became important extensions of this group's freer and more open-minded attitudes, and it was important that these attitudes should be seen and recognized. Hence the appeal of aesthetic objects—Japanese knick-knacks, blue and white china, liberty prints—for it was through such emblems that they could find mutual recognition

and acceptance. Their houses were generally smaller than the great mansions of those who had made their money in the goldrush days. In contrast to the property-owners from the Western District, who had opulently decorated town houses, the new middle classes were interested in art. People like Felix Meyer, Professor Marshall Hall, Carl Pinscoff and Louis Abrahams made discerning buyers and patrons, unlike, for instance, the Chirnsides of Werribee Park, who bought their pictures in job lots at Scottish auctions. In their homes the emphasis was on domesticity and comfort rather than pomp and grandeur. So it is not surprising to find that these lawyers, businessmen and doctors interested themselves in the art they found around them, and were keen to patronize local artists and to mix with them socially.

Essentially a cultivated flower of a well-developed and stable society, Aestheticism should have found the dusty roads, the roistering larrikins of Bourke Street, the confusion of architectural styles and tastes that characterized Melbourne in these wealthy post-goldrush days, an unsympathetic breeding ground. Yet it would seem that it struck root in

1 'Sketches on the Block', frontispiece, *Australasian Sketcher*, Saturday 27 August 1881

Melbourne much earlier than has been previously assumed. We find the fashion in Melbourne some eight years before the arrival of that fashionable dandy from Sydney, Charles Conder.

Ada Cambridge precisely locates the arrival of the new fashion to the 1880 Exhibition:

At that date [1870s] when we stay-at-homes were all for gold and white wall paper and grass green suites . . . in our drawing rooms, I believe G—— was unique in the colony as the first example of the new order.

Her friend G——, taken to the International Exhibition of 1880, wandered from court to court and found no exhibits more pleasing . . . 'than the treasures she had gathered for herself in foreign parts'. G—— not only had her own advanced tastes confirmed but the genteel and artistic circles in which Ada Cambridge moved soon followed suit: 'I must say here that we became rapidly aesthetic afterwards, because it is our constant habit to follow English fashions ardently as soon as we get an idea of what they are'.[1]

The fashion must have caught on rapidly, for within a year it is being gently satirized on the front page of the *Australasian Sketcher* for 27 August 1881, where an 'Aesthetic Lunch at G—— Cafe' (presumably the fashionable Gunters) is depicted as one of a number of 'Sketches on the Block' (1). Three ladies, one with a rather dashing cloak slung carelessly over the back of her chair, and another in a loose-fitting gown with unfashionable (but aesthetic) long full sleeves, gaze at their distinctly unaesthetic repast subtitled 'a Bun and a Bottle of Ginger Beer'.

The sketch is of course a direct steal from the aesthetic characters created by George Du Maurier in the London *Punch*, slightly modified for local conditions. Du Maurier began his sustained series of cartoons on the aesthetic movement in the mid 1870s, and, in the pages of *Punch*, up until the trial and fall of Oscar Wilde in 1895 the reader could become thoroughly familiar with all the trappings of this elaborate cult of beauty: the craze for blue and white china, for loose-fitting gowns and flat shoes for ladies, for fleshly poets, artistic wallpapers and furniture, lilies and sunflowers, medieval art and music.[2]

The English *Punch* must be considered as one of the most important sources for those living in Australia for keeping up with English fashions. And it would seem that the educated middle classes, people such as Ada Cambridge, managed to conceive a very precise idea of what the new fashion entailed without ever leaving Australia. As Ada Cambridge emigrated from a rural English setting in the early 1870s and remained in Australia for the following thirty years, she could only have known of the movement through the literary and visual sources that were available to her in Melbourne. Yet she managed a very clear idea both of the trappings of aestheticism and its less fashionable commitment to social welfare, as she reveals in her short story, *The Perversity of Human Nature*, published in the *Illustrated Australian News* Christmas Supplement for December 1887. Here is her description of 'The Nest', the heroine's home in fashionable St Kilda:

The inside matches the outside. Persian carpets on the dark floors. Liberty stuffs at the windows; Morris chintzes on the chairs and sofas; good, though not rare, pictures on the walls which are tinted on purpose to suit them: low book cases running like dados round the rooms, filled with books to read and not to look at and bearing on the top shelf dainty bric-à-brac, of which every piece has been selected on its own merits, and not at the command of a vulgar fashion. A thoroughly refined and harmonious household in short; such a house as could only belong to cultivated and enlightened people.

The inmates of 'The Nest' had met at the temple of Aestheticism, the Grosvenor Gallery, where 'he' was on a tour from Australia in search of pictures whilst 'she' was

SKETCHES FROM "THE COLONEL," AT THE OPERA-HOUSE.

visiting the gallery from her aesthetic lodgings in Whitechapel. They marry and come to Australia where, in spite of the aesthetic pleasures of 'The Nest' and her own aesthetic narcissism—'she was picturesquely dressed in sage-tinted Library silk draped Greek fashion in mysterious loose folds from her shoulders to her feet and slightly held to her slender figure with a silk cord tassled at the ends'—she is bored.

She can't find a suitable social circle to dominate, but is confronted daily by 'The Philistines of the tight waists, whose acquaintance she would not condescend to', and so runs away back to London. A change of heart sees her returning to Melbourne, and after a series of melodramatic mishaps the pair are reunited in parental bliss in 'The Nest'.

2 Frontispiece, *Australasian Sketcher*, Saturday 22 April 1882

Although Ada Cambridge's sources are overwhelmingly literary (the heroine is referred to as Mrs Cimabue Brown, after a Du Maurier character, by her envious Philistine acquaintances), there was another local source she may have been aware of. And that was the popular theatre. Aestheticism became a popular satirical object for writers, singers and producers in the early 1880s. Frank Burnand's now forgotten aesthetic spoof *The Colonel*, first produced in London in 1881[3], was performed in Melbourne only a year later at the Opera House. Characters from the play made up the frontispiece of the *Australasian Sketcher* for Saturday 22 April 1882 (2). All the favourite aesthetic characters are there: the Philistines, 'The Colonel and Mrs Blyth', he in City clothes and she in a tight-fitting riding habit; the aesthetic artist, 'Basil Giorgione', clutching a sunflower; the reverence for Japanese teapots and for bizarre emotions:

Oh the beauty of bitterness
Oh the rapture of regret.

The play was enormously successful and paved the way for Gilbert and Sullivan's *Patience, or Bunthorne's Bride*, which was staged in Melbourne at the Theatre Royal three months later. It had been premièred in London only a year earlier, at the Opera Comique on 23 April 1881. And again we find the characters and favourite scenes illustrated on the frontispiece of the popular weekly, the *Australasian Sketcher* for Saturday 15 July 1882 (3).

Aesthetic attitudes, costumes and interiors all seem to have had wide publicity in Melbourne in the early 1880s, via the press, the theatre and imported periodicals. The craze for Japanese art, so much a part of Aestheticism, is also noted and explored in the local press. James Smith presents a characteristically didactic and solemn account of this rising fashion in the *Argus* in March 1881, in a lengthy article entitled 'The Japanese Exhibits and Japanese Art'. Basing his account on the objects shown in the Japanese Court at Melbourne's 1880 Exhibition, Smith displays a perceptive awareness of the extent and depth of the craze, quite remarkable for a man who had arrived in Melbourne in the 1850s, well before Japanese artefacts were brought to Europe. He wrote:

When the invasion of Japan by Western ideas took place, it could scarcely have been anticipated that a great reflex movement would have occurred, and that Japanese art would so profoundly affect the artistic productions of Europe and America as it actually has done.[4]

Smith attempts to account for this in a number of ways, but finally comes down, acutely, in favour of the 'originality and loyalty to nature' as the primary appeal of Japanese art to the West.

In all the choicer exhibits to be found in the Japanese Court, as well as in the fine collection displayed by Mr Singleton you meet with continual evidence that the art-workman has looked at nature with an ingenuous freshness and naivete of feeling, with a simple and unsophisticated admiration of her various forms and manifestations, and with an honest determination to interpret them with literal and loving fidelity.[5]

. . . in other words having all the virtues of primitive or 'archaic' art so prized by the aesthetes.

This conjunction of the aesthetic and a love of Japan became quite established in the 1880s and appears to have been a commonplace assumption for the reporter on the *Australasian Sketcher*, in his account of Eduardo Remanyi, the 'eminent virtuoso and aesthete' who gave a concert in the presence of the Mikado on 10 August 1886 in Tokyo. As the writer commented, for one such as Remanyi 'on his tour around the World [he] could not fail to visit that most interesting of all Eastern countries—Japan'.[6]

The Japanese cult not only affected the serious (Smith) and the talented (Remanyi), but the socially ambitious world of fashionable Melbourne dinner parties. In the fashion notes for the *Australasian Sketcher* for August 1886 a Japanese touch is recommended:

For the especial luncheon or dinner, the *menu* may be written on the back of a tiny Japanese fan, narrow ribbon may be hung upon the handle, and the name of the recipient, signifying that it is to be taken away as a souvenir, on the handle.[7]

3 'Sketches at *Patience*, Theatre Royal', frontispiece, *Australasian Sketcher*, Saturday 15 July 1882

Japanese and other oriental furnishings and artefacts were readily on sale in Melbourne and Sydney in the 1880s and 1890s. The very fact of their cheapness and availability meant that this side of aestheticism achieved rapid popularity. This fashion lingers into the 1890s where, as late as December 1895, Arthur Streeton, in a sketch of his tent at Sirius Cove, Mosman, includes a Japanese lantern hanging prominently from the tent pole.[8]

So it would seem that in Melbourne the fashion-conscious public were well aware of the Aesthetic Movement from the early 1880s. Their awareness was stronger in the decorative than in the fine arts, however. This is noticeable when the Whistler painting which toured Australia in the Anglo-Australian Exhibition of 1885 excited no press comment. Hitherto it has been assumed that this was simply because of the ignorance of the press and the public, but in the light of the fairly extensive public exposure of aestheticism before this date, this silence can no longer be assumed to be the result of ignorance.

Aestheticism in painting involved primarily an attitude to art and to oneself. An aesthetic painting was one to be appreciated for its colour, its form, its design; subject-matter was of secondary importance. What mattered was the aesthetic state, the mood or reverie that the painting could strike through the eyes of the viewer. The aesthetic artist must himself be master of such moods, must be responsive to them as they occur in nature around him, and able to see and create them where others cannot. Hence the remarkable mutual cultivation that occurred with the trio Roberts, Streeton and Conder during the years of the Heidelberg Camp, and for Streeton and Conder for some years afterwards. Their almost instant nostalgia for the camp when it broke up, the repetitive recallings in letters of the colours of the eastern sky at sunset, their reverence for nature and the constant claims of falling short of their dreams in their art, the love of reverie which occurs *ad nauseam* in the correspondence of the three, was really a process of conscious cultivation of their aesthetic sensibilities.

Streeton is the most articulate as we can see here, writing to Roberts in 1890 about a proposed return to Melbourne from Sydney when they

... will have a good long smoke and think through all the past 'summer'—the enjoyment of 'the last summer at Eaglemont' was to me more intense than anything I have up to the present felt.

Its suggestion is a large harmony, musical, rosy—fancy if you could grasp all you thought into a scheme which would embrace sweet sound, great color and all the slow soft movement sometimes quick with games and through all the strength of the great warm and loving sun.[9]

This aesthetic aspiration to fuse dream and reality in his work occurs again in another letter to Roberts from Glenbrook, N.S.W., a year later:

Oh to go quietly to rest this night and breathing all through the dark hours the sweet fragrance of new hay with which my pillow smells and my heart beats on while my nerves bind together and strive strongly to pierce the twilight weaved through certain written words—Nevermind Bulldog things shall take their course, and—I'll stick it all into my work ...[10]

Many of the titles of the works shown in the 9 x 5 Exhibition of August 1889 indicate precisely this intention of conjuring up a mood, a reverie, rather than painting something naturalistically from nature. Roberts exhibits an 'Andante', presumably a sombre mood piece; Streeton showed 'A Scheme in Apple and Fawn', a decorative essay, and 'A Dying Day', an evocative sunset. Conder contributed 'Harmony in Old Rose', a Whistlerian title; 'Dolce far niente', suggesting a specific mood; and two tributes to the master of the transient mood, 'A Page from Herrick' and 'Herrick's Blossoms'.[11]

It has generally been agreed that it was Roberts who had the first contact with Aestheticism in London, where it seems fairly likely that he saw the Whistler exhibition of small oil studies on wood panels shown at Dowdeswell's Gallery in May 1884; but it is possible

4 Tom Roberts, *Portrait of Mrs Louis Abrahams in a Black Dress*, oil on canvas, 40.6 x 35.6 cm, 1888. National Gallery of Victoria, Melbourne

that Roberts knew of the movement even before he left Melbourne for London in 1881. His first effort at painting in an aesthetic manner, however, occurs in London with his small scale studies of the Thames. These are followed by his remarkable oil study of Bourke Street, painted in the year following his return to Australia (1885-86) and given a title in emulation of Whistler's professed striving for 'the condition of music' in his painting, the brisk 'Allegro con Brio'.[12]

Two years later, Roberts again demonstrates his awareness of Whistlerian aesthetics in his wedding portrait of Louis Abraham's bride, Golda Brasch, in the dark-toned *Portrait of Mrs Louis Abrahams in a Black Dress* (4). However Roberts is not solely interested in a study of dark tones on dark, but reveals his love of scene setting by adding several props indicating that the lady's taste is fashionably aesthetic. She is seated in an oriental cane chair, and a Japanese lantern and fan can be seen above the doorway in the top right-hand

corner of the picture. Three coffee cups are placed upon a black and red japanned tray on top of the table in the near right, and the flower arrangement, which also balances rather uneasily upon the same table, features the favourite flower of the aesthetes, the sunflower.

These pictures indicate that Roberts was aware of Aestheticism and would use its props and credos when it suited him—as it suited him to use from time to time the props of the aesthetic dandy, the top hat and the opera cloak. But his commitment to Aestheticism was never total: he shed the persona very easily to become, at other appropriate times, the portrayer of the outback nationalistic ethos in his painting trips to Brocklesby, N.S.W., to make studies for *Shearing the Rams*, or the respectably suited friend and portraitist of politicians.

The greatest proponent of Aestheticism in Australian art is usually considered to be Charles Conder. In Sydney he formed part of a social circle, centring on Madame Constance Roth, that included Blamire Young, who had been associated with the Cambridge Fine Art Society before coming to Australia in 1885, Phil May and the American black and white artists who were working on the giant project of the *Picturesque Atlas of Australasia*. Blamire Young created an aesthetic studio in the grounds of Katoomba College, N.S.W., where he taught, which contained a blue-tiled fireplace, silk madras muslin for the curtains and Mirzapore rugs on the floor. Not long afterwards in Melbourne, Conder established a similar scene for himself, a studio

attractively fitted up with soft draperies of Madras muslin, liberty silks and other light falling fabrics, while souvenirs of Sydney are scattered all over the room—sketches by Phil May, F.B. Schell, Mahony, Julian Ashton, Minns, Nerli and Madame Constance Roth. Scraps of seascape, riverviews and a few of the artist's own pictures are scattered about the walls, among fans and other odds and ends of curious little articles.[13]

The question is—just how original were Roberts, Streeton and Conder? Was Aestheticism, as has always been assumed, introduced into Australia by these artists, or were they, alternatively, exploiting a currently fashionable vogue?

The attitude of the contemporary press, particularly *Table Talk*, in such accounts as the 1888 description of Conder's studio (above) and of Roberts' Grosvenor Chambers rooms (which were fitted out with draperies of blue silk), and of the 9 x 5 Exhibition at Buxton's Galleries (which consisted of red liberty silk 'drawn, looped and knotted among the sketches, Japanese umbrellas, screens and handsome Bretby Jardinières'[14]) tended to highlight the exoticism of such settings and the radical artistic nature of their perpetrators—'Messrs Tom Roberts, Conder and Streeton are not at all free from the charge of Whistlerism'.[15]

But then Maurice Brodsky's *Table Talk* was notoriously sympathetic to artists, and the sustained build-up that the 9 x 5 Exhibition received in his journal throughout the earlier part of 1889 suggests that someone was stage-managing the event to attain the elixir of Aestheticism, maximum publicity.

The fact that aesthetic attitudes had been characterized in the popular press as early as 1881, that satirical plays about the aesthetes had been performed on the Melbourne stage in 1882, and that lengthy descriptions of aesthetic interiors and costumes appeared in romantic novelettes in the mid-1880s, must mean that there was a tolerable understanding of Aestheticism well before the descriptions of artists' studios and the exhibition were publicized and on view in 1889. The probability that such interiors and attitudes were much more commonplace at the time than has been realized strikes home when one is aware of just how easily aesthetic props were come by in Melbourne in the late 1880s. Dr Hoff pointed this out some years ago, but without developing its implications:

Drapery was high fashion in Melbourne and the printed Indian muslins, liberty silks and other fabrics suitable for the drapery of the walls, windows, bedsteads, easels and any other of the numerous objects which require drapery in modern rooms could be bought at the establishment of Kalizoic, Collins St. and other places. Messrs Cullis, Hill and Co. announced a sale of such stock on January 14, 1889 'at lowest possible prices'.[16]

So one is left with a rather different interpretation of that exhibition which was the culmination of the Heidelberg Camp. A carefully controlled publicity campaign before the exhibition; maximum public exposure at the time of the exhibition, with adverse criticisms pasted up outside the door and a letter to the Press by the artists concerned; a stage-managed exhibition interior made to look as much like a fashionably comfortable drawing room as possible, and in which the tiny pictures became essential decorative objects; all this begins to look like an aesthetic exercise *par excellence*, designed to appeal to the then middle-class idea of fashion and taste, rather than a die-hard stand against society by a group of radical outsider artists. This interpretation of Australian art history's most intriguing exhibition is given credence by the very fact of its commercial success precisely amongst the professional and middle classes. Most of the pictures were sold to doctors, lawyers, merchants, university teachers and their wives.

But the 9 x 5 Exhibition must also be seen as coming at the end of the aesthetic craze in Australia. Only two years later, in a review of the Brough and Boucicault Company's Sydney revival of Burnand's satire, *The Colonel* (which, as we have seen, was originally produced in Melbourne in 1882), we find that it has

... scored a decided success in spite of the fact that the motive of the satire is now a happily bygone craze ... Burnand struck a happy vein when he conceived the idea of ridiculing the aesthetic craze of ten years ago, and though the application has somewhat lost its point now, the relative value of naturalness and artificiality is only heightened by the effect of time.[17]

RUTH ZUBANS Emanuel Phillips Fox: St Ives and
the Impact of British Art, 1890-1892

The tradition of associating Fox's *oeuvre* with French art goes back to his own lifetime. As early as 1893 a critic wrote that 'Mr. Fox work[s] by the light of . . . French ideals and for this reason [is] more interesting to the artist than the art lover'.[1] The overriding influence of French art is one that has been stressed in Australian criticism up to the present day. Yet such an assessment of Fox's art is partially misleading, for it underrates the significance of other overseas experiences and results in a distorted view of the ideas he brought back and their consequent effect on Australian art. It is doubtful whether Fox's work would have received the limited but sure acceptance that it did in Australia in the 1890s, had it been solely French-oriented. It is not the intention of the present article to challenge the importance of French training and French art for Phillips Fox, but rather to adjust the balance by examining his activities in England during the years 1890-92.

Perhaps it was Tom Roberts who suggested that the young artist should continue his art abroad. Emanuel Phillips Fox (1865-1915) had spent eight years training at the National Gallery School in Melbourne under O.R. Campbell and George F. Folingsby[2]; and although he had acquired the basis of his craft there, the breakthrough was to come only overseas. In February 1887, at the age of twenty-one, Phillips Fox sailed for Europe.[3] For the colonial artist, England was an obvious choice to begin his European stay, and Fox arrived there in the spring of 1887. He spent over a month in London, establishing contact with English artists and getting 'a great deal of good out of the conversations . . .'[4]; subsequently he left for France to immerse himself in the study of art.[5] During the three ensuing years in Paris, he trained at Julian's (especially under William Bouguereau), and entered the École des Beaux-Arts as a pupil of Jean-Léon Gérôme in 1889, for a time

1 E. Phillips Fox, *The Milking Shed*, oil on canvas, 39.4 x 101.6 cm, c. 1893. Art Gallery of New South Wales, Sydney

2 E. Phillips Fox, *The Cabbage Patch*, oil on canvas, 60.5 x 100 cm, signed and dated l.l. 'E. Phillips Fox, 1890'. Private collection, Sydney

attending also the classes of the American marine and genre figure painter, Thomas Alexander Harrison (1853-1930), a familiar figure at many *plein-air* centres. Like many other students, Fox spent his summers painting in the open in the various artists' colonies, such as Étaples in Picardy—where he first encountered Harrison—at Giverny and on the coast of south-west Brittany. Having completed his training in Paris, Fox crossed the Channel again, and stayed in England, mainly at St Ives, between 1890 and 1892, before returning to Australia.[6]

Few paintings by Fox have come to light from the early St Ives period: his Salon picture for 1891, *The Convalescent*[6] (1890, Holmes aCourt collection, Perth)[7]; an undated sketch for a landscape, probably depicting St Michael's Mount (private collection, Melbourne); a landscape entitled *Evening, Shoreham* (5) (formerly private collection, Sydney); and a portrait head with a landscape background (9) (private collection, Sydney). The only documented work is *The Convalescent*; we are not absolutely certain that the other canvases were painted at this time. There are, however, a number of surviving works painted during the preceding years in France and a more substantial body of work from the period following Fox's return to Australia in 1892.[8] What happened in the intervening years at St Ives is puzzling, for these two sequences of paintings present the viewer with the paradox of reversed development. The bright palette, the high key and the impartial visual observation seen in the early works in France are discarded in favour of muted colours, a lowering of key and some narrative allusion. The delicate impartial portrayal of the early peasant figures is replaced by a more traditional concept of figure painting, and the seemingly retrogressive landscape treatment suggests augmented interest in painters of the Barbizon school rather than French Impressionism. A glance at *The Cabbage Patch* (2) (1890 private collection, Sydney), or *The Communicant* (3) (1889-90, private collection, Sydney), painted in France, and the later *Milking Shed* (1) (c 1893) and *Adelaide* (4) (1895, both works in the Art Gallery of New South Wales), executed in Australia, illustrates the point.

Hardly any records concerning Phillips Fox have survived from this period. The present essay seeks to establish a context for Fox's activity in England and to suggest some of the

reasons for the basic changes in his style in the light of his new milieu. Although the range of contacts may have spread more widely, the immediate context was probably provided by the artists' colony at St Ives and more obliquely by certain trends and artists associated with the New English Art Club in the early years of its development.

Phillips Fox left France in 1890 and in the summer or autumn of that year settled in the artists' colony at St Ives. His careful signature is found in St Ives Arts Club *Suggestions and Hints* of 22 September 1890[9], and a 'Fox' is recorded as having attended a general meeting on 8 August of that year.[10] It was probably Phillips Fox, as the English artist Ernest R. Fox, who also visited St Ives, was not a member of the club.[11] Phillips Fox remained at St Ives until 1892, interrupting this sojourn for a painting tour of Spain; at the Prado in Madrid, in the summer of 1891, he made an intensive study of Velazquez's works and travelled to Elche, painting some landscapes.[12]

Other Australian artists had made contact with Cornwall before Fox's visit. Russell had painted in the fishing town of Polperro in 1884[13]; Mortimer Menpes, in the company of Whistler and Sickert, journeyed to St Ives in the winter of 1883-84[14]; Tom Roberts had contact with artists who had painted there; and in 1886 the Australian-born Louis Grier settled at St Ives, becoming an active figure at that particular centre.[15] The Newlyn painter Thomas Gotch had visited Melbourne in 1883, and in 1885 and 1889 the founders of the Anglo-Australian Society of Artists brought out to Australia their first important exhibitions containing works by the Newlyn School.[16] So Fox was not treading entirely unfamiliar ground, and perhaps some knowledge of the artistic activities in the Cornish centres was transmitted to him through these sources. But more importantly, numerous English and some American artists, who like Fox had worked in the Breton centres, later joined the sister settlements flourishing in Cornwall in the 1880s and 1890s[17]; Fox's decision to stay in Cornwall should be viewed in this latter context. However his choice of St Ives rather than the more 'notorious' centre of Newlyn, already identified with a vital and forceful movement of outdoor painting in English art in the mid 1880s, is curious.

In the 1880s interest in the peasant theme and *plein-air* landscape preoccupied artists in Britain, as it did in France and elsewhere in Europe. Both aspects had been central to Fox's art during his years in France. Among the major English *plein-air* painters particularly identified with these interests by the mid 1880s were George Clausen, Herbert H. La Thangue, Edward Stott, Stanhope Forbes and the Newlyn School[18], but the movement was far-reaching and artists sought out many indigenous sites. The two key centres of *plein-air* painting and rural genre in England were the Cornish fishing hamlets of Newlyn and St Ives. There, living was inexpensive and the climate mild enough to allow year-round work in the open air; both centres were known for their luminous atmosphere and St Ives, in particular, for its picturesque scenery. Situated in the remote corner of Cornwall, Newlyn and St Ives were a kind of Barbizon to the English painters.[19] It was a region relatively unspoilt by industrialization, not unlike Brittany in its landscape formation and coastline, and its people who shared common descent from the Celtic race. Leaving behind the sophistication of city life, many settled there, seeking 'to lead the simple lives of artists, with nature for their mistress'.[20] The very idea of an artists' colony or brotherhood was revered as a way of life and, widely established on the Breton coastline, had found expression in the Pont-Aven circle as much as in Van Gogh's ardent yearning to share mind and heart with fellow artists in the South of France. Newlyn and St Ives were a continuance of this ideal.[21]

At Newlyn, the first of the artists' settlements, most of the painters, headed by Stanhope Forbes (1857-1947), T.C. Gotch (1854-1931), Frank Bramley (1857-1915) and Walter Langley (1852-1922), sought to depict with authenticity the ordinary lives of the

local fishing people in large-scale figure paintings.[22] Avoiding anecdotal and dramatic emphases, the artists sought impartial observation, immersing their figures evenly in 'sincere grey daylight'[23] or silhouetting them against the pale light of a small window in the sombre interiors of the local cottages. Sometimes interests overlapped and the St Ives painters depicted similar scenes, while some of the 'Newlyners' painted at St Ives[24], and joint group exhibitions (including also the works of the Falmouth painters) were held at Dowdeswell's in December 1890, at Nottingham Castle Museum in September 1894, and in the Whitechapel Gallery from March to May 1902.[25] Critics thus sometimes used the blanket term 'The Cornish School', or loosely embraced artists from the several centres under the shorthand term 'The Newlyn School'.[26] Nevertheless the Newlyn painters, because of their relentless concentration on a particular subject in a specific locale, the realism of their style and the grey tonalities of their choice, were generally regarded as a distinct school, gathering momentum in the mid and late 1880s. As a group they were strongly indebted to Bastien-Lepage and Dagnan-Bouveret in the particular kind of *plein-air* painting practised: the even-toned light, the careful observation of values and the relatively low-keyed palette hint at their source, and the square brush technique likewise derived from Bastien-Lepage. Despite early criticism of their work for 'mere imitation',

3 E. Phillips Fox, *The Communicant*, oil on canvas, 42 x 33 cm, c. 1889-90. Private collection, Sydney

4 E. Phillips Fox, *Adelaide, Daughter of Professor Tucker*, oil on canvas, 109.2 x 61 cm, signed and dated l.l. 'E. Phillips Fox, Dec. '95'. Art Gallery of New South Wales, Sydney

gloomy subjects, 'Quaker-like absence of colour' and aggressive brushwork[27], the paintings of the Newlyn School gained rapid acceptance at the Royal Academy, and the increasingly illustrative element pervading their work soon found appeal.[28] Their subjects, chronicling the life-cycle of a particular fishing community (initially regarded with distaste), ultimately found a niche within the realist genre of Victorian narrative painting.

The low-toned realism and the implicit social concern of the Newlyn painters probably contrasted too sharply with Fox's aims, suggesting one reason for his preference of St Ives. More broadly, perhaps the attraction of the community at St Ives lay in the diversity and flexibility of approaches prevalent there.[29] At St Ives the group was larger and less cohesive and, although enjoying the stimulus of an artistic fraternity, they pursued different styles, fundamentally sharing only in the commitment of working directly from nature. Moreover, a feature constantly stressed by contemporary writers—sometimes as the very reason for the differences in style—was the greater luminosity and abundance of sunlight at St Ives, resulting in strange and exquisite chromatic effects. Another reason for Fox's choice of St Ives may simply have been to join friends met earlier in Breton art colonies or in Paris. We do not know whether he was accompanied by Tudor St George Tucker (1862-1906), his fellow student at the National Gallery School in Melbourne and later in Paris, whereas David Davies (1862-1939), motivated probably by Fox's example, came to St Ives in 1892 or early 1893.[30] Nor do we know who were Fox's immediate friends: some artists who had already settled at St Ives before Fox had been part of a circle at Concarneau in Brittany, and painted there with Fox's American teacher, Alexander Harrison.[31]

The so-called 'St Ives School' awaits detailed investigation. To establish the careers of the various painters, and to date accurately the scattered and amorphous body of their work, is a task outside the scope of this article. However, we know many of the names of the artists who were resident at St Ives during Fox's sojourn there, and it is possible to reconstruct some of the background against which his art developed during those years.

St Ives as an artists' centre was established in 1885, after the Newlyn settlement, and initially, in the early 1880s, when it was used as a temporary sketching ground, Whistler had worked there in the company of Sickert and Menpes, painting small studies of the sea and shop fronts in the winter of 1883-84. Artists began to settle there permanently in the winter of 1885, when the Americans Mr and Mrs Henry Harewood Robinson and the Englishman William Eadie established studios there.[32]

The following summer a number of painters swooped down on St. Ives . . . Mr. and Mrs. E.E. Simmons, Mr. Louis Grier (followed by his brother Mr. E. Wylie Grier), Mr. Howard Russell Butler, Mr. and Mrs. Chadwick, and afterwards in quick succession Mr. and Mrs. Adrian Stokes, Mr. and Mrs. Gronwold, Mr. Julius Olsson, Mr. Lowell Dyer, Mr. Zorn . . . Miss Scherfbeck, Mr. Blomefield and Mr. W.H.Y. Titcomb

reports an anonymous writer, probably H.H. Robinson, in 1896.[33] Many other artists went to St Ives, amongst them Herbert Marshall, Alfred East, Algernon Talmage, Ernest Noble Barlow, Folliott Stokes, the Glasgow painter T. Millie Dow, Bosch Reitz, Laurence Eastlake and Arnesby Brown. The sail lofts, abandoned by fishermen whose trade had declined, were turned into studios.

Since part of the community was nomadic, presumably not all artists were there during Fox's two-year stay at St Ives. Fortunately some previously unpublished records of the St Ives Arts Club have come to light, filling part of the vacuum surrounding the early years of the St Ives settlement. They comprise the *Minutes* (the earliest of which coincide with Fox's arrival there in 1890), the *Suggestions and Hints* and the *Visitors' Book* (between August 1890 and December 1892), the reverse side of which lists members' names,

presumably for the years 1890-92. These sources provide a record of the annual commit-
tees, whimsical suggestions and grievances, a hint of the periodicals subscribed to, an
incomplete record of the names of club members, visitors' names, and fleeting glimpses of
the committee meetings recorded with ever increasing brevity. Importantly, they establish
Phillips Fox as a member as early as September 1890 (possibly early August) and securely
link some of the other resident artists' names with definite dates, allowing one to assume
that Fox was familiar with their works and presumably also with their ideas. The names
of Adrian Stokes (president), E.W. Blomefield (treasurer), H. Harewood Robinson (sec-
retary), William Eadie, C.G. Morris, E.E. Simmons and W.H.Y. Titcomb are listed as
members of the first committee, confirming their presence at St Ives during 1890-91.[34]
Other names appearing with some regularity are those of Louis Grier, Bosch Reitz, Mrs
Adrian Stokes and, from 4 December 1890, L. Dyer and J. Olsson. The most prominent
artists at St Ives during those years were Julius Olsson (1864-1942), Adrian (1854-1935)
and Marianne (1855-1927) Stokes, W.H.Y. Titcomb (1858-1930), Louis Grier (1864-
1920), William Eadie and E.E. Simmons (1852-1931).

The St Ives colony was cosmopolitan in character and included artists from Scotland,
the United States, Canada, Australia, France, Germany, Austria, Denmark, Sweden, etc.
By the time Phillips Fox arrived there a real sense of artistic community had been estab-
lished. In 1887 a small gallery was opened for the exhibition of members' works.[35] In the
autumn of 1888 Louis Grier organized an artists' club, which became quite active,
included both sexes and, by 1890, permanently housed at Westcott's Quay, comprised a
'membership of about eighty'.[36] The club provided social life, an opportunity to work
from the nude twice weekly[37] and, above all, possibilities for new contacts and a rich
exchange of ideas. Some of the artists belonged to the New English Art Club: Adrian
Stokes was a foundation member (in 1886), served on the selection committee in 1888
and exhibited there in 1887 and 1888[38]; Julius Olsson became a member of the New
English Art Club in 1891, having exhibited there since March 1890[39]; T. Millie Dow
(1848-1919), one of the 'Glasgow boys', another member of the Club, sometimes painted
at St Ives, settling there finally in 1895—he may have been one of the links with the new
developments in the 'Glasgow School'.[40] Various members of the St Ives Arts Club
exhibited also at the Grosvenor, the New Gallery, Dowdeswell's, the Royal Academy, the
Salon and elsewhere.[41] So the atmosphere was extremely lively and the current London
exhibitions must have been very much in the news. Fox presumably visited London
during the St Ives period, but we do not know which particular exhibitions he may have
seen there or what contacts he established. If Louis Grier's account is correct, that 'the
general Spring dispersion, [to] Paris and townwards, closed the club for the season [until]
. . . early in the following autumn . . .'[42], Fox may well have seen a number of displays.
The summer migration would also explain the timing of Fox's trip to Spain during several
summer months in 1891.

Phillips Fox's identification with the community can be inferred from his membership,
his signing a nonsense suggestion and his exhibiting with the Cornish painters at Dow-
deswell's in London in December 1890, where he showed his newly finished *The Con-
valescent*[43] (6) (subsequently exhibited in the Salon of 1891). He also exhibited with the
Institute of the Painters in Oil Colours, to which many of the St Ives painters sent their
work.[44]

In assessing the impact of the community of St Ives on Fox's art two aspects should be
distinguished: first, a direct contact with the art and ideas of the local artist residents, and
second, the stimulus and ideas accessible through them and contacts with movements
outside St Ives.

Although many of the artists painting at St Ives were French-trained, the diversity of trends prevalent at this centre was considerable. For example, the works of William Eadie and William Holt Yates Titcomb, in their genre approach to figure painting, bear some similarity to the works of the Newlyn painters; Edward E. Simmons' paintings, on the other hand, show an idealized interpretation of Bastien-Lepage and Dagnan-Bouveret, while H. Harewood Robinson, Ernest Noble Barlow and Alfred East reveal Barbizon moods in their landscapes, sometimes recalling Constable.[45] Louis Grier's work reflects Whistler's influence and in some paintings a possible contact with Manet and early Sickert.[46] Thus no single cohesive movement may be said to have developed at St Ives which could be as easily identifiable as that at Newlyn. The concept of a 'school' in the St Ives context tended to be vague and implied mainly an attitude on the part of a group of painters working in the same geographical locale, whose common bond was to submit to 'faithful depiction of nature' rather than to share a particular style. The artists ranged from genre figure painters, such as William Eadie, Titcomb and Marianne Stokes, to landscape and animal painters, with the sea providing constant fascination, as seen in the work of Adrian Stokes, Julius Olsson, Louis Grier and others. Predominantly, in contrast with the artists at Newlyn, however, they were landscape painters. The other distinguishing features observed by contemporary writers were their greater love of colour and observation of sunlight and moonlight effects.[47]

Contemporary writers invariably commented on the peculiar visionary light at St Ives and the effect of the sun in evoking endless play of colour on water and landscape. Many of the prominent St Ives artists, like Adrian Stokes, Julius Olsson and the frequent visitor Alfred East (1849-1913), painted atmospheric landscapes instilled with light and colour. The nocturnal scene, especially in Louis Grier's work, formed part of the repertoire, and Olsson's moonlight scenes later won wide acclaim.[48] On the technical side, however, their interests were tempered by the gentle tonal method inherited from the Barbizon masters, from Bastien-Lepage and from Whistler, rather than evoked with the sparkle and brightness of an Impressionist palette. Olsson's seascapes, for example, are colourful and display blues, pinks, mauve, yellow, cream, and are thickly worked, with prominent tactile paint surfaces. The light gleams over the surfaces, yet the chromatic view is presented in a relatively low key, massed in tonal areas, dramatized and far distanced. Adrian Stokes' landscapes have greater immediacy; they are lighter in key and more decorative in colour, yet colours are again muted. Alfred East, who periodically sojourned at St Ives, envisaged the locale as a Barbizonian 'domestic view of nature'[49], and he favoured quiet greens and subdued yellows. Louis Grier, whose particular love was the seascape and the nocturne, painted Whistler-inspired low-keyed scenes, with evening lights flicked over in dashes of orange. Some of his early daylight paintings (c 1890), with boats, water and sky, are dispassionate visual portrayals in broad flat areas of tonal contrasts, suggesting contact with Manet's seascapes—but their beige-blue colour chord evokes Sickert's early work at St Ives.[50] Again, as with the other painters, despite interest in luminosity, the muted palette dominated.

The above discussion suggests that the St Ives paintings were colouristically conservative. Contact with the painters at St Ives may have been one reason for the modified palette seen in Fox's later Australian landscapes and may partly account for his increased interest in landscape painting. One surviving sketch by Fox, seeming to depict St Michael's Mount (private collection, Melbourne), and painted in muted greens and soft blues, provides tentative evidence that such a change did take place in Fox's work at St Ives. A further landscape, *Evening, Shoreham* (5) (private collection, Sydney), may also have been painted during this period: it depicts a small town at a twilight hour; a shepherd leads his

flock homewards and a haycart issues from a distant city-gate. The long line of roofs in the background closes the distance at a high horizon-line, and a triangular sheet of water stretches between the houses and the road on the left. Nothing is known about the painting, but the mood and the subdued colours are quite new, totally at variance with the fresh brightness of Fox's French *oeuvre*, and suggestive rather of interest in such artists as Anton Mauve and Charles Jacque than French Impressionism. In technique, the thin, liquid paint is reminiscent of Whistler's art. There is no record of Fox having visited Sussex at this time, nor of such a trip being made after his return to England in 1901, although then he did travel more extensively. The broad compositional similarity to *The Cabbage Patch* (2) (1890) in the wide-angled view, the triangular area in the middle-distance and the 'zig-zag' into the background suggest that *Evening, Shoreham* belongs to the early years in England. Moreover, the palette is unlike any other known later work by Fox and in some ways recalls works painted previously in France. It is curious that the painting was not exhibited in any known exhibition during Fox's lifetime but was shown for the first time in Melbourne in 1925.[51]

Perhaps more significant than any particular painting or style Fox may have seen at St Ives was the general Barbizon-oriented outlook. English *plein-air* painters in the 1880s were not receptive to French Impressionism, but tended to look to the Barbizon painters, to Bastien-Lepage and to the Dutch ruralists: Maris, Mauve and Israels. Landscape painters, particularly, followed the Barbizon masters and their late followers, such as Cazin, Lepine and Harpignies, who lightened their palettes while retaining a tonal approach. The work of David Davies, who was at St Ives in late 1892 and 1893, reflects this general context, and the similarity between some of his and Fox's landscape work later in the decade may be due to the common background. The situation at St Ives reflected a general attitude of reverence and admiration for these French masters in England: of all

5 E. Phillips Fox, *Evening, Shoreham*, oil on canvas, 45.7 x 76.7 cm, signed l.l. 'E. Phillips Fox', c. 1891-92. Private collection, Sydney

other French painters their works were the most exhibited, written about, emulated and collected. Impressionist art was slow to infiltrate this conservative milieu.[52]

Apart from any specific contacts that Fox may have made with paintings of the St Ives artists, the club provided a stimulating context for transmission and interchange of ideas. It was from St Ives that Fox went to Madrid to study Velazquez's work, and it must have been at St Ives that Fox became acquainted with the vital currents of the New English Art Club and developed an interest in Whistler's art.

Although admiration for Velazquez was widespread during the time in England, France, Australia and elsewhere, the immediate stimulus for Fox's trip probably arose at St Ives. The Swedish artist Anders Zorn, resident at St Ives until 1888, arrived there directly after a prolonged stay in Spain.[53] The American painter, Edward E. Simmons, was just back from a recent trip to Madrid, having also taken a journey to Elche, a pattern repeated by Fox who, judging by an entry in the catalogue of his first one-man exhibition held in Melbourne in December 1892, painted some landscapes there.[54] Contemporary critics in Britain viewed Velazquez as an Impressionist because of his broad technique and his subordination of detail to an overall effect, a view particularly championed by the progressive Scottish critic R. A. M. Stevenson (cousin of the novelist) and expressed forcefully in his monograph on Velazquez in 1895—one of the most widely read and influential books of the time. Stevenson, incidentally, was also a great admirer of Corot and his unified tonal ensembles.

Phillips Fox made his pilgrimage to Spain in the summer of 1891, studying and copying the work of Velazquez intensely for several months.[55]

The exhibition catalogue of December 1892 records that he copied at least three major works: *Los Borrachos*, *Las Hilanderas*, *Portrait of a Sculptor*, as well as *Head from Picture*. The first two must have given him valuable experience in dealing with large-scale figure compositions, a lesson which he would find helpful when later faced with large figure paintings, initiated with *The Art Students* (Art Gallery of New South Wales) in 1895, which was followed by many others, including *The Landing of Captain Cook*, (1902, National Gallery of Victoria). Velazquez's mastery of structure, tonal control and broad unified effects were also eagerly studied, and absorption of these features may be seen even in such late paintings by Phillips Fox as the strongly characterized portrait, *Margaret Harris* (Art Gallery of New South Wales), painted in 1914, a year before his death. It may have been Velazquez's example, too, that contributed to the lowering of the key and a more tonal approach in his Australian works of the 1890s, particularly in portraiture. Phillips Fox retained his admiration for Velazquez's work to the end of his life.

In the absence of particular evidence, we are less sure about other contacts established by Fox during these years. Nevertheless, some clues are provided by the Australian press critics in their reviews of Fox's *oeuvre* immediately after his return to Australia in 1892, and several years later by the British press commenting on Fox's paintings displayed in the first loan exhibition of Australian works at the Grafton Galleries in London, in 1898.[56]

Particularly suggestive are the Australian press comments on the early major work, *The Convalescent* (6), painted by Fox in Autumn 1890 soon after his arrival at St Ives: 'The Convalescent, . . . is an admirable example of the teaching of the Cornish school, [in] that it is the probable and unexpected incident which an artist should choose for illustration', wrote the critic of the *Table Talk*.

A girl of about 14 years of age, clad in white, reclines in a wicker arm chair, placed so close against the mantelpiece that the golden light of the fire shines upon her frock, though the grate itself is unseen. A younger child, standing behind the chair, is arranging the pillow on which the invalid's

head is resting. There are no deep shadows, and the fire-light plays in patches over the white dress like molten gold. The wan, patient face of the convalescent tells its own story of wearying suffering, and the attitude of the other child is expressive of affectionate solicitude. The contrast of flesh tints between health and sickness is masterly . . .[57]

The critic for *The Sun* expressed a more direct view: 'The Convalescent . . . is a picture with a story . . .', thus immediately drawing attention to its different orientation from the works painted by Fox in France. 'The sick girl has laid down her book and is gazing dreamily before her, while her little attendant bends forward enquiringly . . .'[58]

The two new elements, a hint of story-telling and suggestion of a mood, indicate contact with English narrative painting. Although the sickbed as a theme fascinated *fin-de-siècle* artists all over Europe, in Fox's *oeuvre* it stands out as an uncharacteristic subject, and in its treatment reflects Victorian sentiments. Early in 1891, in the eighth exhibition of the Institute of Painters in Oil Colours, he showed another work with a narrative title, *Day Dreams*[59], and in his first retrospective exhibition held in Australia were two further paintings with narrative titles, *Waiting* and *A Lullaby*.[60] Unfortunately, no descriptions of these works have survived. However the foregoing comments suggest that changes in Fox's art at St Ives were wrought not only in landscape but also in figure painting. Here for the first time Fox came into prolonged close contact with English painters, and although they mainly shared interest in outdoor landscape work, some vestiges of Victorian narrative painting filtered through. As stated above, the importance

6 E. Phillips Fox, *The Convalescent*, oil on canvas, 95 x 77 cm, signed and inscribed l.r. 'E. P. Fox, 90. (?) St Ives'. Collection Holmes aCourt, Perth

7 Sir John Everett Millais, *For the Squire*, oil on canvas, 85 x 63.5 cm, signed and dated l.r., 1882. Forbes Magazine Collection

of St Ives for Fox must have been not merely in the direct contact with certain painting styles, but also in introducing him to a new range of ideas. *The Convalescent*, apart from displaying a new 'narrative' emphasis (in so far as Fox's art can ever be regarded as narrative), is set indoors in the reflected light of a fire, and in this respect shares similar preoccupations with some of the St Ives and Newlyn painters.[61] As in *Evening, Shoreham* (5), colours are subdued; the bluish-green tonality of *The Convalescent* creates a mood of malaise.

A distinct interest in Whistler's art is one feature that emerges from the press critiques. In reviewing Fox's exhibition in Melbourne in 1892, the critic for the *Table Talk* observed that a '. . . portrait of a young lady seated in profile . . . reminds strongly of Whistlerian art'.[62] A further work, shown with the Victorian Artists' Society in Melbourne early in the following year, entitled *A Harmony in Gold*, as described by the *Age* critic, leaves no doubt about its original inspiration; it depicted '. . . a lady with rich brunette colouring, in a bright golden satin dress, seated against a dull, dark yellow background . . . [with a] gold rose in her hair'.[63] These paintings cannot be traced, but the effect of Whistler's art is evident in a number of surviving works painted by Fox in Australia in the 1890s. It is thus not surprising to find that the English critics reviewing the later Grafton exhibition of 1898 were also quick to note it. In the *Daily News* of 9 April 1898, with reference to Fox's portraits of *Mary Nanson* (1897, now lost), *Adelaide* (1895) (4), and *My Cousin* (1893, National Gallery of Victoria), we read: 'In these three works we have a suggestion of Mr. Whistler's style, of his breadth, of his chiaroscuro, of his subtlety has not quite been reached'. The critic of the *Standard* found even *The Art Students* (1895) 'a little pleasantly Whistlerian . . .'[64] The poses, the soft-toned effects and the wistfulness clearly betray such an interest, but Fox's characteristic portrayal of people is always more forthright and naturalistic.

It was suggested that Fox's interest in Whistler was probably stimulated by his contacts at St Ives: directly through Louis Grier's homage to the American painter and indirectly through the St Ives members of the New English Art Club—Adrian and Marianne Stokes, Julius Olsson and Titcomb.[65] Fox's American teacher, Alexander Harrison, was also acquainted with Whistler.[66] Moreover, through the wide publicity given the events, Fox must have known of the acquisition of two major paintings by Whistler in two public collections in 1891: *Arrangement in Grey and Black, No. 2: Thomas Carlyle*, for the Glasgow Art Gallery, and *Arrangement in Grey and Black, No. 1: The Artist's Mother*, for the Luxembourg Gallery, Paris. But the really major Whistler event in England was his triumphant exhibition at Goupil's in April and May 1892, which reinstated his prestige after the Ruskin trial.[67] Among the forty-six works displayed were portraits, landscapes and seascapes. It is difficult to imagine that Fox would have foregone the opportunity of seeing it. His own works in Australia in the 1890s, *My Cousin* (1893), the surviving sketch for *Mary Nanson* (c 1897, formerly private collection, Melbourne), *The Orphan* (1895, private collection, Sydney) and others, as well as the reviews noted above, suggest that he had seen the display.[68] The memory of Whistler's nocturnes seems to have lingered even in the emerald harmonies of Fox's moonlight scenes, painted at Heidelberg well into the 1890s.

The British press found in Fox's works at the Grafton Galleries not only similarities with some aspects of Whistler's art but affinities with Millais, J. J. Shannon, the Scottish painter Guthrie and the 'Glasgow School'. These observations are indeed interesting, and an affinity between Sir John Everett Millais' work, such as his *For the Squire* (1882, Forbes Magazine Collection) (7) and Fox's *Adelaide* (1895) (4) is clearly evident in mood if not in style. Perhaps the rather Victorian spirit with which Fox's children's portraits are

imbued can find parallels also in the works of other English painters, such as Mouat Louden, Greiffenhagen, etc., and in that masterpiece of Sargent's, *The Boit Children* (1882, Museum of Fine Arts, Boston).

Even more fascinating is the identification of Fox's interests with those of the painters of the 'Glasgow School', particularly James Guthrie. The critiques regarding the Glasgow painters are worth citing in full:

If there is any British work to which the Australian pictures bear a close resemblance, it is that produced by the young men of Glasgow, and we know how strongly French influence has told on them,

wrote the critic of the London *Times* on 4 April 1898. 'Mr. E. P. Fox . . . the painter of a charming portrait of a child in a quaint white frock and sun bonnet [i.e., *Adelaide*], might almost have worked with Mr. Guthrie . . .' The comment in the *Daily Telegraph* of 7 April 1898 was similar:

. . . This artist more frankly avows the influence of the Glasgow School in the 'Art Students'. The latter is a portrait group of a decorative character, rather flat, but in its unconventional way very cleverly composed . . . 'Adelaide', . . . a sparkling study in white . . . again sets us thinking of North Britain . . .

There is some overlap in the critics' minds as to what elements were to be linked with the 'modern French School', with Whistler and with the 'Glasgow School', and this overlap in itself is interesting not only because it indicates Fox's personal integration of his sources but because the painters of the 'Glasgow School' had combined elements of French art with great admiration for Whistler, absorbing them into an original style.

The so-called 'Glasgow School' represented the most vital and progressive developments in Scottish painting.[69] Reacting against sentimental narrative, its corollary descriptive style and the exclusivism of the Royal Scottish Academy in Edinburgh, this group of artists stood for a new force of realism and *plein-air* painting in Scotland. The movement, already fully established by 1885, developed independently of the Newlyn School and other *plein-air* movements in Britain. Gravitating around three principal figures, James Guthrie (1859-1930), W. Y. MacGregor (1855-1923) and the French-trained John Lavery (1856-1941), their experiments in naturalism, although symptomatic of the changes sweeping through Britain, developed as a simultaneously parallel movement. The inspiration for their open-air painting and realism, as in English art, was not drawn from French Impressionism, but rather from the excited discovery of Bastien-Lepage, an appreciation of the Barbizon masters, Courbet and the 'modern' Dutch school: the brothers Maris, Mauve, Israels and Mesdag. Peripheral contacts with Manet's art and a deep admiration for Whistler, combined with interests derived from the circle of British artists settled at Grez-sur-Loing, particularly those of William Stott of Oldham and Frank O'Meara.[70] The Scottish artists approached these sources with originality and freshness and achieved in their art a more directly visual, less posed effect than in the works of many of their English *confrères*. Their particular hallmark is a vigorous emphasis on paint textures and a decorative tendency. The 'Glasgow boys' painted sunshine as well as grey light, and their portraits were fresh and direct. Although sometimes subdued, colours are vital and tonally rich and the works display a fine balance between naturalism and decorative effect. The prominent square brushstroke, ultimately inherited from Bastien-Lepage, was used structurally as well as decoratively.[71] Vigour and naiveté characterize the particular naturalism of the Glasgow painters and, unlike the Newlyn School, narrative and social comment play no part in the unforced visual portrayal. The personal styles of the 'Glasgow boys' varied considerably: much of Lavery's work in the 1880s shows a particular

fragile delicacy, while Guthrie's more masculine conception is displayed in a vital robustness.[72] Whistler's influence is very much integrated with their art and towards the later 1880s tended to modify the 'innocent', 'wide-eyed' naturalism.

It is true that some of Fox's figure paintings of the 1890s are similar to those of Alexander Roche (1861-1921), Lavery and Guthrie, and indeed he could have seen their works. Not only did the latter two exhibit at the Salon, but Lavery showed at the Royal Academy and the Exposition Universelle in Paris in 1889; in addition the Scottish painters formed an important sector of the New English Art Club during the early years of its existence.[73] Whether Fox saw any of the exhibitions of the N.E.A.C. is uncertain. He himself never showed with the Club, but he could have known of the developments there through other artists, especially Adrian Stokes and Olsson at St Ives, and earlier through Alexander Harrison, all of whom had been members and exhibitors.[74] Moreover, the wide publicity given the exhibitions would hardly have allowed him to remain unaware. Since at that stage (by 1890) Fox had probably already made contact with Monet's art in France and was interested in other Impressionists[75]; the exceptional event for London of inclusion of Monet's and Degas' work in two of the exhibitions (1888 and 1891) may have drawn the N.E.A.C. into further focus. Fox also knew personally two other exhibitors there: Tom Roberts' friends Buxton Knight and John Peter Russell.[76] Furthermore, several groups of artists exhibiting with the N.E.A.C. had been French-trained, had painted in France and in the very broadest terms paralleled Fox's own interests.

Founded in 1886 in reaction to the restrictiveness of the Royal Academy, and seeking a forum for expression, the New English Art Club, with its aim of showing 'all good modern art irrespective of style', drew together several vital streams of British art.[77] Since most of these streams, although not the most radical ones, were associated with reformulation of art through direct contact with nature, at the outset the N.E.A.C. had been the rallying point of the various naturalistic movements in Britain: among them the Newlyn School, several of the St Ives painters and the 'Glasgow boys', and such key figures of the English *plein-air* movement as George Clausen, Edward Stott and, in the first year, also H. H. La Thangue. The more radical artists of the Club, such as Walter Sickert, Wilson Steer, Theodore Roussel, etc., were more strongly affiliated with Whistler, and shared the latter's beliefs in selectiveness and decorative principles rather than 'imitation'.[78] Whistler's influence was evident also in the work of the 'Glasgow boys'. We do not know Fox's attitude to the various factions in the Club, but the preoccupations in his own art suggest that he was aware of and interested in the activities of the N.E.A.C.

The principal exhibition forum for the Scottish painters was the Glasgow Institute of Art, and Fox also sent a work there in 1892.[79] By the early 1890s, moreover, the 'Glasgow boys' were gaining international renown. In London they largely established a reputation through a major exhibition at the Grosvenor Gallery in the late spring of 1890. Since Fox arrived in England only in the late summer that year, he is certain to have missed that display, but probably saw the exhibition of pastels by Guthrie at Dowdeswell's.[80] Lavery had a one-man exhibition at Goupil's Gallery in June 1891, but if Fox was in Spain in July he may not have seen it.[81] As we are not absolutely sure which particular works he did see, it would be speculative to suggest specific influences. Nevertheless, in the spontaneous naturalism, the forthright quality, the sensitive tonal control and sensuous response to paint, a general similarity between some of Fox's works and those by the painters of the 'Glasgow School' is evident. If likeness is sought, Fox's work appears closer to some of Lavery's paintings of the period between about 1883 and 1888 than to the denser, more commonsense pictures of Guthrie. For example, the way paint is applied flatly to form the blonde highlights in *Adelaide's* hair (4), or in the surviving study for *Mary Nanson*, lightly

with a soft touch, recalls Lavery's wispy flat strokes of tonal contrast in such works as *The Hammock—Twilight* (1884, private collection) and *A Flower Girl* (8) 1888, formerly d'Offay Couper Gallery, London), before his paint becomes liquid and his figures extremely elegant. Fox also shared the open artless quality of Guthrie's work of about the same period (1883-90)—for example, the latter's *Hard at it* (1883, Glasgow Art Gallery and Museum), *Miss Helen Sowerby* (1882, private collection, London) and *Midsummer* (1892, the Royal Scottish Academy, Edinburgh)—but his paint is never as dense and heavy as that of the Scottish artist, nor does he use the square brushstroke. Interest in the pictorial qualities overall, rather than narrative emphasis, is a further feature shared with the Scottish artists.[82]

If the Scottish painters did indeed have an effect on Fox's figure painting, it would to some extent help to explain the change from his crystalline early visions of the human figure (3) to the more sturdy and forthright portrayal of his sitters in Australia, and his stronger tonal orientation in the Australian works. A change in attitude, however, cannot be explained merely through an influence. Perhaps it would be more reasonable to argue that exposure to all the new elements Fox encountered through his English contacts helped to mould a new attitude: English portrait painting, Whistler's art, the art of the 'Glasgow boys' and Velazquez's paintings. To some extent these strands are intercon-

8 Sir John Lavery, *A Flower Girl*, oil on canvas, 20.3 x 15.2 cm, signed and dated l.l., 1888. Formerly d'Offay Cooper Gallery

9 E. Phillips Fox, *Reverie*, oil on canvas, 30.5 x 20.3 cm, signed l.l. 'Ema.y(?) Fox, c. 1891-92'. Formerly collection of Mrs C. Young, Sydney

nected; all of the British artists, including Millais, deeply admired Velazquez, and Lavery's stay in Spain may in fact have coincided with Fox's trip there. The links with Whistler's art have already been noted.

A rather suave portrait head, *Reverie* (c 1891-92, formerly private collection, Sydney, illustration 9), by Phillips Fox, seems also to belong to the English context. In structure and foreshortening it resembles the standing figure in *The Convalescent* (6): the gaze is averted; the eyes look down. The new-found refinement of bearing imparted to the figure suggests that the portrait was painted in England; it seems to reflect an awareness of George Frederick Watts' work. A tentative comparison may be made with a painting accessible to Fox at the time, the portrait *The Lady Catherine Thynne*.[83] None of Fox's known French paintings is quite as consciously structured, or shows as firm a sense of volume and delineation of form. Although the scene is set outdoors, tonal contrasts are marked and the figure is more strongly focused, with the screen-like trees providing a landscape background.

It is possible to suggest contact with British art also in the few rural scenes painted by Fox after his return to Australia in 1892. The slight but evident focus on the 'incident' and the narrative title of a work like *Homewards* (1895, private collection, Melbourne)[84] implies such a link. A similar picture reported to illustrate Gray's 'The ploughman homeward plods his weary way' was painted by Fox as a 'lesson' in the summer school organized by him and Tudor St George Tucker at 'Chartersville' in the 1890s.[85] The weary rural workman riding up the hill in *Homewards*, the ploughman with the heavy horses in *Upland and Sky* (c mid 1890s, private collection, Melbourne) are not direct echoes of Millet, but seem envisaged through the eyes of British painters of rural themes, although, like the Scottish artists, Fox avoids descriptive treatment. It is quite possible that some 'anglicization' in Fox's art took place after his return to Australia, either through illustrations of British art locally available (through such periodicals as the *Art Journal*, *The Magazine of Art*, *Royal Academy Pictures*, *The Studio*, etc.), or simply in response to the more conservative English-oriented local taste and general context of art, for these pictures were painted in Australia well into the 1890s. It seems, however, equally plausible to suggest that such features had been absorbed in direct contact with British artists rather than second-hand. The landscape, *Evening, Shoreham* (5), already discussed, would support such a view.

Two English pastoral painters whose works in some respects evoke similarity with Fox's work are George Clausen (1852-1944) and Edward Stott (1859-1918), both trained in France and affiliated with the N.E.A.C.[86] Influenced by Bastien-Lepage (Clausen more profoundly), both artists (but especially Edward Stott) developed increasing reverence for Millet's work and by the early 1890s appear to have absorbed some aspects of Impressionism. Their techniques and styles are hardly identical, with Stott often seeking soft-focus twilight moods. However, of interest for the present context is their absorption of some of Millet's pastoral themes, filtered through personal styles that combined Millet's influence with some features of Impressionism. In English pastoral painting this was an interesting breakthrough from Bastien-Lepage's methods and a Barbizon or Constable-inspired approach: warm sunlight effects were now evoked by combining Millet's 'mealy paint texture'[87] with the broken strokes and colour of the French Impressionists, built into densely layered grounds. Such works as Clausen's *Brown Eyes* (1891, Tate Gallery, London), or Stott's *Winchelsea Churchyard* (1887?, private collection, London), show the colours nearly merged, conveying the impression of an almost single-colour, yellow straw ground. Impressionism in the work of these artists remains peripheral: rather than fully accepting Impressionist techniques and fresh sun-

light effects, they subordinate these features to personal and subjective experience.[88] A general similarity of attitude may be observed in Fox's *Homewards* (1895), where a retrospective rural subject is combined with Impressionist technique of broken brushstrokes in a personal and subjective way. The general change in attitude evident in such Australian works in the 1890s would carry over to a later period of Fox's second return to England in 1901[89], as may be seen in his pastoral scene *The Cornfield* (c 1905, private collection, Melbourne), and some of his harvesting studies (private collection, Melbourne). A warm light is released by the blending colours, and the rusticity of the scene is evoked by the 'mealy' paint texture, with bristly strokes suggesting the rough ground of a harvest field. Several of Fox's undated sketches (possibly from this second period in England), show a single figure ploughing in a wide field and recall Stott's *Ploughing—Early Spring* (probably the picture exhibited in the N.E.A.C. in April-May 1891; now in Rochdale Art Gallery).[90]

Some of Fox's Australian works of the 1890s appear also to share in certain compositional preferences of the two English artists. A recurrent compositional pattern observable in Stott's work is that of an uphill view with furrows, or a winding road curving upwards and back into space without weakening of the colour by the distance. An uphill view is frequently combined with the broad elliptical curve of a pool in the fore- or near-middleground.[91] This type of composition occurs in several of Fox's Heidelberg paintings, such as his *Autumn Showers* (1900, Art Gallery of New South Wales).

Likeness with Clausen's work may be discerned in the direct close-up views of frontally presented figures, such as Fox had already painted in France. The major difference lies in the treatment of the figure, which Clausen brings into sharp Bastien-Lepage-like focus, while Fox, softly blurring and generalizing it, conveys a sense of reserve. Clausen's works suggest parallels with Fox's later experiments with figure painting outdoors at 'Chartersville' in the 1890s: the girl's head, cushioned against crisp, fresh leaves, in Clausen's *A Girl's Head* (1886, Manchester Art Gallery), seems to anticipate Fox's *Portrait of Miss Veitch* (c 1900, formerly private collection, Melbourne), placed against foliage. Clausen's later work, *Brown Eyes* (1891), is stylistically different from *A Girl's Head* and projects a large white accent against a high horizon-line, the tilted ground pressing the figure forward. A similar compositional arrangement is present in Fox's *Portrait of Miss Veitch*, shown seated against a sharply sloping ground. Of the *plein-air* painters in England, Clausen was perhaps one of the most influential figures, and the acquisition of one of his works by the Chantrey Bequest in 1890[92] gave his name added stature. Whether the later manifestations in Fox's work were affected by Clausen's example, or whether they represented parallel developments, is not known. The high horizon-line and the close-up presentation of the figure, inherited from Bastien-Lepage, were frequent compositional devices of Clausen's in the later 1880s, and it is possible that contact with Clausen's work may have reinforced this general heritage of Bastien-Lepage in some of Fox's Australian works, without implying direct emulation.

The various trends and attitudes that Phillips Fox encountered in England thus perhaps provided a climate for a change in his own attitudes, and may to some extent help to explain his more conservative approach to figure painting, the lowering of key and the more traditional treatment of landscapes in the ensuing decade in Australia.

URSULA HOFF The Everard Studley Miller Bequest

It became public knowledge in 1956 that Everard Studley Miller, who died in that year, had left to the National Gallery of Victoria a bequest worth about £200,000 for the acquisition of portraits '. . . of persons of merit in history, painted, engraved or sculpted before 1800'. The bequest was so unusual in its formulation and has so significantly enriched the collections of the National Gallery that one is curious to know how the funds for it originated, and what prompted the donor to stipulate such precisely worded conditions.

Everard Studley Miller came from a prominent Victorian pioneer family whose history reflects the development of banking, building, insurance and other business in Melbourne. The founding father of the Melbourne Millers, Captain Miller, did not himself set foot in Victoria. He came from an old established family, some of his forebears having been bankers in and mayors of Londonderry, Ireland, and arrived in Sydney in 1823 as lieutenant of the 40th Regiment of Foot, in charge of a detachment of his regiment and a group of convicts.[1] In the same year he became the first commandant of a convict settlement at Moreton Bay, Queensland.[2] Early in 1825 Miller and his regiment were sent to Van Diemen's Land, where he retired from the army and settled in Hobart. The vast fortune which eventually enabled a great-grandson of his to make the portrait bequest to the Melbourne Gallery owes its origin to Captain Miller's eldest son, Henry.

Henry Miller (1809-88) was thirteen years of age when he accompanied his father and younger brother to Sydney in 1823.[3] He had begun school in Paris, where his father was stationed after the battle of Waterloo, and remembered the Tuileries and the Place de la Concorde. In 1815 he continued school in Glasgow, the home town of his father's regiment, and started grown-up life in 1825 in Hobart as an accountant in the government audit office. Fourteen years later, on hearing reports on the settlement of Port Phillip, he visited it in 1839. From the drawing by Robert Russell of *Melbourne from the Falls* in 1837, we can see what the Port Phillip settlement looked like shortly before Henry Miller arrived.[3a] We can make out a few houses and a tent on the river. In 1838 when Russell made his etching from this drawing, he was able to identify a dozen houses. George Russell of Golf Hill describes Melbourne in 1837: 'Melbourne at this time consisted of three or four wattle and daub huts, a few turf huts, and about twelve or fifteen tents. The country immediately round at this time looked very pretty'.[4] However in the same year the surveyor Hoddle marked out the basic plan of Melbourne and by 1839 the Melbourne Club was founded, so the settlement soon began to develop its social amenities. The favourable reports Henry Miller had heard proved correct. The spectacular growth of the city can be gauged from a later drawing by the same artist, made in 1854: three years after the first gold discoveries Melbourne had streets, stone houses of several stories and the beginnings of Renaissance facades, i.e., the Customs House and the St James Old Cathedral, both designed by Robert Russell himself.[4a]

Impressed by the pastures and the promise of the country, Henry Miller decided to settle. From 1840 onwards he lived on his farm nearly opposite the site of the present Richmond Town Hall; he set up as an independent financier in Latrobe Place and in 1845 as a merchant at no. 6, Queen Street.[5] Between 1839 and 1859 he acquired properties all

over the city area, particularly in Collins Street and Bourke Street; later he continued to increase his holdings, and developed his wealth from these rent-returning properties.[6] In 1849 he established the Victoria Fire and Marine Insurance Company, which he later reconstructed into the Victoria Insurance Company and which in 1888, the year of his death, could still be described as 'a most successful institution'.[7] It celebrated its centenary in 1949 under the chairmanship of Mr L.F. Miller.[8]

In 1850 he founded a 'Union Terminating' building society, to be followed by seven others, of which he chaired six.[9] 'It is difficult', writes Richard Twopeny, 'to over-estimate the social value of the work that has been done by building societies'.[10] Miller further engaged in building ventures of his own, such as the Granite Terrace in Gertrude Street, Collingwood, designed for him by the architects Robertson and Hale and clad with granite from his own quarry on the Mill Park Estate at Janefield. This terrace remained in use until a few years back, when it was demolished to make way for a Housing Commission estate. The writer of the notice in *The Builder*[11] stated that 'among the numerous classes of residence which have been erected in Collingwood none are more distinguished than the block of houses . . . called "Granite Terrace" '. Set back some feet from the footpath, an austere row of piers and arches, romanesque in style, carried a two storey facade, while the ground floor behind the arches acted as a basement. The arcade and the wall above up to the windows of the first floor were of granite; but this proving too hard to work, the rest of the building was constructed in brick and cement. The articulation of the front was simple; the romanesque of the arcade changed into a rudimentary neoclassicism in the first and second floor, resembling the style of the Royal Terrace in Nicholson Street, thought to be by Charles Laing[12], which was finished a year before Granite Terrace. Miller's houses contained eight rooms and a kitchen, as well as all the requirements of town residences for 'respectable occupants'. The architects chosen by Miller, now mainly known from illustrations in *The Australian Builder*, seem to have produced well proportioned and meticulously detailed work, but also had a reputation for undercutting the prices recommended by the Victorian Institute of Architects.[13]

Miller was among the promoters of the Bank of Victoria, which was incorporated in October 1852, and was elected first chairman of directors, a post which he continued to occupy until the day of his death. This bank was the largest and most spectacular bank of the 1850s. The other banks trading in Victoria at that time were mostly English (with the exception of the Bank of New South Wales) and 'Henry Miller objected to "foreign" banks profiting so much from the gold discoveries'.[15] It first occupied a building in Swanston Street, opposite the present city square, but in about 1863 removed to its new headquarters at 251 Collins Street (1).[16] The new building had been designed and its construction supervised by the architect Alfred Louis Smith, whose offices were registered since before 1860 at Thorp's Chambers, 49 Collins Street West, and in 1862 at Bank Place, 77 Collins Street West.[17] One of the lesser architects of the day, he is perhaps best commemorated by the Law Courts in Lonsdale Street, for which he won the competition in May 1873.[18]

Smith's design for the Bank of Victoria was held to be in the 'Italian taste'.[19] Above the faceted and pointed rustication of the ground floor rose arched windows framed by Corinthian pillars and architraves. Inspired by sixteenth-century Venetian palaces, this kind of *facade*, much used for bank buildings during this period, 'expressed the economic and social pre-eminence of their owners'.[20] Despite heavy losses sustained in 1878, the Bank of Victoria was for long the leader among local banks and remained under the control of the Miller family until 1927, when it and more than 120 branches were sold to the Commercial Banking Company of Sydney.

Apart from widespread business undertakings, Henry Miller also took part in Government.[21] After the separation of Victoria from New South Wales in 1851, he became a member of the Legislative Council in the O'Shanassy government, and between 1851 and 1856 sat on fifty-three select committees, including the one that framed the new Constitution. He held various ministerial positions, but a change of sides lost him public confidence and after his defeat in the 1867 elections he retired from political life.

Henry Miller owed his wealth to a large extent to his brilliantly successful investments in real estate. Some of his city property holdings formed part of Everard Studley Miller's bequest to the National Gallery, such as 353 Flinders Lane (on the south-east corner of Bond Street) and the Richmond Market, acquired by Henry Miller in 1858.[22] Among Henry Miller's widespread country possessions, the farm at Bacchus Marsh and that at Mill Park, Janefield, will play a further part in this account.

The first house Henry Miller and his wife Eliza (born Mattinson) occupied in Victoria stood on his Richmond farm. Nearly all his children were born there.[23] In 1871 he acquired the thirty-acre property at Kew, which in 1857 had been bought by Stephen Henty of Portland from Sir James Palmer; built in the gothic style it may have been designed by Sir James' architect, Charles Laing.[24] Stephen Henty had named the house

1 Alfred Louis Smith, The Bank of Victoria, 251 Collins Street, Melbourne, c. 1862 (sold in 1927 to the Commercial Banking Company)

2 Marcus Stone, *An Appeal for Mercy, 1793*, oil on canvas, exhibited Royal Academy, London, 1876

'Findon', after the village in Sussex where he, his brothers and his father used to buy and sell at the big sheep and cattle fairs.[25] Here Henry Miller spent the remaining twenty years of his life. He improved the grounds and engaged in the breeding of thoroughbreds, for which he established 'stables fit for princes'. He made substantial alterations to the house, adding a dining-room, a ballroom and a gallery, in which the owner's portrait hung over the mantelshelf on which stood several racing trophies. We know little about the sixteen paintings owned by Henry Miller. Many of them, it seems, were bought from the International Exhibition held in 1880 at the Exhibition Building. The titles of two of them have come down to us: Marcus Stone's *An Appeal for Mercy, 1793* and Edward Fahey's *All among the Barley*. Both painters were English exhibitors at the London Royal Academy.

An Appeal for Mercy, 1793 (2) was shown there in 1876, no. 1326, winning an associateship for its painter.[26] In a *Louis Seize* apartment, commandeered by the revolutionaries, a young woman dressed in costly garments kneels behind a Jacobin officer who, turning his back on her, reads the letter, the envelope of which is still in her hand. Behind the officer lounges an ill-mannered underling, casting a speculative eye on the *décolletage* of the pretty pleader. It is an early example of Marcus Stone's favourite genre in costumes of the French Revolution.[27] The painter, long out of favour, has recently made a come-back. Versions of *An Appeal for Mercy* have gone through the auction rooms[28]; his *In Love*, painted in 1888, was included in the exhibition 'Great Victorian Pictures' at the Royal Academy in 1978, where it drew much critical acclaim.[29]

Miller paid £1000 for his version of the Marcus Stone[30]; since the total value of all his paintings amounted to only £1,200 at probate[31] none of the others can have been of exceptional merit. 'A conservatory', write Grant and Serle, 'a ballroom and a gallery, whose paintings of negligible worth were proudly displayed, completed the essentials of the Melbourne 'Man of Property'.[32] Both in his choice of architects and in his selection of pictures Henry Miller conformed to established conventions and exercised due caution in expenditure.

One would like to know what kind of man Henry Miller was, but few biographical facts remain. The only portrait of him, painted six years before his death by the head of the National Gallery Art School, George Frederick Folingsby, shows us a man of typical Victorian appearance, formally dressed in a dark suit, half his features hidden by a well-trimmed, spade-shaped white beard (3).[33] He was described in contemporary records as a man of considerable culture and distinguished connections. Sutherland wrote:

In his personal characteristics Mr. Miller was methodical, homely and unobtrusive. His business transactions were carried out with a surprising absence of fuss or ostentation ... He never travelled, and lived altogether a very uneventful, easy-going life, always remarking that he preferred to live and die in the colony where he had been so successful.[34]

We get a glimpse of Henry Miller at an earlier age from George Meudell's writing. Meudell describes how in the early 1850s his father, William Meudell, and a friend arrived in Geelong from Edinburgh. They were picked out from the crowd of immigrants by Henry Miller, who was on the wharf looking for farmhands for his property at Bacchus Marsh. He asked the two young men to take palings from Geelong to Bacchus Marsh by bullock team, an experience which apparently left an indelible impression on the city-bred Meudell senior. Later he 'slept alongside the gold for eight years' in the Bendigo branch of the Bank of Victoria, after which he was rewarded by being made manager of the Collins Street head office, where he remained until after Henry Miller's death. Miller made a protégé of William Meudell 'because he knew he could rely on him'; writes his son: 'the old man was as straight as a gun barrel'. George Meudell praised Miller for his personal courage and for a genial and friendly manner; it would appear that 'our Victorian Croesus'[35] had the gift of inspiring loyalty.

There are also less favourable contemporary comments. The press was wont to criticize Henry Miller for omitting to contribute to charity appeals. In the obituary in *Table Talk* we read:

The Hon. Henry Miller cannot be regarded as having been a public man in the true sense of the word ... the only substantial charitable act I know of is his contribution of £5000 [made before 1886] towards the building fund of the Anglican cathedral [St Paul's].[36]

In 1868, when the Corporation of Melbourne floated a loan of £50,000 for markets and public works, Miller took up four-fifths of it. The press was convinced that he gained political influence by such moves; while this is presumably correct, the subscription undoubtedly helped the development of the city. Used to thinking on a big scale, Miller felt that the £100,000 probate on his estate would be a reasonable return to the country for the opportunities it had afforded him. *Table Talk*, even after his death, continued to regale its readers with stories of Miller's parsimony; one of these, against the writer's intention, touchingly illuminates the devotion to the unremitting discipline necessary in financial matters which was one of the secrets of his success. Just before his death, *Table Talk* writes, 'he sent one of his sons with 4s6d to the bank to deposit, as he did not like capital lying idle in the house "eating its head off"'.[37]

In his last years Miller lived quietly at 'Findon', often surrounded by his grandchildren,

to whom he was particularly attached. One of these was Everard Studley, Henry Miller's grandson. Studley did not, however, recollect any of the family gatherings, since he was barely two years old when his grandfather died in 1888.

Henry Miller's eight children inherited equal shares in their father's estate and a collection of financial interests which they continued to take care of in close co-operation.[38] The eldest, William Henry Miller, was accountant of the Bank of Victoria. Albert and Septimus Miller managed various properties of their father's, and Arthur Miller was a solicitor in the firm of Moule and Seddon. Edward Miller (1848-1932), a director of the Bank of Victoria, succeeded his father as chairman and retained this

3 George Frederick Folingsby, *Henry Miller*, oil on canvas, 1882. Collection Mr Edward J. Miller, Melbourne

position until 1927, when the bank was incorporated into the Commercial Banking Company of New South Wales.

Possibly as a result of the vociferous criticism voiced by the press at Henry Miller's lack of support for charities, his children responded generously to appeals. Henry Miller's daughter, Mrs Bowen, wife of a Collins Street oculist, who had inherited 'Findon', made the house and the grounds the occasion for parties and bazaars, such as a garden fête of 1903, organized for drought relief.[39] Edward Miller became treasurer of the Australian division of the Red Cross Society and was knighted for his service. He was also treasurer of the Talbot Home for Epileptics and member of a number of hospital boards. His wife received the Order of the British Empire for charitable services rendered during the first World War.

It is a fair assumption that no great additions were made by the family to the financial empire created by Henry Miller. The second generation had passed from the desire to acquire wealth to the wish to enjoy it. Several of the Miller brothers were keen racing and hunting men. Henry Miller had created a stud for race horses on his properties at Bacchus Marsh and Mill Park, near Janefield, but he left it to his sons 'to represent him on the turf'. Septimus Miller owned the horse 'Redleap', which made racing history by winning the Grand National three times.[40] The Millers supported the 'Findon Harriers', a pack of hounds introduced from England in 1871, with which they and their friends hunted in style in the country adjoining Kew, Mill Park and Alphington. A print by Herbert Woodhouse entitled *The Meet of the Melbourne Hunt Club 1892* has a key bearing the names of such pioneer families as Chirnside, Lempriere, Manifold, Payne, Crooke, Grice and Miller.[41]

Sir Edward and Lady Miller and other members of the family figured prominently in press reports of the leaders of fashion on notable social occasions. After their marriage in 1900, the Edward Millers lived for short periods in various old houses in Toorak and Kew.[42] In 1908 their new house was built on a property along Kooyong Road; it was called 'Glyn' and designed by the architect Rodney Howard Alsop, who later became famous for the buildings of the University of Western Australia (4). One need only compare this house with 'Linden'[43], built in 1870, to see that the Victorian Town House with its Italian Renaissance proportions, its symmetry and emphasis on horizontals and verticals, on an inviting facade, differed strikingly from 'Glyn', which represents the new mode of high gables, curved roof lines, absence of facade and absence of symmetry. Instead of the stucco painted white at 'Linden', dark wood and rough cast wall finishing are used at 'Glyn'; despite its size the house looks more like a cottage than a palace. In all this 'Glyn' resembles to a certain exent 'The Red House', which had been built by Philip Webb for William Morris at Bexley Heath in England in 1859.[44] Here the high pitched roofs of the gothic style and the irregularity of fourteenth century domestic architecture have been used for a new departure in private houses suitable for the middle class.

Echoes of this style reached Melbourne through Walter Richmond Butler, an Englishman who between 1905 and 1925 became one of Melbourne's best-known architects, and who was also a close friend of the young creator of 'Glyn'.[45] In England Butler had belonged to a group from the office of Norman Shaw, who supported the Arts and Crafts Movement which had been founded by William Morris. Butler, who had emigrated to Melbourne in 1889, had married Rodney Alsop's cousin and must have encouraged Alsop, who had been greatly impressed by the style of Art Nouveau which he had seen at the Exposition in Paris in 1900. The inside of 'Glyn' fulfills the new ideal of a house built from inside out: all living rooms face south and south-east, overlooking the valley and the cottage-type garden. The stairwell occupies the north side and adjoins on each storey a

4 Rodney Howard Alsop, 'Glyn', Kooyong Road, Toorak, 1908-09, garden front

spacious hall from which the rooms open out; on the ground floor wide double doors allow a flow of space from the entrance hall into three large rooms. The simply and impressively designed staircase (5) has dark bannisters and posts decorated with gum leaf designs in the Art Nouveau manner. Similar patterns appear in the stained glass windows, on copper overmantles and door shields; light fittings were in keeping with the rest. The house is an early example of a style which was to find its finest expression in the work of Harold Desbrowe Annear. To have chosen an architect of only twenty-seven years of age, enthusiastically devoted to the most 'modern' overseas trends, shows unusual daring in the Edward Millers. During the same years, Dame Nellie Melba still insisted on tradi-tional 'Palladian' for her Coombe Cottage near Lilydale, designed by John Grainger (Percy Grainger's father) and built between 1909 and 1912. It is hard to explain the reason for Edward Miller's choice. Does it point to a wish to be abreast of the latest trends, to be a leader of fashion? Did the young architect, still in his twenties, submit a more satisfactory estimate of costs than his older colleagues?

In contrast to the patriarchal family of nine which had succeeded Henry Miller, the progeny of the Edward Millers consisted of two sons, ten years apart in age. The eldest, Edward Eustace, called Esmé, left Australia early to live in England and little is known of him. Like his great grandfather, he joined a regiment, took an interest in Egyptology[46] and died in Africa. Studley, born in 1886, was educated at Melbourne Grammar and then sent to England to continue his training at Sherborne in Dorsetshire, a well-known, small, exclusive public school. He would have liked, I am told, to have gone on to Cambridge and become a don, but instead returned to Melbourne to go into the family business in the Bank of Victoria. Once back, he continued with his studies and for a while was privately tutored by Archibald Strong, a noted classical scholar and writer who later became

lecturer in English at Melbourne University, before accepting the Chair of English at Adelaide in 1922.[47]

Studley appears to have been the very opposite of his father. He did not share the family's interest in business, finance, politics or their enjoyment of society, of racing and hunting. Instead of the forward-looking, enterprising spirit and the grand manner which had distinguished his forebears, he was inclined to contemplation and was of a retiring disposition. A contemporary of his, Major Stuart Love, who had known him since 1919 (when Studley was thirty-one years of age), described him as 'shy and retiring' even then.[48] He liked engineering and photography, and took an interest in history and archaeology; in 1914 he joined the Historical Society of Victoria, retaining his membership to the year of his death, and for many years he attended meetings of the Classical Association of the University of Melbourne. His marked interest in Egyptology, which induced him to assemble a good number of books, some of them standard scholarly texts, may have been inspired by his brother Esmé. After a visit to Italy in 1924 Studley told his friend Major Love about the Roman antiquities he had seen, but did not then seem to the Major to have been interested in the great masters of painting. After his father's death in 1932, the care of his mother's affairs fell to Studley, as the only remaining son. After Lady Miller's death in 1941, Studley continued to live alone in the big dark house in Kooyong Road, with a few servants and two nurses; he rarely went out and when he did, was always accompanied by the senior nurse, Miss Winifred Montford. Some of his outings were to the National Gallery, where he called on the director, Sir Daryl Lindsay, evincing considerable interest in the administration of the Felton Bequest, without however giving any indication of what must have been in his mind.[46]

He also frequented the antique shops in Chapel Street, where he enjoyed acquiring small *objets d'art* and prints, which he then brought to the Gallery to obtain information about them. He had a particular fondness for the early chromolithographs published in England in the 1860s by the Arundel Society, which for the first time in history had reproduced many of the Italian paintings of the Renaissance in colour.

In his academic studies Studley had remained at the level of an amateur. Photography, on the other hand, he mastered like a professional. His earliest dated photographs were taken in 1903 at the first motorcar meet held in Melbourne, at Maribyrnong; soon his photographs reveal what indeed was to him the chief function of this art, namely 'to record and make permanent'. In a typed manuscript entitled *Photography for the purposes of historical study*, dated October 1914, in which he discussed the apparatus and processes of this technique, he saw the role of photography as preserving 'the monumental memories of early Australia'. He filed his photographs in a series of albums, the first of which was called *Historical Monuments in Victoria, I.*[49]

In 1908 (if we can believe the dates inscribed on the negatives), he travelled around Tasmania, then twenty years of age, taking photographs at Port Arthur, in New Norfolk, in Hobart and elsewhere. One possible motivation for undertaking this tour might have been the wish to trace the whereabouts of his forebears, as well as to record the earliest aspects of the colony. The tomb of Captain Miller, who was buried in Hobart in 1866 (his tomb was re-fashioned in 1887), and the tomb of Captain Miller's second wife, Mary Elizabeth (he had remarried in Tasmania), are among Studley's negatives. From 1913 stem prints of the old cemetery at Portland, of the jail there and the Henty House; such pursuits continue during the war years, suggesting that Studley was not eligible for military service.[50]

Between 1914 and 1919 he joined the Reverend Mr Isaac Selby in protesting against the resumption of the old Melbourne cemetery, which had been established since 1837

5 Rodney Howard Alsop, 'Glyn', staircase. Photograph by courtesy of the National Gallery of Victoria, Melbourne

between Queen, Peel and Franklin Streets, next to the Flagstaff gardens.[51] It contained the monuments of many men of distinction during the early years of the Port Phillip settlement. Selby reports that his friend, the poet George Gordon McCrae, 'could not think it right to erect monuments to the men of today, and forget these men of merit, who so valuably served their country long ago'. This phrase of George Gordon McCrae's, which Everard Studley Miller preserved in his album among the records of the cemetery controversy, may well have been the seed from which sprang the phrase in his will which has proved so beneficial to the National Gallery of Victoria.

To the memory of men of merit in history, Studley Miller continued to devote many hours of his time. After recording the houses and monuments of pioneers in Australia, he followed their steps back to their country of origin and travelled around England in 1924

photographing the tombstones of pioneers to be found in English graveyards; he also visited their houses and assembled a considerable body of photographic prints of historical interest.

It is not clear what the dates of his travels to other places were and how often he went abroad. But his photographic collection suggests that he broke journey on this and other occasions at various ports, such as Colombo; from Port Said he may have gone North into Palestine and South into Egypt. The second World War put a stop to travel and his health prevented much activity in later years. After his death in 1956 his belongings were divided up according to his wishes: some books and slides were chosen by Professor Harold Hunt for the department of classics at Melbourne University; albums, photographic negatives of Australian interest went to the Royal Historical Society of Victoria.

Property and money to the value of about £200,000 were bequeathed to the National Gallery of Victoria, as a purchasing fund to be used for the acquisition of 'portraits of persons of merit in history, painted, sculptured or engraved before 1800'. The author of the entry on Studley Miller in the *Australian Encyclopedia* states that surprise was caused by this bequest as the testator had not been known to be greatly interested in art. The reason for the bequest need, however, not have rested mainly in aesthetic considerations. Studley Miller's notes on photography show that he was anxious that the memory of the monuments of the past should be retained by later generations. In the last resort he may well have, consciously or unconsciously, been moved by a general desire to stem oblivion, to counteract the erosion of time, for he had a sense of living at the end of an era, of being the last of his line—on the photograph of 'Glyn' in his album he wrote 'the last large house'. He may well have agreed with Pliny the Younger (second century A.D.), who, in his *Natural History*, refers to the Roman habit of setting up portrait busts in libraries, 'in honour of those immortal spirits, who speak to us in the same places . . .' 'In my view,' Pliny continued, 'there is no greater kind of happiness than that all people for all time should desire to know what kind of man a person was'.

URSULA PRUNSTER Norman Lindsay and
the Australian Renaissance

In 1923 a new 'little magazine', called the *Vision Quarterly*, appeared in Sydney with the stated object of providing not only 'an outlet for good poetry' but proclaiming that 'a Renaissance is a necessity, and we believe that already the stirring of the wings can be felt'.[1] The fountainhead of this new movement was Norman Lindsay, who formulated the terms of its aesthetic in a book he published in 1920 called *Creative Effort*; its chief spokesman was his son Jack Lindsay and its chief poets were Hugh McCrae and Kenneth Slessor.

It was Norman who suggested the title *Vision* and provided the cover design of a faun pursuing a butterfly (1). His sprightly line decorations gave much of the magazine's visual appeal and he also contributed stories and essays, but primarily he was the catalyst of the enthusiastic gatherings and discussions at Springwood that gave birth to the project. This resulted not only in the publication of the *Vision* magazine, but in the foundation of the Fanfrolico Press and the publication of numerous fine art volumes of poetry, philosophy and the classics with Norman Lindsay decorations.

In the Foreword to the first number, Jack Lindsay, writing as 'Apollo's advocate' (Apollo being Norman), set out the ideas behind *Vision* as follows:

We would vindicate the youthfulness of Australia, not by being modern, but by being alive . . . to find Youth by responding to the image of beauty, to the vitality of emotion. To the Modernist the very use of the word Beauty would seem to indicate a parochialism, the provinciality of a continent removed from schools, manifestos, Salons of the Rejected and Da-Da concerts. But we do not ask him to return to the great expressions of the past; for he belongs to a period in which that past is an unimaginable future . . . Considering the depths of devitalisation the world touched in the War . . . considering that now for the first time in history Primitivism in the Arts has been expressed by a deliberate intellectual choice, it is clear that unless consciousness soon takes an upward turn, vitality will sink too low ever to recover . . . When Picasso hung a geometrical pattern in gold paint in the last Autumn Salon, or Satie put typewriters in the orchestra of 'Parade', they were both as old as any other form of Egyptianism . . . If then we are to vindicate the possession of Youth, we must do so by responding to all other expressions of Youth, and by rejecting all that is hieroglyphic, or weary and depressed. If Australia alone in the world is doing this . . . then the Renaissance must begin from here . . .[2]

The ideas Jack expressed here were originated by Norman Lindsay, who, some twenty years earlier, had identified the contemporary world with decadence and, following Nietzsche, seen the Pre-Christian civilization of the Greeks and Romans as the integer of cultural vitality. As he wrote in a letter to his brother Lionel, 'it is the moderns who are old and senile and ugly. The ancients only have the secrets of eternal youth'.[3]

The Vision Movement, when viewed in its historical perspective, can be seen as essentially an attempt to 'continue and broaden the work Norman Lindsay had done before the war in attacking Australian wowserism and parochialism in life and art', with the aim of encouraging 'the growth of a robust and sensuous kind of art that would affirm what Lindsay thought of as true art-values—Beauty, Life and Courage (according to Nietzschean canons).[4] The influence of this Nietzschean strain in Australian literature has often

1 Norman Lindsay, pen drawing, cover decoration for the *Vision* Quarterly, no. 1, May 1923

been remarked on, but as Fitzgerald noted, the main stimulus came from Lindsay himself:

> It was not Nietzsche who inspired and invigorated that time and gave to creative thought and work in Australia an impetus which has not yet expired: rather it was the vitality and energy released by Norman Lindsay's own contribution to art and literature.[5]

The invigorating influences Lindsay provided were the emphasis on a vital and concretely sensuous imagery, and the conception of a mystic brotherhood of artists, an intellectual elite, transcending the normal processes of history and limits of nationality, which fired him with the idea of 'transforming our culture to the broad new level in which the great achievements of Antiquity, the Renaissance, the Romantic epoch might be taken in and built on afresh'.[6]

His personal dream of an Australian Renaissance grew out of his developing certain aspects of Romantic thought to propose that the artist was by definition alienated from a society concerned with the ephemeral problems of 'Existence', and was in contact with universal forces or energies that were a permanent constituent of the immortality of 'Life'. These eternal values (which John Docker lists as 'passion, beauty, sexuality, courage, vitality') were in turn constituents of the human mind, which Lindsay believed to be indestructible. In a Platonist sense, these essences, emotional and intellectual, formed the higher reality with which the artist should properly concern himself.

Thus Norman Lindsay believed that the primary reality was self, and the primary goal of the artist was self-knowledge, to be achieved by looking inward and not by 'observing an unreal social mechanism'.[7] As a predestined individual, the artist, via his imagination, could connect himself 'in a neo-Platonic way with universal Essences'.[8] Therefore, imagination, myth and fantasy were expressions of an insight into reality not normally granted the average man, and the art image acquired a transcendental, almost mystical value.

Norman Lindsay's concept of a renaissance was therefore not born of a historical desire to revive the styles of the past (like the nineteenth century academicians) but out of his conviction that the artist operated outside the normal processes of history. The artist, according to his aesthetic, had access to precognitive values (the 'Hidden Symbol') which linked him with the similarly predestined individuals who embodied the value he called 'consciousness' through the generations.[9]

From Nietzsche, Lindsay absorbed the idea that history does not follow a linear evolution through time but is caught in an essentially static cycle of 'eternal recurrence'. This renders the ordinary concept of progress meaningless, for history simply repeats itself and mankind does not move forward. The only development possible is an individual one, moving towards 'consciousness', that pre-existing value created by the Greeks and periodically rediscovered by 'the great revealing passionate minds' who, fusing intellect with emotion, attained a higher and more enduring awareness of self and life.[10] Because these minds 'inhabit no actual history', Lindsay is free to assume that Australian artists, although isolated in time and space from the great European tradition, could still legitimately base their work on its achievements.

The value of Norman Lindsay's contribution lay in an aesthetic that challenged the insularity and complacency of Australian culture by asserting that our artists need not limit themselves to writing about drovers or painting gum trees, and by demanding that 'provincialism end and Australia enter the currents of world culture'.[11] Jack expressed this Lindsayan challenge to chauvinist nationalism when he wrote:

all true poets are really one stock. If they belong to any nationality, it has no name on the maps of the world, but lies with Pindar's Hyperboreans, whither 'neither by land nor by seas shalt thou find the way' . . . the old Dionysiac truth holds here: blood is spirit: out of this body we must build all higher ones.[12]

Although the Vision group repudiated all forms of what they called 'modernism', they formed what Tregenza called 'virtually . . . the only avant-garde circle in Australia in the early twenties'.[13] Despite some of its more reactionary pronouncements, the *Vision* magazine generated a sense of adventure and excitement wholly lacking in Australian culture at the time. It promoted a feeling of optimism and confidence in the future, re-asserting what many Australian writers had believed earlier in the century, that 'Australia, because of her youth and sunny climate and her freedom from inter-racial and international hatreds, was in a position to heal the sickness of war-weary and disillusioned Europe'.[14]

Yet the value of Lindsay's contribution needs to be qualified in the light of his reactionary tendencies. On the one hand, he broadened the range of expression available to the Australian artist, theoretically offering him an escape from provincialism, from the feeling that his art was doomed to be produced on the sidelines of world culture, remaining peripheral to the mainstream developments of European art. But on the other hand, he cut him off from contemporary developments in European culture, thus reinforcing the very provincialism he sought to escape, by excluding modernism from his definition of great art and calling it retrogressive and a betrayal of the stimulating 'consciousness' that had defined and maintained vital art since the Greeks.

Jack Lindsay later summed up the anomalies of this position when he wrote:

the sharp issues of collapse and re-integration posited by Picasso, Apollinaire and the fauves and futurists, the dadaists and surrealists, could have no relevance to us. Yet by demanding that provincialism end and Australia enter the current of world-culture, we were bringing ourselves into alignment with these issues.[15]

The Australian Renaissance remained a peripheral movement because:

we wanted, not any sort of Futurism, but a new Great Art linked with Praxiteles and Rubens, Rembrandt and Turner, Aristophanes and Shakespeare, Catullus and Keats, Rabelais and Blake.[16]

Much of the *Vision* movement's energy was expended fighting battles for artistic and sexual freedom that had already been won overseas. As Jack explained it, 'we seemed doomed to fight a hopeless double-battle against local philistinisms of a deadly kind' while at the same time resisting the threat of modernism in 'decadent disintegrations washing in from without'.[17]

The basis of the Lindsays' critique of modernism was two-pronged, first that it was decadent and devitalizing in content and second that it was disintegrative in form. An example of Norman Lindsay's criticism of a specific modernist work can be found in an essay he published in *Vision* called 'The Sex Synonym in Art', where he attacked James Joyce for 'vilifying all that is gay and upright in love, . . . making the human body the symbol of decay and death'. *Ulysses* represented for him an inverted puritanism manifested in a disgust for the body, because although Joyce spoke frankly of sex, he distorted it in 'the stale idiom of the slums'. Lindsay argued that if the art image is 'malformed or related to the essentially ugly conditions of actuality, the effect will always be one of depression' acting as a 'devitalizing influence on life'.[18]

Thus Norman Lindsay could not accept the modernist idiom because it seemed to him to betray the idea of vital beauty and joyous sensuality in art and to offer in its place intellectual formulae, dead abstraction or malformed ugliness. Although Lindsay often repudiated what he called the 'humanitarianism' of the moral reformer, his aesthetic also incorporated a fundamentally humanist ethic:

We believe that by seeking to create a standard of beauty in art we will help to create a condition of beauty in life, so that much that is squalid in existence will disappear.[19]

He blamed the horror of the recent War on a devitalizing preoccupation with ugliness, which he detected in the modern art produced just before 1914. For him the War and movements like Futurism were equally culpable expressions of a disintegrating consciousness.[20] His extreme reaction against the horror of the War, which had maimed and killed the youth of many countries, contributed that element of moral earnestness to his aesthetic programme which was echoed in the Foreword to the second number of *Vision* where Jack wrote:

We must first see the War in perspective. It was only a surface expression of a devitalization that went deeper than political causes . . . The last century saw the apotheosis of complacency and hypocrisy . . . We believe that the generation now arriving, which has seen the bloody finality of the last century's tribal ethics in war and in Futurism, will turn again to Beauty and Passion. It must or the world is doomed. It must turn to Life with a spontaneity of gladness and desire: it must believe only in Nietzsche's God that dances; it must have a gay hardness for all pain and tragedy: it must fling overboard all valuations that are complacent and repressive . . . the future of the world rests with these young and free spirits who will find Life again a thing of mystery and beauty, who will unveil their eyes to see again the gods come to earth . . . Apollo in the fields and Aphrodite on the lily slopes.[21]

For the purposes of this essay I have identified the pronouncements of *Vision* with Norman Lindsay's ideas. However it must be remembered that Jack tended to over-simplify and exaggerate his father's ideas for the purpose of issuing striking manifestos. The ethic and aesthetic of *Creative Effort*, as set out by Norman Lindsay, operated on more levels than catch-phrases like 'Aphrodite on the lily slopes' would suggest. *Creative Effort* was not a programme advocating pagan subjects for art over kookaburras, but a

personal statement about the validity of art as a directly life-enhancing expression of the self: it hinged on the idea that the artist can use word form or sound to define new levels of self-awareness.

In rejecting the values of his contemporary society and of contemporary art, Lindsay also rejected the idea of a social role for the artist as spokesman of communal values, stressing instead the individuality and loneliness of his struggle to create beauty in a world where society was driven by materialistic greeds and hatreds.

As Jack Lindsay later wrote:

One of the verifications of *Creative Effort* would be the gathering of a devoted company of poets, artists and musicians in Sydney, all pledged in the face of the stock exchange, the churches and the police force, to bring about a fresh Graeco-Roman Renaissance.[22]

This artistic community would be self-sufficient and alienated from the mass of society, which was presumed to be either hostile or indifferent to its aspirations. This isolation bred a sense of companionship within the 'magic circle' of the group, encouraging the sharing of ideals and mutual support. These positive results must however also be weighed against the negative effects of deliberate isolationism, for insulating oneself against the rough and tumble of the real world produces a blindness to the issues that enliven contemporary society. Art produced from an ivory tower must necessarily have an esoteric and limited appeal and relevance.

Within these limits, the books which Norman Lindsay illustrated, promoted and helped to publish in the 1920s have endured, appealing to the collector for their visual beauty, rarity and the care with which every detail has been harmonized to form an integrated whole. An example of this artistry was Hugh McCrae's *Idyllia* volume of poems, published in 1922 with five original etchings by Norman Lindsay. It set the model for the numerous privately printed and Lindsay-decorated books that were to follow.

Idyllia was printed in a limited edition of 'de luxe' quality, the etchings tipped in and the hand-drawn title page, the initial letters and cover design all carefully harmonized with the bold type on hand-made paper, and excellently bound. The design and production were the work of the artist; his wife Rose printed off all the etchings herself and the entire enterprise was virtually a cottage industry, conceived and executed among family and friends and marked with the sphinx insignia of the 'Norman Lindsay' press.

This spirit of closeness, the intimacy which marked it as a personalized production is summarized in Hugh McCrae's dedicatory poem to Norman Lindsay:

Behold our eagle-eyed
Olympian ride—
The Muses by his side
. . .
A fire-flashing star
From Attica.[23]

McCrae and Lindsay were old friends who had earlier collaborated in producing an art volume of poetry in 1909—the John Sands edition of *Satyrs and Sunlight: Silvarum Libri*. But in the 1920s their association took on a new aspect. The 1914-18 war had been for McCrae, as for Lindsay, a decisive watershed in his life. Judith Wright said of McCrae:

If ever he had hoped to influence his world or change its puritanical cruelties and pomposities by his own sensuously joyful poems, that hope must have been put away during those years of unprecedented fury and hatred. So he went (retreated is not the right word, for no poet has remained so undefeated by time) farther into his own world, the world of the poem.[24]

In the 1920s the need for poetic detachment brought them closer together, for both poet

2 Norman Lindsay, etching,
illustration to 'The Yellow
Lady', poem by Hugh
McCrae, *Idyllia*, Norman
Lindsay Press, Sydney, 1922

and artist were vulnerable to the criticism of the outside world and repelled by the horrors
of the recent war. If McCrae retreated into the world of his poems, Lindsay also set
himself new goals as an artist. He expressed these in a letter to Baldwin Spencer, where he
wrote that he was 'breaking away from the realistic tradition and striving only for the
element of beauty', turning more 'to the desire to express an intrinsic beauty of texture
without bothering about the problem of actuality'.[25] In his *Idyllia* illustrations, the fleshly
qualities of Lindsay's art (apparent in the *Satyrs and Sunlight* volume) have become
attenuated, and there is more emphasis on pure decoration.

In the 1920s McCrae and Lindsay both developed a sense of themselves as outsiders,
alien to the world of the present. This was expressed in a letter McCrae wrote to Norman:

directly we touched again in these golden nineteen-twenties I saw the sacred fire begin to throw its
chequering light on everything about me. Norman, you have the greatest genius . . . that which does
not daunt, which never diminishes its fellow-traveller, but while rising, seems to carry all else with it
. . . We are two arrows sped from two 'trees' of the same wood. We traverse dark night side by side.
Fells and valleys, cities, forests, and rivers roll dimly under us . . . With hidden purpose, we journey
eternally the tenebrious void.[26]

What is particularly revealing in this passage is the way that the world stretches beneath but does not touch them. Only an inner sense of purpose gives conviction and direction 'of hidden hands projected' to their work. It is as though their paths are preordained and have nothing to do with the circumstantial reality in which they find themselves as men. McCrae, a poet of instinct more than intellect, was not given to theorizing, but he responded intuitively to the more mystical aspects of *Creative Effort*. He believed like Lindsay that artistic inspiration came under the guidance of one's personal daemon, writing:

each of us has had knowledge for a long time of our cousins-in-the-air . . . invisible kinsmen . . . where I did my best work I felt their presence most acutely . . . But dear Norman, it was first through you, the miraculous Beauty of everything you did, that the Invisible began to reach into me.[27]

McCrae found inspiration not only in his conversations with Norman Lindsay but directly from his art imagery, and Lindsay in turn found ideas for new pictures through reading McCrae's poems.[28] The particular style of their collaboration is neatly exemplified by the *Idyllia* poem, 'The Yellow Lady' (2). Together with its etched decoration and ornamented initial letter, it illustrates a typically Lindsayan fantasy, with its prodigal exoticism and airy sing-song of make-believe loveliness conjured from a vision of 'a thousand years ago, or two . . .' The light touch of McCrae's skipping rhymes is perfectly echoed in the light touch of Lindsay's etching line as it describes the sinuous curves of Cheefoo's body. She is seated buddha-like before an oriental screen inscribed with a dragon and rippling patterns that could be clouds or fire. As an oriental love-goddess she is also linked with age-old symbols of femininity, the moon, the mirror and a peacock feather headress. (Peacocks being the emblem of Juno and also associated with immortality).

The delicate flat patterning of Lindsay's image is matched by the shallow ripples of word-sense in McCrae's verse. Both are exquisite artifice, like a song with pure bell-like notes and no words, to be appreciated for their beauty alone. McCrae makes this clear when he qualifies his experience by beginning: 'A thousand years ago . . . I dwelt (or dreamt I did) in sin/With one, a yellow lady . . .' And reinforces the fantasy element further on with tripping rhythms like:

Cheefoo! Cheefoo! Sharp-toothed Cheefoo!
If only you might bruise my chin
As once, Cheefoo, you used to do . . .

In this poem McCrae is experimenting with word music, turning poem into song, just as Lindsay is experimenting with the surface of his copper plate, striking lights and shadows, textures and linear arabesques with his needle. So his image is an ideal accompaniment to the poem, in so far as the limitations of illustration will allow, for the concrete image can never finally visualize all the subtleties and suggestions that a poet's imagery can conjure in the mind of his reader. Still there is a rightness, an inevitability about the pairing of Lindsay's pictorial design with lines like:

And when the moon grew round and bright
Like a coiled dragon, I would put
Into my breast for sheer delight
Your tiny rose-leaf Chinese foot . . .

The reason for this may be that often Norman Lindsay's ideas and his pictures inspired the imagery of poets like McCrae, thus reversing the normal relationship between poet and illustrator. McCrae was aware of this process when he recorded that:

like all my verses 'Joan' was written with a procession of Norman Lindsay pictures continually passing through my mind . . . I felt your spirit thrill through my blood when I wrote: 'Wrist deep and buried fingers . . .'[29]

McCrae was referring here to the projected but never finished verse-drama which was published in fragmentary form in *Art in Australia* under the title *Joan of Arc*. Norman Lindsay produced an illustration to the confrontation between the Queen and Orléans in her bedchamber (3) which McCrae had described with sensuous vividness in the lines:

> I hold so fast
> Wrist-deep, and buried fingers, past
> My second bracelet through this vast
> Combed beard of yours, you cannot stir,
> Strive as you will . . .
> I thrill to feel the muscles pull
> Through cut velvet, spy the damp
> Drench the broad forehead, where the clamp
> Mark of your siege-caps left a line—[30]

This image is a typical example of Lindsayan vitalism, with its stress on concrete sensations, period flavour, and sexual allusions where the woman is objectified as a symbol of desire. Note also the element of violence in this love, as though it were a form of cannibalism. In the intensity of such imagery McCrae was striving to revive the darkly passionate but unreal world of Elizabethan drama in plays like *The Duchess of Malfi*. But

3 Norman Lindsay, wood engraving, illustration to 'Orleans and Isabelle, A Tragedy in Three Scenes' by Hugh McCrae, *Satyrs and Sunlight*, Fanfrolico Press, London, 1928

the piled horrors and brilliances of this style were too loaded to be maintained at any length and he found himself unable to complete the work. McCrae, like Lindsay, was attracted to brief, sensuously immediate images, and it is in the shorter lyrics that his poetry triumphs.

Lindsay's illustration, like McCrae's verse, is characterized by a richly elaborated surface emphasizing the voluptuousness of the theme. In it he exploits the technical possibilities of wood-engraving to achieve a density of texture which also harmonizes excellently with the printed page. The decoration featuring the initial 'T', which he made for *Joan of Arc*, demonstrates the peculiar strengths of Lindsay's work in this medium when matched with the generally high standard of contemporary Australian woodcut designs.[31]

Lindsay's expertise was not in the bold, animated and reductive style of Margaret Preston's work for example, but rather in a richly differentiated surface texture, grading flesh tones with fine lines, like woodgrain against the sumptuous display of deep velvets and transparent lace. He thus achieved a pictorial range of intense blacks and sparkling highlights that gave impact to his designs and a suggestion of colour to the black-and-white medium. Though compact in scale, his images were supremely decorative variations on the theme of the female nude.

The woodcut designs which he produced to embellish the pages of two small volumes of poetry, Jack Lindsay's *Fauns and Ladies* and Kenneth Slessor's *Thief of the Moon*, are excellent examples of the organic unity of pictorial design and text that characterized his collaboration with the poets he influenced. The moon goddess decoration to Slessor's poem is one of the loveliest examples, her body appears to be modelled in light, as though her flesh were impregnated with it (4).

In the 1920s a general revival of interest in the fine art book can be traced in England and its influence was felt in Australia. Norman Lindsay's interest, however, went beyond questions of craftsmanship. He wanted books not only to adorn existence, to collect and preserve the evidence of artistry, but to embody Creative Vision, a stimulus to life. The crusading spirit of the Fanfrolico publishing venture that he initiated is captured in Fotheringham's description of its emergence: 'out of the ashes of the Great War rose the phoenix of the free spirit; Rabelais "fay ce que vouldras" . . .'[32]

Norman Lindsay suggested the name, a whimsical variant on the Rabelaisian 'fanfreluche', meaning bawdy gaiety, and Fanfrolico published only books that bore as a common signature: 'a love for life'. Its policy was declared to be anti-censorship, promoting poetry, philosophy and reprints of the classics that defined 'beauty in terms of delight . . . to piece together the fragments of aesthetic consciousness shattered by the War'.[33] The programme on which it was based was essentially a continuation of the *Vision* manifesto position: a return to the Greeks (i.e., youth and beauty).

Fauns and Ladies (1923) and *Thief of the Moon* (1924), both printed on handmade paper using a hand press belonging to John Kirtley at Kirribilli, were the modest beginnings of this enterprise, although the first book to appear with the Fanfrolico Press imprint was a translation by Jack Lindsay of Aristophanes' *Lysistrata* completed in Sydney in April 1925. The choice of Aristophanes was consistent with Norman Lindsay's views on the timeless appeal and vitality of the ancients, and had the added bonus of presenting a challenge to modern prudery in the frank eroticism of the uncensored text.

The *Lysistrata* volume with its risqué pen decorations by Norman Lindsay was quickly sold out, being 'so lovely a production that English and American collectors became interested'.[34] It was then decided that they should try for a wider market by transplanting Fanfrolico to England. So in 1926 Jack Lindsay and Kirtley, working from a Bloomsbury

address in London, issued a second *Lysistrata* edition which proved equally successful. The *Lysistrata* book was conceived as 'a manifesto of Hellenic joy to a tired and muddled modern world', or so the 1928 prospectus *Fanfrolicana* described it. The message of Aristophanes' bawdy comedy—'make love not war'—was seen by Norman Lindsay and his followers to have a peculiar relevance to post-war Europe, for, in the light of the recent conflict, the action advocated by Lysistrata to the women of Athens seemed once again seductively contemporary.

It all reinforced Lindsay's idea that vital art, irrespective of the historical period when it was produced, embodied truths that were perennially relevant to humanity. Fanfrolico was to proclaim this universality of art and literature.

By sending his son to London, Norman hoped to swim against the normal current of ideas—spreading from England to Australia—and to change the European scene from here. It was a revolutionary idea but had only a limited success. As a commercial proposition, Fanfrolico flourished for a time until internal quarrels about policy, and the Depression, put an end to it. But Norman's concept of a literary and artistic renaissance never became the international phenomenon he had hoped for. Its influence was restricted to a relatively small audience of bibliophiles who pursued and collected rare editions for their libraries, and it never gained enough support among overseas artists and writers to become a real cultural force for change. The basic idea of a renaissance was in any case out of tune with the forward thrust of modern thinking after the war, when tradition was something to be discarded, not revived.

Nonetheless the Fanfrolico press successfully issued numerous beautifully presented books. Among those featuring illustrations by Norman Lindsay were: *A Homage to Sappho*, a second and larger edition of Hugh McCrae's *Satyrs and Sunlight*; Slessor's *Earth Visitors*; an edition of *Gaius Petronius*; Aristophanes' *Women in Parliament*; *Propertius in Love*, translated into English verse from the Latin by Jack Lindsay; Norman Lindsay's *Hyperborea*; and also *Loving Mad Tom*, subtitled 'Bedlamite Verses of the 17th and 18th Centuries' with a foreword by Robert Graves.

In some ways Norman Lindsay and the Vision school in the twenties revived the *fin de siècle* spirit of paganism, hedonism and escapist fantasy associated with the Beardsley period and publications like *The Yellow Book* and *The Savoy*. For this they earned a similar notoriety and were criticized for their 'fleshly' imagery. One critic said of the *Vision* magazine, 'it is doubtful whether there are enough readers in Australia suffering from satyriasis and nymphomania to add sufficiently to its circulation'.[35]

Like Beardsley before him, Norman Lindsay exerted an influence far outside the confines of his practice as an illustrator, and because of his involvement with literary circles he also turned writer. In his story of *Hyperborea*, as is the case with Beardsley's unfinished romance, *Under the Hill*, Lindsay revived the imagery of the *fête galante* in a magical garden setting that was essentially a literary translation of his pictorial imagery. But while Beardsley's descriptions of exquisite carnality concealed eroticism beneath tapestried artifice, Lindsay's catalogue of sensual delights was less brittle and more fleshy. In this stress on vital sensation one finds the essential difference between the Vision school and the English Aesthetic Movement. Through Lindsay's influence one finds in the local school a more robust paganism, a hoydenish delight, even disorderliness, that contrasts with the drawing-room fastidiousness and sophistication of the English model, although both expressed their aesthetic through the luxurious art publication.

The common denominator in all of Lindsay's illustrations was the female nude. Because of his interest in erotic themes, Lindsay's name has frequently been linked with that of Aubrey Beardsley—but in their unexpurgated versions Beardsley's drawings for *The*

4 Norman Lindsay, wood engraving, illustration to Kenneth Slessor's poem in *Thief of the Moon*, privately printed, Sydney 1924

Lysistrata of Aristophanes represented a far stronger challenge to censorship than did Lindsay's illustrations made some thirty years after. Nonetheless some interesting analogies—stylistic and thematic—can be made between the two series of Lysistrata drawings (5 and 6).

Both artists chose to echo the linearism of Greek vase painting in their decorations—an appropriate model in view of the text—but Beardsley's style is more classically austere. The tightly formalized discipline of Beardsley's line and his unerring eye for the abstract qualities of pattern and design gave the fetishistic and bizarre exaggerations of his figures more shocking impact. By contrast, Norman Lindsay's decorations lack both this formal concentration and obsessive sexual intensity—the extremes of frustration, satire and grotesquerie, the biting irony and the disinterested perfection of line.

Lindsay presents his theme as a comedy of errors and elaborates it using an illustrative action and setting, unlike Beardsley's pared down and static tableaux. Overall, Lindsay conveys in a more light-hearted way the Aristophanic joy and bawdy laughter of the text, making its moral (the passionate plea against the stupidity of war) seductively appealing through humour blended with voluptuous presentations of the nude. Also, Lindsay's use of stipple pattern, which in Beardsley's work adheres to the two-dimensional surface of the page, is manipulated illusionistically to give the effect of tone, rendering draperies transparent and softening flesh with atmospheric effects. Lindsay aims at a more directly sensuous apprehension of his forms, stimulating a tactile response to the qualities of his surfaces—a concrete and hence 'vital' image.

The differences between their respective approaches to erotic subjects can be sum-

marized in an analysis of their illustrations to the theme of Lysistrata confronting the Athenian women with her plan. Beardsley characterizes his Lysistrata as an aggressive almost shrewish figure, encasing her in stiff, bulky garments of a masculine cut. Lindsay, by contrast, emphasizes the feminine charms of his heroine, which wisps of drapery do nothing to conceal, giving her exaggerated breasts and buttocks, a narrow waist and strong thighs tapering into impossibly small ankles. By representing Lysistrata inspecting her ranks in a parody of an army inspection, Lindsay plays with the idea of their readiness to do battle for love and emphasizes the bargaining power of female desirability. Beardsley's women express a frustration that leads one to make a lesbian gesture, while Lindsay's ladies are ebullient and convey the tension of anticipation rather than frustration. This ebullience is captured in the springiness of Lindsay's line with its elastic upward curves and by the light-footed poses of the ladies as they stand eagerly on tiptoe.

Eroticism in Lindsay's imagery is innocently self-delighting, while in Beardsley's imagery it is more ambivalent, combining sexual freedom with a revulsion against the physical. Their attitudes are betrayed by their technique, for while Bearsdley's line is hard, sparse and frequently angular, Lindsay's is predominantly curving, generous and sinuous. Beardsley, with the spartan rigorousness and concentration of his line, emerges as a more economical draughtsman and a more daring innovator. Norman Lindsay's style, though mannered, suggests the palpable, sculptural curving of the planes of the body, while Beardsley's figurations remain two-dimensional designs, isolated in abstract space, without even a horizon line to suggest background.

Lindsay prefers to soften outlines by an accumulation of decorative detail, which fills

5 Aubrey Beardsley, pen drawing, illustration to the *Lysistrata* of Aristophanes, trans. S. Smith, first published by Leonard Smithers, London, 1896

6 Norman Lindsay, 'Lysistrata and the Athenian women', pen drawing, illustration to the *Lysistrata* of Aristophanes, trans. by Jack Lindsay; first published Fanfrolico Press, Sydney, 1925, second edn London 1926

7 Norman Lindsay, 'A Triumphal Procession', illustration to *Lysistrata*

most of the picture space, giving a certain lushness to his imagery which is an appropriate showcase for the plump figures of his female ideal. Such effects of ripeness and exuberant decoration are evident in Lindsay's illustration of the triumphant revels that celebrate the success of the women's stratagem. Beardsley does not end his series on this same note of triumph, for his last drawing in this series represents the frustrated Ambassadors. It is very much in character that Lindsay should choose to end on a more optimistic note with a 'Bacchanal' (or triumphant procession) of Dionysian abandon, including images of a fecund earth, grapes and wine, flowers and vines, organically merging with lively figures in praise of nature and fertility (7).

This theme of an abundant and generous earth (not found in Beardsley's art) is conveyed by the animation of Lindsay's picture, which is filled with activity and figures that seem about to spill over the edges of the frame. The pictorial focus is off-centre, enhancing the Baroque impression of movement in this composition. This movement is carried by linking gestures echoed in the main lines of the design, conforming with Lindsay's theory

that 'a constructive principle in rhythm' was the binding force of a vital art work, a theory which he based on his study of masters like Rubens.[36] Following Rubens, he makes the focus of his design the climax of a mounting pictorial rhythm, in this case a woman poised in mid-dance, her back arched in the traditional pose for ecstatic maenads or bacchantes. (It is a pose he frequently employed in his multi-figured compositions). For Lindsay—as it had been for the baroque painters or Romantics, like Delacroix, that he admired—action is an important component of his imagery, hence his loosely organized frieze of figures are caught spontaneously in mid-carouse.

Overall, Lindsay's erotic imagery is playful rather than carnal, assisted by carnival touches like the frilly costumes and ringletted curls of his ladies, the rough satyr-like beards of the men and the looping garlands of flowers and vine leaf crowns worn slightly askew. This lusty and light-hearted approach to pleasure is Lindsay's peculiar idealization of the healthy attitude to sexuality which he always associated with the pagan world and contrasted with the punitive and repressive attitude of Christian morality. Like Beardsley, Lindsay was anti-puritan, exhibiting in his work a continuation of an adolescent curiosity about sex, but without the violence of distortion Beardsley was capable of giving to his images of foetuses, freaks or grotesques. For Lindsay, who disliked pornography and rejected such descriptions of his work, believed sex should never be depicted as unnatural or ugly, only as life-enhancing and joyful.

This affirmation of the innocence of physical delight frequently spilled over into comedy in his illustrations. For example, his representation of 'The Infuriated Husband', where he reverts to his practice as a cartoonist when caricaturing the frustration of Myrrhina's husband (even his toes are expressive) as she teases him. This aspect of Lindsay's art disturbs some of his critics, who would label such comic exaggerations vulgarisms. That a certain amount of vulgarity can be found in Lindsay's treatment of sexual themes is undeniable, because he believed vital art did not exclude a little rough or bawdy humour and because he was not swayed by arguments that certain inclusions were not 'tasteful'. So it is typical to find him including in his image the group of women peeping in at the window and exhibiting a mixture of malicious glee, excitement and scandalous delight. For they are depicted as enthusiastic voyeurs—a role usually reserved for the male of the species. Another example of Lindsay's brand of whimsical and bawdy humour and his cleverness as a caricaturist is the drawing of the wrathful but impotent and wowser-like old men frowning behind the commanding gesture of the Junoesque female who dominates the scene in 'Lysistrata and the Old Men'.

In the *Lysistrata* book illustrations Lindsay's strengths are those of an illustrator who approaches his material with zest and an animated, even anecdotal enjoyment. Beardsley, on the other hand, used the Lysistrata theme to create a remarkable series of staccato images that can be appreciated as forceful designs wholly apart from the text. However, in his illustrations to another Fanfrolico book with a pagan theme, Sappho's love poetry, Norman Lindsay does come closer to this pure artistry. In the fifteen small etchings that were used to decorate the *Homage to Sappho*, published in 1928, Lindsay echoes not only the themes of Aphrodite and Eros but the flexible line, light movements, wind-blown drapery and harmonious arrangement of figures within a circular boundary that belong to classic Greek precedents (8 and 9).

The *Homage to Sappho*, beautifully bound in white with a gold decoration incised on the cover, depicting a slender and dreamily narcissistic nude framed by doves, was one of the rarest and most exquisite productions of the Fanfrolico Press. It contained an introduction by Jack Lindsay, 'Beauty's Hermaphrodite', a selection of Sappho's poems in translation and some verse by Jack Lindsay titled 'Sappho's Garden'. The idea for the

book and the selection of poems were jointly arrived at by Norman and Jack before the latter left for London. Lindsay's sensitive handling of the dainty nudes in these decorations may have been due to a personal fondness for the lyrical imagery of the poems.

If one takes a selection of Lindsay's imagery, one finds certain themes recurring: desire between male and female in which the male takes the active role, lesbian love themes with narcissistic connotations, and the idea of a transcendent love in the fusion of male and female into a bisexual or hermaphroditic form. Examples of all these types of love are found in the Sappho illustrations. These images have a poetic intensity which goes beyond a purely mechanical and physical approach to the act of love; essentially they are symbols which find their meaning in the hermetic world of the poems. Above all, they remain exquisite designs combining interlocking figures with luminous atmospheric suggestions and delicate pattern.

Although the lightness and grace he gives to his images recall the erotic representations of eighteenth-century French artists such as Boucher, Lindsay does not view his love themes in entirely frivolous terms. On occasions he seems to transform his lovers from purely fleshly substance into a subtler essence, matching Sappho's words: 'from earth mixed with light our love is born'. The technique he employed to achieve this particular effect was to work through a magnifying glass, scratching into the copper with his needle the myriad of tiny dots and strokes which, when viewed with the naked eye, fused to create tones. The emphasis he gave to light effects in these works can be related back to Lindsay's post-war interest in spiritualism, which spurred him to make the Platonic equation of light with spirit as the substance of immortality.

Overall, the attempt to launch a renaissance of poetry and fine art publishing in the *Vision* magazine and Fanfrolico Press cannot be understood without reference to the charismatic force of Norman Lindsay's personality. For, as his son Jack wrote, 'Norman Lindsay faced with a living person, was always infinitely more supple and responsive than his absolutes on paper would suggest'.[37] Even for a poet like Slessor who did not accept all his ideas, Lindsay generated a 'perpetual powerhouse of stimulation', and being with him

8 Norman Lindsay, etching, decoration for Jack Lindsay, *A Homage to Sappho*, Fanfrolico Press, London 1928

9 Norman Lindsay, etching, decoration for *A Homage to Sappho*

was like witnessing 'a volcano at close quarters'.[38] Not only the indomitable character of the man but the very atmosphere of Springwood itself seemed to cast a spell over his followers.

This mountain retreat with its secluded walks, punctuated by life-size statues of nymphs and centaurs, sirens and satyrs, and its quiet pool with a concrete naiad 'shading her unimaginable face' before the 'pale green water rippling at fallen gum seed', left an indelible impression on the memory.[39] The images of women, beautiful or menacing, of flowers, trees and lightbursts and magical landscape transformations that appeared in many of the Vision school poems were a compound of the reality of Springwood and the personal dream that was Norman Lindsay's inspiration.

From 'Delphic Springwood' Norman emerged as a figurehead who spoke authoritatively and engendered confidence and assertiveness in those who listened. The kind of influence he spread, for good or otherwise, was expressed in the last couplet of Slessor's poem *Marco Polo*: 'I am sick of modern man. I wish you were still living, Kublai Khan!' The Lindsay circle in the 1920s set out under Norman's guidance to create their own 'pleasure dome' through art, and freedom took on an exclusively sexual and artistic connotation.

The Lindsayan aesthetic has been called escapist, and out of touch with the realities of the contemporary world. Lindsay himself was not insensitive to the implications of his position, as he wrote to Lionel,

Isolation must have certain effects upon the mind, and it becomes a moral problem to retain a just mental balance to man, mind, and affairs in withdrawing from them.[40]

Within these limitations, what he offered was a redefinition of reality. Slessor, in the poem he called *Realities* and dedicated to Norman Lindsay's etchings, describes this world behind the veil:

then the skies open with a light from no moon or star
the dark terraces tremble, melt in a shower of petals;
Flowers turn to faces; faces, like small gold panes,
Are bodied in a mist of limbs—no dark remains . . .
The world's tissue has utterly crumbled away,
Time is a crusty pond, and that old Mirror, Life,
Has broken, and the ghosts of flesh are stirred
With a new blood, the fluid of eternity.[41]

The artist's revelation is more than dream because it can be concretized in the form of poem or picture, so that by responding sensuously to a work of art one finds,

substance there and flesh . . .
Love that's more bodily, and kisses longer,
And Cythera lovelier, and the girls of moonlight stronger,
Than all earth's ladies webbed in their bony mesh.

Norman Lindsay and the poets who published in *Vision* did not see themselves as escapist; on the contrary, they believed 'Art is not merely a form of escape . . . it is a desperate effort to find the inner core of life, to realise one's inner knowledge of joy and beauty'. What they proposed was that the core of life was not found in the external world we call real, but revealed to a select few by the inner world of the imagination. So that for them myth *becomes* reality, and truth is found in the symbolic world of the poetic and art image. This truth, however, proves elusive. As Norman wrote: 'revelation comes only at intervals, rare and vivid, like a statue seen by lightning on a dark night'.[42]

HUMPHREY McQUEEN Jimmy's Brief Lives

Geneal histories of Australian painting have had difficult births. William Moore's two volumes were published by Angus and Robertson in 1934, but only after Moore had raised a guarantee of £500, which was almost the whole cost of printing and blocks.[1] Bernard Smith's *Place, Taste and Tradition* (1945) suffered from war-time printing restrictions and from some slight censorship by his friend and publisher, Sydney Ure Smith.[2] Robert Hughes's version (1966, 1971) was held up for five years after almost all the first edition had been pulped.[3] Only H.E. Badham's *A Study of Australian Art* (1949) and Smith's *Australian Painting* (1962 and 1971) appeared smoothly. Yet these five titles were published, unlike James S. MacDonald's proposed survey. All that we have seen of that project are the discontinuous essays of *Australian Painting Desiderata* (1958) published six years after the author's death. In addition, there are his monographs on McCubbin, Davies, Lambert, Penleigh Boyd and Charles Wheeler, not to mention countless articles on everything from 'Radio English' to Tiepolo.

In preparing for his general history MacDonald kept a series of alphabetically indexed, but undated, exercise books for his experiences of and thoughts on Australian art. How much of these would have gone into a final version is difficult to say, because many of them were then libellous. Now that almost all of MacDonald's subjects are dead it is possible to approach his notebooks as one reads Aubrey's *Brief Lives*, that is, for their lively personal details as much as for any factual or aesthetic content.

MacDonald's own life was at least as interesting as those of the people about whom he made journal entries. Because his impressions of others were taken from working encounters with them, it is appropriate to arrange an introduction to his notes around a sketch of his life as the most controversial and conservative figure in Australian art between the wars. In his overlapping careers of critic, gallery director and author, MacDonald was one of the leading opponents of Modernism and the champion of the Heidelberg school of Australian landscape. He was a devoted philologist and an intimate of leading politicians. He provides an opportunity to observe the intersections of the politics of art and the art of politics. He wrote splendidly and had a ferocious intellect furnished with encyclopaedic knowledge. Whilst recognizing his severe limitations, I hope to rescue him from some of the obloquy into which he has been cast as the butt of ill-informed Modernist jokers.

James Stuart MacDonald was born in Melbourne on 28 March 1878, the second son of a prospering solicitor, Hector MacDonald, who became part of the Collins House group of mining companies. On his own account, the young Jimmy had his first painting lesson perched on Tom Roberts' knee.[4] At the age of six he is supposed to have decided to become an artist when told that Judge Bunny's son was leaving for Europe to study art.[5] Sixty years later, MacDonald had lost all desire to follow in Bunny's footsteps:

With a lot of unsaleable work on his hands goes modernist, but without conviction. Pals up with the inefficient; but also and chiefly with the (rich) Tweddles.[6] Expects me, as director of gallery, to hang all his work all the time—never mind about anyone else.[7]

Irrespective of the truth of the earlier anecdotes about Roberts and Bunny, MacDonald undoubtedly knew Fred McCubbin, who painted his father's portrait. McCubbin was teaching at the Nationl Gallery Art School during the six years which MacDonald spent there before going to London's Westminster School in 1898. For the next six years he travelled and studied across Europe. In Paris he attended Julian's and Colarossi's, where he met George Lambert who had won the New South Wales's Society of Artists' travelling scholarship for 1900.

Lambert: Always intent on showing that he was a very clever painter rather than that he had seen something so interesting that he burnt with a desire to show it to others and that this desire was so absorbing that it left no room for thought of himself. No; he always says: 'you may see what I see but you must say first: what a wonderful man this is!'

MacDonald became an early critic of these very features of Lambert's work which, by the 1920s, had made him Sydney's pre-eminent portraitist:

He had a strange inability to draw hands, mouths and necks, but by a formula. He overemphasized subtlety of modelling. He made hair look like shavings and his eyelids were from stock . . . His good bits were not sustainable over large areas, but they had the effect of gagging the half-knowing from making criticism. He had no faculty for largeness of design.
 Perpetually trying to be the equivalent of 'literary'—to be a stylist deliberately.
 —a keen mind, an alert and vivid intelligence, a power to discriminate between gaudy shams and bleak truth in music and art and literature: but it is only a *head* knowledge and he simply cannot relate it to life.
 Dealer in pictorial epigrams.

Not even Lambert's artistic bravado could match the bravura of his sociability, which MacDonald warmly appreciated as a high-keyed version of his own delight in good company:

L. was a wonderful mimic: he could not only imitate living people (and carry on a monologue in their voices and idioms of speech) but imitate long-dead celebrities. With a slouch hat, a piece of cloth and a napkin he would do Van Dyck and Rembrandt (his beard limited his repertory) with uncanny resemblance. He could also do animals. One night at Colarossi's school in Paris he kept the whole body of students and the model so occupied with interest and laughter that nothing in the way of work was done. He wound up by grabbing a paint brush and a chair and using the brush as a tail and making the vertical rungs of the back of the chair do for the bars of a cage gave a wonderful imitation of a lion. When he had finished and the uproarious applause had died down, one of the students piped up: *'Merci, m'sieu: maintenant voulez-vous nous imiter le lion, s'il vous plaît?'*

At Gerald Kelly's studio, MacDonald met an even greater show-off, Aleister Crowley, whose black magic he dismissed as 'cheap, unimaginative stuff' with all the old 'bats, cats, urinating in the font, fornicating in the pews'.
 Maud Keller was also an art student in Paris when MacDonald asked her to marry him, which she did in Melbourne on 8 August 1904. They then went to her home city, New York, to teach for five years in a high school run by her sister.
 MacDonald joined the Australian Expeditionary Force on 9 September 1914, was promoted sergeant, wounded at Gallipoli and invalided to England. Presumably a little of his choleric temper was the result of his stomach wound. By 1918 he was well enough to work as a war artist in France; several of his oils and pencil sketches are in the Australian War Memorial, Canberra.
 For all his personal combativeness, MacDonald's artistic preferences were lost in a Romantic halflight. Poetic was a term of praise and Harold Herbert was criticized for being 'superb in assertion' but taking 'no interest in the remote in either time or place—in nothing unseen'. Despite his very conservative political views, MacDonald was not active

No. 2 - 2c proofs J.S. MacDonald

J.S. MacDonald,
self-portrait, lithograph,
36.69 x 36.2 cm. Art Gallery
of New South Wales, Sydney
(gift of Mr J. Lane Mullins)

in the R.S.L., or around ANZAC Day, and like very many returned soldiers, appeared to suppress his memories of the war.[8]

After his return to Australia, via the United States, MacDonald became art critic for the Melbourne *Herald*, whose new editor was Keith Murdoch. In 1924 MacDonald involved the paper in a libel action against a Captain Falcke, whose collection of 'old Masters' MacDonald said were fakes. R.G. Menzies cross-examined him about a late Rembrandt: 'Your honour', he replied, 'if Rembrandt had painted that nose, you could pull that nose!'[9] A judgement of £3,000 damages against the *Herald* was reversed on appeal, so that this difficulty is unlikely to have caused the rift between Murdoch and MacDonald which eventually helped to ruin the latter. According to Frederic Eggleston, a National Gallery of Victoria trustee, MacDonald and Murdoch fell out after MacDonald 'let Murdoch down' as art advisor in the twenties, when he took £1,000 each from Murdoch and Fink but bought Murdoch only six pictures against the seven he got for Fink.[10]

Late in 1928, MacDonald was appointed director-secretary of the Art Gallery of New South Wales in circumstances worthy of John Aubrey, for as Sid Ure Smith wrote to Lionel Lindsay:

I couldn't help laughing at the serious attitude of the Trustees to J.S.MacD's habit of 'having a couple'. They really were very decent about it when you consider their wowser-like attitude to most things. They sat seriously round that table looking like a lot of bank-directors deciding whether someone should be allowed an overdraft.

Someone said that J.S. MacD's NOSE was probably the outcome of indigestion!!!!

The Chief Justice said: 'Has the President taken any steps to determine Mr MacD's character other than pointing out the peculiarities of his NOSE!'

All this seriously—.[11]

As a director, Ure Smith found MacDonald 'a great disappointment . . . his outlook is narrow and biassed . . . It is Melbournian'.[12]

By 1936 MacDonald was more than ready to leave Sydney. The manner of his appointment to the Melbourne directorship set the tone for his five stormy years there. Against the trustees' choice of Hardy Wilson, by seven votes to five, the Victorian government appointed MacDonald. R.G. Menzies (then Commonwealth attorney-general) wrote congratulating him:

As you probably know, I made a most unsuccessful attempt to get the vote of one of the Members of Parliament and quite a successful one to get the support of I.H. Moss, but when I saw that the Trustees had recommended somebody else I must confess that I saw no hope left. It was quite useless for me to approach the Victorian [Country Party] Government, which is not to be numbered amongst my warmest supporters. Stanley Lewis[13] however, appears to have worked like a Trojan and with a success that has given great pleasure to all your friends.[14]

Professor Wood Jones resigned his trusteeship in protest.[15]

MacDonald faced a board which grew ever more hostile to his outlook and methods. The catalogue of artists whose works he opposed for purchase is nothing if not catholic: Lancret, Prud'hon, Cézanne, Monet, Manet, Degas, Sisley, Delacroix, Millet, Constable, Burne-Jones, Morris, El Greco, Clouet, Nanteuil, Matthew Smith, Crome and John. That some of these were rejected as inferior or over-priced examples is shown by his willingness to buy other items by Degas, Sisley and Constable. A few were thrown out as Modernist, with Cézanne getting seven refusals from him. His very determined views offended a number of trustees.[16] From the start, there had been those, like Alfred Bright, who objected to MacDonald's appointment:

Gave me perfunctory welcome and waited for opportunity to strike. Got tired of waiting and showed his hand when I reported a painting as 'a poor guts-less work'. He did his best to make out that this was most improper wording to come from a director: very, very coarse. F. Clarke defended it; said it had a good A.S. ring about it and was descriptive.

Of another trustee, J.D.G. Medley (vice-chancellor of Melbourne University), MacDonald wrote:

. . . like the Arab woman could never say 'no' when asked to open a picture exhibition whether stodgy, orthodox, contemporary. Pledges himself to each. He and Daryl Lindsay equal favourites for the incumbency of Bray. A medley of allegiances.

Over and above his dislike of individuals, MacDonald developed a very poor opinion of trustees in general:

Trusteeships are solicited, angled for, by materialists, for the same reason that dogs and cats search for grass, or whatever it is they eat; as a corrective to their usual bloody meals. They pretend, even to themselves, that trusteeship is something selfless, unconnected with gain, unremunerated, unrewarded; but they bring to it the same predatory, gainful, inhuman spirit that gave them their wealth.

Similar judgements were passed on painters, curators, critics and professors of Fine Art, the latter being put down as 'the mouthpieces of owners of works of art, those who collect to gratify the sense of possession'. And he failed to see 'What relation . . . a critical edition of Hogarth's *Analysis of Beauty* [has] to pictures: even if poor Hogarth did write it, a matter as unsure as the authorship of the Gospels'.

Most of MacDonald's troubles in Victoria centred on his opposition to Sir Keith Murdoch, whose 1939 exhibition of modern art MacDonald described in an official report as 'the product of degenerates and perverts'.[17] The notebooks show this obsession with Murdoch's personal and public behaviour:

Devoid of any sense of art. Has read and picked up a meretricious and superficial piece or two of learning. Urges the purchase of dealers' and art writers' recommendations. No convictions of his own. A materialist of the worst type—coarse-fibred mentally and essentially a vulgar individual . . .

Bought a fine unfinished painting by Lambert—had it completed (finished) by Geo. Bell!

He gets de luxe books on art on approbation, reads them thoroughly and then tells the bookseller they are too dear and asks that they be sent for.

If only great men dare to use clichés M. is not only one of the greatest but one of the bravest men in the world.

It is not on record that he ever took in or made a joke. To him an irony of whatever kind was a confused statement, a jumbled utterance, a hash of words which meant nothing, at best a puzzle.

Has a profitable stutter which he uses with fabian resourcefulness—makes it collaborate with Daryl Lindsay's advantageous deafness.

MacDonald's hatred of Murdoch inevitably extended to the latter's art world favourites, Daryl Lindsay and Basil Burdett. MacDonald at first saw Lindsay as an honest man, that is, not a stooge for Murdoch, but this opinion soon changed:

Lindsay: a liar, who gives himself away, by doing his obvious damnedest to give you the impression that he is holding nothing back: telling you all he knows; coming clean about everything. He is so gol-darned candid that you know that something's all wrong. Naiveté overdone. He looks the whole world in the face, for he trusts not any man. Expert in frank-appearing.[18]

Burdett, who organized the *Herald's* 1939 exhibition for Murdoch, was even more roundly denounced:

. . . actually had a Miss Nancy estimate of Art. Lionel unthinkingly gave Burdett a letter to Campbell Dodgson then editor of The Print Collector's Quarterly. Coming from such a source this made B.B. persona grata. He loaded C.D. with two articles on etchers one from Spain, the other from Lithuania, neither of whom L. would have pissed on . . . he knew that C.D. not knowing much about art, but all about signatures . . . would accept anyone sent by L.L. as one knowledge-able. . . Burdett's articles were ill-conceived, badly constructed, affected, mannered and by praising these amateur's botches hit at all L.L. tried in his art to validate.

Burdett: Exiguous, Panoply, Empathy, Nostalgic, Picaresque, Reseda, Caloudula, Orchestration, Organise: all used wrongly.

To a man who read the *Encyclopaedia Britannica* in bed each night, such errors were sacrilegious.

Early in 1940 MacDonald was away sick for three months with a cerebral lesion.[19] Eighteen months later his directorship was not renewed and Daryl Lindsay was appointed in his place; not one of the trustees voted to retain MacDonald. The secretary of the trustees, E.R. Pitt, reported to the under-secretary of the Chief Secretary's Department that:

. . . the present lack of harmony between the Trustees and the Director is almost entirely due to the Director's own fault, in that it could have been avoided by the exercise of more tact and moderation on his part. Outspokenness and fearlessness on the part of a Director is a great attribute, but in this case it has been marred by the personal tone of his reports, and his unjustifiable imputation of unworthy motives.[20]

In 1943 MacDonald became the *Age's* art critic, until on 25 March 1947 he handed in his

resignation to ed. H.A.M. Campbell an amiable and able man. On review of 4 yrs work I note that all deletions have been of allusions quite understandable to those interested in art, but not by

Campbell. In this way he mutilated, innocently, much of the best stuff I wrote; so that it lost its intended effect: nullified my stand agst. Murdoch.

In case MacDonald's obsession with Murdoch be thought paranoid, it should be added that other ex-employees, such as John Hetherington and Cecil Edwards, described Murdoch in the same terms.[21]

Moreover, not all MacDonald's comments on people were destructive. Louis McCubbin had 'no moral guts; but loveable'; P.M.C. Smyth, interim director at the National Gallery of Victoria, 'was a sweet natural gentleman and friend and too fine to be hurt'; Napier Waller was a 'true artist and a noble-man; great at oil and water-colour painting, woodcuts, engraving, mosaic and painted glass. A man impossible not to love; beautiful physically and spiritually'.

In 1944 MacDonald appeared as the expert witness for the plaintiffs in their effort to strip Dobell of the Archibald Prize for his 'caricature' of Joshua Smith.[22] In his note on Dobell, MacDonald observed that many of his portraits take on the character of insects, reptiles: 'Joshua Smith—stick insect; L.F. Giblin—Goanna; B. Penton—Toad or Lizard; Irish Youth—Newt; Scotty Allen—Gecko; Jimmy Cook—Chameleon; Billy Boy—a gigantic oyster'. Given his conservative political outlook and his poor opinion of Dobell's work, it is not surprising that MacDonald recommended to the Commonwealth Art Advisory Board that Dobell be commissioned to paint the portrait of Labor prime minister, J. B. Chifley.

MacDonald died on 12 November 1952.

It is unlikely that MacDonald will be replaced as the main target for anyone wishing to poke fun at Australia's anti-Modernists: his opinions are too robust and widespread for that to happen. Indeed, his notebooks will add to this side of his reputation. Yet it is to be hoped that scholars will go to them for more than a ready-made straw-man. MacDonald's tactless and intolerant judgements provide access to the passions and pecadilloes of the art world and the writing of its history can be the richer for them. Nonetheless, his disjointed notebooks are a fair indication of his fractured achievements and flawed talents as an artist, an author and an administrator.

BRUCE ADAMS Metaphors of Scientific Idealism: The Theoretical Background to the Paintings of Ralph Balson

The single-mindedness with which Ralph Balson adhered to principles of non-figurative art left him in an insular and exclusive position within the history of modern Australian art. From the 1930s, when his attitudes were formed and became clear, then on through many years until his death in 1964, Balson came to epitomize a rigorous and disciplined formal approach to painting. This essay concerns the theories which motivated that approach and the kind of worldview consistently suggested by Balson in his paintings.

Founded upon certain essentialist notions about the 'absolute' nature of art, Balson's attitude to painting required a denial of many of the particularities of experience. Ignoring the more literary expression of many of his contemporaries in Australia, he did not wish to see his art as explicitly related to either his own personality or his sense of placement within Australia. He disregarded the specifics of his own immediate, social and regional contexts. Self-effacement was his natural manner, but it was also a studied and central element of his platform. In his effort, however, to produce an art that did not seem culture-bound, Balson subordinated himself to a wide and allegorical view of modern culture. His painting became a metaphorical description of a notion of scientific idealism.

Balson aligned painting to a model of science that was grand and romantic. Science encompassed experiment and analysis, but above all it was seen as the affirmative investigation of universal and timeless values. To Balson, painting too was an affirmative activity, and like science it was 'pure' in the sense that it pertained to absolute and benign laws of nature.

In explanation of the *Constructive Paintings*, a long series of geometric, non-figurative paintings which Balson first exhibited in 1941, Herbert Badham in 1949 restated the belief held by Balson that 'the source of true design is to be found in cosmic laws and that this truth offers a better basis for progress than any other'.[1] The language of this remark supports Balson's later admission that, especially in his geometric series, his 'greatest single influence' was Mondrian.[2] As early as the 1930s he had access to Mondrian's writings, notably the essay *Plastic Art and Pure Plastic Art*.[3] Mondrian urged a movement towards a spiritual though scientifically based art which embraced the universe and negated the individual ego, 'an evolution from the individual towards the universal, of the subjective towards the objective; towards the essence of things and of ourselves'.[4] Hegelian idealist theory seemed influential in the Neoplasticist belief that abstract art, adhering to fixed but intangible laws, could transcend itself to reveal some essence on a spiritual plane. The insistence upon laws of revelation became dogma to Mondrian and his followers:

... there are 'made' laws, 'discovered' laws, but also laws—a truth for all time. These are more or less hidden in the reality which surrounds us and do not change. Not only science, but art also, shows us that reality, at first incomprehensible, gradually reveals itself, by the mutual relations that

are inherent in things. Pure science and pure art, disinterested and free, can lead the advance in the recognition of the laws which are based on these relationships.[5]

Science and art were seen as mutual concepts based upon inherent laws of nature. In practice what Mondrian called 'the true way of art'[6] became for painting a self-sufficient exercise concerning the formal relations of plastic elements on a picture plane. When Balson adopted purely geometric motifs in his Constructive Paintings, he was also adopting all the constraints of this shared, presumably objective style of painting.

The sources which motivated Balson extended beyond Mondrian to Moholy-Nagy, Kandinsky, the *Abstraction-Création* group and others advocating a geometric, concrete art. But Balson was not merely a distant recipient of secondary sources from abroad. Through his working relationship with the painter Grace Crowley, Balson during the 1930s was also brought into direct contact with a body of theory on abstract art which had its origins in the teachings of two Cubist-oriented painters, André Lhote and Albert Gleizes. Both Lhote and Gleizes had exhibited with the *Section d'Or* group in Paris in 1912, and Lhote especially had considerable impact on Crowley in Paris in the 1920s. From her own first-hand experience of them as teachers, Crowley was later in a position to offer Balson some insight into their ideas. Although, according to Crowley, Balson did not seem greatly influenced by them[7], the teachings of Lhote and Gleizes helped to link these few isolated painters in Sydney with the current thought behind European abstraction in the 1930s.

Grace Crowley had studied under Lhote between 1927 and 1929, then much more briefly under Gleizes, both in Paris and at his art colony, Moly-Sabata, near Serrières, Ardèche, in the Rhône Valley, in the summer of 1929. Accompanied by Anne Dangar, who was previously with her at the Sydney Art School, Crowley had gone to France in 1926. Both women forwarded news of their Paris studies in letters which were published in a Sydney student periodical, *Undergrowth*. Balson, then a part-time student at the Sydney Art School, would no doubt have seen their reports. In 1928, for example, the magazine published an essay by Lhote on Cubism, in which he maintained that 'today the universal wish is to be classic'.[8] The letters of Crowley and Dangar preached Lhote's ideas with the enthusiasm of the converted:

The more you understand the greater laws which govern nature, the more profound will be your work. There is a secret law which governs all clouds, rocks, trees, etc . . . Learn to work by the geometry, the numbers . . . Work with your intellect more and let your eyes have a holiday.[9]

Purely perceptual information was suppressed in the pursuit for the inner logic and structure of things, and of a sense of order which was also deemed to have social benefit. Both Lhote and Gleizes reinforced their analytical approach to painting with a call to a new age of classicism, based upon art, science and the machine.

The co-author with Jean Metzinger of the first book on Cubism in 1912, Albert Gleizes in the 1920s was associated with the Purist artists, including Ozenfant, with whom Crowley also studied briefly. The Purist periodical, *L'Esprit Nouveau*, heralded an heroic machine age. The mechanistic, geometric forms of Purist art were to mirror the new spirit of social and scientific idealism. The movement also evoked universal laws, but these were now to be found equally in the functional design of an automobile as in a classical temple. During a visit to Australia in 1928, Anne Dangar became the bearer of the romance of *l'ésprit nouveau*. She published in *Undergrowth* an extended statement, or manifesto, thoroughly evangelical in tone, where she enlisted art into the service of mechanical modernity:

Art reflects—it does more—it foretells and expresses the thought of its own period . . . It stands for

1 Ralph Balson, *Portrait of Grace Crowley*, oil on canvas on cardboard, 109 x 64 cm, 1939. Estate of the late Grace Crowley

life run by machinery, by mathematical accuracy, by scientific law and order, and we find artists of today are those who through research have learned to express the elements of proportion and rhythm as employed in the machinery of our times.[10]

Art was to be the expression of its age, but Dangar denied it any more specific levels of association. 'The one language for all people, it is not personal, nor is it a national affair'.[11] Self-expression and the sentiment of subject-matter, like false ornament, were discouraged. Upon her return to France, Anne Dangar immersed herself in the work and philosophy of Gleizes. She became a permanent member of his art colony, Moly-Sabata, and established a pottery workshop there.

Grace Crowley, on the other hand, remained closer to the methods of Lhote, and these she made a basis for instruction at the art school she established with Rah Fizelle at 215a George Street, Sydney. After 1934 Balson often came to paint there at weekends. Another frequent visitor was Frank Hinder, who with his wife Margel had returned from America,

where he had studied at Chicago, New York and Taos, New Mexico. Hinder brought with him ideas that were very sympathetic with Crowley's background in Paris. When friction with Fizelle prompted Crowley to close the school in 1937, she moved her studio into rooms where she had lived since 1933-34, at nearby 227 George Street. Some classes and an evening sketch club continued there, and with his need for painting space, Balson kept on working with Crowley. Although most of his ideas about abstraction were to come from his own reading, discussions in the Crowley studio and the company of other artists with an informed background, were no doubt most valuable for Balson.

Just before the outbreak of the Second World War, Anne Dangar forwarded to Crowley several series of hand-written notes outlining Gleizes' theories. The French painter had suggested that Crowley use the notes to develop exercises with her students, and these could then be sent across to him for criticism. However the war then interrupted communication with France, and Gleizes' proposal was not adopted. But Dangar's extensive explanations of his concepts did offer Balson some primary access to contemporary French theory. Her notes contained, for example, a very clear definition of Modernism, with its progression towards increasing formal reduction:

The further we advance . . . the more we shall realise that our aim must be the presentation of the plastic fact of the surface, which we have animated and which we have created by the simplest means possible. The surface is our fundamental truth and is two-dimensional, we ought *as much as possible* to *eliminate all three dimensional effects which break the flatness of the surface.*[12]

As with later post-war formalist theory, the problem of style was identified as a central issue, with the 'advance' of painting being through the reconciliation of all pictorial elements with the flat, surface structure of the picture plane. Identifying the central difference between the approaches of Lhote and Gleizes, Grace Crowley has observed in retrospect that

Lhote seemed loath to leave the visual world around him, and like Cézanne made a compromise between the object seen and the wall (the two dimensional picture plane). Gleizes *began* with the wall and insisted that one *never forgot it.*[13]

In their own methods of composition Hinder, especially, as well as Crowley and Fizelle, acknowledged formulae such as Dynamic Symmetry, a theory of proportions matching the Golden Section, which was popularized by an American mathematician, Jay Hambidge, during the 1920s. Claiming the discovery of his system in Greek and Egyptian art, Hambidge found further proof of Dynamic Symmetry in the patterns of natural structures such as shells and plants. The system may have seemed a rule-bound attempt to establish immutable laws of design, using proportions derived from a certain spiral form. It was not however a static system, for Hambidge stressed 'the potential of change'[14], so important in Balson's later thinking. As described by Crowley, Dynamic Symmetry was one component in the instruction at her school:

A Fizelle-Crowley student got into the habit of selecting a limited range of colour, simplifying each colour into a large geometric plane, arranging the shape one with another with an eye to their proportions and relationships . . . As an underlying structure for the picture, what Lhote called *l'architecture mentale*, light and shade, would be considered . . . as a geometric, abstract element, together with line, and the geometry of the given space of the picture plane. That space could and frequently was evolved from the student's knowledge of Dynamic Symmetry.[15]

Paintings such as his *Portrait of Grace Crowley* of 1939 (1) typify the results of Balson's association with these other painters in George Street. The colour range is limited to cool pastels, and the figure is only sketchily delineated, then dispersed into the plastic surface of paint, creating areas of ambiguous, flattened space. Like his other works of this time the

portrait is direct and painterly in style, it has a freshness indicative perhaps of a more intuitive and expressive approach than the ideas of the group would have suggested.

The group movement towards geometric abstraction had its climax and early collapse with Exhibition I at the David Jones' Galleries in 1939. The participants were Balson, Crowley, Fizelle, Frank and Margel Hinder, Frank Medworth, Eleonore Lange and Gerald Lewers. A catalogue essay by Lange reiterated their message of a revelation in art: 'Painting today is abandoning the representation of objects in order to establish a *new realm of visual experience*'.[16] Critical reaction dismissed such an announcement as dry pendantry, and attacked their failure to make a 'pure' art: 'Their sterility is apparent in the conventionalism of all colour, design and form, a quality which would excuse some under the heading of applied art'.[17] The group activity did not survive Exhibition I, and the move into geometric non-figuration with his Constructive series (e.g., 2) became a private and independent concern for Balson in the 1940s, working in the company of Crowley. From then until 1964 the two artists were in virtual isolation from the painting world of Sydney. Through the 1940s they painted together at 227 George Street, and later Balson occupied a garden studio in a country house, 'High Hill', bought by Crowley at Mittagong in 1954.

Allusions to science continued through the non-figurative phases of Balson's work. Einstein especially fired his imagination, and during the 1950s changed his conception of the physical world and, correspondingly, his art. His acquaintance with Einstein's theory of relativity exposed the shortcomings of his more fundamental, mechanistic view of order and regularity. Balson began to appreciate a more complex and plausible model of science, as static unity gave way to the continuous flux and variability of an entropic,

2 Ralph Balson, *Constructive Painting*, oil on hardboard, 63.5 x 79.5 cm, 1951. Estate of the late Grace Crowley

unbounded universe. It was a conceptual break which facilitated a stylistic shift, from the finite geometry of the *Constructive Paintings* towards more exploratory, painterly procedures.

The *Non-Objective Paintings* (e.g., 3), the series which flourished in 1956, after his retirement from housepainting, perhaps represented his maturity as an artist. They coincided with a number of statements in which Balson posited a visionary, allegorical role for his art, the first being in a letter to Michel Seuphor in 1955:

It seems to me that today painting must dig deeper into the mystery and rhythm of the spectrum and that means existence of life itself. Not the age old form but the forces beyond the structure. Abstract, yes. Abstract from the surface, but more truly real with life.[18]

The *Non-Objective Paintings* (cf. 3 and 4) consisted of an all-over, finely modulated field of dappled colour, which spread without major interval across the surface of each composition. In format and mood the paintings echoed the expansive fields of gesture and colour employed by the Abstract Expressionists in New York, whom Balson also acknowledged in his letter to Seuphor. There were affinities too with earlier painterly movements, to Seurat or Monet, but Balson looked outside the history of painting for his own explanations, as his note in the catalogue of the 1956 Pacific Loan Exhibition made clear:

As one grows older one contemplates more and more, and maybe the ultimate goal of all the arts is the ineffable. With words James Joyce surely reached that condition in *Finnegan's Wake*, while in painting the Chinese came closest to it. I want my forms and colours to have the density and at the same time the fluidity of Joyce's words.[19]

Even here Balson's interests seemed to echo the speculations of European art theorists, in this case Moholy-Nagy. In his *Vision in Motion* of 1947 Moholy-Nagy compared the literary construction of Joyce's *Ulysses* to Cubist collage,

where different elements, fragments of reality, were fused into a unity of new meanings. Joyce showed that the seemingly inconsistent, illogical elements of the sub-conscious can give a perfect account of man, the unknown.[20]

The stream of consciousness, the conjoining of nouns, verbs, adjectives into forcefully amalgamated images and sounds, forsaking any logical continuum of time or space, Joyce carried further in *Finnegan's Wake*, a massive and multi-faceted verbal assemblage where, as Moholy-Nagy maintained,

Joyce tried to avoid the limitation of a precise subject-rendering. The outpourings of the sub-conscious sphere did not allow an unalterable fixation. The pluralistic, timeless meanings could be better safeguarded if they remained flexible, not defined too sharply but enveloped in the amorphous quality of the dream.[21]

Through Joyce, Balson may have become more sympathetic to the automatist and psycho-analytic procedures of Surrealism, also seminal to painters he now admired most, such as Pollock. In his ideas Balson was groping for intangibles, and Joyce gave him a feeling for the relative precariousness and ambiguity of things, which connected with his metaphysic of universal flux and change. The limitless fields of the Non-Objective Paintings were quite evocative of this, they alluded to some condition of the sublime, that which Balson preferred to call 'the ineffable'.

By striving to bring the universe within the range of his perception, Balson maintained in 1960 that it is man's comprehension and understanding that alters. He saw the changes in his own understanding as the product of a wider cultural progression, away from Newton 'with his mechanistic concept of the absolute, absolute bodies in absolute space, moving in absolute time and created by an absolute God'.[22] Abandoning the strictures of

3 Ralph Balson,
Non-Objective Painting, oil
on hardboard, 106.5 x
137 cm, 1958. Estate of the
late Grace Crowley

that worldview led to the acceptance of an atheistic and more pluralist concept of the physical world, as exposed in the new science:

The next tremendous step is the concept of Einstein, the concept of relativity, the destruction of the absolute, the static. A mathematical, abstract concept, its parallel in painting Cubism with its breaking up of form.

The concept of relativity, the vision I get of it as a painter fascinates me. A universe without beginning, without end. A continuous creating, destroying, and expanding movement, its one constant the speed of light. ('The Space Age'.)[23]

Balson may have responded too naively to science, making a fetish of its mystique, as some of his later critics have suggested[24], but the allegory of science was a vital bridge for Balson, taking him out of his own individual circumstances into a wider community of thought. And then, despite the affirmation and idealism with which he had always embraced scientific theory, by 1962 he had come to recognize the human difficulties implied by his theoretical stance. There is an uncharacteristic and somewhat existential nihilism suggested in his last recorded statement, which he made that year. He described a 'world of ceaseless movement where reality is nothingness and nothingness reality'[25], a state of indeterminacy where man is no more than a 'lonely creature on his speck of matter'.[26]

After his exposure to European Tachism and Art Informel, during a trip to England and France in 1960, Balson commenced his last major series, the *Matter Paintings*. (e.g., 4) Negating the meditative, formal procedures of his earlier work, Balson indulged in very fluid, automatic techniques, pouring his paint and allowing it to slip and bleed across the

4 Ralph Balson, *Painting No. 32* (a matter painting), synthetic enamel on hardboard, 85.5 x 110 cm, 1961. Art Gallery of New South Wales, Sydney

board and coagulate in heavy layers which cracked or rippled as they dried. When exhibited in 1963 these paintings provoked a violent verbal attack from one critic, James Gleeson, who accused Balson of abrogating all his rights as an artist and as a human being: 'For an artist to deny that he is a man means that he has become less than an artist. He has become an accident's assistant'.[27] Balson was accused of being an anti-artist, forsaking both art and humanity, but his new label hardly seemed appropriate for a man whose self-denial was more in the nature of asceticism than anarchy.

In the *Matter Paintings* Balson took risks with his medium, and compared to the contemplative ease, the painterly refinement and subtlety of his previous series, they appeared to be difficult and restless works. But his current principle of indeterminacy stressed an infrastructure of variation, accident and growth, and it was as if Balson was putting this into effect. The Matter Paintings were not to be seen merely as symbols, reflecting some notion of growth or change, but by their very form they demonstrated a truism, that as fully physical objects they were subject, like all physical objects, to natural, entropic processes. They seem to evoke Balson's earlier remark to Seuphor that he wished for an art 'more truly real with life', an art that was at one with the physical world.

An attendant difficulty with these works, but essential to their form and purpose, was the increasing sense of removal of the artist from each piece. Like a Pollock they had an apparent randomness of method, they pushed against the convention of the physical agency of the artist, and this may have excluded them from some honorific value as paintings, although their execution did require much more control than Balson's contemporaries cared to acknowledge.

The Matter Paintings did mark a conclusive point in Balson's thinking. Paint was presented for what it was, a physical substance on a surface, obeying physical laws. It was not a vehicle for transcendence into some other realm. It was as if the scientific idealism of Balson's whole metaphorical quest for some universal 'essence' was finally resolved by a more earth-bound affirmation of physical fact. As Balson put it, rather rhetorically, in 1962: 'A rose is a rose because it's a rose. We don't try to make it a daffodil or a cabbage. Or do we?'[28]

LUCY GRACE ELLEM Utzon's Sydney Opera House

I: THE RIGHT OF EXPRESSION

Ideas perish as soon as they are compromised. Therefore . . . build in fantasy without regard for technical difficulties. To have the gift of the imagination is more important than all technology, which always adapts itself to man's creative will.

—Walter Gropius, Pamphlet for the 'Exhibition of Unknown Architects', 1919

In their romantic optimism and homage to creative freedom and the human will, here expressed as the victory of aestheticism over pragmatism, these words best convey the spirit which brought the Sydney Opera House into being, and the ideals which initially inspired its architect, Jørn Utzon.

But the victory of aestheticism is not easily won. The Sydney Opera House has been, since its inception, the centre of a world-wide controversy in architectural circles. The enormous effort and inflated cost[1] required for the realization of Utzon's 'simple poetic idea'[2] bring into question the validity of an aesthetic conception of architecture. From the beginning, the Opera House was beset by technical difficulties and political exigencies which finally brought about the architect's resignation amidst a storm of protest. Meanwhile successive compromises of the original design weakened the building's aesthetic integrity. Finally, even the man primarily responsible for its realization—Ove Arup, the structural engineer—was uncertain whether the Opera House was 'a colossal architectural folly or an outstanding masterpiece . . .'[3]

The history of the Opera House began in 1954, when the Premier of New South Wales, the late John J. Cahill, decided to build a music centre for Sydney. The decision to hold a world-wide competition, with its attendant publicity and prestige for the design of the

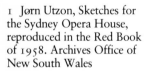

1 Jørn Utzon, Sketches for the Sydney Opera House, reproduced in the Red Book of 1958. Archives Office of New South Wales

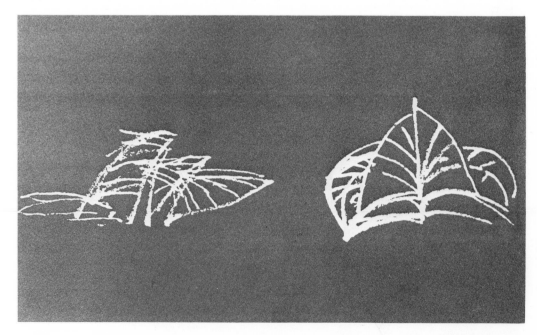

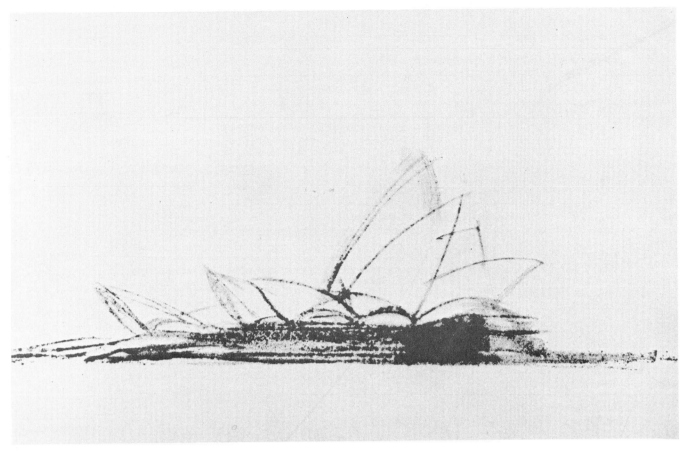

2 Jørn Utzon, Sketch for the
Sydney Opera House,
reproduced in the Red Book
of 1958. Archives Office of
New South Wales

place

centre, and the choice of a dramatic and exposed site, indicate that the music centre was
intended as a 'civic symbol for a city which seeks to destroy once and for all the suggestion
that it is a cultural backwater'.[4] Indeed the site chosen, Bennelong Point, conforms to the
essential characteristic of a status symbol: maximum display. The location of the music
centre at the edge of the large and beautiful harbour which divides the city of Sydney along
a roughly east-west axis, on a site surrounded on three sides by water and close to a major
shipping channel and the main lines of communication between the city's business centre
and the residential North Shore, ensured maximum exposure for the projected building.
This exposure, together with the problem of scale—since any building placed on such a
site would have to compete with the colossal structure of the Sydney Harbour Bridge—
provided the major aesthetic problems for the architect. The practical problem was to
design a complex which met the competition requirements for two halls (a large dual
purpose hall for concerts and grand opera and a smaller hall mainly for dramatic presen-
tation and intimate opera) within the narrow confines of the site.

The world-wide competition for the design was held throughout 1956 and attracted
over 200 entries. In January 1957 the first prize was awarded to a scheme submitted by a
young Danish architect, Jørn Utzon, which conceived of the building as a massive plat-
form from which rose a series of staggered vaults housing the two auditoria (3-7, 11). The
assessors for the competition wrote of the winning design:

The drawings submitted for this scheme are simple to the point of being diagrammatic. Neverthe-
less, as we have returned again and again to the study of these drawings, we are convinced that they
present a concept of an Opera House which is capable of becoming one of the great buildings of the
world. We consider this scheme to be the most original and creative submission. Because of its very
originality, it is clearly a controversial design. We are, however, absolutely convinced about its
merits.[5]

The judges' decision had been based on the aesthetic merit of the design, a major factor
being the physical empathy of the building with its site. Although at the time Utzon's
design was, ironically enough, regarded by the assessors as the most economical, this was

not the most important factor in their choice; and on the whole the practical factors seem to have been largely disregarded or overlooked.[6]

Utzon's design represented a very unorthodox solution to what he and the assessors considered the major problem of the site—the creation of a satisfactory silhouette from all directions. Yet it was a solution which meant an infringement of the conditions of the competition. Utzon's scheme exceeded the limits of the site, and did not provide substantially the accommodation prescribed. It placed restrictions of volume on the shape of the auditoria, and failed to provide for side stages.[7] Utzon's submission made virtually no reference to construction techniques.[8] All this indicates that Utzon had in his design made choices consistent with a conception of the architect as creator-artist, freed from the normal exigencies of his material and profession. The panel of judges concurred with Utzon's priorities.

Indeed the design was a brilliant solution to the aesthetic problems posed by the building and the site. The system of complex shapes created by Utzon's series of 'shells' opposed the static horizontality of the surrounding water and gardens; and their free forms mocked the controlled curves and stability of the great Harbour Bridge and the closed rectangular blocks of the city. The design was a brilliant solution to the problem of scale. No building placed on such a site could compete with the Harbour Bridge in size; but by his use of a cluster of radiating shell and leaf shapes, tiled brilliantly white and suggestive of a vivid plant by the water's edge, Utzon was able to compete successfully with the bridge in dramatic effect. The problem of designing a building which would be

3 Jørn Utzon, Competition Submission, site plan. Archives Office of New South Wales.

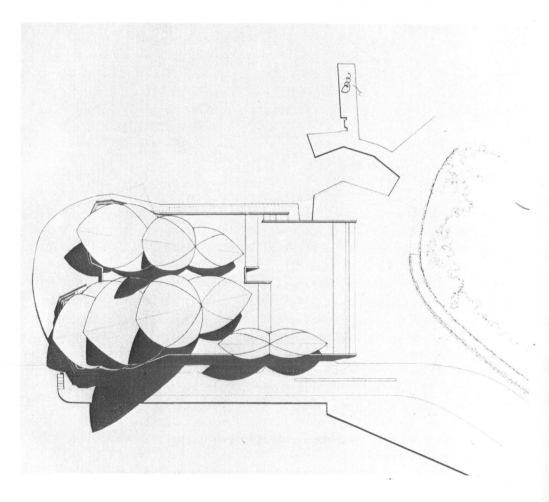

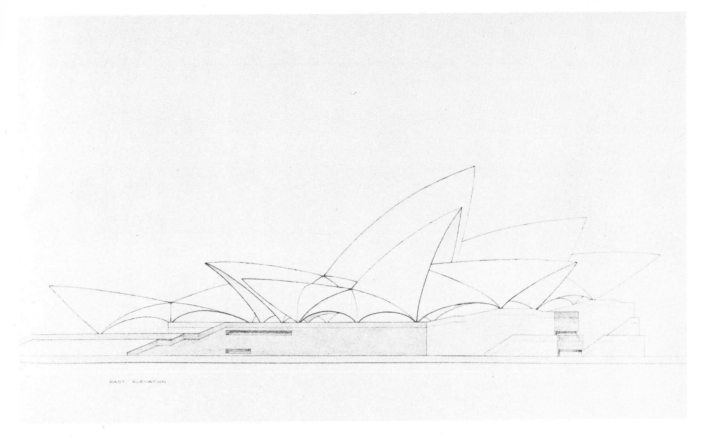

EAST ELEVATION

4 Jørn Utzon, Competition Submission, east elevation. Archives Office of New South Wales

seen as much from above as from eye level, and thus completely exposing the roof, was solved by the elision of the wall/roof relationship in the superstructure of the building. The difficulty of integrating the two tall stage towers into a coherent design was ingeniously solved by this use of a system of shells, the tallest of which masked them completely (4). The placement of the two halls side by side solved simply and effectively problems of access and circulation, and allowed full dramatization of the approach and utilization of magnificent views over the harbour. Despite its failure to solve the practical problems of the site, Utzon's design won the competition because it was primarily an aesthetic solution to an aesthetic problem.

The competition's promoters had wanted an Opera House that would become a national symbol. Utzon's submission corresponded perfectly to their aspirations: a conception of architecture as symbolic form permeated all aspects of its design. The clear separation of platform base and roof structure symbolized in visible form the separation of their respective functions. Utzon wrote:

In the Sydney Opera House scheme, the idea has been to let the platform cut through like a knife and separate primary and secondary functions completely. On top of the platform the spectators receive the completed work of art and beneath the platform every preparation for it takes place.[9]

This separation of function was paralleled by Utzon's separation of aesthetic experience from the experience of daily life. A conception of the theatre as an escape into a fantasy world, for which the theatre-goer must be prepared both by the building and by his route of arrival, lay at the root of his concern with the site and its approaches, and with the aesthetic effect of the structure. Much of his very brief Competition Report deals with the approach of the audience up the great staircase, and the visual and emotional impact of the building (3 and 5). Noting that 'The approach of the audience is easy and as distinctly pronounced as in Grecian theatres . . .', he went on to describe the arrival of the audience almost in terms of a ceremonial procession: 'The audience is assembled from cars, trains and ferries an [sic] led like a festive procession into the respective halls, thanks to the pure stair-case solution'.[10]

Utzon was clearly conscious of the symbolic significance and emotional impact of such

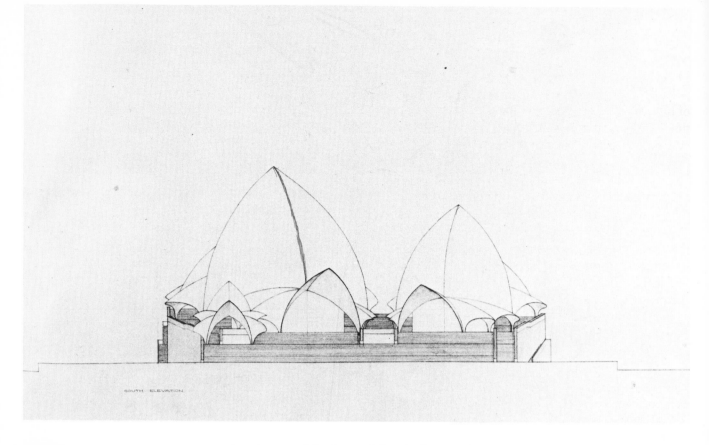

SOUTH ELEVATION

5 Jørn Utzon, Competition
Submission, south elevation.
Archives Office of New
South Wales

a processional ascent. The form of the platform and its great staircase in fact derived from Utzon's experience of religious architecture in Mexico, which he visited in 1949. He wrote of the platform temples at Yucatan:

By introducing the platform with its level at the same height as the jungle top, these people had suddenly obtained a new dimension of life, worthy of their devotion to their Gods. On these high platforms—many of them as long as 100 meters—they built their temples. They had from here the sky, the clouds and the breeze, and suddenly the jungle roof had been converted into a great open plain. By this architectural trick they had completely changed the landscape and supplied their visual life with a greatness corresponding to the greatness of their Gods.

Today you can still experience this wonderful variation in feeling from the closeness in the jungle to the vast openness on the platform top.[11]

In a similar vein he noted of the temple complex at Monte Alban near Oaxaca that:

By the introduction of staircase arrangements and step-like buildings on the edge of the platform and keeping the central part at a lower level, the mountain top has been converted into a completely independent thing floating in the air, separated from the earth, and from up there you see actually nothing but the sky and the passing clouds,—a new planet.[12]

In Utzon's view, the function of the temple platform was to detach the worshipper from terrestrial experience so that as he ascended the great staircase he experienced the sensation of entering a new dimension of existence, one freed from the bonds of gravity, 'a new planet'.

Utzon's attempt to recreate, in the podium and superstructures of the Sydney Opera House, this almost mystical experience of the platform-temples of Mexico suggests his perception of an inner affinity between the functions of aesthetic and religious architecture. As in the Mexican temples the ascent to the platform prepared the worshipper for religious experience, so in the Opera House the processional approach up the great staircase and under the awe-inspiring shell forms prepared the audience for aesthetic experience. The ascent both effected and symbolized the physical and mental transition from the everyday world. Utzon's use of the platform temples to determine the overall form and relationships of the Sydney Opera House establishes that the primary purpose

of his design was to induce a specific emotional state. His association of this mood with that evoked by the ancient architecture of Mexico reflects a romantic historicism, expressing both a spiritual affinity and a desire for continuity with the emotional experience of the past.[13]

Utzon was clearly aware of the isolating remoteness of his platform design, and the sense of sanctuary engendered by his building is reinforced by its isolation from the city by a protective circle of water and parkland. Yet the creation of a fantasy world is achieved only by rejection of the real world. Utzon's symbolic escape from urbanism into isolationism, by means of a platform solution which allowed his building to stand 'in an undisturbed composition', implies also a rejection of the demands of modern urbanism and its complexity.[14] It is an aesthetic isolationism which is consistent with his disregard for the practical problems of site and construction in his competition submission.

If consciousness of symbolic function determined the shape of the Opera House platform, Utzon shaped the roof superstructure primarily in response to the site. Conscious of the total exposure of the building, from above and from all sides, he wrote:

... one could not design a building for such an exposed position without paying attention to the roof ... one must have a fifth façade which is just as important as the other façades. Furthermore ... people will see it as a round thing ...

Therefore, instead of making a square form, I have made a sculpture—a sculpture covering the necessary functions ...[15]

The Opera House is primarily sculptural in that it originated as a three-dimensional non-geometric form only loosely connected with its specific function, a function which was ingeniously, even brilliantly, fitted into that form. Appropriately, a building that in many ways symbolized a rejection of modern urbanism was derived from a conservative if not obsolete tradition of sculpture—a sculpture of volume, weight and mass.[16] Although the Opera House superstructure is reminiscent of Brancusi in its integral relationship with its base, the definition of Henri Laurens best describes the sculptural quality of its shell vaults: 'Sculpture is essentially occupation of space, construction of an object with hollows and solid parts, mass and void, their variations and reciprocal tensions and finally their equilibrium'.[17] Like the sculpture of Laurens, the ultimate effect of the forms of the Opera House rests on a system of volumes which engender each other, and in which a balance between solid and void is an essential factor.

Utzon had met Laurens in Paris in 1948, and learned from him, according to Giedion, 'how one builds forms in the air, and how to express suspension and ascension'.[18] Utzon was particularly aware of suspension or weightlessness in architecture, and his experience in Mexico of the mountain top 'floating in the air' doubtless encouraged him to believe that a similar effect could be achieved in the Opera House. He wrote of the roof superstructure: 'Light, suspended concrete shells accentuate the plateau-effect and the character of the staircase construction'.[19]

A series of sketches which demonstrate the relationship of the shell vaults to their platform base show it to be that of clouds hovering over the sea, or a pair of folded 'wings' suspended in space above a horizontal platform.[20] And, in the competition sketches, indeed the energetic thrust into space of Utzon's shell forms, their thin, fluid surfaces and the lightness with which their curving spans touch down upon the platform, does suggest, in contrast to the massive stability of the podium, a relative freedom from the law of gravity.

Although suspension and the denial of mass and weight can be expressed in sculpture without necessarily transgressing the limits of that medium, the vastly different scale of architecture demands the closest attention to the properties of mass, weight and loadbear-

ing: suspension is a sculptural rather than an architectural quality. The wish to escape gravity embodied in Utzon's conception of the roof shells is consistent with his rejection, in the competition submission, of the traditional practical concerns of architecture. (It is ironic, in this context, that the form Utzon's roof structure took in the competition sketches actually was 'freed' from the law of gravity: subjected to it in the process of construction, the shell vaults as originally designed simply could not stand.)

Utzon's conception of the superstructure of the Opera House as 'sculpture' was entirely compatible with his consciousness of its symbolic function. For its sculptural qualities have an important bearing on the building's effect. Utzon placed the inducement of an emotional response through a controlled, isolated and superbly beautiful environment above the practical exigencies related to the building's use. The shell roofs became a symbol of this aesthetic function.[21]

This conception of form as symbol, and of function as that symbolic form, directly link the Opera House across three decades to Expressionist architecture of the 1920s. Like Utzon's design, those of Mendelsohn and Finsterlin stem from the belief that the outward form of a building, rather than expressing the underlying structure and the spaces determined by the directly functional needs of the building, should symbolize its purpose: a purpose which was often interpreted in fantastic sculptural forms. The visual affinity of Utzon's design to Hermann Finsterlin's architectural drawings has been pointed out by Pevsner, and there are even closer parallels with Erich Mendelsohn's designs.[22] Like the drawings of these Expressionist architects the design of the Opera House was inspired by organic forms and demonstrates a developed sense of organic relationship.

Utzon's organic grouping of the major architectural forms of the complex and the obvious visual relationship of their constituent elements to leaf or shell forms was not accidental: the architectural conception of the Opera House appears to derive directly from natural forms. Two early sketches (1), progenitors of the side and south elevations, show the roof vaults as leaves, complete with leaf veins. Another, more developed sketch (2) of the idea for the superstructure shows its intimate connection with and dependence on organic forms.[23] It resembles not so much a building but a cluster of leaves radiating from a central point in the dynamic and bursting shapes of a typical plant form. This dynamic interplay of forms which spring from a common centre is retained in the competition submission (4). So too is the organic interpenetration of shapes: shapes which are apparently self-propagating, repeating each other in subtly varied shapes and in diminishing sizes but always retaining their genetic affinity. These structures give a sensation of growth, and this impression of vitality is reinforced by the sensitive, highly individualized lines and fluid surfaces which connect the shells.

Organic in appearance, the Opera House is also organic in its principle of design. The site plan of the complex (3) shows a family of forms in a picturesque grouping which parallels the way nature composes—symmetry in each part, but the whole governed by an equilibrium of balance, not symmetry.[24] The relationship of these structures to each other and to the whole is governed by an intuitive sense of arrangement rather than imposed by a predetermined geometrical plan.[25]

Utzon seems to have thought of his building as a living organism. He believed that the interplay created by the constantly varying silhouette of the shapes of a building together with the effects of sun, light and clouds 'makes it a living thing'.[26] He chose a highly reflective, brilliantly white surface for the Opera House roof because of the sensitivity of such a surface to variations in light values: 'This roof will be very sensitive. Unlike a building which has only light and shade, it will be a very live sort of thing, changing all the day long'.[27] An organic relationship is further implied in his conception of roof design, in

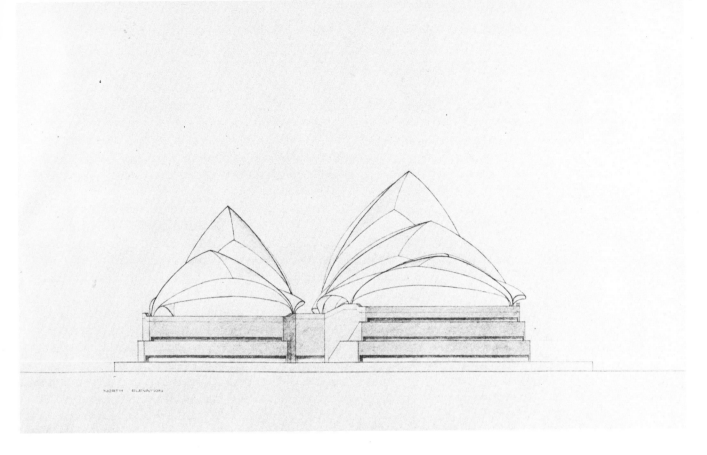

NORTH ELEVATION

6 Jørn Utzon, Competition
Submission, north elevation.
Archives Office of New
South Wales

which the force of gravity acting on inert mass is counteracted by the dynamic energy of a
living organism: 'The roof can be hanging above, it can be spanning across or jumping
over you in one big leap or in many small ones'.[28]

This organic conception of architecture not only inspired Utzon's scheme but consis-
tently shaped its developing form. In the competition sketches the design of the roof had
no geometric definition and all the surfaces were free shapes.[29] And there was an almost
total elision of right angles from the rest of the design. Utzon's prize-winning submission
represents a mode of architecture which rejects the predetermined, conceptual order of
geometric design.

The Opera House has its spiritual ancestors not only in the organic sculpturalism of
Expressionist architecture but in the sources on which it drew: Art Nouveau and the
architecture of Gaudi. In its free-flowing, curving surfaces and organic design, and espe-
cially in the fungoid shapes created by the lower edges of the shell roofs (11), Utzon's
design is closer to the spirit and forms of Art Nouveau than it is to contemporary
architecture. While rejecting the purely decorative aspects of the earlier style, Utzon's
design nevertheless illustrates its sinuous curves and transmogrified plant forms; but they
are more simplified and abstract, purified of superficial ornament. The result is unified,
'streamlined' movement. The continuously flowing surface movement of Art Nouveau
decoration is, in the Opera House, developed in space; as if an ornamental detail, sub-
jected to the stylizing process of Art Nouveau, has been blown up to vast scale and become
the whole building.

Although Utzon's design looks back to Expressionist architecture of the 1920s, it
should not be regarded as a revival of this tradition but rather as a continuation, since the
tradition had never fully died out. It survived, for example, in Europe, in the church
designs of Bruno Taut and Enrico Castiglioni; in the U.S.A. in Frank Lloyd Wright's
symbolic church architecture and the fluid concrete structures of John MacL. Johansen;
and in Mexico in the work of Felix Candela. Perhaps it was an ominous portent that, with
the exception of the Sydney Opera House, the more 'visionary' projects remained on the

drawing board, lacking either clients or the technical certainty that they could be built. Utzon was not alone in his interest in sculptural form, his concern for the physical empathy of the building with its site, and his romantic historicism[30]; and his attempt in the Sydney Opera House to achieve hovering, apparently weightless forms is only one example of that search for the conquest of gravity which is one of the great utopian dreams of architecture in this century.[31]

Yet the Opera House cannot be regarded merely as an updated revival of early twentieth-century styles. A conception of architectural design in which the organization of function was subsequent to the establishment of *a priori* or 'ideal' forms was a widespread phenomenon of the 1950s, and especially in association with the use of thin reinforced concrete shell construction and paraboloid forms. Gunther Gunshel, Frei Otto, Eero Saarinen and Felix Candela were among those who used the relatively 'free' shapes of paraboloid forms to create architecture which exploited the inherent dynamism and expressionistic qualities of these mathematical forms. The designs of these architects were further linked to the Opera House by a common desire to exploit fully the structural and plastic qualities of concrete.[32]

Utzon's design thus united two contemporary tendencies—the continuation of symbolic, organic and sculptural architecture derived from Expressionism and Art Nouveau, and the tendency towards 'ideal' forms which found expression, in the fifties, in the extensive use of parabolic geometry and in the exploitation of light shell concrete construction.

II: COMPROMISE

In explaining the choice of Utzon's submission, the Assessors' Report had made clear the priority of creative expression over pragmatism in their decision; but Utzon's imaginative design had yet to be realized. The provisions of the competition allowed the winning architect to remain as architect for the developing project. Ove Arup and Partners, a firm of international repute, was engaged as structural engineers. The design and construction work was divided into three stages: I, the podium or platform base; II, the roof shells; and III, the acoustic interiors, the enclosing glass walls and interior fittings throughout the whole building.

The building of Stage I, the podium, posed relatively few structural problems, although a premature start on its construction in 1959, before the design of the roof shells was finalized, meant that it had to be partly demolished when subsequent design changes in Stage II planning required the podium to be strengthened. But the construction of Stage II, the roof shells, presented problems which were almost insuperable.

Utzon had submitted sketches of the roof design without giving any indication of its method of construction, other than describing it as a 'concrete shell', and it is doubtful whether he had ever given this aspect of his design serious consideration. According to Ove Arup, senior partner of the firm of structural engineers, Utzon did not expect to win the competition[33], a view which is supported by the scant attention he paid to its requirements. He had not consulted a structural engineer prior to submitting his sketches[34], and it would seem that his submission was the result of an intellectual exercise in problems of design rather than a serious attempt to gain the award and build his winning scheme. He had simply assumed the structure could be built. The judges' decision had been based on the aesthetic merit of Utzon's solution, but they too certainly considered the design to be buildable. Recent architecture had made extensive use of thin reinforced concrete shell construction, particularly in conjunction with paraboloid forms. The success of such

buildings, and their visual affinity with the shapes of the Opera House design, was undoubtedly a factor in leading the assessors to believe that Utzon's Sydney Opera House could be built. They wrote confidently in their report that 'the technique of building shell vaults has now been developed in many countries of the world . . . The use of this form of construction seems to us to be particularly appropriate'.[35] In reality, it was highly inappropriate. Utzon's pointed vaults could not be constructed by this method.[36] Indeed the design in the form that Utzon had envisaged in his competition submission was not feasible.

The history of the compromise of Utzon's original design began in 1957 with the collaboration of Utzon and the structural engineers, Ove Arup and Partners, in what was to become a six year long struggle to design an Opera House that could be built. It was a collaboration crucial to the building's realization.[37] From the outset, the difficulty of building Utzon's shell vaults was apparent to the engineers. Ove Arup defined the basic problems thus:

Utzon's original design was only an indication of his intentions, in the form of freehand sketches without geometric definition. Their form was chosen mainly for aesthetic reasons, but Utzon certainly thought that he had found a solution which was structurally reasonable. He was therefore very disappointed when I told him at our first interview that the shape was not very suitable, structurally, for he was particularly keen on the idea of an ideal marriage between Architecture and Structure.[38]

At his first meeting with Utzon, Arup suggested major design changes which would have simplified the construction of the roofs. These included the elimination of the pointed arches, and the replacement of the discontinuities in the roof design by a dome-like structure over the whole of each or both halls.[39] These suggestions are a measure of how structurally unsuitable Arup considered Utzon's design to be, but it is hardly surprising that Utzon rejected such radical redesigning of his building. The engineers agreed with his decision: 'any alteration to the cross-section . . . would completely destroy the architectural character, the crispness and the soaring sail-like quality of the structure'.[40] The design had been chosen for its aesthetic effect, and aesthetic priorities determined the decision to attempt to build the design in its original form.

Arup had defined two problems facing the engineers and architect: the building lacked geometric definition, and it lacked a method of construction suitable to its shape. Late in 1957, Arup's firm and Utzon began the search for a geometrical definition of the roof shells.[41] In their first solution, a system of parabolas cast over the free shapes of Utzon's original design a net of mathematical control. The roughly triangular surfaces of the shells were now formed by a series of co-axial parabolas which met at the point of support of each roof shell; the ridge or spine connecting the two surfaces of each pair of shells was itself part of a parabola. This was the definition presented to the government of New South Wales in March 1958, in a report known as the Red Book (8). The parabola was a suitable choice by which to define the Opera House shells. Forms derived from conic section (parabola, hyperbola and ellipse) are inherently more dynamic in appearance than those based on the square or circle, and retain to a large extent the appearance of the hand-drawn curve. Yet despite the relative freedom of parabolic geometry, the Red Book designs show a tightening and stiffening of Utzon's sensitively curved surfaces and a more monotonous line, particularly noticeable if the lower curves of the side shells which flank the main vaults are compared with those of the original design (7 and 8). The tense vitality of the original design is lost.

The Red Book also introduced an important structural modification: the introduction of shell ribs for the support of the roof. This necessity stemmed from the second major

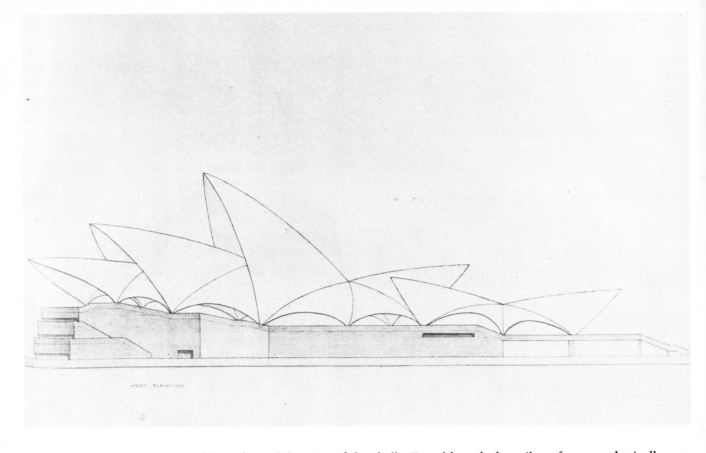

WEST ELEVATION

7 Jørn Utzon, Competition
Submission, west elevation.
Archives Office of New
South Wales

problem, the stabilization of the shells. For although the sail roof was aesthetically very
effective, it was now beginning to be realized that it was structurally impossible—no
building in the world had ever had such a large and intricately curved roof. The problem
was two-fold. In the first place, each of the paired structures rested on only two points of
support. Secondly, their weight was not distributed evenly around these points of support
but tipped over so that each pair of shells transmitted a force to the next pair.[42] The Red
Book solution of 1958 was based on the principle of longitudinal support and was arrived
at by considering the shells of each structure as one. Louvre walls which 'closed' the main
shells were also introduced in the Red Book design as part of this rigidly interconnected
system of support. Ribs were added to strengthen the concrete shell. A system of glass
walls now enclosed the previously open shells and further circumscribed their freedom. A
fourth pair of shells was introduced in the minor hall which, in the original submission,
had consisted of only three main shell pairs. The minor hall now repeated on a smaller
scale the shape of the major hall.

The result of all these changes was a compression of each of the shell structures along its
long axis (particularly noticeable in the small restaurant shell) and at the same time a
vertical elongation (very evident in the north and south elevations). The relatively low
profile of the original design was elevated as the visual centre-point of the building (the
V-shaped junction of the foyer and main shells) was raised and the shells on either side
were shortened, raised and tipped back towards it (cf. 7 and 8). It was as though the
building, catlike, was drawing itself in and arching its back. The Red Book thus presented
a more self-contained, stable form. Yet despite these modifications, the essential shape of
the original submission was retained.

But the Red Book changes were only the first. Over the next three years, from 1958 to
1961, the shape of the Opera House underwent continual modification in the search for a
structurally stable design. The geometry of the design underwent further change. The side
shells which connected the main shells of each roof were redesigned from parabolas to
elliptic paraboloids, establishing the principle of differentiating the geometry of the side
shells from that of the main shells. Subsequently the whole roof geometry was changed to

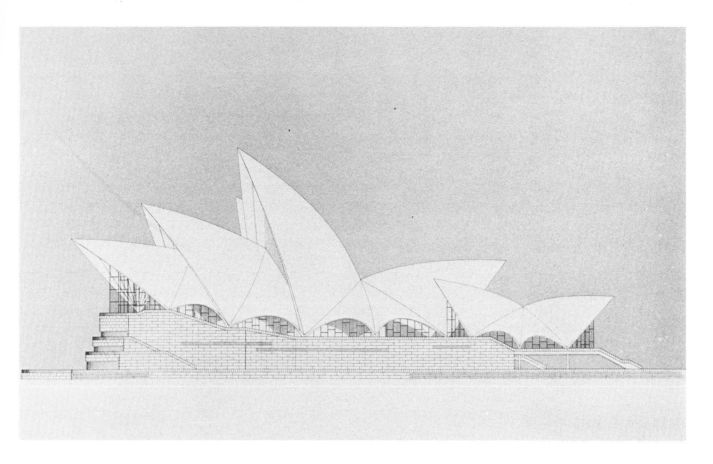

ellipsoids.[43] These changes, made mainly to facilitate calculations, were claimed by the structural engineers to have 'little, if any, visual effect'.[4] But in fact, they reinforced the tendency of the Red Book solution to contract and stabilize the design.

Since all known methods of theoretical structural analysis would give at best only approximate results, models were constructed to test load bearing and wind pressure.[45] The structural tests and analyses resulted in further changes. Utzon's original intention to build in single-skin, reinforced concrete shell, modified by the introduction of ribs in the Red Book designs, was now found to be inadequate, and a scheme was evolved using double concrete shells, about four feet apart and strengthened by steel web members. Early in 1961, this too was found to be inadequate. A system of structural steel ribs combined with concrete slabs was considered, but it was a scheme disliked by Utzon, who by then was also dissatisfied with several aspects of the design: the shape of the roof, its internal appearance, its method of construction and the louvre walls.[46] Utzon suggested abandoning these designs, which were all based on the *in situ* casting of the concrete roofs in favour of a folded, rib construction made up of segments which could be precast and assembled.[47]

By this time it was also clear to the engineers that the process of structural and design modifications was iterative: parts of the structure would be reshaped during strengthening, but this altered the forces, requiring further strengthening and reshaping, and so on. Ove Arup and Partners decided to undertake a full reappraisal of the roof design, which was carried out in the northern summer of 1961. They came to two main conclusions. Firstly, the scheme on which they had been working for three years (reinforced concrete poured *in situ*) was feasible, but it would have to be amended so that the structure became essentially a three-dimensional steel skeleton. Secondly, the folded roof solution was possible but it meant that 'the structural, and, if necessary, the architectural design would have to be adapted to a rather different construction method'.[48] Clearly the engineers' reappraisal had included not only structural aspects but a reassessment of priorities, reversing the primacy of aesthetic considerations in favour of the practical concerns of construction.

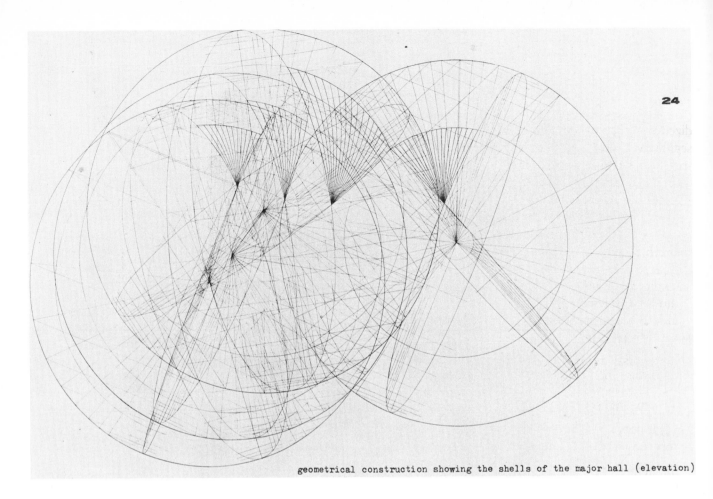

geometrical construction showing the shells of the major hall (elevation)

9 Jørn Utzon, Yellow Book, 1962. Geometrical construction showing the shells of the major hall (elevation). Archives Office of New South Wales

Faced with the alternatives of the steel skeleton or the rib construction, Utzon chose the latter, even though it meant abandoning three years of work. He had become dissatisfied with the appearance of the interior of the roof—the broad expanse of plain concrete which in the original submission he had shown painted in gold—and the ribbed undersurface now offered greater visual appeal. The podium concourse, constructed as a series of folded beams, had already demonstrated some of the possibilities of this type of construction. However, these beams, poured *in situ*, showed a lack of finish unacceptable to Utzon in the roof shells. The folded rib construction, by allowing the rib segments to be precast, offered far greater quality control than the steel skeleton with concrete poured *in situ* in gigantic formwork. Utzon wrote that his 'desire for a perfect underside of the shells' was the main reason why he wished to prefabricate the roof.[49] This potential for prefabrication was therefore a crucial factor in his decision in favour of the rib construction.

It was not at first apparent that this choice would entail a major change in the external appearance. For although the folded rib solution involved significant structural changes, notably the abandoning of the longitudinal system of support, the articulation of the roof into three structurally independent sets of shells, and the replacement of the reinforced, poured concrete construction by a massive assemblage of huge concrete segments, it did not at first entail a change in profile. The elliptical definition of the roof shells was retained. As a result, each surface was different, making precasting of segments a complex and costly operation.[50]

At this stage in 1961, and apparently in response to the problem of precasting unstandardized rib segments, Utzon hit on a solution in terms of spherical geometry (9). The curved surfaces of each shell were defined as segments 'cut' from the same sphere, so that the curved surfaces were identical and the shells varied only in size. The ribs which made up each shell differed only in length and in the angle at which they were cut off at the spine edge. The spine of each roof vault also became a regular curve based, like the surface curvature, on a sphere with a radius of 246 feet. This use of spherical geometry standar-

dized the once free shapes of the shell roofs. Since the ribs were now identical their segments could be precast using the same moulds.[51] The advantage of Utzon's brilliant structural solution was that it allowed the roof structure to be entirely prefabricated as a modular system.

From the engineers' point of view it was a practical solution. From Utzon's point of view, it must have seemed the discovery of that 'ideal marriage between Architecture and Structure' which he had mistakenly believed he had found in his original design. For if the solution of spherical geometry was a direct response to problems of precasting occasioned by the structural transformation of the building from concrete shell to concrete rib construction, it was equally the product of a new appreciation on the part of the architect of modular systems of building. The Opera House now became, in Utzon's eyes, a symbol of industrialized methods of construction. In his Descriptive Narrative with Status Quo of 1965, Utzon wrote:

The exteriors of the building stand as an expression for something basic in the concept,—the idea of dividing the various parts up into equal components, which can be produced industrially and afterwards put together to form a structure of the desired form,—in other words the use of machine made components in the building industry.[52]

There followed a defense of machine-age technology reminiscent of Giedion (with whom Utzon had corresponded in 1963):

Man can no longer afford the time nor the ability of craftsmen to hand make our buildings. We must find the machines to make our components and devise some means to put these elements together . . . The architect . . . having found the scope of minimum and maximum capacity of the machine . . . works within this discipline.[53]

The principle of prefabrication became of paramount importance for Utzon. He redesigned the glass walls, the auditoria interiors, and the corridor panelling for industrialized production. According to a close friend and associate of Utzon, Bill Wheatland,

In the end, in fact, he (Utzon) saw the Opera House not as a piece of sculpture he had put on Bennelong Point or anything arty like that, but as a revolutionary sort of demonstration of what could be done with prefabricated building, even for the hardest shapes.[54]

And so, on a freely drawn, organic design, a machine-age technology requiring strict geometry and mechanical precision and repetition was imposed. In his enthusiasm for the principle of industrialized production, Utzon seems to have overlooked its incompatibility with the organic principles of design which had governed the form and appearance of the original drawings. Far from being 'basic in the concept', prefabrication had not been even envisaged in the competition scheme. Utzon seems also to have been unaware or to have ignored the fact that the introduction of spherical geometry would transform the shape and consequently the aesthetic of the original design.[55]

The design changes resulting from spherical geometry were incorporated in a report, known as the Yellow Book, presented to the government in 1962 (9). Utzon, confronting his client with a *fait accompli*, extolled the virtues of geometry:

. . . this means that firstly, these spheres are in harmony with one another, they come from the same sphere, with the same radius and therefore when they are built up in space, we know that they will intersect in accordance with a certain law,—therefore the composition is in equilibrium.

My new shell geometry is clean and as beautiful as anything in nature and gives a controlled harmony between the different architectural portions seen from all angles.[56]

It was also in this controlled harmony that Giedion saw the building's major aesthetic virtue: 'The real secret of Utzon's Sydney opera house is in the eternal architectural law:

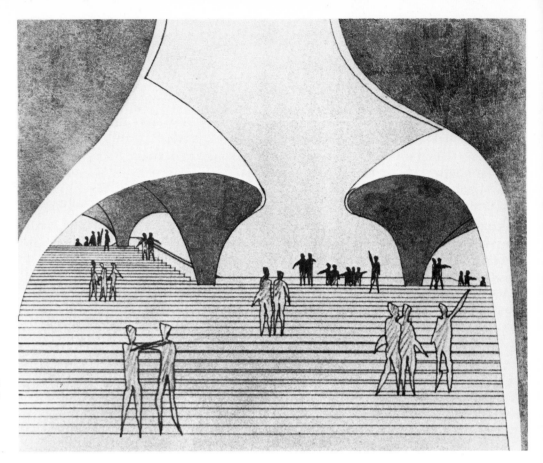

10 Jørn Utzon, Competition Submission. Perspective from staircase between two halls looking towards the north. Archives Office of New South Wales

the inner relation between architecture and geometry'.[57] Yet the introduction of spherical geometry came late in the evolution of the roof design, as an afterthought consequent upon structural changes and imposed on a freely drawn design that had emerged from Art Nouveau and Expressionist architecture. It was an imposition which involved a reversal of the original principle of design, substituting for the imaginative adaptation of organic forms drawn from the natural world the projection of an ideal, conceptual order. And it was fundamentally the result, not of aesthetic considerations nor even structural necessity, but of Utzon's new-found enthusiasm for industrial design. The organic design and dynamic appearance of the Sydney Opera House were sacrificed to the principle of prefabrication.

Utzon's use of spherical geometry to solve the problem of building the roof shells wrought the most radical changes in appearance that the building had yet suffered. The sensitive and highly individual line and the fluid surfaces of the competition submission underwent metamorphosis, through the imposition of an abstract order and perfect precision, to result in rigid, impersonal and unvarying surfaces and forms. Two features of the design, once considered essential by Utzon, were finally abandoned. The vertical spring of each shell from its base was replaced by an inclined angle, 'bracing' the arch of the vault, and the flattened, free form of its spine was replaced by the dull, uniform curves of arcs cut from the same circle. Unlike parabolic geometry, whose hidden order is not so apparent, spherical geometry imposes its order in perceptible form; the curves of the spines and surfaces not only are identical, they appear so. This evident order was consciously reinforced by the patterns of Utzon's prefabricated tile lids.[58]

A comparison of the original design with the building in its final form (7 and 12) demonstrates not only the conformity and evident discipline of the final form but an increased stability in the whole structure. The tendency of the Red Book design and subsequent geometric definitions to telescope the shell structures is increased, resulting in a marked longitudinal contraction of the whole roof complex. The shells are further raised and tipped back, giving it a more compact shape. The articulation of each roof into

three separate shell systems results in a more static system of discrete interlocking shapes. Where once the harbourside shells formed part of a dynamic, centrifugal movement, expressed in the variously angled thrusts of the shell points, they are now individually stabilized around their points of support, and offer static repetition.

An essential element in the stabilization of the building was the transformation of the side shells. Originally envisaged as 'frills' floating at the base of the main structures, the side shells now lock the main shells into a stable, inert system of support which visually counteracts the upward thrust of the 'sails' and anchors them solidly to the bedrock of the podium. The shape of the side shells was changed from light, arched curves, which echoed the shape of the main shells, to stiff, angular wedge-shaped forms which play a central, bracing role in the system of structural support. In the final design, these shells were 'cut' from cylinders rather than from spheres, resulting in flatter surfaces and straighter edges which clearly distinguish their shapes from those of the main shells.[59] Together with the abrupt transitions introduced by the structural concrete flanges at the junctions of the shells, this differentiation destroyed the visual affinity of the shapes of Utzon's competition sketches and their effortless transitions, and further reinforced the appearance of the Opera House as an assemblage of discrete shapes. The clear visual separation of parts also accentuates the increased stability of the design, the static triangles of the side shells emphasizing the self-contained shapes of the main shells.

Increased stability was accompanied by increased weight. From almost any angle, the thickness of the roof is apparent. Where Utzon once visualized a suspended, fluidly curving roof, lightly dropping down to narrow, vertical points of support (10), now large fan ribs gather into massive reinforced pedestals, while side shells rest on thick concrete piers, angled and braced for their support. The view between the two halls dramatically

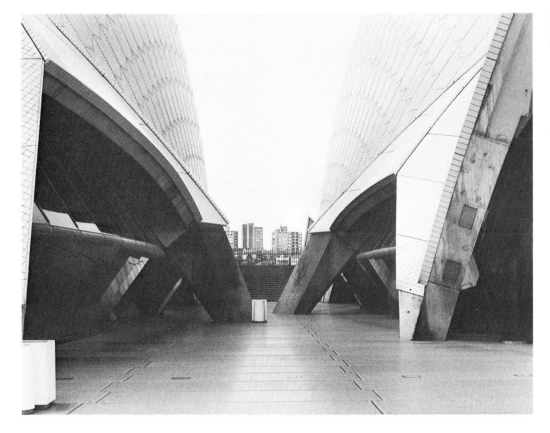

11 Sydney Opera House. View between the two halls, looking north

illustrates the transformed aesthetic of the finished building (11). Instead of an airy, open space lightly covered by curving, gilded undersurfaces, supported on thin, springing shafts, there is now a narrow crevice bounded by massive walls, angular junctions and huge concrete pedestals. Thus the articulation of the building and the introduction of spherical and cylindrical geometry resulted in a more balanced, stable form; but in the process the organic unity of the competition design, its apparently self-propagating parts, their mutual interdependence and visual affinity were lost, and the dynamic movement from part to part destroyed. Where once free curves soared in space, there now stands a massive, geometrically defined, angular structure, impressive in the complex assemblage of its huge forms in space, but in its aesthetic expression, vastly different from the prize-winning design.

Thus the victory of aestheticism over pragmatism and of imagination over functionalism, so decisively won in the choice of Utzon's design, was reversed and structural and practical concerns came to determine the final shape of the Opera House. Utzon's competition submission was a brilliant design solution to a particularly formidable design problem, but it had not been tested against reality. It was therefore a fantasy, and from the moment an attempt was made to give it substance practical exigencies forced the increasing abandonment of the original scheme, and with it the inspiration and lyrical beauty of the design which won the competition. A building which owed its conception to expressionist, organic principles of design moved towards realization in a form diametrically opposed to and even incompatible with those principles. The introduction of spherical geometry was the last in a long series of compromises, but it was the decisive one, and with it the aesthetic integrity of the building was destroyed. Only the core of the original design remained. The aesthetic fundamental to its expression had been transformed.

It seems scarcely possible that the extent of this transformation went unnoticed by those most intimately connected with the Opera House, but this seems to be the case. As late as 1965, when the roof shells were half built, Utzon was still referring to the 'light and graceful shells' and expressing commitment to the principle of hovering suspension in his designs for the auditoria interiors.[60] The Roof Report submitted by the engineers in the same year claimed that 'the fundamental concepts of the design' embodied in Utzon's competition submission had 'not really been altered'.[61] Yet so apparent were the changes to more detached observers that the Executive Committee in charge of the Opera House project had to defend itself against the charge that the design of the shell roofs showed a 'vastly different shape' by the statement 'This is not true . . .'[62]

Perhaps those concerned with the project were unwilling to admit how far they had permitted the design to be altered. Perhaps relief that a buildable solution had finally been achieved blinded them to the aesthetic transformation embodied in the new design. For surely these changes must be considered fundamental. Not only did Utzon's ultimate solution to the problem of building his design profoundly alter the appearance of the Opera House, it reversed the architectural principle governing its design and the aesthetic governing its shape.

Certainly the core of the building remains. But to Utzon the aesthetic effect of the original design had been of primary importance, just as it was to the assessors who awarded him first prize. And indeed the principle of design must be considered the most fundamental determinant of any architectural construction. In the Opera House, a building begun in an organic tradition, and inspired by a romantic, emotional response to the elements of the natural world, was completed by the imposition of an abstract order which has its origin in the controlling logic of the rational mind. An organic principle of

12 Sydney Opera House, west elevation

design derived from living, changing shapes is scarcely compatible with a design principle which projects onto this natural world an ideal, immutable order. In the Opera House the mutual exclusion of these two principles is demonstrated: the transition to the one destroying the aesthetic integrity of the other.

It was practical exigencies of quite another kind which forced the resignation of the architect in 1966 and led to the completion of the building by an architectural panel—exigencies determined by the political nature of the client.[63] Since Utzon's resignation it has been common to point to the destruction of the aesthetic integrity of the Opera House by distinguishing Utzon's contribution to the building—the podium and the roof shells—from the glass walls and interiors designed by Peter Hall. Yet the alteration of the roof construction from concrete shell to massive concrete rib, together with the transformation of the design principle from organic dynamism to conceptual geometry had already wrought a far more fundamental compromise of the original design.

Yet the compromise was not entirely one-sided. The construction of the roof shells was one of the most difficult projects ever undertaken.[64] If no major breakthroughs in technology were made, existing technology was certainly pushed to its limits in the unprecedented ingenuity and co-ordination of effort required to construct Utzon's masterpiece.[65]

Despite the compromise of Utzon's prize-winning design under pressure from practical exigencies, both structural and political, his 'simple poetic idea' has not entirely perished. That the Sydney Opera House stands at all, even in greatly altered form, is witness to 'the gift of the imagination' in architecture, and a symbol, even if a tarnished one, of the adaptation of technology to 'man's creative will'.

PATRICK McCAUGHEY The Artist in Extremis: Arthur Boyd 1972-73

To be born under Saturn is to be both blessed and cursed, to know glory and to share in suffering. The image of the artist has provided a potent theme for recent art history and criticism, a theme to which Bernard Smith has added some important variations and interpretations. A conception of the artist as hero underlies much of the modern chapters in *Australian Painting*. It was shrewdly remarked by a contemporary artist that whereas William Dobell was the hero of the first edition, Leonard French (and in a minor role, Mike Brown) emerged as heroes of the second. In the cases of Dobell and Brown, the heroic strain comes from the confrontation between artist and a hostile society—philistine, conservative, anti-intellectual. Both artists faced particular crisis points when significant works were put to the test—Dobell's winning entry in the 1944 Archibald Prize, *Portrait of an Artist* (Joshua Smith) and Brown's satiric *Mary Lou as Miss Universe* (1965). The crisis is one of initial rejection, when the artist and his work must stand the test alone, and then of eventual acceptance. Both artists find themselves rejected because what they offer is a criticism of life, not simply because they adopt extreme positions or produce extravagant novelties.

The case of Leonard French is different again. His recurring interest in the hero and his struggle to survive, be he the martyr Edmund Campion, or the crucified anonym of *The Raft* series, becomes the metaphor of the artist's struggle to make art.[1] As the hero takes on a new significance through his struggle, so the artist finds his identity through the effort to make sense of the brute, recalcitrant matter of his art.

Bernard Smith returned directly to this theme in his final Power Lecture in 1976, *The Death of the Artist as Hero*.[2] He sketched the progressive estrangement of the artist from romantic self-assertion to the isolated individual of modernity, no longer nourished and responsive to his surrounding community but cut off from it in both his practice and by what he produces. His practice is to work singly, without the benefits usually of a group or school, and his products are increasingly recherché and hermetic, addressed to a tiny, no less isolated group of cognoscenti. Yet from this situation there emerges a view of art and society which sees the single individual as 'creative' and the surrounding culture or society as essentially 'uncreative', indeed even as belligerently anti-creative. Although one may choose not to follow Bernard Smith in the conclusion he draws from this situation—his belief in a revival of the crafts to restore the lost relationship between art and community and to regenerate the creative energies of society—there is no mistaking the force and clarity of his analysis. It brings me to the subject of this essay: what happens to the artist in this situation of estrangement? As the artist today moves towards the limit situation, what is our image and our understanding of him?

One terrible group of images comes readily to mind, that of the excesses of the 'body artists' of the 1960s and 1970s, where self-inflicted pain is the most spectacular example of the alienated artist. However fashionable or modish the work, 'alienation' *is* a condition of sickness and despair. Whatever justifications or rationalizations are proposed for the body artist who suspends himself from the ceiling on meat-hooks piercing his skin, or

who holds lighted matches within his mouth, these must also appear as symptoms of a nihilist desperation. In his isolation, the artist seeks ever more extreme measures to attract the attention of his audience, to register that what he does is singular and exceptional, unlike any other activity in his society. Certainly no explanation of this and other post-minimal phenomena is complete without seeing both practice and product as the result of the estranged artist.

The works which I want to discuss are, however, notably different in kind and culture. They are both less familiar and richer in reference, but no less telling about the position of the artist in extremis. They are a group of paintings by Arthur Boyd, painted in 1972 and 1973, both in Australia and England. A substantial number of them came to the Australian National Gallery as part of the Boyd Gift in 1975, when the artist presented to that institution practically all work still remaining in his possession. They are a puzzling group. They don't have even the loose literary or iconographic programs of earlier Boyd series. Formally, there is a great discrepancy in quality within the group. What they turn on and what accounts for their extraordinary formal properties is their image of the artist in extremis, and they reflect what it is like to make art out of that situation. Although some paintings remain baffling, the complications and difficulties of the group become explicable once the image of the artist becomes the focus of attention and they are seen as a testament.

II

The series was begun in 1972, when Boyd was an artist-in-residence at the Australian National University, and completed in England the following year. A large group was exhibited in May-June 1973 at Fischer Fine Art Ltd in London.[3] The catalogue of that exhibition listed sixty-eight paintings, and that did not include the outsize paintings of the series, two of which were exhibited for the first time in 1977.[4] Thus, in a maximum of fifteen months, Boyd completed over seventy paintings in the series. The speed of their execution is frequently left rawly apparent on the surface. Rarely before has Boyd's touch as a painter looked so loose and unconsidered. The grounds are often caked with oil paint, giving them a glutinous, viscous surface. The figures and motifs disposed on them have, in uncertain contrast, a sketchy, improvisatory and schematic nature. The disparity between the 'drawn' element and the 'painted' grounds is heightened as the series proceeds: the dark interiors contain whitened, skeletal figures; and whitened, glaring landscapes are filled with black, schematically drawn figures. The gestural roughness of the series, the apparent crudities of tone and handling, and the directness of image-making which borders on the melodramatic, have offended and dismayed even staunch admirers of Arthur Boyd. And so, too, has the carnality and bestiality of the imagery, particularly as the grosser and more extreme examples of such imagery are linked with the image of the artist. It is part of my purpose to link that imagery with the mode of execution; both are the products of the limit situation.

The extremist imagery and the most abandonedly handled works come at the end of the series. Boyd works up to them through five earlier 'sets' of paintings.

The series opens with a group of Australian landscapes (1), painted directly from nature. Although a Boydian dog and ram make an occasional appearance, the landscape is treated with a surprising neutrality. The scruffy, unpicturesque nature of the bush is emphasized quite differently from both the pastoral or paradisal iconography of earlier Boyd landscapes and the purgatorial or infernal landscapes of the *Nude and Beast* or *Nebuchadnezzar* series. The landscapes of the 1972-73 series have an atmospheric

1 Arthur Boyd, *Riverbank*, 58.4 x 86.4 cm, 1972. Australian National Gallery, Canberra (Boyd Gift)

truth—the heat and light are unmistakeably of full summer—that is rare in Boyd's landscapes. The series thus begins with a claim on the real world, grounded in familiar experience.

The second set evolves easily from the first. The figure of a nude woman is at first discovered as one element amongst many in the landscape, but gradually the nude figure firms up and becomes the dominant figure and motif as in *Figure by a Creek* (2). This treatment of the nude is unusual for Boyd. It is very much the artist's model, posed somewhat awkwardly in an outdoor setting, far removed from the dramatic and imaginative use of the nude in the landscape found in earlier Boyd. Like the opening set of landscapes, this set emphasizes a normative grip on reality. The model is treated with an almost defiant realism; the sagging breast and roll of flesh are treated in a literal way, undressed by metaphor.[5] Such a use of the nude is specifically a painter's, that of the artist and his model. It is the most matter-of-fact relationship between the artist and the subject of his art. This set of monumental nudes marks the transition from the Australian to the English paintings. The first have the nude seated by a creek, the last versions have them seated in a stream in an English wood.

The third set develops the English woodland landscape, where gradually the artist at work on his canvas becomes the focus of attention. At first he is a Boydian fantasm (3), and then takes on greater corporeality, as in *Figure Watching* (4), as the object of his contemplation—the coupling lovers—becomes more explicit. In this set the series passes over to an imagery more imagined than observed.

Certainly the fourth set—a series of vertiginous, rocky landscapes populated with shadowy, homunculus figures and somewhat bizarre fragments of aeroplanes (5)—have a dream-like airlessness and insubstantiality. They are the least successful and interesting works in the series, because they are so clearly the figments of the fantasy, rather than the shaped product of the imagination, such as one finds in the fifth set of interiors (6), with the artist again as prime target.

Compared to the swimming spaces and thinly painted rocky landscapes of the fourth set, these interiors are the most emphatically painted of all the sets to date. The size of *Figure Supporting Back Legs and Interior with Black Rabbit* is huge for a figure painting and is clearly one of the peaks of the series, a work of testamentary summation. Although this group of interiors possesses its own *terribilità*, nothing in the earlier sets quite prepares us for the sixth and final set of the artist outcast in a blasted inferno, a white-hot landscape (7 and 8).

This set represents the extremity of the series overall. The artist is disfigured beyond particular character, stripped to a nakedness that renders him totally vulnerable to the

2 Arthur Boyd, *Figure by a Creek*, 114.3 x 109.2 cm, 1973. Australian National Gallery, Canberra (Boyd Gift)

3 Arthur Boyd, *Suffolk Landscape, Figure and Book*, oil on canvas, 152.4 x 122 cm. Australian National Gallery, Canberra (Boyd Gift)

landscape. He is alternatively caged and captured like a beast and mounted from behind by a beast—literally monstered. The artist is trapped in a world which is irreducibly carnal and bestial. Here, surely, is the very limit of human endurance, the extreme situation beyond which it is not possible to go and the representative human figure for such a situation is, for Boyd, the artist.

How does the artist find himself to be in this position and what happens to his art once he is there?

III

The mainspring of the series, its central dialectic, is found in the contrast between the opening and closing sets. Boyd begins with the natural and the normative: the landscape as sufficient theme in itself for art and the most traditional use of the nude as a neutrally regarded artist's model. As he proceeds, these fail to satisfy the needs and appetites of the imagination, until at the end he is brought to the desperate conclusions of the whitened

4 Arthur Boyd, *Figure Watching*, 152.4 x 122 cm, 1973. Australian National Gallery, Canberra (Boyd Gift)

landscapes and the image of the outcast artist. Many years ago Margaret Plant formulated with great perception 'the extremes of Arthur Boyd'.[6]

The opening landscape and nude figures (1 and 2) represent Boyd's longing not just for the good but, more basically and less allegorically, for the normal and the ordinary. The activity of just looking at the world and recording it truthfully is a hedge against inward volitions and fantasies; the world is perceived as an object, is a repository of 'health'. The nude, seen similarly as an object, is viewed asexually, neither desired nor desiring in repose. Part of the grotesqueness of the nude paintings, such as *Figure by a Creek* (2), is the distance these lumpen figures are from the characteristic Boydian version of the female nude. As he strains towards obtaining naturalness and normality, his art belies him. Disengaged imaginatively, the paintings are a product of Boyd's hand and eyes. Their awkwardness may have the ring and stamp of truthfulness, but the scale and composure of the figures is implausible, trapped between studio concentration and direct painting from nature. There is an unnaturalness of context for the nude for all the display of truthfulness to nature. The paintings, not unimpressive in themselves, are so out of

character yet so vigorously and ambitiously painted—they are amongst the most solidly worked and painted work in the entire series—as though Boyd wants to exclude a profound part of his sensibility and be absorbed instead by a more purely artisanal task. Seen in that light they are quite moving paintings: the female nude here loses something of the urgent sexuality it possesses elsewhere for Boyd. They put off the dread so frequently associated with Boyd's sexual themes and cling to the daily, observable fact.

'But long it could not last' . . . the paintings of the monumental nude are the set which bridges Boyd's move from Australia to England. The succeeding set of Suffolk pine-wood landscapes continues, in one way, Boyd's longing for the natural and the sufficiency of nature to feed his art. The drenching green of the English landscape obviously struck Boyd with renewed force immediately on his return, and the experience flows directly onto the canvases of this set. But the image of the open book in association with the painter at work on his canvas (3) marks the change in the series from the sufficiency of the natural to the power of the poetic imagination—to those things not seen but arising from inwardness, presented to the psyche rather than to normative vision. Both the figure of the artist

5 Arthur Boyd, *Rocky Landscape with Aeroplane*, oil on canvas, 152.4 x 122 cm. Australian National Gallery, Canberra (Boyd Gift)

6 Arthur Boyd, *Paintings in the Studio: Figure Supporting Back Legs and Interior with Black Rabbit*, 319 x 443.5 cm, 1973. Australian National Gallery, Canberra (Boyd Gift)

emerges in the paintings at this point, and Boyd's reflections on what feeds the artist's imagination, what makes his art. For in *Figure Watching* (4), the artist at work on the canvas focuses on the coupling lovers. What stirs the imagination is not the natural seen in neutrality, but sexual congress which cannot be readily observed but only conceived imaginatively by the artist.

From this point there is a slide in the series towards the final catastrophe. For Boyd, once the imagination is invoked, the way is open to the powers of blackness, to the primal, non-ethical energies of the psyche. And these energies in some appalling way nourish the artist. So at least is the import of the large testamentary interior, *Paintings in the Studio: Figure Supporting Back Legs and Interior with Black Rabbit* (6). That it is a testament may be rightly inferred from both its size (it measures over ten feet by fourteen) and its construction, where the two images—the landscape and the artist at work—are placed like iconic painted images on an airless, neutral charcoal grey ground. While its images are gripping, Boyd wants to keep in equal focus the particular context of a commentary on art and its making for the viewer. What is the relationship between the two disparate images? The brilliant, sun-filled landscape takes the mind back to the open, *plein-air*, Australian landscape with which the series began. But the landscape has increased in burning intensity, compressed into the window frame, less attainable and distanced behind the wire mesh. The artist is supported (or held down) onto his canvas by a ravening fury, which appears to devour and ravish the artist as much as support him. The painter holds brushes in one hand and cradles and fondles a pile of gold with the other. (Gold as a metaphor for excrement became a familiar Boydian trope in the *Nebuchadnezzar* series.) The thrust of the painting is painfully clear: the artist is ·cut off and denied access to the natural, and condemned to the terror of the imagination, and is, ironically, rewarded for this. One other irony occurs in the painting when Boyd projects one of the legs outside the canvas

and so suggests that the drama is not simply of the fantasy, a self-dramatizing myth of the artist, but is a reality for the painter. The artist (or the figure supporting him) literally steps out of the world of painting into a wall close to the viewer's experience.

The perils of the imagination, and the pit from which the profoundest art proceeds, are perhaps familiar enough attitudes or beliefs of the romantic-expressionist thread in modernist art and literature. As general culture has increasingly accommodated modernism, such claims have been heard, believed or acted on less often than before. Arthur Boyd might be seen so far in this series as restating a familiar but somewhat forgotten tenet of earlier modernism. The effects are forceful and salutary, but what makes the series remarkable is that Boyd goes beyond this point to show what happens to the artist once he engages with his perilous task. For the whitened landscapes, with the outcast artist of the final set, show the artist as the victim of his calling. What makes his art drives him to this extremity. If the pit is the constant image for the modern imagination, then the artist must become the denzien of the pit. And so indeed he appears in the final paintings of the series.

7 Arthur Boyd, *Chained Figure and Bent Tree*, oil on canvas, 152.4 x 122 cm. Australian National Gallery, Canberra (Boyd Gift)

8 Arthur Boyd, *Kneeling Figure with Canvas and Black Can*, 114.3 x 109.2 cm. Australian National Gallery, Canberra (Boyd Gift)

Nothing short of this can quite account for the shock of these works—such monstrous images and so scrappily painted. Two basic situations recur. First, there is a series of bondage images; the first is the *Chained Figure and Bent Tree* (7). Secondly, there are images of the artist mounted by a beast, frequently in a sexual way as in the *Kneeling Figure with Canvas and Black Can* (8). They are strangely complementary images of repression and monstrous licence, but in either case the artist is victim, acted on and beleaguered even when outcast. The sexual metaphor is never far from these paintings and sexual and imaginative release have so often found a metaphor in earlier Boyd; now they serve to underscore the bondage and alienation of the artist.

It is startling to pause and reflect how distant this final set of paintings is from the opening paintings of the series. The brilliant light and heat-filled landscapes at the start have intensified to the shimmering, white desert. The pools and river banks of the beginning have given way to a blasted, deserted landscape, where the extremities of human action and passion can be played out. Moreover, these whitened landscapes are the product of memory, done in England in 1973, and not of direct observation. The remembered landscape is quite different from the landscape of dream or fantasy. The latter can somehow be dismissed as fantasy, but the remembered landscape draws forth a world of essential parts, of brilliant salience, of basic elements. The severe tonal contrasts—the black outlined figures on the whitened grounds—contribute to that quality, as does the extraordinarily sketchy application of the paint. They are put down with a rapidity and

looseness of touch with no apparent check or reconsideration of original impulse or impetus. The primal, non-ethical energies, which flow through the artist's imagination, torment him and cast him out into this white wilderness, receive from Boyd an equally primal rendering. The sketch quality gives the paintings authenticity. Were the means more polished, more considered, it would be to exploit the extremity of this imagery. The artist in extremis cannot make aesthetic objects of his plight: he can at best set them down with an almost animal-like voracity.

The alienation of the artist today from his surrounding community — 'the death of the artist as hero' theme — and the resulting atrophy of modernist art is seen more often than not as the result of social conditions and the social system. We might feel in the case of the body artists, inflicting pain upon themselves, that here, despite all the disclaimers, is one more desperate throw of the *avant-garde* for a place in history, one more desperate attempt to reach and to rock bourgeois society. Boyd's version of this alienation is essentially metaphysical by comparison. Nor does it suggest that alienation is to be identified with annihilation. Even at the desperate limit of his being, bestially mounted or chained and caged, Boyd's artist makes his art just as Boyd himself can make art out of such material. It is bizarre, even absurd, if we think about it, that the artist, so monstrously victimized amidst that glaring white waste, should cling to his brushes, doggedly struggle to paint his canvases. There is no consolation in this, no redeeming image. The outraged character and person of the artist and his outrageous condition prevent it. They are paintings beyond tragedy and its redemptive effect; instead they face us with a fearful truth and make it known, if unalleviated.

IV

'. . . to be able to expose myself to the whole danger of my work.'
 — R.M. Rilke

How are we finally to evaluate this series? Critically, it is hardly good enough to pass the matter off by saying that they are 'uneven'. They represent a wholly surprising maturity. Instead of giving us works of summation and completeness, Boyd pushes his vision to a point where he is prepared to risk the aesthetic probity and decorum of his own pictures. He has placed the urgency of his vision before aesthetic considerations. In doing so, he looks far less the maturing master, increasingly able to dominate his means, in order to orchestrate his vision more abundantly, than the painter prone to wild exaggeration of single traits within his sensibility. He looks less the complete artist in this series than he has frequently done before. Indeed, the extreme quality of the imagery and their sketchy handling put his reputation at risk. That makes for their absorbing interest and remarkable aesthetic effect. Here is the painter who in the knowing, self-conscious ambience of modernist painting is prepared 'to expose himself to the whole danger of his work'. What possesses his imagination may not be conducive to 'successful' painting and yet he persists. Yet it is not any old subject or occasion which emboldens him to risk the aesthetic: it is the condition of the artist, and so, in Boyd's case, the condition of the self. To do that is to paint against the grain of recent practice. This is not the art which comes out of other art. The embarrassment which these paintings have occasioned is explained in part by the feeling that Boyd is doing something which either cannot or ought not to be done in contemporary painting.

ANTHONY BRADLEY The Published Works
of Bernard Smith: A Bibliography

This bibliography is based on a list of publications and a book of press cuttings supplied to the compiler by Bernard Smith. As far as possible, all references have been verified. The bibliography is arranged under the following headings: Books, Contributions to books, Pamphlets and contributions to pamphlets, Periodical articles, Book reviews, Art criticism in newspapers, Miscellaneous. Within each section the arrangement is chronological. Material in brackets has been added by the compiler.

BOOKS

Place, Taste and Tradition. A Survey of Australian Art Since 1788. Ure Smith, Sydney, 1945. Revised 2nd edn, Oxford University Press, Melbourne, 1979. (304 pp., illus.)

A Catalogue of Australian Oil Paintings in the National Art Gallery of New South Wales, 1876-1952, with annotations, biographies and index. The Gallery, Sydney, 1953. (234 pp.)

(Editor). *Education Through Art in Australia.* Melbourne University Press, Melbourne, 1958. (xvii, 98 pp., illus.)

European Vision and the South Pacific. Clarendon Press, Oxford, 1960. Paperback edn, 1969. (xviii, 287 pp., illus.)

Australian Painting 1788-1960. Oxford University Press, Melbourne, 1962. (xi, 357 pp., illus.). 2nd edn, 1971 (x, 483 pp., illus.)

(General Editor). Daniel Thomas. *Sali Herman.* Georgian House, Melbourne, 1962.

(General Editor). Noel Macainsh. *Clifton Pugh.* Georgian House, Melbourne, 1962.

(General Editor). Virginia Spate. *John Olsen.* Georgian House, Melbourne, 1963.

(General Editor). Ray Mathew. *Charles Blackman.* Georgian House, Melbourne, 1965.

(With Kate Smith). *The Architectural Character of Glebe.* Sydney University Co-operative Bookshop, Sydney, 1973. (128 pp., illus.)

(Editor). *Concerning Contemporary Art: The Power Lectures 1968-75.* Clarendon Press, Oxford, 1975. (185 pp., illus.). (Spanish translation: *Interpretacion y analisis del Arte Actual*, Ediciones Universidad de Navarra, Pamplona, 1977. Preface by Jesus Ortiz.)

(Editor). *Documents on Art and Taste in Australia: The Colonial Period 1770-1914.* Oxford University Press, Melbourne, 1975. (xi, 299 pp.)

The Antipodean Manifesto: Essays in Art and History, Oxford University Press, Melbourne, 1976. (vii, 222 pp.). Contents: Noel Counihan (1945); Eric Wilson (1947); The English portraits of William Dobell (1947); Henry Moore (1948); Sali Herman (1948); Charles Doutney (1957); Arthur Boyd (1972); Image and meaning in recent painting (1962); The social role of the art museum (1946); Comments on style, change and criticism in Sydney in 1947 (1947); The myth of isolation (1961); Sir Herbert Read and the Power Bequest (1964); On perceiving the Australian suburb (1975); The Whitlam Government and the visual arts (1975); History and the visual arts (1953); The celebration of transience (1954); William Morris and the twentieth century

(1963); Art and industry: a systematic approach (1974); The artist's vision of Australia (1950); The Antipodean Manifesto (1959) (with seven others); Coleridge's 'Ancient Mariner' and Cook's second voyage (1956).

CONTRIBUTIONS TO BOOKS

'Art'. *Soviet culture: a selection of talks at the Cultural Conference, November, 1941. Sydney, N.S.W.* Sydney, The N.S.W. Aid Russia Committee, 1942, pp. 57-63.

'Noel Counihan, contemporary realist'. Sydney Ure Smith (ed.). *Present Day Art in Australia 2.* Ure Smith, Sydney, 1945, pp. 28-30.

'Art'. O. L. Ziegler (ed.). *This is Australia.* The Author in association with Gotham Australasia, Sydney, 1946, p. 56.

'Art'. C. Hartley Grattan (ed.). *Australia.* University of California Press, Berkeley, 1947, pp. 303-13.

'Australian art'. W. J. Beckett (ed.). *The Australian Blue Book.* 2nd edn. Vicrete Investments, Sydney, 1949, pp. 688-9.

'Paintings and Drawings'. Melbourne City Council Olympic Civic Committee. *The Arts Festival of the Olympic Games Melbourne: a guide to the exhibition with introductory commentaries on the Arts in Australia.* The Olympic Organizing Committee, Melbourne, 1956, pp. 18-25.

'Museums and galleries' and 'Visual aids'. A. Grenfell Price (ed.). *The Humanities in Australia: A Survey with Special Reference to the Universities.* Angus and Robertson, Sydney, 1959, pp. 201-11, 219-24.

'William Westall's drawings and paintings on Flinders' voyage'. William Westall. *Drawings.* (Ed.) T. M. Perry and Donald H. Simpson. Royal Commonwealth Society, London, 1962, pp. 23-8.

'Augustus Earle' and 'John Glover'. *Australian Dictionary of Biography*, vol. 1, 1788-1850, A-H. Melbourne University Press, Melbourne, 1966, pp. 248-9, 455-6.

'Sir Oswald Brierly'. *Australian Dictionary of Biography*, vol. 3, 1851-1890, A-C. Melbourne University Press, Melbourne, 1969, pp. 230-1.

'Summary of discussions – the Visual Arts'. *Criticism in the Arts.* Australian UNESCO Seminar. Australian National Advisory Committee for UNESCO, Canberra, 1970, pp. 93-4.

'Australian art' and 'Topographical art'. H. Osborne (ed.). *The Oxford Companion to Art.* Clarendon Press, Oxford, 1970, pp. 91-5, 1146-8.

'Art and architecture'. Venturino G. Venturini (ed.). *Australia A Survey.* Harrassowitz, Wiesbaden, 1970, ch. 26, pp. 525-39.

'On perceiving the Australian suburb'. Rosemary Dobson (ed.). *Australian Voices: Poetry and Prose of the 1970's.* Australian National University Press, Canberra, 1975, pp. 106-19.

Preface to Christopher Tadgell. *Merric Boyd Drawings. Introduction and Catalogue.* Secker and Warburg, London, 1975.

'Art marketing in Sydney 1970-75'. Peter Quartermaine (ed.). *Readings in Australian Arts: Papers from the 1976 Exeter Symposium.* University of Exeter, Exeter, 1978, pp. 74-83.

'The mode of production suited to human beings'. Sue Clark and Lee Emery (eds). *Communicating Arts.* Australian International P. & Pub., Melbourne, 1978, pp. 70-1. (Previously published in *Habitat* and *The Great Divide* under different titles. See section on Periodical Articles.)

'How provincial is Australian culture?' Deakin University, Open Campus Program, School of Humanities. *Regionalism and Australia. Questions and Approaches. Study Guide A.* The University, Geelong, 1979, ch. 5, pp. 92-109.

'Cook's posthumous reputation'. R. Fisher and H. J. M. Johnston (eds). *Captain James Cook and his Times.* Douglas and McIntyre, Vancouver, 1979, pp. 159-85.

PAMPHLETS AND CONTRIBUTIONS TO PAMPHLETS

(Editor of Catalogue). *First Exhibition of the Teachers' College Art Club August, 1938.* The College, Sydney, 1938.

(Editor). The Teachers' Federation Art Society. *Official Year Book.* The Federation, Sydney, 1939.

(Editor and Preface). The Teachers' Federation Art Society. *A series of twenty fortnightly lectures and discussions.* The Society, Sydney, 1940.

(Editor). *The Art of Today and Yesterday. A series of lectures and discussions for 1941.* The Teachers' Federation Art Society, Sydney, 1941.

(Editor of catalogue). *The third exhibition of the Teachers' Federation Art Society from 2nd September 1941 to 22nd September 1941.* The Federation, Sydney, 1941.

(Introduction). *One Hundred and Fifty Years of Painting in Australia.* National Art Gallery and Department of Education of New South Wales Travelling Art Exhibition, no. 1, Feb.– June, 1945, pp. 3-8. Government Printer, Sydney, 1945.

National Art Gallery of N.S.W. *Exhibition of Australian Art.* Second Series 1945-46. The Gallery, Sydney, 1946.

Art in the Country. National Art Gallery of N.S.W., Sydney, 1946. (31 pp., illus.).

(Introduction). *Australian Watercolours from the National Art Gallery Collection 1836 to 1946*, pp. 3-6. The Gallery, Sydney, 1946.

(Foreword). *3rd Annual Exhibition by the Studio of Realist Art in David Jones' Art Gallery from August 18 to August 31.* Sydney, 1948.

Australian Painting Today. The John Murtagh Macrossan Lecture, 1961. University of Queensland Press, Brisbane, 1962. (32 pp.).

(Introduction to Catalogue). *John Perceval. Canberra Exhibition.* Australian National University, Canberra, 1966.

(Introduction to Catalogue). *Clifton Pugh, An Exhibition presented by Qantas Airways, Auckland, May 16-27, 1966.*

'Sculpture abroad'. *Mildura Prize for Sculpture, 1967.* Mildura Arts Centre, 1967, pp. 41-3.

'Statement by Professor Bernard Smith'. Paddington Society. *Paddington, a Plan for Preservation*, The Society, Paddington, October, 1970, pp. 48-51.

National Library of Australia. *The Rex Nan Kivell Room.* The Library, Canberra, 1974. (Contains text of opening address delivered by Bernard Smith on 4 April 1974.)

PERIODICAL ARTICES

'Some aspects of contemporary art in Australia'. *Education, Official Organ of the N.S.W. Public School Teachers' Federation.* The Federation, 22 February 1943, pp. 85-6.

'The New Realism in Australian Art'. *Meanjin Papers*, 3 (1), 1944, pp. 20-5.

'Art Chronicle'. *Meanjin Papers*, 4 (2), 1945, pp. 107-8.

'Encouragement of art'. *Australian New Writing*, no. 3, February 1945, pp. 23-7.

'Art exhibitions in country centres'. *Society of Artists' Book*, 1945-46, pp. 27-31.

'Art Chronicle'. *Meanjin Papers, 5* (1), 1946, pp. 48-9.

'Roderick Shaw'. *Progress, 1*(30), March 1946, pp. 52-3.

'The Art Museum today'. *Meanjin Papers, 5* (2), 1946, pp. 129-32.

'The Fascist mentality in Australian art'. *Communist Review*, no. 58, June 1946, pp. 182-4; July 1946, pp. 215-6. (Under pseudonym 'Goya').

'Comments on style-change and criticism in Sydney'. *Society of Artists Year Book* (Sydney), 1946-47, pp. 47-54.

'Art and the environment in Australia'. *The Geographical Magazine, 19*, January 1947, pp. 398-409.

'The art of Eric Wilson'. *Meanjin, 6* (4), 1947, pp. 245-8.

'The nature of Realist Art'. *SORA* (Studio of Realist Art) Bulletin, August 1947. (No pagination.)

'The English portraits of William Dobell'. *ARNA. Journal of the Faculty of Arts* (University of Sydney), October 1947, pp. 19-23.

'Henry Moore'. *Hermes, Magazine of the University of Sydney*, 1948, pp. 47-53.

'Archibald, Wynne and Sulman Awards'. *Meanjin, 7* (1), 1948, pp. 28-30.

'The art of Sali Herman'. *Meanjin, 8* (3), 1948, pp. 172-6.

'European vision of the South Pacific'. *Journal of the Warburg and Courtauld Institutes, 13*, 1950, pp. 65-100.

'The artist's vision of Australia'. *The Listener, 44* (1135), 30 November 1950, pp. 631-3.

'Fifty years of painting in Australia'. *Meanjin, 10* (4), 1951, pp. 354-8.

'Art Chronicle. Australian Expressionism'. *Meanjin, 11* (3), 1952, pp. 256-8.

'Art in the dog-days'. *Meanjin, 12* (1), 1953, pp. 55-8.

'The French Art Exhibition'. *Meanjin, 12* (2), 1953, pp. 165-74.

'Carping the critics'. *Voice* (Sydney), 2 (8), March 1953, p. 28.

'Archibald, Wynne and the Sulman awards for 1953'. *Meanjin, 13* (1), 1954, pp. 106-8.

'John Russell: Australia's unknown artist'. *Meanjin, 15* (4), 1956, pp. 352-6.

'Coleridge's Ancient Mariner and Cook's second voyage'. *Journal of the Warburg and Courtauld Institutes, 19*, 1956, pp. 117-54.

'Notes on the life of Charles Doutney'. *Meanjin, 16* (4), 1957, pp. 420-4.

'The Antipodeans'. *Australia Today*, no. 55, 14 October 1959, pp. 77-81, 104.

'Evolution and Australian nature'. *Meanjin, 18* (1), 1959, pp. 83-7.

'Art education today'. *Victorian Teachers' Union Journal*, August 1959, pp. 221-4.

'David Boyd in Adelaide'. *Nation*, no. 46, June 18, 1960, pp. 16-17.

'Image and meaning in recent painting'. *The Listener, 68* (1738), 19 July 1962, pp. 93-5.

'Nolan's image'. *The London Magazine, 2* (6), September 1962, pp. 69-74.

'William Morris and the 20th Century'. *Dissent* (Melbourne), 3 (4), Summer 1963, pp. 28-30.

'Sir Herbert Read and the Power Bequest'. *Meanjin Quarterly, 23* (1), 1964, pp. 37-50.

'Art and modern culture. The Power Bequest'. *Hemisphere, 11* (12), December 1967, pp. 2-5.

'The Melbourne Géricault'. *Art Bulletin of Victoria*, 1967-68, pp. 5-11; 1968-69, pp. 16-23.

'The role of an Institute of Fine Arts in the University of Sydney'. *ARTS: the Journal of the Sydney University of Arts Association*, 6, 1969, pp. 5-17. (Inaugural lecture.).

'The art museum and the university'. *Art Galleries Association of Australia Bulletin*, 1969, pp. 4-11.

'Sydney's Power Institute of Fine Arts'. *Studio International, 180* (926), October 1970, pp. 142-4.

'The University and its neighbourhood'. *The Union Recorder, 51* (10), 6 May 1971, pp. 3-5.

'Art in a mystical tradition: Arthur Boyd'. *Hemisphere, 16* (4), April 1972, pp. 18-25.

'Is this the product of a boorish Australia?' (The B.H.P. Art Collection). *B.H.P. Journal*, Autumn 1973, pp. 16-21.

'Making of the future'. *The Spode House Review, 10* (111), February 1974, pp. 17-25.

'Art and industry: a systematic approach'. *Studio International, 187* (965), April 1974, pp. 158-63.

'Notes on élitism in the arts'. *Meanjin Quarterly, 34* (2), 1975, pp. 117-20.

'Modern Masters—Manet to Matisse'. *Art and Australia, 13* (1), 1975, pp. 69-77.

'The teaching of Fine Arts in Australian Universities'. *The Australian University, 13* (1), May 1975, pp. 8-18.

'Death of the artist as hero'. *Meanjin, 36* (1), 1977, pp. 25-41.

'Old painting—new furore'. *The Bulletin, 99* (5060), 4 June 1977, pp. 48-55.

'Art and craft are going back to the people'. *Habitat, 5* (4), November 1977, pp. 7-9. Reprinted as 'Community art workshops'. Charles Merewether and Ann Stephen (eds). *The Great Divide*, Melbourne, 1977, pp. 140-1.

BOOK REVIEWS

Review of *Elioth Gruner*. The Shepherd Press, Sydney, 1948. *Meanjin, 7* (4), 1948, pp. 273-4.

Review of S. Ure Smith (ed.). *Adrian Feint Flower Paintings*. Ure Smith, Sydney. *Australian Books, 2* (9), October 1948, pp. 32-3.

'Island revels'. *Southerly, 10* (1), 1949, pp. 53-5. (A review of Douglas Stewart's *Shipwreck: a poetic drama*. The Shepherd Press, Sydney, 1947.).

Review of M. H. Ellis. *Francis Greenway His Life and Times*. Angus and Robertson, Sydney. *Historical Studies: Australia and New Zealand, 6* (24), May 1955, pp. 486-7.

Review of Robert Crossland. *Wainwright in Tasmania*. Oxford University Press, Melbourne, 1954. *Historical Studies: Australia and New Zealand, 7* (25), November 1955, pp. 107-8.

Review of J. C. Beaglehole (ed.). *The Journals of Captain James Cook on his Voyages of Discovery*, vol. 1, *The Voyage of the Endeavour, 1768-1771*. Cambridge University Press, 1955. *Historical Studies: Australia and New Zealand, 7*, 1957, pp. 480-2.

Review of Ursula Hoff. *Charles Conder: His Australian Years*. National Gallery Society of Victoria, Melbourne. *Meanjin, 19* (4), 1960, pp. 446-9.

'The London myth about art in Australia'. The *Age* (Melbourne), 24 August 1963, p. 19. (Review of John Douglas Pringle. *Australian Painting Today*. Thames and Hudson, London.).

'Some books on art'. The *Age* (Melbourne), 31 August 1963, p. 19. (Reviews of Giorgio Vasari. *Lives of the Painters, Sculptors and Architects*. Everyman; and Robert Campbell. *Paintings of Tom Roberts*. Rigby, Adelaide.).

'Illustrations do not make an art journal'. The *Age* (Melbourne), 5 October 1963, p. 21. (Review of *Art and Australia*, vol. 1, no. 2. Ure Smith, Sydney.).

'Difficulties and triumphs of the Felton Bequest'. The *Age* (Melbourne), 15 November 1963, p. 23. (Review of Sir Daryl Lindsay. *The Felton Bequest: An Historical Record 1904-1959*. Oxford University Press, Melbourne.).

Review of Elwyn Lynn. *Contemporary Drawing*; and of John Reed. *New Painting 1952-1962*. Longmans, Melbourne. *Quadrant, 7* (4), 1963, pp. 77-9.

'Profiles of forty living artists of Australia'. The *Age* (Melbourne), 23 November 1963, p. 21. (Review of John Hetherington. *Australian Painters: Forty Profiles*. Cheshire, Melbourne.).

'A professor's fourteen essays on the theory of art'. The *Age* (Melbourne), 29 February 1964, pp. 23-4. (Review of E. H. Gombrich. *Meditations on a Hobby Horse*. Phaidon, London.).

'Berenson: The last decade of enjoyment'. The *Age* (Melbourne), 2 May 1964, p. 23. (Review of N. Mariano (ed.). *Bernard Berenson: Sunset and Twilight*. Hamish Hamilton, London.).

'Recent art journals'. The *Age* (Melbourne), 23 May 1964, p. 22.

'Education and the Artist'. The *Age* (Melbourne), 5 September 1964, p. 39. (Review of Herbert Read. *Art and Education*. Cheshire, Melbourne.).

'John Ruskin's influence'. The *Age* (Melbourne), 30 January 1965, p. 39. (Review of John D. Rosenberg (ed.). *The Genius of John Ruskin*. Allen & Unwin, London, 1964; and Kenneth Clark (ed.). *Ruskin Today*. Murray, London, 1964.).

'Old Masters retold'. The *Age* (Melbourne), 20 February 1965, p. 39. (Review of Elizabeth Ripley. *Gainsborough*. Oxford University Press.).

'Cézanne: Loneliness into creation'. The *Age* (Melbourne), 3 July, 1965, p. 23. (Review of Kurt Badt, *The Art of Cézanne*, Faber, London.).

'Nolan as mythmaker'. The *Bulletin*, 89 (4570), 7 October 1967, pp. 77-9. (Review of Elwyn Lynn. *Sydney Nolan: Myth and Imagery*. Macmillan, London.).

'Architecture in Australia'. *Historical Studies: Australia and New Zealand*, 14 (53), October 1969, pp. 85-92. (Review of J. M. Freeland. *Architecture in Australia*. Cheshire, Melbourne.).

Review of C. B. Christesen (ed.). *The Gallery on Eastern Hill: the Victorian Artists' Society Centenary*. The Society, Melbourne, 1970. *Historical Studies*, 15 (59), October 1972, pp. 472-4.

Review of Donald F. Lach. *Asia in the Making of Europe*, vol. 2, *A Century of Wonder*. *Book 1: The Visual Arts*. Chicago University Press, Chicago, 1970. *The American Historical Review*, 77 (2), April 1972, pp. 482-4.

Review of Robert Hughes. *The Art of Australia*, Penguin, Harmondsworth, 1970. *Historical Studies*, 15 (6), October 1973, pp. 777-80.

Review of Leonard B. Cox. *The National Gallery of Victoria 1861 to 1868. A Search for a Collection*. The Gallery, Melbourne, 1971. *Historical Studies*, 16 (62), April 1974, pp. 152-3.

Review of Geoffrey Serle. *From Deserts the Prophets Come: The Creative Spirit in Australia 1788-1972*. Heinemann, Melbourne, 1973. *Historical Studies*, 16 (63), October 1974, pp. 289-91.

Review of M. Mahood. *The Loaded Line: Australian Political Caricature 1788-1901*. Melbourne University Press, Melbourne, 1973. *Australian Journal of Politics and History*, 20 (3), December 1974, p. 430.

Review of Peter Blake. *Architecture of the New World. The Work of Harry Seidler*. Horwitz, Sydney. The *Sydney Morning Herald*, 22 February 1975, p. 15.

Review of Max Dimmack. *Noel Counihan*. Melbourne University Press, Melbourne. *Overland*, 62, Spring 1975, pp. 78-80.

Review of John Hetherington. *Norman Lindsay: The Embattled Olympian*. Oxford University Press, Melbourne, 1973. *Australian Journal of Politics and History*, 21 (2), 1975, pp. 122-3.

Review of Australian Council of National Trusts. *Historic Houses of Australia*. Cassell,

Melbourne, 1974. *Journal of the Royal Australian Historical Society*, *61* (2), June 1975, pp. 139-40.

Review of Michael Hoare. *The Tactless Philosopher*. Hawthorn Press, Melbourne. *Canberra Times*, 4 September 1976, p. 10.

Review of Ronald Meek. *Social Science and the Ignoble Savage*. Cambridge University Press, 1976. *Historical Studies*, *17* (68), April 1977, pp. 408-10.

Review of Joseph Burke. *English Art 1714-1800*. Clarendon Press, Oxford. *Art and Australia*, *15* (2), December 1977, pp. 150-1.

Review of Kym Bonython. *Modern Australian Painting 1970-75*. Rigby, Adelaide.*Times Literary Supplement*, no. 3963, 10 March 1978, p. 290.

'In a particular light'. *Times Literary Supplement*, no. 3697, 14 April 1978, p. 423. (Review of Elwyn Lynn. *Australian Landscape Painting*. Sydney, Bay Books.).

Review of Ann Galbally. *The Art of John Peter Russell*. Sun Books, Melbourne, 1977. *Art and Australia*, *16* (1), Spring-September 1978, pp. 35-6.

ART CRITICISM IN NEWSPAPERS

'The carp of the critic'. *Honi Soit* (Sydney), 15 May 1947, pp. 6-7.

'Bernard Smith reviews the exhibition'. *Honi Soit* (Sydney), 12 June 1947, p. 5. (Australian University Students National Art Exhibition).

'Great display of recent British sculpture'. The *Age* (Melbourne), 23 July 1963, p. 5.

'New and familiar styles in art'. The *Age* (Melbourne), 30 July 1963, p. 5. (Duncan Grant, Ken Whisson, William Peascod, Maurice Carter, Ambrose Griffin, Mel Underwood, Philip Luton).

'Only one exhibition of real interest'. The *Age* (Melbourne), 6 August 1963, p. 5. (Edward Heffernan).

'Serenity in the work of contemporary artists'. The *Age* (Melbourne), 13 August 1963, p. 5. (Melbourne Contemporary Artists).

'Zest of Spring touches the exhibition'. The *Age* (Melbourne), 20 August 1963, p. 5. (Helen Maudsley, Sam Atyeo).

'Wheeler holds up the mirror to nature'. The *Age* (Melbourne), 3 September 1963, p. 5. (Charles Wheeler, Joy Hester, Morris Davis, Bernard Gordon).

'The accent is on youth in this week's shows'. The *Age* (Melbourne), 27 August 1963, p. 5. (Lindsay Edward, Robert Rooney, Joe Rose, The Young Mind, Urban Woman).

'Wealth of interest in Melbourne exhibitions'. The *Age* (Melbourne), 10 September 1963, p. 5. (Australian and New Zealand Pottery, June Stephenson, Dawn Sime, Eskimo Stonecut Prints, Robert Grieve, Victorian Artists' Society, Nikolaus Seffrin).

'Pots, prints, posters for home and industry'. The *Age* (Melbourne), 17 September 1963, p. 5. (Australian and New Zealand Pottery, Studio One Printmakers, Australian Commercial and Industrial Artists' Association, Nora Foy).

'Francis Lymburner shows his mastery'. The *Age* (Melbourne), 24 September 1963, p. 5. (Includes the Blue Brush Group and others).

'Large exhibition by William Frater'. The *Age* (Melbourne), 1 October 1963, p. 5. (Also incl. reviews of exhibitions by Alan Brisbane, Philip Dains, Howard Sparks and others).

'Olsen and French give opportunity to compare'. The *Age* (Melbourne), 8 October 1963, p. 5. (Also incl. reviews of exhibitions by Jacob Pins, Donald Laycock, John Powell).

'Sculpture exhibition and new gallery'. The *Age* (Melbourne), 15 October 1963, p. 5. (Norma Redpath, Museum of Modern Art and Design of Australia, Victorian Sculptors' Society, Graham Cantieni, Geoff La Gerche and others).

'Change of vision from sojourns overseas'. The *Age* (Melbourne), 22 October 1963, p. 5. (Moya Dyring and Erica McGilchrist).

'Nature invariably makes comeback'. The *Age* (Melbourne), 29 October 1963, p. 5. (Maximilian Feuerring, David Kwiatkowski, Ray Crooke, Ronald Millar).

'Japanese influence shows this week'. The *Age* (Melbourne), 5 November 1963, p. 5.

'Paintings of distinction found among shows'. The *Age* (Melbourne), 12 November 1963, p. 5. (Phyl Waterhouse, Blake Prize, Ian Burn).

'Human figure remains a central figure'. The *Age* (Melbourne), 19 November 1963, p. 5. (James Gleeson, Marc Clarke, Robert Langley, Viscount Collection, Alan Ickeringill).

'Pottery prominent in week's exhibitions'. The *Age* (Melbourne), 26 November 1963, p. 5. (Frederick Olsen, Robert Hughan, Klytie Pate, Newman College Loan Exhibition, Tor Schwanck and others).

'Junk yard sculpture has a beauty of its own'. The *Age* (Melbourne), 2 December 1963, p. 5. (Robert Klippel, Tom Sanders, Murray Walker, Michael Goss, The Holly Group and others).

'The importance of a modern art museum'. The *Age* (Melbourne), 10 December 1963, p. 5. (Museum of Modern Art and Design Exhibition, A. W. Harding, Geoffrey Hopper, Mary Atkins, Johnson Lee).

'Sculpture beginning to gain some respect'. The *Age* (Melbourne), 17 December 1963, p. 5. (Tom Bass, Pino Conte).

'Extravagant claim not realised'. The *Age* (Melbourne), 18 December 1963, p. 5. (Peter Upward).

'Better industrial design for our products'. The *Age* (Melbourne), 4 January 1964, p. 17.

'Tasmanian artist takes prize after many years'. The *Age* (Melbourne), 18 January 1964, p. 5.

'Child art from 70 countries on show'. The *Age* (Melbourne), 11 February 1964, p. 5.

'Woodcuts from the hand of a master on show'. The *Age* (Melbourne), 18 February 1964, p. 5. (Shiko Manakata, Phillip Sutton, Alun Leach-Jones).

'Abstraction has its moment of triumph'. The *Age* (Melbourne), 26 February 1964, p. 5.

'Distorted picture of Australian painting'. The *Age* (Melbourne), 4 March 1964, p. 5. (Australian Painting Today Exhibition, Michael Brown).

'Two sensitive shows are welcome relief'. The *Age* (Melbourne), 11 March 1964, p. 5. (Margaret Olley, David Armfield, Peggy Fauser).

'Adelaide gives art a boost'. The *Age* (Melbourne), 14 March 1964, p. 23. (Adelaide Arts Festival).

'Change of style seen in Charles Blackman show'. The *Age* (Melbourne), 18 March 1964, p. 5.

'Religious show is a promising venture'. The *Age* (Melbourne), 25 March 1964, p. 5.

'Two exhibitions by mature artists'. The *Age* (Melbourne), 1 April 1964, p. 5 (Fred Williams and Michael Shannon).

'International flavor in wide exhibition range'. The *Age* (Melbourne), 8 April 1964, p. 5. (Hans Erni, Jaime del Poso, Ojars Bisenieks, Clytie Lloyd Jones and others).

'Print-making enjoys revival in Australia'. The *Age* (Melbourne), 15 April 1964, p. 5.

'Sepik highlight of exotic exhibitions'. The *Age* (Melbourne), 22 April 1964, p. 5 (Sepik River Art, James Daly, Reginald Ross Williamson, Sonya Weinfeld).

'Visual criticisms of our urban life'. The *Age* (Melbourne), 29 April 1964, p. 5 (Colin Lanceley, Albert Tucker).

'Australian Sculpture gathers strength'. The *Age* (Melbourne), 25 April 1964, p. 7.

'Rare Arthur Boyd works on show'. The *Age* (Melbourne), 6 May 1964, p. 5. (Arthur

Boyd, Clifton Pugh, Owen Piggott, Normie Gude, Alastair Gray, Allan Bernaldo).

'Lively Autumn Show by Artists' Society'. The *Age* (Melbourne), 13 May 1964, p. 5. (Victorian Artists' Society).

'Print displays are most rewarding'. The *Age* (Melbourne), 20 May 1964, p. 5 (Jan Senbergs, Leonas Urbonas, Max Dimmack, Reg Parker).

'Carl Plate reaches his abstract goal'. The *Age* (Melbourne), 27 May 1964, p. 5 (Carl Plate, Sam Middleton, David Kwiatkowski, Max Ragless).

'Gothic work display is outstanding'. The *Age* (Melbourne), 3 June 1964, p. 5. (Gothic Art, Helen Ogilvie and others).

'Vitality springs from many sources'. The *Age* (Melbourne), 10 June 1964, p. 5 (John Coburn, David Boyd and others).

'Baldessin sculpture a welcome change'. The *Age* (Melbourne), 17 June 1964, p. 5.

'400 years through artists' eyes'. The *Age* (Melbourne), 24 June 1964, p. 5. (*Scenes from Everyday Life*, National Gallery of Victoria).

'Display emphasises drawing's value'. The *Age* (Melbourne), 1 July 1964, p. 5. (Francis Lymburner, S. Ostoja-Kotowski, Judy Cassab and others).

'Opportunity to see true folk work'. The *Age* (Melbourne), 15 July 1964, p. 5. (*Eskimo Art*, National Gallery of Victoria).

'Distinctive artist of younger generation'. The *Age* (Melbourne), 8 July 1964, p. 5. (Richard Crichton).

'Some magic is missing from Perceval'. The *Age* (Melbourne), 22 July 1964, p. 5 (John Perceval and others).

'Direct positive color and structure'. The *Age* (Melbourne), 29 July 1964, p. 5 (Gareth Jones-Roberts and others).

'Dobell: his art and his story'. The *Age* (Melbourne), 1 August 1964, p. 21. (Reviews of Dobell retrospective at Art Gallery of New South Wales and of James Gleeson. *William Dobell*. London, Thames and Hudson.).

'Fine tribute paid to Felton adviser'. The *Age* (Melbourne), 5 August 1964, p. 5. (A. J. L. McDonnell purchases; Bob Haberfield, Jon McMahon).

'Australian landscape in lively hands'. The *Age* (Melbourne), 12 August 1964, p. 5. (David Newbury, Ben Kypridakis, Julian Smith).

'Paintings to rouse spirit of all'. The *Age* (Melbourne), 19 August 1964, p. 5 (Jean Bellette, Eric Smith and others).

'Young painter's style is vigorous to the point of brutality'. The *Age* (Melbourne), 26 August 1964, p. 5. (Dale Hickey, Emanuel Raft, Garry Shead and others).

'Laurence Daws' work is impressive'. The *Age* (Melbourne), 2 September 1964, p. 5.

'Art and the Young Mind' (letter). The *Age* (Melbourne), 4 September 1964, p. 2.

'Own style fashioned from abstract'. The *Age* (Melbourne), 9 September 1964, p. 5 (Arch Cuthbertson, John Rigby and others).

'Great improvement in year by O'Loughlin'. The *Age* (Melbourne), 22 September 1964, p. 5. (Geoff O'Loughlin and others).

'Expanses of colour which are suave and easy on the eye'. The *Age* (Melbourne), 30 September 1964, p. 5. (Henry Salkauskas).

'Handsome pottery has purposeful air'. The *Age* (Melbourne), 7 October 1964, p. 5. (Peter Laycock, Michael Kmit and others).

'Brown's show most original for year'. The *Age* (Melbourne), 14 October 1964, p. 5. (Michael Brown, Rodney Milgate and others).

'Sculptors' show is highlight of crowded week'. The *Age* (Melbourne), 21 October 1964, p. 5. (Victorian Sculptors' Society).

'Much improvement in Sam Fullbrook exhibition'. The *Age* (Melbourne), 28 October 1964, p. 6. (Sam Fullbrook and others).

'Fine reproductions of Australian art for classrooms'. The *Age* (Melbourne), 4 November 1964, p. 5.

'Abstracts in red and black'. The *Age* (Melbourne), 11 November 1964, p. 5. (Graham Cantieni and others).

'Great comparison in exhibitions'. The *Age* (Melbourne), 18 November 1964, p. 5.

'Poverty reputation of Gallery'. The *Age* (Melbourne), 25 November 1964, p. 5 (Felton Bequest acquisitions).

'Finest showing kept until very late'. The *Age* (Melbourne), 2 December 1964, p. 5. (Constance Stokes and others).

'Promising figurative painters on show'. The *Age* (Melbourne), 9 December 1964, p. 5. (Anthony Woods and Kevin Connor).

'Well-displayed show at Gallery A'. The *Age* (Melbourne), 16 December 1964, p. 5.

'Art judges withhold Archibald Prize Award'. The *Age* (Melbourne), 23 January 1965, p. 5.

'Masters of drawing'. The *Age* (Melbourne), 23 January 1965, p. 39. (Review of National Gallery of Victoria. *The Art of Drawing*).

'Survey exhibitions open the year in most city galleries'. The *Age* (Melbourne), 17 February 1965, p. 5.

'Selected 21 cover wide range'. The *Age* (Melbourne), 24 February 1965, p. 5. (Roger Kemp, Jean Bellette, Richard Crichton, Michael Kitching, Asher Bilu and others).

"Gallery surveys for Moomba week'. The *Age* (Melbourne), 3 March 1965, p. 5.

'Minor masterpiece of presentation'. The *Age* (Melbourne), 10 March 1965, p. 5. (Leonard Crawford, Leonard French, George Johnson, Roger Kemp, Jan Senbergs).

'"Naive" painters in novel exhibition'. The *Age* (Melbourne), 18 March 1965, p. 5.

'Solutions to bad design in industry'. The *Age* (Melbourne), 24 March 1965, p. 5. (Design 65, Museum of Modern Art and Design of Australia).

'Mordant perception in Brack work'. The *Age* (Melbourne), 31 March 1965, p. 5 (John Brack and others).

'Achieves results in water colour'. The *Age* (Melbourne), 7 April 1965, p. 5. (Len Annois and others).

'New £500 award raises standards'. The *Age* (Melbourne), 14 April 1965, p. 5.

'Provocation and courage on canvas'. The *Age* (Melbourne), 21 April 1965, p. 5. (Gareth Sansom, Peter Burns).

'Fascinating shows afford style study'. The *Age* (Melbourne), 28 April 1965, p. 5. (Kevin Connor, Tate Adams and others).

'Little to attract young painters'. The *Age* (Melbourne), 5 May 1965, p. 5. (Victorian Artists' Society. Autumn Exhibition, Brian Kewley, Bernard Hesling and others).

'Central conflict of form and figure'. The *Age* (Melbourne), 19 May 1965, p. 5 (R. Haughton James, Greg Irvine and others).

'Quiet dignity in vision of nature'. The *Age* (Melbourne), 26 May 1965, p. 5 (Audrey Snell, Michael Kmit and others).

'Better standard and more varied'. The *Age* (Melbourne), 2 June 1965, p. 5. (Fred Cress, Neville Matthews, Ladislas Kardos and others).

'Fine chance for study of detail'. The *Age* (Melbourne), 9 June 1965, p. 5. (Charles Bush, Jan Riske and others).

'Sumptuous colour of the decorator'. The *Age* (Melbourne), 16 June 1965, p. 5. (John Olsen and others).

'Tribute paid to leader of moderns'. The *Age* (Melbourne), 23 June 1965, p. 5. (George Bell and others).

'Magical touch in show of sculptures'. The *Age* (Melbourne), 30 June 1965, p. 5. (Bob Parr, Ojars Bisenieks, Desiderius Orban and others).

'Struggle to find own style'. The *Age* (Melbourne), 7 July 1965, p. 5. (Tony Underhill, Ronald Millar, Roger Gee, Clifford Bayliss).

'Picasso—and our neglect'. The *Age* (Melbourne), 14 July 1965, p. 5.

'An exhibition of color contrasts'. The *Age* (Melbourne), 21 July 1965, p. 5. (John Perceval, Sydney Ball, Geoff La Gerche, Margaret Dredge and others).

'The conquest of a fresh field'. The *Age* (Melbourne), 28 July 1965, p. 5. (Arthur Boyd and others).

'The Spanish School reflected by a craftsman'. The *Age* (Melbourne), 4 August 1965, p. 5. (Peter Clarke, William Drew, David Tolley, Bruce Tolley, Jennifer Purnell).

'Exhibitions worthy of Spring'. The *Age* (Melbourne), 1 September 1965, p. 5. (Paul Partos, Fred Coventry and others).

'Textures measure a skill'. The *Age* (Melbourne), 8 September 1965, p. 5.

'Rare opportunity presented'. The *Age* (Melbourne), 15 September 1965, p. 5. (Ian Fairweather and others).

'Nolan (without heroes) in trouble'. The *Age* (Melbourne), 22 September 1965, p. 5. (Sidney Nolan and others).

'Wit, intelligence and skill'. The *Age* (Melbourne), 29 September 1965, p. 5. (Donald Friend, William Peascod and others).

'Optical painting fascinates'. The *Age* (Melbourne), 6 October 1965, p. 5. (Frank Eidlitz, Donald Laycock and others).

'Four displays—and each is first rate'. The *Age* (Melbourne), 13 October 1965, p. 5. (Pino Conte and others).

'Craft-entertaining mixture'. The *Age* (Melbourne), 20 October 1965, p. 5. (Arts and Crafts Society of Victoria; Sheila McDonald; Nora Foy, Robert Sperring).

'From a Cubist of distinction'. The *Age* (Melbourne), 10 November 1965, p. 5. (Jacques Lipchitz and others).

'Eltham, a colony of busy artists'. The *Age* (Melbourne), 17 November 1965, p. 5.

'Bright aesthetic riddles'. The *Age* (Melbourne), 24 November 1965, p. 5. (Edwin Tanner, L. Hirschfeld-Mack, Dick Ovendon, Robert Dickerson and others).

'Period flavor in show by three Sydney painters'. The *Age* (Melbourne), 1 December 1965, p. 5. (Stan Rapotec, William Rose, Tom Gleghorn and others).

'Talent fresh from a classroom'. The *Age* (Melbourne), 8 December 1965, p. 5. (Gerald Bland, John Bursill, Douglas Wright and others).

'Lively show minus gimmicking'. The *Age* (Melbourne, 15 December 1965, p. 5. (Gallery A, Paddington Exhibition).

'New notes are a let down'. The *Age* (Melbourne), 11 January 1966, p. 2.

'Vitality shows through conservatism'. The *Age* (Melbourne), 9 February 1966, p. 5.

'Fine Dobell work on display'. The *Age* (Melbourne), 16 February 1966, p. 5.

'Portrait prize has new spirit'. The *Age* (Melbourne), 23 February 1966, p. 5.

'"Super-man" work impressive'. The *Age* (Melbourne), 2 March 1966, p. 5. (Jan Riske and others).

'The keynote is experiment'. The *Age* (Melbourne), 9 March 1966, p. 5. (Gareth Jones-Roberts and others).

'From Czechoslovakia, a timid touch'. The *Age* (Melbourne), 16 March 1966, p. 5.

'Show by Charles Blackman rich and varied'. The *Age* (Melbourne), 23 March 1966, p. 5.

'Anti-conscription angle of German artist'. The *Age* (Melbourne), 30 March 1966, p. 5. (Udo Sellbach and others).

'Local prophet worthy of more honour'. The *Age* (Melbourne), 6 April 1966, p. 5. (Roger Kemp and others).

'1754 portrait put on show'. The *Age* (Melbourne), 13 April 1966, p. 5. (François Boucher. *Madame de Pompadour*, 1754).

'Magnificent display of tapestries'. The *Age* (Melbourne), 20 April 1966, p. 5.

'Pottery relics from an older London'. The *Age* (Melbourne), 27 April 1966, p. 5. (English medieval pottery, Albert Tucker and others).

'A painter relates—and pleases'. The *Age* (Melbourne), 4 May 1966, p. 5. (Michael Shannon, Anton Holzner, Anne Graham and others).

'Unusual and original one-man show'. The *Age* (Melbourne), 11 May 1966, p. 5. (Michael Dulic and others).

'Display by outstanding painter from N.Z.'. The *Age* (Melbourne), 24 May 1966, p. 5. (Michael Smither, Tom Gleghorn and others).

'World art on show'. The *Age* (Melbourne), 16 July 1966, p. 21. (Review of 33rd Venice Biennale).

'Greco gives renewal to the past'. The *Age* (Melbourne), 18 May 1966, p. 5.

MISCELLANEOUS

'The days are balanced rocks' (poem). *Meanjin Papers*, 2, (12), 1943, p. 27.

'Dry Dock' (poem). *Australian New Writing*, no. 1, 1943, p. 23.

'The Tower', 'To Henry Lawson' (two poems). *Voices. A Quarterly of Poetry*. Australian issue ed. by Harry Roskolenko and Elizabeth Lambert, no. 118, Summer 1944, pp. 35-6.

'Opportunity School' (poem). *Poetry: The Australian International Quarterly of Verse*, no. 17, 1945, p. 13.

'To Henry Lawson' and 'And so we come to the Present' (poems). Marjorie Pizer (ed.). *Freedom on the Wallaby: Poems of the Australian People*. Pinchgut Press, Sydney, 1953, pp. 189, 197.

'Waterfront at Glebe' (letter). The *Sydney Morning Herald*, 15 September 1970, p. 2.

'Will black wattles bloom in Blackwattle Bay?'. The *Sydney Morning Herald*, 26 September 1970, p. 21.

'A house with a history' ('Lyndhurst'). The *Sydney Morning Herald*, 26 February 1972, p. 20.

'Lyndhurst' (letter). The *Sydney Morning Herald*, 22 March 1972, p. 6. (With Archbishop James Freeman, R. N. Johnson, D. B. Knox, K. J. Cable).

'Impending move for art students' (letter). The *Sydney Morning Herald*, 5 July 1974, p. 6.

'New hope in the world of the arts'. *Age National Review*, 29 July 1974, p. 12.

'Alternative freeway route' (letter). The *Sydney Morning Herald*, 11 October 1974, p. 6.

'Kicking the avant garde can'. The *Australian*, 22 February 1975, p. 16.

'The way of the Sun King or the Czarina'. The *Australian*, 1 March 1975, p. 16.

'How an expressway would destroy Glebe'. The *Sydney Morning Herald*, 24 June 1975, p. 7.

NOTES

RÜDIGER JOPPIEN:
Sir Oswald Walters Brierley's *First Arrival of White Men*

My acquaintance with the work of Sir Oswald Walters Brierly, in particular with his painting of the *First Arrival of White Men* and his studies from the *Rattlesnake* voyage, goes back to late 1975, when as a Visiting Fellow of the Humanities Research Centre at the A.N.U. I had the chance of visiting the National Library of Australia in Canberra and the Mitchell Library in Sydney. Initial research for this paper dates from that time. I would like to thank the authorities of the National Library of Australia, of the Dixson Galleries, of the Mitchell Library and of the National Maritime Museum, Greenwich, for their kind permission to reproduce works in their custody. I am equally indebted to Dr H. Becher (Hanover), Dr W. Stöhr and Dr K. Volprecht (both Cologne) for information and advice.

[1] Algernon Graves, *The Royal Academy of Arts*, vol. 1, London, 1905, p. 281.

[2] The paintings by Hodges here referred to are *The Landing at Erromanga, The Landing at Middleburgh (Eua)* and *The Landing at Tanna*, all in the National Maritime Museum, Greenwich. On Hodges' 'landing pictures' see Bernard Smith, *European Vision and the South Pacific 1768-1850*, Oxford, 1960, p. 53 ff.

[3] The most comprehensive art historical notes on Brierly are in *Thieme-Becker, Lexikon der Bildenden Künstler*, vol. 5, Leipzig, 1911, p. 13; Col. M. H. Grant, *A Dictionary of British Landscape Painters*, Leigh-on-Sea, 1952, p. 28; *The Australian Dictionary of Biography*, vol. 3 (1851-90), Melbourne, 1969, pp. 230-1 (entry by Bernard Smith and Marnie Bassett); Christopher Wood, *Dictionary of Victorian Painters*, London, 1971, p. 15.

[4] Later historical studies which treated the voyage of the *Rattlesnake* are by Marnie Bassett, *Behind the Picture. H.M.S. Rattlesnake's Australia, New Guinea Cruise 1846 to 1850*, Melbourne, 1966; and by Adelaide Lubbock, *Owen Stanley R.N. Captain of the Rattlesnake*, Melbourne, 1967.

[5] Julian Huxley (ed.), *T. H. Huxley's Diary of the Voyage of H.M.S. Rattlesnake, edited from the unpublished Ms.*, London, 1935. A year later that edition was published in Garden City, New York, and in 1972 it was reprinted again by Kraus Reprint, New York.

[6] John MacGillivray, *Narrative of the Voyage of H.M.S. Rattlesnake commanded by the late Captain Owen Stanley . . . during the years 1846-50*, London, 1850, vol. 1, p. 192.

[7] Preface to John Milner and Oswald W. Brierly, *The Cruise of H.M.S. Galatea, Captain H.R.H. the Duke of Edinburgh. K.G. in 1867-1868*, London, 1869.

[8] Miss Jane Langton, Registrar of the Royal Archives, Windsor Castle, very kindly informed me about Brierly's nomination as Marine Painter in Ordinary to Queen Victoria at the beginning of February 1874 (letter 22 June 1978). Miss Langton says that there is nothing in the papers at Windsor Castle 'to show on what grounds the appointment was made apart from a letter from Brierly himself to Sir Thomas Biddulph, Keeper of the Privy Purse to Queen Victoria, asking to be considered for the appointment on the death of John Christian Schetky in January 1874'. (R.A. PP. 15641. 1874)

[9] A catalogue of a *Loan Exhibition of Works by Sir Oswald Brierly* is listed in the general catalogue of the British Library (7854. dd.46); unfortunately the catalogue no longer exists.

[10] No art historical study has as yet been done on Brierly. An idea of his *oeuvre*, however, particularly of the decades from the early 1850s to the late 1870s, can be formed from the photographs of his works that are kept in the Witt Library, London.

[11] The Royal Library in Windsor Castle owns some eighty watercolours by Brierly, mainly of places outside England that he had visited in the company of his royal patrons (Egypt, France, Greece, Italy, Palestine, Turkey, Australia). Some of his drawings are preserved in Queen Victoria's Souvenir Albums. This information I owe to the kind assistance of Miss Charlotte Miller of the Print Room, Royal Library, Windsor Castle. The National Maritime Museum, Greenwich, owns a number of sketches, drawings and paintings by Brierly, including two sketch-books with scenes of shipping and of naval actions of the Baltic Fleet (20. 1894); a painting, *Man Overboard*; and about fifteen pencil drawings from the voyage of the *Rattlesnake*.

[12] Brierly's works now preserved in Australian collections include the following:

Mitchell Library: DG D 19; PX+ D 71; PXD 73; PXD 74; PXD 81; PX+D 81; PX+ D 82, plus Brierly's annotated journals from the voyage of the *Rattlesnake*, A 503 ff., Dixson Galleries, DGD19.

The National Library of Australia: *The First Arrival of White Men amongst the Islands of the Louisiade Archipelago; The Wanderer, Sydney 1846* (N.K. 6873 and 6874); *H.M.S. Rattlesnake off Sydney Heads.* (R. 3985)

Art Gallery of New South Wales: *Whalers of Twofold Bay*, ill. in *Art Gallery of New South Wales, Picturebook*, Sydney, 1972, p. 67.

Melbourne Club: two paintings of *The 'General Ship' of the Andalusian Squad of the Spanish Armada* and *The Spanish Armada sailing from Ferrol, morn-*

ing of July, 22nd 1588. The Duke of Medina Sidonia on board the San Martin (by kind communication of Miss N. Zelenka, University of Melbourne, Dept of Fine Arts).

For another work by Brierly in a private Australian collection see n. 27.

[13] The albums containing sketches from the *Rattlesnake* voyage are DG D19; PXD 74; PX⁺D.81 and PX⁺ D82.

[14] PXD74 f. 58, located and dated: 'Isles Duchâteau Aug. 3 1849'.

[15] Huxley's and Stanley's drawings from the voyage of the *Rattlesnake* in the Mitchell Library are at: (Huxley) Z. ML 115; SV⁺ NG-E/1-4; DG D19 f.26; DG SV⁺ Explo/1; DG SV4B/1; (Stanley) PX C 281. Two other collections of drawings by Huxley from the *Rattlesnake* voyage are preserved in the National Library of Australia (NK 2091) and in an album in the College Archive, Imperial College of Science and Technology, London; they include drawings of natives and of canoes from the Louisiade Archipelago, of which some were reproduced in the 1935 edition of Huxley's diary (see *op.cit.*). Huxley's drawings were made accessible to me through the kindness of Mrs J. Pingree, the College Archivist.

[16] For comparison see Stanley's PX C281 f.88 and Brierly's PXD 74 f. 20.

[17] PX C281 f.4: 'H.M.S. Rattlesnake leaving Port Essington Nov. 17th 1848'; despite Brierly's name in the lower left corner, on stylistic grounds an attribution to Stanley is more likely.

[18] PX C281 f.74 and MacGillivray, *Narrative*, vol. 2, opp. p. 37.

[19] The modern name of Dufaure Island is Mugula Island.

[20] Very little of Brierly's activities during the voyage is recorded and one can only speculate to what extent he collaborated with the other members of the expedition. In Huxley's diary he is mentioned a few times, amongst which there are references such as these: 'Brierly and I spent the greater part of yesterday on the Island [Mount Ernest Island, or Tragé], on a regular sketching expedition', Huxley, *Diary*, p. 251.

[21] In the Mitchell Library this drawing was also attributed to Huxley on the grounds that its composition corresponded to Huxley's pencil drawing in SV⁺ NG-E/2. However, the fact that this drawing is enclosed in an album containing no other drawings but Brierly's, and the stylistic treatment of the sketch clearly suggest Brierly as author.

[22] MacGillivray, *Narrative*, vol. 1, p. 195-6.

[23] ibid, vol. 1, p. 223; see also p. 185 and the illustration in vol. 1, opp. p. 223. For comparison with the latter see Stanley's watercolour drawing at PX C281 f.90.

[24] For other drawings by Brierly of Southern Massim canoes see PXD 74 f.6; f.54, f.56 and PX⁺ D81 f.74.

[25] For a long description of the sailing canoes of the Louisiade Archipelago, see MacGillivray, *Narrative*, vol. 1, pp. 202-7. For an extensive survey of the many types of canoes and sailing canoes of the Massim district see A. C. Haddon and James Hornell, *Canoes of Oceania*, vol. 2: *The Canoes of Melanesia, Queensland and New Guinea*, Bernice P. Bishop Museum Special Publications, Honolulu, 1937, pp. 240-63. The authors refer frequently to descriptions given by MacGillivray, but seem to have been unaware of the existence of Brierly's, Huxley's and Stanley's drawings, which certainly would have well illustrated the written accounts they quote from various sources.

[26] Duchâteau and nearby islands can be found on the map in Peter Ryan, *Encyclopaedia of Papua and New Guinea*, M.U.P., 1972.

[27] The watercolour is illustrated in colour at the end of Marnie Bassett, *Behind the Picture*, Melbourne, 1966, and is owned by the authoress.

[28] MacGillivray, *Narrative*, vol. 2, p. 291 (no. 333) and p. 294 (no. 402).

[29] On the construction of these boats see MacGillivray's detailed description in vol. 2, pp. 15-17. References to this type of boat, which was customary from the Cape York area to the Kiwai district in Papua New Guinea, are given in Gunnar Landtman, *The Kiwai Papuans of British New Guinea*, London, 1927, pp. 207, 210, 211. See also A. C. Haddon, *Report of the Cambridge Anthropological Expedition to Torres Straits*, vol. 4 (Arts and Crafts), Cambridge, 1912, pp. 205-8, 213-15; as well as Haddon and Hornell, *op.cit.*, pp. 193-8. A canoe very similar to the one represented by Brierly had been depicted by H. S. Melville, the accompanying artist on H.M.S. *Fly*, in 1845.

[30] The modern name for Prince of Wales Island is Muralug.

[31] Titled *Canoe of Torres Strait*, PX C281 f.108.

[32] See MacGillivray, *Narrative*, vol. 1, pp. 255-6 and Huxley, *Diary*, p. 215.

[33] On the types of petticoats worn by the female natives, see MacGillivray, *Narrative*, vol. 1, pp. 215, 229, 263, 271.

[34] Huxley noted on p. 197 of his diary: 'At some distance in the background three or four ladies made their appearance in their peculiar dress, looking like ballet girls, a resemblance not a little increased by the jumps and springs they occasionally took . . .'

[35] On bracelets, flower and plant decorations and tattooing see MacGillivray, *Narrative*, vol. 1, pp. 215, 216, 241, 262-3, 294. See also Brierly's drawing at PX⁺ D82 f.9 for a woman of Brumer Island profusely tattooed on face, arm and breast.

[36] On the comb ornament and hairstyles, see MacGillivray, *Narrative*, vol. 1, pp. 189, 217 and 276.

[37] ibid, pp. 191 and 216.

[38] ibid, pp. 191 and 280.

[39] PXD 74 f.65, measuring 36.5 x 60.3 cm.

[40] Mrs J. Pingree, College Archivist, Imperial College of Science and Technology, informs me that among the letters of Thomas Henry Huxley there is no reference to contacts between himself and Brierly.

[41] A painting of similar subject-matter which Brierly may have known is James Wilson Carmichael's *The Erebus and Terror in New Zealand 1841*, now kept in the National Maritime Museum, Greenwich, together with its pendant *The Erebus and*

Terror off Victoria Land 1841, signed and dated 1847. Carmichael, though a marine and reporter artist—he joined the Baltic Fleet as artist for the *Illustrated London News* during the Crimean war—had not accompanied the *Erebus* and *Terror* expedition to the Antarctic; his paintings were thus not based on his own eyewitness testimony.

JOAN KERR: Early and High Victorian

Illustrations of Blacket's buildings mentioned in the text can be seen in Morton Herman's *The Blackets* Angus & Robertson, Sydney, 1963, while Hunt's churches are illustrated in J. M. Freeland's *Architect Extraordinary: The Life and Work of John Horbury Hunt*, 1838-1904, Cassell, Melbourne, 1970.

[1] H. G. Woffenden: entry on Blacket in the *Australian Dictionary of Biography*, M.U.P., 1969.

[2] J. M. Freeland: entry on Hunt in the *A.D.B.*

[3] Woffenden, op.cit.

[4] J. M. Freeland, *Architect Extraordinary: The Life and Work of John Horbury Hunt: 1838-1904*, Cassell, Australia, 1970, p. 11.

[5] G. M. Blacket: annotation on a photograph of Holy Trinity, Berrima, donated by O. H. Blacket to the Mitchell Library.

[6] Phoebe Stanton, *The Gothic Revival and American Architecture: An Episode in Taste 1840-1856*, John Hopkins, Baltimore, 1968. See especially chapters 2 and 3.

[7] Most of the Blacket books I have located are in the Fisher Library of the University of Sydney, including Pugin's *Present State*. The quotation is on p. 108, and the italics are, of course, Pugin's.

[8] *Ecclesiologist*, vol. XXII (1861), p. 199.

[9] ibid., p. 282.

[10] A. J. Beresford Hope, *The English Cathedral of the Nineteenth Century*, Murray, London, 1861, p. 80.

[11] For a discussion and bibliography of parallels between Richardson and Hunt, see Howard Tanner, 'Stylistic Influences on Australian Architecture: Selective Simplification 1868-1934', *Architecture in Australia*, April 1974, pp. 51-60.

[12] Freeland: *Architect Extraordinary*, op. cit., p. 43.

[13] See Henry Russell Hitchcock, 'G. E. Street in the 1850s', *Journal of the Society of Architectural Historians*, vol. XIX (1960), pp. 149-51.

[14] According to Freeland, op.cit., p. 21.

[15] H. W. A. Barder, *Wherein Thine Honour Dwells, the Story of One Hundred Years of St Mark's Parish Church, Darling Point, N.S.W.*, Sydney, 1948, p. 19.

[16] The *Ecclesiologist*'s comments on Homerton are cited by B. F. L. Clarke in *Parish Churches of London* (London, Batsford, 1966, p. 67). Walsh's eulogy on St Paul's, Redfern, was published in the *Ecclesiologist*, vol. IX, no. LXX (February, 1849), p. 264.

[17] In an unpublished and undated manuscript in the University of Sydney archives (drawn to my attention by W. J. S. Kerr, to whom I owe much of my Sydney University material), Blacket states: '... In building an university, therefore, in the nineteenth century, one has the difficulty at the outset which never troubled the founders of those ancient seats of learning which it is our ambition to imitate. We shall have to determine which of all Architectural styles shall be used ... In this perplexity it is gratifying to consider that there is one great peculiarity that overrides all others ... I mean the *fitness of association*. It is impossible for an Englishman to think of an University without thinking of Medieval Architecture. We cannot entertain the most visionary idea of study or learning without associating in some way or other the forms and peculiarities of the Gothic Styles'. This is a splendid example of colonial Anglomania, and virtually the only statement we have of Blacket's architectural principles.

[18] Begley Papers, RIBA MSS.B10 1282, 'Ecclesiological Society—biographical files: Charles Nicholson': Nicholson to Begley, 2 February 1943.

[19] Anthony Trollope, *Australia and New Zealand*, Chapman and Hall, London, 1874, chapter 3, p. 26. Trollope was in N.S.W. at the end of 1871 and in June and July 1872.

[20] See H. S. Goodhart-Rendel, 'Rogue Architects of the Victorian Era': *RIBA Journal*, third series, vol. 56 (1949). For a reinterpretation of these rogues within the Victorian context see Stefan Muthesius, *The High Victorian Movement in Architecture 1850-1870*, Routledge and Kegan Paul, London, 1972.

[21] Freeland, op. cit., p. 60.

[22] *Armidale Express*, 2 April 1870: quoted by K. H. Aubrey, 'The Church of England in New South Wales 1847-1867 and in the Diocese of Grafton and Armidale 1867-1892', unpublished M.A. thesis, University of New England, 1964. [23] ibid., p. 72.

[24] In England Turner designed at least two churches—St Maurice, Ellingham, Northumberland (begun 1862) and St John the Evangelist, Greenside, Ryton Woodside, Durham (1853-54: enlarged F. E. Dotchin 1907). In Australia he designed three known churches—Boggabri and Moree in 1891 and Holy Trinity, Dulwich Hill (1885-86), in the diocese of Sydney. However he normally believed that a professional architect should be employed no matter how expert the client may be, and these are only tiny buildings (Moree was of wood), clearly provided only 'for fear of finding something worse' if the parishes were left to their own devices.

[25] Hunt cutting book, Mitchell Library, Q 720.8B, p. 52.

[26] B. F. L. Clarke, *Anglican Cathedrals outside the British Isles*, S.P.C.K., London, 1958, p. 94.

[27] *Australian Churchman*, 18 December 1884, p. 13. For the full story of Hunt's dismissal see Freeland, pp. 110-11.

[28] *Sydney Morning Herald*, 13 December 1884.

[29] *Australian Churchman*, 24 August 1882, pp. 399-400.

[30] See Mark Girouard, *Sweetness and Light: The 'Queen Anne' Movement 1860-1900*, Clarendon Press, Oxford, 1977.

[31] *Report of the Church of England Lay Association for New South Wales for the years 1844-5*, Sydney, 1846, p. 14.

HEATHER CURNOW: William Strutt

[1] The first issue of the *Illustrated Australian Magazine*, vol. 1, no. 1, July 1850, appeared in August 1850. The magazine ceased publication at vol. 4, no. 21 (August 1852).

[2] 'Government but United', *Illustrated Australian Magazine*, vol. 1, no. 5, November 1850.

[3] 'Autobiography of William Strutt', 1850-1862', p. 31. Typescript, National Library of Australia, Canberra, NK 4367.

[4] Melbourne *Argus*, 19 November 1850.

[5] ibid.

[6] 'Autobiography of William Strutt', op. cit., p. 36.

[7] 'Autobiography of William Strutt', op. cit., p. 32.

[8] The sketch is in 'Victoria the Golden', an album of Strutt's Melbourne drawings in the Victorian Parliamentary Library, Melbourne. The drawing is also in the Parliamentary Library.

[9] Receipt of money advanced to Strutt by Fawkner, in private collection.

[10] 'Autobiography of William Strutt', op. cit., p. 124. [11] ibid.

[12] Strutt's sketches are in 'Victoria the Golden', pp. 27-31, Victorian Parliamentary Library, Melbourne. The drawing (presented by J. P. Fawkner) is in the La Trobe Collection, State Library of Victoria.

[13] The original watercolour is in the Mitchell Library, Sydney.

[14] 'Victoria the Golden', p. 33. Victorian Parliamentary Library, Melbourne.

[15] The portraits of Greeves and Russell were at one time hanging in the Town Hall, Melbourne. They are believed to have been destroyed by a fire which extensively damaged the Town Hall in 1925. (Information supplied by the Town Clerk, Melbourne, 1977.)

[16] 'Autobiography of William Strutt', op. cit., p. 39.

[17] *The Actors' Cart*. 'Melbourne drawings', 1st series, f.16. The Dixson Library, Sydney.

A race for life through Cape Otway Forest. 'Victoria the Golden', p. 6. Victorian Parliamentary Library, Melbourne.

[18] 'Autobiography of William Strutt', op. cit., p. 67.

[19] Walter Friedlaender, *From David to Delacroix*, Cambridge (Mass.), 1968, p. 7.

[20] 'Autobiography of William Strutt', op. cit., pp. 127-8.

[21] The *Argus*, 20 May 1861, noted the exhibition of Strutt's watercolour in Wilkie's music shop in Collins Street.

[22] 'Autobiography of William Strutt', op. cit., pp. 128-9. The watercolour of *The first day's order of march* is in the La Trobe Collection, State Library of Victoria.

[23] 'Autobiography of William Strutt', op. cit., pp. 140-1.

[24] Leonard Joel, Melbourne. Auction of Australian paintings, 7 November 1973 (lot 200).

[25] William Strutt, 'Autobiography and other papers, 1788-1955', ML MSS 867/2, pp. 219-21, Mitchell Library, Sydney.

[26] William Strutt, 'Memorandum and account book, 1862', private collection.

[27] Unnamed, undated newspaper article in William Strutt, 'Press cuttings 1864-1902', private collection.

[28] Lieut.-Colonel Charles Pasley to William Strutt, 2 June 1866, letter in private collection.

[29] Edward Wilson to William Strutt, 29 June 1866, letter in private collection.

[30] Note of sale of *Black Thursday* in Strutt's manuscript diary for 1882, in private collection.

[31] *South Australian Advertiser*, 25 April 1883.

[32] Melbourne *Argus*, 16 March 1883.

[33] *South Australian Register*, 26 April 1883.

[34] Undated article from the *South Australian Register*, in William Strutt, 'Press cuttings 1864-1902', private collection.

[35] Thomas Gill to the President of the Public Library Board of South Australia, 17 December 1902, the State Library of South Australia, Archives.

[36] *The Windsor Magazine*, November 1912, noted that *Black Thursday* had been purchased for a private collection.

[37] Nicholas Chevalier's illustration of the Duff children appeared on the cover of the *Illustrated Melbourne Post*, 22 September 1864. S. T. Gill's illustration was published in his *Australian Sketchbook*, 1865.

[38] William Strutt, manuscript diary, 1906, private collection.

[39] Over thirty preliminary drawings for the *Bushrangers* are in the National Library of Australia, Canberra. (Acc. 3967/1-31)

[40] William Strutt to Charles Brooke Crawshaw, 6 July 1887, letter in private collection.

[41] 'Autobiography of William Strutt', op. cit., p. 140.

[42] Strutt's watercolours of *Bourke's* [sic] *death* and *The Burial of Burke* are in 'Victoria the Golden', pp. 38 and 39, Victorian Parliamentary Library, Melbourne.

[43] James Smith to William Strutt, 30 April 1872, in William Strutt, 'Autobiography and other papers', ML MSS 867/6, Mitchell Library.

[44] William Strutt to James Smith, 8 February 1870, in 'James Smith Papers', ML MSS 212/2, pp. 241-4, Mitchell Library.

PETER MORONEY: Walter Vernon

[1] Even the interior facades of this building were classical Georgian.

[2] His Church of St John the Evangelist at Camden can hardly be classed as government architecture, even though commissioned by the government.

[3] p. 77, Architect Extraordinary.

[4] Australian Association for the Advancement of Science.

[5] AAAS Report, Melbourne 1913, p. 559.

[6] *Hermes*, October 1909, p. 71.

[7] Given to the Institute of Architects of N.S.W., 30 November 1892.

[8] *The Australasian Builder and Contractor's News*, vol. VII, no. 180 (1890), p. 281.

[9] ibid., p. 282.

[10] PWD Report 1898.

[11] This is speaking generally and does not include major buildings such as the Art Gallery of New South Wales or Central Railway, or minor ones, like Newcastle Post Office, which are exceptions.

[12] Apart from some large and important ones such as the Registrar General's building and Old Fisher Library.

PETER QUARTERMAINE: 'Speaking to the Eye'

In its present form this article was written in 1974. It forms part of a larger study nearing completion as a doctoral thesis for the University of Exeter.

[1] B. Smith, *Place, Taste and Tradition*, Ure Smith, Sydney, 1945, p. 71. See also Frank S. Greenop, *History of Magazine Publishing in Australia*, K. G. Murray Publishing Co., Sydney, 1947.

[2] For an examination of the cultural role of the popular illustrated press in England see 'Pictures from the Magazines' by M. Wolff and C. Fox in volume 2 of *The Victorian City*, (ed.) H. J. Dyos and M. Wolff, Routledge, 1973. Aaron Scharf's *Art and Industry*, Open University, 1971, discusses the effect of mechanical techniques for reproducing engravings in the popular press upon the actual image.

A valuable study of the relative roles of painting and photography in the nineteenth-century popular press is Estelle Jussim's *Visual Communication and the Graphic Arts*, Bowker, New York and London, 1974.

[3] *Melbourne Illustrated News*, vol. 1, no. 1, 29 October 1853. [4] ibid.

[5] *Illustrated Melbourne News*, 2 January 1858.

[6] *Melbourne Pictorial Times*, vol. 1, no. 1, 7 July 1855. [7] ibid.

[8] *News Letter of Australasia*, no. 45, May 1860.

[9] op. cit., no. 7, January 1857.

[10] See B. Smith, op. cit., ch. 3, and Daniel Thomas, *Outlines of Australian Art*, Macmillan, 1973, ch. 4. For more detailed general studies see Van Deren Coke, *The Painter and the Photograph: From Delacroix to Warhol*, Albuquerque, University of New Mexico Press, 1964, and Aaron Scharf, *Art and Photography*, Allen Lane, 1968.

[11] *Illustrated Melbourne Post*, 25 November 1863.

[12] ibid. The textual variation occurs in an issue of 21 November 1863.

[13] op. cit., 25 April 1863.

[14] ibid.

[15] ibid. See *The Writer in Australia*, edited with commentaries by John Barnes, O.U.P. 1969, for an exploration of similar attitudes during the period 1856-1964.

[16] *Illustrated Melbourne Post*, 25 April 1863.

[17] ibid.

[18] ibid.

[19] ibid. *The Illustrated London News*, vol. XVIII (1851), p. 451, reprinted an article from *The Economist* entitled 'Speaking to the Eye', which argued the importance of the illustrated press in the popular dissemination of ideas.

[20] The relationship between town and city, as expressed in the articles and cartoons of the popular illustrated press in Australia, is a fruitful field for exploration and the subject of a larger research project I am engaged in.

[21] See B. Smith, *Australian Painting*, 1788-1970, O.U.P., 1971, chapters 2 and 3, for a discussion of the period 1821-85.

[22] *Illustrated Australian Mail*, 22 February 1862. The article is a general account of von Guérard's work, and does not mention specific paintings. Further insights into von Guérard's aims in art, and critical reaction to his work, can be gained from the 1870 review of his painting by James Smith and from von Guérard's (unpublished) reply. Both are reprinted in B. Smith, *Documents on Art and Taste in Australia*, O.U.P., 1975, pp. 161-71.

[23] *Illustrated Melbourne Post*, 21 November 1863.

[24] B. Smith, *European Vision*, p. 255.

[25] *Illustrated Melbourne Post*, 22 November 1864.

[26] *Illustrated Australian Mail*, 18 January 1862.

[27] *Illustrated Melbourne Post*, 25 January 1865.

[28] ibid. See the essay by G. A. Wilkes in *The Australian Experience*, (ed.) W. S. Ramson, ANU Press, Canberra, 1974, for an interesting discussion of 'typical landscape' in the works of Chevalier and others in relation to *Geoffry Hamlyn*. The concept of 'typical landscape' in the Australian visual arts is discussed in B. Smith's *European Vision*.

[29] The bulk of the comments on Australian scenery was originally written to accompany photographs by Thomas Chuck which were issued in a monthly series edited by Clarke entitled *Photographs of Pictures in the National Gallery, Melbourne*. The passages Clarke used in his preface to Gordon's poems appeared in the issues for May and September 1874. See Barnes, op. cit., pp. 36-7, and L. T. Hergenham 'Marcus Clarke and the Australian Landscape', *Quadrant*, XIII, 4 (1969), pp. 31-41.

[30] Jack Cato, *The Story of the Camera in Australia*, Georgian House, Melbourne, 1955, p. 99. See also William Moore, *The Story of Australian Art*, Angus and Robertson, Sydney, 1934, vol. 2, p. 131, for the poignant tale of Frederick Woodhouse, who painted the winners of the Melbourne Cup from 1861-88. 'Photography knocked me out. Now an owner can get a picture of his horse in a sixpenny weekly, or for nothing—wrapped round the meat'. For a perceptive examination of the problems artists like Woodhouse faced following the introduction of photography see William Ivins, Jnr., *Prints and Visual Communication*, Harvard U.P., 1953, especially chapter 7.

[31] *News Letter of Australasia*, no 6, December 1856.

[32] *Illustrated Australian News*, 23 February 1865.

[33] op. cit., 25 August 1865. The writer claims that 'were some of our weary denizens of the pent-up city

to make a pilgrimage to this secluded spot, . . . they would get a new idea of the happiness of bush life in Australia'.

[34] *The Australian News*, 25 April 1864.

[35] op. cit., 25 May 1964, p. 12.

[36] W. S. Jevons, *Letters and Journals*, edited by his wife, Macmillan, 1886, p. 121. The letter was written from Beechworth.

[37] See also, for example, *Illustrated London News*, 8 August 1863; London *Graphic*, 26 February 1876; *Australian Sketcher*, 19 January 1878; *Illustrated Australian News*, frontis., 27 July 1867; *Illustrated Sydney News*, 15 September 1864; *Illustrated Melbourne Post*, 9 August 1862.

[38] *Illustrated Australian News*, 25 November 1885.

[39] op. cit., 27 December 1869.

[40] No. 1, vol. XIII, January 1887. For an illustration of the detail captured by engravings after photographs, see G. F. James and C. G. Iee, *Walhalla Heyday*, Robertson and Mullen, Melbourne, 1970, pp. 8 and 11.

[41] *Australian Sketcher*, 8 August 1889.

[42] *Illustrated Australian News*, 29 January 1869. See also issues for 27 October 1866, 12 June 1869 and 11 April 1869.

[43] op. cit., 27 October 1866.

[44] ibid.

[45] op. cit., 31 December 1873.

[46] ibid.

[47] op. cit., 12 June 1869.

[48] op. cit., 4 November 1869.

[49] I am indebted to Mr Daniel Thomas for having drawn my attention to the photographic quality of Piguenit's work and to the notebook mentioned below.

[50] This notebook is now in the possession of a relative in Sydney.

[51] *Australian Sketcher*, 15 April 1876.

[52] ibid. It would seem that this particular artistic and phototographic *plein air* event has yet to be fully researched.

[53] Piguenit's photographic work appears to have been lost; it would have provided an interesting comparison (especially with his monochrome oil paintings, perhaps).

[54] These points are in a general photographic album in the Historical Collection of the La Trobe Library, Melbourne.

[55] *Illustrated Australian News*, 16 April 1877. A lecture given by Piguenit in 1892 to the Australian Association for the Advancement of Science is reprinted in B. Smith's *Documents*, pp. 171-9.

NIGEL LENDON: Ashton, Roberts and Bayliss

[1] The quotation is taken from the text which accompanies the illustration of *Shearing the Rams*. Campbell's book is a slim volume, containing an introductory essay and colour reproductions of twelve paintings, with commentaries accompanying each illustration. It has been chosen because it is an early example (in relation to Roberts) of a simplified account of the relationship between painting and photography in the late nineteenth century, which still persists today. It is difficult to disentangle what Campbell actually means when he uses the term: apparently the 'concentration on detail, the carefully studied portrait heads and the meticulous drawing of the interior' is a liability, for it is 'in spite of' these 'almost photographic' qualities that the picture 'hangs together extremely well' . . . The use of the term 'photographic' in relation to realist or naturalistic painting can be descriptive, or disparaging, or both. In its strictly descriptive use it refers to the particular qualities of photographs as reflected in a painting or as used by the painter. This use may be combined with a negative value judgement, resulting in a critical assessment ranging from the mildly disparaging to an expression of an openly derogatory viewpoint, which usually coincides with conservative assumptions of a static hierarchy of forms. Virginia Spate uses the term in both ways, while avoiding the excesses of the latter, in her book *Tom Roberts*, Melbourne, 1972. See pp. 19 and 21 for examples of the former ('the student was taught to aspire to photographic fidelity to detail', and 'Gérome's formal subject-paintings were highly finished and photographically exact') and see pp. 12 and 20 for examples of the latter ('enabled Roberts to go beyond the photographic littleness encouraged by the academic training' and 'Thus English painters of "modern life" . . . gave photographic descriptions which trivialised rather than deepened the emotions of what they portrayed').

[2] This is distinct from the current interest in the *craft* of photography, i.e., a historical view derived from its technological development.

[3] For an account of photography and technological progress which can best be described as *phenomenological*, see Lucia Moholy, *A Hundred Years of Photography*, Harmondsworth, 1939, p. 9 and pp. 63-5.

[4] Aaron Scharf, *Art and Photography*, Harmondsworth, 1974, p. 42.

[5] See particularly Scharf, *op.cit.*, and *Creative Photography*, London and New York, 1965; Van Deren Coke, *The Painter and the Photograph*, Albuquerque, N.M., 1964; see also Beaumont Newhall, *The History of Photography*, New York, 1964, for the writings of Helmut Gernsheim and, in an approach which was proved particularly influential, the assumed 'connoisseurship' of the writings of John Szarkowski.

[6] Scharf, *Art and Photography*, ch. 1, *passim*.

[7] ibid., chapters 4, 5 and 9, *passim*.

[8] Jack Cato, *The Story of the Camera in Australia*, Melbourne, 1955, p. 107.

[9] For reference to Conrad Martens' use of photography, see Bernard Smith, *Documents on Art and Taste in Australia*, Melbourne, 1975, p. 100, 'A Lecture on Landscaping Painting'; for reference to C. W. Piguenit, see Daniel Thomas, *Australian Art in the 1870s*, Sydney, 1976, p. 41.

[10] Tom Roberts' work, *The Flower Sellers* (1893-6), shows a particularly clumsy use of the convention of 'framing' after the manner of a photograph. By contrast, Degas used this convention to impart an illusion of motion and the 'fleeting impression' of a scene.

[11] Scharf, ibid., chapters 3 and 7, *passim*.

[12] ibid., pp. 77-9.

[13] ibid., pp. 77-82.

[14] Quoted in Spate, op.cit., p. 91 from R. H. Croll, (ed.), *Smike to Bulldog*, Sydney, 1946.

[15] Quoted in L. Bénédite, *Gustave Courbet*, London, 1912, p. 22.

[16] In a letter of 1892, see R. H. Croll, *Tom Roberts: Father of Australian Landscape Painting*, Melbourne, 1935, p. 173.

[17] Here the essay by Terry Smith in this volume is relevant.

[18] The growth of the popular press in Australia in the decade of the 1880s meant a corresponding increase in demand for artist/illustrators. In the *Victorian Census*, 'Occupations of the People', we find that the number of 'authors, editors, writers and reporters' more than quadrupled, from eighty-nine in 1881 to 359 in 1891. Apart from Ashton, artists who provided illustrations for the popular press and encyclopaedic publications like *The Picturesque Atlas of Australasia* included Conder, Mahony, Fullwood, Smedley, Schell and Mather, as well as Roberts (referred to later).

[19] Julian Ashton, *Now Came Still Evening On*, Sydney, 1941, p. 31.

[20] The year 1880 marks the height of 'wet-plate' photography in Australia. This refers to the wet-collodion process of making the photographic negative, which rapidly became redundant after 1881, in which year J. W. Lindt is credited with the first use of the new 'dry-plate' technology. This new technology not only meant faster exposure times, but the whole photographic apparatus necessary for wet-plate work was reduced to a box of unexposed plates. A photographic expedition become a much less complicated affair, greatly enhancing the mobility of the photographer.

[21] Ashton, op.cit., pp. 31-2.

[22] An argument that the coincidence of these figures in the Lindt photograph is simply fortuitous can be countered by an appreciation of the laborious process by which a photograph was made with the wet-plate technology. Working with a camera as cumbersome as that depicted in the photograph, and with an exposure time slow enough to require people to stand still (note the blurred head of the child who *did* move), the composition and the figures in the photograph would have been matters of some deliberation on Lindt's part.

[23] Keast Burke, *Gold and Silver: Photographs of Australian Goldfields from the Holtermann Collection*, Harmondsworth, 1973, pp. 48-53.

[24] In the form of large lumps of gold: See Burke, ibid., pp. 11-35, for the most extensive biography published.

[25] ibid., p. 27.

[26] Con Tanre, *The Mechanical Eye*, Sydney, 1977, p. 107.

[27] See Cato, op.cit., pp. 106-7; see also Croll op.cit., p. 64.

[28] See Cato, ibid., and cf. Spate, op.cit., p. 18.

[29] Jocelyn Gray, 'Louis Buvelot: Landscape and Portrait Photographer', in C. B. Christensen (ed.), *The Gallery on Eastern Hill*, Melbourne, 1970.

[30] In the years before 1881, Roberts worked as an illustrator on an occasional basis (B. Smith, *Australian Painting*, Melbourne, 1917, pp. 71-2).

[31] Roberts' own class position *vis-à-vis* his audience and questions of conflicting interests between the city and country bourgeoisie are raised by essays by Ian Burn and Terry Smith in this volume.

[32] R. H. Croll, op.cit., p. 34.

[33] 'Landscape' photography as such, other than landscapes which show pastoral development or other signs of 'progress' (bridges, lighthouses, etc.), is largely limited to photographs of well-known scenic attractions (waterfalls, etc.). Professional photographers whose work is an exception to this range of categories were almost unknown: Nicholas Caire stands out as the most notable exception.

IAN BURN: Beating About the Bush

[1] The same features can be seen in Roberts' *A Summer Morning's Tiff* (1887): see (6).

[2] There are few exceptions to this throughout the pictures of the Heidelberg school. For example, in Roberts' *The Splitters* (c 1886), a tree on the right-hand side appears blackened by fire. In the context of the other bush pictures this looks a highly incongruous detail. There are also Roberts' portraits of Aboriginals painted about 1892, and also a painting by Roberts called *Corroboree* (1892) in which the Aboriginals appear as small patches in the distance dwarfed by the forest setting. These were done at a time when it was thought that the Aboriginal people were facing extinction. A major exception would seem to be McCubbin in his series *Down on his Luck* (1889), *The Bush Burial* (1890), *On the Wallaby Track* (1896), etc. But it can be argued that the harshness of the bush has been 'universalized' and is no longer necessarily specific to bush life or conditions.

[3] One example of how a property relationship might be depicted is seen in the various 'portraits' of country properties by von Guérard, e.g., *Yalla-y-Poora Homestead* (1864), reproduced in D. Thomas, *Outlines of Australian Art*, Macmillan, 1973. Another example is seen in the photographs by Charles Bayliss which illustrate Nigel Lendon's essay in this volume. The photographs are three from a series in an album, probably commissioned by the landowner. In the majority of these, the owner assumes a deliberately non-working pose, is centrally placed, surrounded by underlings, and showing no interest in any particular aspect of the landscape or the activities in the shearing shed.

[4] This is not to deny that country children became

lost, even at the time. I am pointing to it as a theme, as an attitude towards becoming lost. Compare and contrast with the passage about the lost girl in chapter 5 of Joseph Furphy, *Such is Life* (completed by 1897 but not published till 1903).

[5] p. 98.

[6] *Argus*, 30 September 1893. Quoted in V. Spate, *Tom Roberts*, Lansdowne Press, Melbourne, 1972, p. 56.

[7] Graeme Davison, 'Sydney and the Bush: an urban context for the Australian Legend', in *Historical Studies*, vol. 18, no. 71 (October 1978), p. 208.

[8] A. B. Paterson, 'Clancy of the Overflow' (1889).

[9] For example, looking at Roberts' *Holiday Sketch at Coogee* and Conder's painting of the same scene, *Coogee* (both 1888), we are struck in both pictures by the feeling of a leisurely 'natural' beach setting, away from the city and the signs of progress. So it comes as a surprise to learn that just slightly to the right of the selected view stood the Coogee Palace Aquarium, a new large amusement centre which had just opened in 1887 and which must have been a very imposing aspect of the beach scene. Also, at this time a tramway ran from the city all the way to the edge of the beach. A similar point can be made about Roberts' *Bourke Street*, which is dated *c* 1886. On 2 October 1886 the second line of the Melbourne cable tramway system was opened, which started at Spencer Street, ran the full length of Bourke Street and out to North Fitzroy. The first line, which ran along Flinders Street and out to Richmond, opened in November 1885. This line took about a year to build and one assumes that the second line took approximately as long. Roberts arrived back in Australia about May 1885. Without knowing exactly when that part of Bourke Street was excavated and cables and tracks laid, what Roberts painted was either a scene which would be dramatically changed by urban progress within a few months, or one in process of being changed, or even one already changed. Assuming he painted it just before the change, then it is still the case that if he had much interest in scenes of urban progress, he would have painted Flinders Street. Anyway, it is argued, it seems Roberts had scant interest in depicting signs of urban progress.

See also Terry Smith's reference to blade shearing.

[10] Davison, op.cit.

[11] Russel Ward, 'The Australian Legend re-visited', in *Historical Studies*, vol. 18, no. 71 (Oct. 1978). Ward, who has written the most influential account of Australia's cultural origins, *The Australian Legend*, Melbourne, 1958, holds the view that a national ethos of egalitarianism and collectivism was nurtured in the bush frontiers and that, in the late nineteenth century, through various agencies including the *Bulletin*, these traditions were imported from the bush to the cities. Thus the culture of a section of society was transformed into a national culture. While this differs from the view I have made use of here, it has little effect on how the quote from Ward is used.

[12] B. Smith, *Australian Painting*, OUP, Melbourne, 1962; Spate, op.cit.

[13] The question of precedents for the imagery in the popular illustrated press of the day needs more research than we have done. It is clear however that a number of minor and major artists during the 1870s and 1880s supported themselves by illustrating for the popular press, and that the constraints of the medium encouraged them to treat landscape in ways not dissimilar to the Heidelberg imagery. The gum tree is used in a formally decorative manner, often used to frame or break up the space. We can contrast these decorative applications to the woodblock transcriptions of (say) Buvelot's drawings and paintings, which look in comparison quite dull as small illustrations. The standard illustrations (e.g., the majority of the landscape illustrations in various publications like the *Picturesque Atlas of Australasia*) appear to be those which cut off the tops of gum trees, which have a strong sense of distributing or arranging elements across a flat surface, which present an intimate 'corner' of the bush and not a grand view, a few sharply delineated details, and so on. Often the illustrations are made to fit with the vertical format of the columns of type—perhaps this has some bearing on the number of vertical landscapes painted by the Heidelberg artists.

[14] The sense of a particular definition of the bush 'feeling right' would also extend to the feeling right to absorb certain artistic influences and to exclude others.

[15] This is slightly suggestive of the way a sense of space is created in Chinese paintings of landscape. But it equally reminds one of the sense of space experienced while viewing stereo-cards through a stereoscope, a pastime very popular in the late nineteenth century. With these one is conscious of the photographer having conceived the view in terms of composing *in depth*, rather than across a flat surface. Roberts' approach appears to be similar, though of course his pictures lack a similar illusion of depth, appearing spatially more unresolved.

[16] Spate, op.cit., pp. 49, 38, 52, 96 respectively.

[17] The list is not intended to limit the Heidelberg school artists merely to Roberts, McCubbin and Streeton.

[18] It is hard to think of a single figure in any of the bush pictures which shows some facial expression. All emotion is conveyed by body posture.

[19] The argument is far more complex than the way it is sketched out here. For a further treatment of it, see Terry Smith's article in this volume. Also, in this section of the article, I have used the male pronoun deliberately in certain instances to imply that the perception and world-view being discussed is male-dominated.

[20] J. S. MacDonald, 'Arthur Streeton', in *Art in Australia*, October 1931. Quoted in Smith, op.cit., p. 196.

[21] For a general discussion of this period, see Leon Cantrell's 'Introduction' in *The 1890's: Stories, Verse and Essays*, University of Queensland Press, 1977.

[22] The re-evaluation of Roberts' role seems to have developed during the later 1930s and 1940s, and probably gained its most impetus from the retrospec-

tive of his work which toured the State Galleries of New South Wales, Victoria and South Australia during 1947-48. During this same period the literature of the 1890s began to undergo further refinement in interpretation, which culminated in Vance Palmer's *The Legend of the Nineties* (1954) and Ward's *The Australian Legend* (1958). The persuasiveness of these books spawned a number of critical responses which have gradually built up a more critical interpretation of the literature. So far this critical perspective has not been extended to the paintings of the Heidelberg school.

23 Any number of sources could provide a statement similar to this. This one is quoted from the inside jacket of *Great Australian Paintings*, Lansdowne Press, Melbourne, 1971.

24 Cantrell, op.cit., p. xv.

25 See, for example, Bob Connell/Terry Irving, 'The Making of the Australian Bourgeoisie', *Intervention*, no. 10/11 (Aug. 1978).

26 Cantrell, op.cit., p. xii.

TERRY SMITH: The Divided Meaning of *Shearing the Rams*

*I am indebted to Virginia Spate, Ian Burn and Nigel Lendon for their critical comments on drafts of this essay, and to Helen Topliss, the Rev. Brian Burton, Mrs A. Leslie and many others for information and assistance.

1 V. Spate, 'Tom Roberts', M.A. thesis, University of Melbourne, 1962, p. 190. Comment (all 1890): the *Age*, 30 May, p. 7; the *Argus*, 31 May, p. 4; 24 June, p. 6; 28 June, p. 8. Correspondence (all 1890): the *Argus*, 24 June, p. 6; 26 June, pp. 6, 9; 28 June, p. 10; 4 July; 9 July, p. 5; *Table Talk*, 16 May, p. 8; 30 May, p. 7; 18 July, p. 10.

2 The interpretations listed in this paragraph occur in both the trivial (e.g., E. Lynn, *Tom Roberts*, Sydney 1978) and the substantial writing on Roberts and the art of the period, e.g., V. Spate, *Tom Roberts*, East Melbourne, 1972, *passim*; B. Smith, *Australian Painting 1788-1970*, Melbourne, 1972, pp. 82-5, 88-90, 115-21 and *Documents on Art and Taste in Australia*, Melbourne, 1975, pp. 230-7; V. Palmer, *Legend of the Nineties*, Melbourne, 1954; R. Ward, *The Australian Legend*, Melbourne, 1958, and *Australia, A Short History*, Sydney, 1975, pp. 103-5; G. Serle, *From Deserts the Prophets Come*, Melbourne, 1973, pp. 76-9.

3 Shearing generally occurred at that time from Queensland south, although 'early' and 'late' sheds in all states effectively spread the season over six months, from July to January. The seasons for Riverina stations are inferred from lists of starting dates in local newspapers and in shearers' union newspapers, such as *The Shearers' Record*, *The Hummer* (1981-82) (renamed *The Worker* 1892) and *The Shearer* (1904). In the *Argus*, 26 June 1890, p. 6, a journalist wrote of Roberts' 'eight months of hard labour', of him working 'all one spring' (1888) and returning the next. A portrait of Brocklesby's

owner, Alexander Anderson, dated by Roberts 24 September 1889 (cf. V. Spate, 'Tom Roberts Catalogue', part of M.A. thesis, op. cit., no. 58), and a report in the *Corowa Free Press*, 29 November 1890, establish his presence during the 1889 season.

4 The *Argus* journalist (26 June 1890) mentioned 'between seventy and eighty sketches', mostly detail studies, none of which seems to have survived.

5 Department of Prints and Drawings, National Gallery of Victoria. It will be discussed by Leigh Astbury in the *Art Bulletin of Victoria*, National Gallery of Victoria, no. 19, 1978. The date is presumably that of the dedication, to (Frank?) C. S. Paterson, an amateur painter, decorator, businessman and brother of the painter John Ford Paterson, whose portrait Roberts painted in 1888 (V. Spate, *Tom Roberts*, p. 106).

6 The *Argus*, 26 June 1890, p. 6.

7 See *Aspects of Australian Art 1900-1940*, Australian National Gallery travelling exhibition, 1978-79, cat. no. 33. The woolshed is on the Wanganella Estate and the ram from the Falkiner Stud, N.S.W. When exhibited at the Museum of Modern Art, New York, reference was made in the catalogue notes to the weight and price of the fleece (*Art of Australia*, S. U. Smith for the Carnegie Corporation, 1941).

8 The *Argus*, op. cit. Half of the report is devoted to an accounting of Roberts' expenses: 'A good shearer received £12 to pose for a good many days, and a merry-faced tar boy got a pound or two to stand to attention when required . . . The modest estimate of his own worth is not much more than that of a first class artisan, one of a hundred thousand . . .' The article is cited in R. H. Croll, *Tom Roberts, Father of Australian Landscape Painting*, Melbourne, 1935, p. 33.

9 The *Argus*, 28 June 1890, p. 8.

10 Letter to Roberts, October 1891, cited Croll, p. 185; to McCubbin, c 1891, cited Smith, *Documents*, pp. 259-62; to Roberts, 6 November and 17 December 1891, cited ibid., pp. 258-9. The watercolour painting in the Art Gallery of New South Wales is one of the few paintings of work in progress, but this is no more articulated than the landscape itself.

11 McCubbin's images of women usually possess a psychological subtlety and strength deeper than that evident in his images of men, despite the fact that women are usually depicted with children while the men work. These images are unmatched until those of E. P. Fox, Rupert Bunny and, especially, Hugh Ramsay's portraits. Withers typically placed an unindividualized farmgirl in his landscapes. Women artists associated with the Heidelberg School do not seem to have emphasized a female perspective, although their contribution remains relatively unstudied. For contemporary documents both reflecting and attacking the sexism of the period, see B. Kingston, *The World Moves Slowly*, Stanmore, 1977, especially pp. 16, 38, 65, 74, 93, 141, 162 and 164.

12 Smith, *Australian Painting*, p. 126.

13 These methodological remarks draw on the theory and practice of many writers and artists, e.g., P. Macherey, *A Theory of Literary Production*, Paris

1966, London 1978; N. Hadjinicolaou, *Art History and Class Struggle*, Paris 1973, London 1978; T. J. Clark, *Image of the People* and *The Absolute Bourgeois*, London, 1973. I explore the work of some artists from Goya to the present in 'Modern Art, Politics and Ideology', *The Visual Arts Now*, ed. D. Brook, forthcoming.

[14] Compare U. Hoff, 'Reflections on the Heidelberg School', *Meanjin*, no. 2, 1951, p. 129.

[15] Letter to Francis Wey, late 1849, cited T. J. Clark, *Image of the People*, p. 30.

[16] See A. Boime, 'Ford Madox Brown and Karl Marx: Meaning and Mystification of Work in the Nineteenth Century', Marxism and Art History Caucus, College Art Association Meeting, Los Angeles, February 1977. Brown drew one of the few other images of shearing: *The Sheep Shearer (Summer)* 1862, one of four watercolours illustrating the seasons, which emphasizes one man's struggle to roughly subdue the animal, his shepherd symbols cast aside. See *The Pre-Ralphaelites and Their Circle in the National Gallery of Victoria*, 1978, cat. no. 10.

[17] See J. Maas, *Victorian Painters*, London, 1969; H. Dyos and M. Wolff, eds, *The Victorian City: Images and Realities*, 2 vols, London, 1973; A. Boime, *The Academy and French Painting in the Nineteenth Century*, London, 1971; E. Lucie-Smith and C. Dars, *Work and Struggle: the Painter as Witness 1870-1914* and *How the Rich Lived*, London, 1977. [18] Spate, *Tom Roberts*, p. 85.

[19] Spate, 'Tom Roberts', p. 194.

[20] D. H. Souter, *George Clausen*, London, 1923, p. 15. See V. Spate, *Tom Roberts*, p. 88; R. A. M. Stevenson, 'George Clausen', *Art Journal*, October 1890, pp. 289-94. See also McCubbin's letter to Roberts, 1 June 1892, on Clausen and Realism (cited Croll, pp. 172-3).

[21] See A. Galbally, 'Aestheticism in Australia', in this volume.

[22] Compare S. T. Gill's Chromolithograph, *Splitters*, from his *The Australian Sketchbook*, reproduced in T. Ingram, *A Matter of Taste*, Sydney, 1976, pl. B8. *The Splitters* may be an inaccurate title: *The Charcoal-burners* has been suggested.

[23] See Leigh Astbury, 'George Folingsby and Australian Subject Painting', in A. Galbally and M. Plant, eds., *Studies in Australian Art*, Melbourne University Department of Fine Arts, 1978.

[24] *Australian Critic*, October 1890, p. 22. His lecture to the Victorian Artists' Society was reported in the *Argus*, 26 November 1888. A correspondent in the *Melbourne University Review* wrote similarly on 27 September 1884, and another cited Longstaff, McCubbin and Richardson's local pathos as an important 'channel . . . in which coming Australian art will find expression', May 1890. See Spate, *Tom Roberts*, pp. 85-6; Smith, *Documents*, pp. 238-43 (Henri) and 245-51 (Dickinson). Much of the initial commentary on *Shearing the Rams* praised or criticized its Australian character.

[25] G. Vaughan, 'The Armytage Collection: Taste in Melbourne in the late Nineteenth Century', in Galbally and Plant, op. cit.

[26] *Thirty Years in Australia*, London, 1903, p. 185. See also M. Cannon, *The Land Boomers*, Melbourne, 1966, and *Life in the Cities*, vol. 3 of *Australia in the Victorian Age*, Melbourne, 1977; E. A. Boehm, *Prosperity and Depression in Australia 1887-1897*, Oxford, 1971; G. Serle, *The Rush to be Rich*, Melbourne, 1971.

[27] The *Argus*, 26 June 1890, p. 6. On the Gallery's social role see, e.g., Francis Adams writing in May 1885: 'We see the throng of the virtuous wives of the Bourke Street tradespeople and of "our wealthy lower orders" moving about that badly constructed room, with its badly chosen and badly hung pictures' (cited I. Turner, *The Australian Dream*, Melbourne, 1968, p. 221; see also ibid., pp. 212-13). The internal quotation is Marcus Clarke's disparaging reference to the Melbourne upper class (see ibid., p. 192). On the other hand, during the 1883 dispute over the Sunday closure of the Gallery and parks the advantages of an 'elevating' holiday for the working class were emphasized — by J. R. Shiels, M.P., for example (cited G. Serle, *The Melbourne Scene 1803-1956*, Melbourne, 1957, p. 151). Roberts' views on the audiences for his art are rare. There is the frankly elitist remark to D. H. Souter: '. . . you don't usually sell your stuff to people who rent cottages at seventeen and six a week' (cited Croll, p. 40); and indirect evidence such as Streeton writing to Roberts in support of Professor G. W. L. Marshall-Hall's determination to attack a Professor Morris for claiming that 'the public (the multitude) is the best judge' of questions concerning music, painting and literature (letter, early 1892, cited Croll, p. 189).

[28] R. Twopeny, *Town Life in Australia*, London, 1883, pp. 42-3, 246-7. These passages deserve to be read in full because, as well as attesting to the popularity of prints across the classes, they denigrate this taste unmercifully. Twopeny's picture of city life has the remarkable accuracy of an observer caught between class ideologies: son of the Archdeacon of Flinders, South Australia, his working life was that of a journalist, yet the opinions he adopts are aristocratic, enabling him to look down lucidly on the class struggles occurring 'beneath' him. See especially pp. 82-112, e.g., p. 111: 'In Melbourne the masses seem worst off, and the display of riches, if not the actuality thereof, is most noticeable'. He was South Australian Secretary at the Paris, Sydney and Melbourne International Exhibitions of 1878, 1879 and 1880 respectively. His book is in the form of letters to England, and so has an additional dimension of cultural 'superiority' built into it.

[29] Croll states that 'Robertson and Moffat issued a reproduction in 100 signed Artist's Proofs at three guineas and a number of prints on India paper at a guinea', p. 34. The diaries of Betty Fraser indicate a date of August 1900, during the painting of 'The Big Picture' (see Croll, p. 74).

[30] For example, the issue of 31 October 1874. See also Hatherell's engraving in E. E. Morris, ed., *Cassell's Picturesque Australasia*, London, New York, Melbourne, 1889, p. 432, which, interestingly, includes an aboriginal shearer.

31 This sepia photograph is inscribed on verso in Roberts' hand: 'Brocklesby Shed Corowa Painted Shearing the Rams here T.R.'. It was taken by Roberts. It once belonged to R. H. Croll, who inserted it in his no. 1 copy of *Tom Roberts*, and is now in a private collection in Victoria. I am indebted for this information to Ms Helen Topliss. See D. I. Stone and D. S. Garden, *Squatters and Selectors*, Sydney, 1978, for photographs of sheep stations during this period.

32 The periodization of Australia's economic history is complex and contested. I have found most useful the work of political economists such as David Clark, 'Australia: Victim or Partner of British Imperialism?', in E. L. Wheelwright and K. Buckley, eds, *Essays in the Political Economy of Australian Capitalism*, vol. 1, Sydney, 1975.

33 See ibid.; n. 66 below; R. Markey, 'Trade Unionists and the Language of "Class": N.S.W. 1880-1900', paper to the Class Analysis Conference, Sydney, August 1975.

34 'The Labor Movement in Australia', *The Fortnightly Review*, August 1891; reprinted in full Turner, op. cit., pp. 190-206.

35 Markey, op. cit., p. 9; and Markey, 'The Return of Frankenstein's Monster: The Political Demobilisation of the Australian Working Class in the late Nineteenth Century', paper to the Class Analysis Conference, Sydney 1976, p. 4.

36 This finding conflicts with Bernard Smith's remark that '. . . during the eighties and the nineties it is fairly clear that the sympathies of Ashton, Streeton and Roberts lay with the Labor Movement', that these were 'broad humanitarian sympathies' and that they changed after 1893 (*Australian Painting*, pp. 120-1). As indicators he lists Roberts' letter about *Shearing the Rams*, Streeton's about 'Fire's On', friendship with Dr William Maloney, and the connection of many of the artists with the 'great republican and radical weekly', the *Bulletin*. None of this is unambiguous, and certainly none of it suggests any sense of the collectivity, the organizational forms necessary to support a labour *movement*. Indeed, Streeton's response to the 1890 Great Strike is defensive, alarmist: 'I think if it comes to riot or serious strife the Military and Police would be insufficient. The public would have to defend their property' (Smith, *Documents*, p. 254).

37 Petit-bourgeois ideology is evident in Roberts' remarks to D. H. Souter and to his son (Croll, pp. 40, 63, 66; see also Spate, *Tom Roberts*, p. 88); his liberalism in the portrait group of Cardinal Moran, Sir Henry Parkes and Justice Windeyer entitled *Church, State and Law*, 1891, and in his portraits of, and letters to, Parkes (e.g., 24 November 1894, supporting Federation, Parkes Correspondence, p. 347, Mitchell Library); and his royalism in his notes and comments regarding 'The Big Picture' (Roberts Papers, vol. 6, Mitchell Library; cited Croll, pp. 61-6, 226).

38 Spate, *Tom Roberts*, p. 88; Spate, 'Tom Roberts', p. 202.

39 An important methodological principle advanced by L. Althusser, 'A Letter on Art' and 'Cremonini, Painter of the Abstract', *Lenin and Philosophy*, London, 1971; and 'The "Piccolo Teatro": Bertolazzi and Brecht', *For Marx*, Paris 1966, London 1977. See also n. 13 above.

40 G. L. Buxton, '1870-1890', in F. Crowley, ed., *A New History of Australia*, Melbourne, 1974, p. 182.

41 T. A. Coghlan, writing in 1888-89, cited G. L. Buxton, *The Riverina 1861-1891*, Melbourne, 1967, p. 180; Buxton, op. cit., p. 176; B. Burton, *Flow Gently Past, The Story of the Corowa District*, Corowa, 1973, ch. 9. Contrast R. B. Ronald, *The Riverina: People and Properties*, Melbourne, 1960, p. 184, which concentrates on the western Riverina.

42 A. Andrews, *The First Settlement on the Upper Murray 1835 to 1845, with a Short Account of Over Two Hundred Runs 1835 to 1880*, Sydney, 1930, p. 153; Buxton, *The Riverina*, table 5, p. 185; Burton, pp. 25-6.

43 Burton, pp. 90, 99-100; Buxton, *The Riverina*, tables 7 and 10, p. 217.

44 Anderson was a leading figure in the district, a magistrate in the town and led the petitioners against efforts to incorporate the municipality in 1895 (Burton, pp. 90, 101 and 104). I am indebted to Reverend Burton for information on the property; see also the film 'All this began at two bob a night at Collingwood', Australian Broadcasting Commission, 1972.

45 Re *Bailed Up*, see Roberts' remarks, cited Croll, p. 38; *Bushranging* shows Fred Ward (Captain Thunderbolt), who was captured near Uralla, near Armidale, N.S.W., in mid 1870. See B. Scott, *Complete Book of Australian Folklore*, Sydney, 1978, pp. 338-40.

46 Re *Bourke Street*, see Ian Burn's essay in this volume; re *The Breakaway*, see the journalist's report on a visit to Brocklesby while Roberts was painting it, cited Croll, pp. 35-7.

47 Buxton, *The Riverina*, pp. 251, 264; F. Wheelhouse, *Mastering the Land*, Sydney, 1978, ch. 4. Roberts would, of course, have found the struggle between man and animal without the aid of machines more 'heroic'. My point is, however, to ask why such preferences were held and which class viewpoint they represent.

48 K. Swan, *A History of Wagga Wagga*, Wagga Wagga, 1970, pp. 159-61 (cf. H. McQueen, *Social Sketches of Australia 1888-1975*, Penguin, 1978, p. 8). See also Buxton, *The Riverina*, chs. 8 and 9, esp. pp. 264-5.

49 *Letters from Queensland*, London 1893; cited J. Harris, *The Bitter Fight*, St Lucia, 1970, p. 81.

50 R. Lawson, *Brisbane in the 1890s*, St Lucia, 1973, *passim*.

51 Buxton, *The Riverina*, p. 264.

52 ibid., p. 266.

53 Trollope cited at length by J. Fisher, *The Australians*, New York, 1968, pp. 151-65; *Such Is Life*, ch. VI. See G. A. Wilkes, 'The Australian Legend: Some Notes Towards a Redefinition', *Southerly*, no. 3, September 1977, pp. 318-30.

[54] See Nigel Lendon's essay in this volume.

[55] This sepia stereograph is inscribed 'Newstead Jany 1895' on the border and 'Tom Roberts with Duncan Anderson and family' on verso (Private collection, Victoria). I am indebted to Ms Helen Topliss for this information. The photograph reveals that the figure bending into the shed from the right in *Shearing at Newstead: The Golden Fleece* is Duncan Anderson. The relatively benign relationship to the shearers parallels that of the white-bearded overseer in *Shearing the Rams*, and is a softening of convention of the strutting, centralized owner typical of at least some newspaper illustrations. However, only he (and the wool boy: one of Anderson's sons?) look towards the front from amidst their busy workers, in a striking parallel to the owner in the Bayliss photograph. On the friendship between station-owner and artist see the recollections of Anderson's son, Alick, letters from Roberts, etc., cited Croll, pp. 147, 165-71 and references in Croll (ed.), *From Smike to Bulldog*, Sydney 1946, pp. 111 and 117. No relationship between the Andersons of Brocklesby and the Andersons of Newstead has been established.

[56] The *Argus*, 26 June 1890. While painting *The Breakaway* he stayed in a hut next to the woolshed, which was 12 km approx. from the house. See Croll, pp. 33 and 35-7.

[57] See Spate, 'Tom Roberts', p. 35; K. Kestel, 'A Gentleman Named Roberts', unpublished manuscript, Corowa, 1974, p. 7.

[58] Further, Kestel claims that Roberts and Alexander Anderson met on the *Lusitania* in 1885, became friends, thus Roberts' invitation to Brocklesby in 1888 (ibid., p. 3). In the entry on *Brocklesby*, an 'impression' of April (?) 1889, V. Spate notes that Roberts' brother Dick married Alexander Anderson's only daughter ('Tom Roberts Catalogue', no. 54). The portrait of Anderson of September 1889 is a roughly painted sketch of a good-humoured man relaxing with his pipe (reproduced *Woman's Day*, 23 December 1963).

[59] I am indebted to Ms A. Leslie, editor of the *Corowa Free Press* for this report. It reads in full:
BROCKLESBY WOOLSHED
'A correspondent writes:—"Believing in the adage that 'It is the unexpected that generally happens', I cannot but narrate how, one day last week, being in search of some lost sheep and anticipating at the utmost finding only sheep, I found to my intense delight and astonishment a veritable 'Landseer' or 'Raphael'—calmly and unostentatiously squatting down on the shearing board at Anderson's woolshed, at Redlands, dressed in a blue shirt and moleskins or cords (I forget which), with brush in hand, giving the last finishing touches to a picture in oils, about 5 ft. x 4 ft.—a gentleman named Roberts—who has succeeded in transferring to canvas the busy scene that occurs in an Australian woolshed at shearing time, delineating not alone the tout ensemble of the living drama being enacted, but a wonderful and life-like representation of every man and boy on the board—aye, and I might almost say of every sheep too, for they have different features; and you bet old Burns knows most of them by their faces. Conspicuous above all sits Frank Barnes, smoking a short pipe, with the sun lighting up his bronzed features, and looking so life-like that you cannot but wonder at the amazing skill of the master-hand that did it. Then in the background, pressing wool, Mr. A. Anderson, sen., facing his brother Charles, whom you could swear to in the dark. On the shearing board are Jim Coffey, busy stripping a sheep of its covering, then a man next to him engaged in like manner, true to the life, and so on to the very boy, young Detlefsen, who is hurrying with a fleece to throw on the table before the wool-roller, whose likeness is surprisingly good. Altogether, from the portrayal of every minor detail to the faithful perspective of the shed, with its row of massive pine posts, and lights and shadows of the sheep pens, crammed full, I do not hesitate to say it would grace the National Gallery, to say nothing of the Melbourne Gallery. I am not 'blowing', but giving honour to whom honour is due; and if you don't believe me, and have a soul above wool and mutton, and can appreciate a masterpiece of artistic skill, I daresay you will be allowed to see it and judge for yourself on application."'
Neither Anderson is clearly depicted in the painting, which was 'finished' in Roberts' Melbourne studio and thus differs slightly from this description. The abovementioned portrait of Alexander Anderson shows the head of a bearded man who may be the woolpresser facing away from the viewer.

[60] Kestel, op. cit., p. 3; Burton, 90f and 100f. The 'Frank' of the dedication may refer to Francis Barnes. See n. 5 above.

[61] The above report identifies the main shearer and the woolboy at left; the second shearer may be Jack Wise and the 'tar boy' Susan Bourne, daughter of the 'working overseer' referred to by the journalist reporting on *The Breakaway* (Kestel, p. 3; Croll, p. 35).

[62] vol. 1, no. 1, Brisbane, 1 March 1890, p. 1.

[63] Francis Adams, *The Australians: A Social Sketch*, London, 1893, pp. 167-9, cited N. Ebbels, *The Australian Labor Movement 1850-1907*, Sydney, 1960, pp. 118-19, wherein see also *General Rules and By-Laws of the Amalgamated Shearers' Union of Australasia*, revised and adopted 1890, especially general rule 17 and by-laws 44, 45, 64 and 65.

[64] Markey, 'Frankenstein's Monster . . .', op. cit., pp. 11-12.

[65] Buxton, *The Riverina*, p. 262.

[66] The 1890 Strike is still regarded as the key to interpreting this period. Among the many studies are W. G. Spence, *Australia's Awakening: History of the A.W.U.*, Sydney, 1911; T. A. Coghlan, *Labour and Industry in Australia*, London, 1918; R. Gollan, *Radical and Working Class Politics*, Melbourne, 1960, pp. 129-35; N. B. Nairn, 'The Maritime Strike in N.S.W.', *Historical Studies*, no. 37, November 1961, pp. 1-8; H. McQueen, *A New Britannia*, Penguin, 1970. A recent summary is B. K. de Garis, '1890-1900', in F. Crowley (ed.), op. cit., 230ff. For the relatively muted effects of the Strike in the Riverina see Buxton, *The Riverina*, pp. 262-7. On the question

of class formation see S. Macintyre, 'The Making of the Australian Working Class: an historiographical survey', *Historical Studies*, vol. 18, no. 71, October 1978, pp. 233-53, and H. McQueen, *Labour History*, no. 32, May 1977, pp. 91-4.

[67] See ibid., e.g., B. K. de Garis, pp. 218-28.

[68] See his *National Life and Character*, 1891; extract in Turner, *The Australian Dream*, op. cit., p. 164-70.

[69] *In Bad Company*, 1901, written about 1885; cited ibid., pp. 140-3.

[70] Henry Parkes, *Fifty Years in the Making of Australian History*, 1892; cited ibid., p. 125.

[71] Cited Smith, *Documents*, p. 208.

[72] Cited Croll, p. 33.

[73] Ward, *The Australian Legend*, op. cit., pp. v, 99.

[74] G. Davison, 'Sydney and the Bush', *Historical Studies*, vol. 18, no. 71, October 1978, p. 200.

[75] L. Cantrell, 'Introduction', *The 1890s*, St Lucia, 1977. [76] See n. 34.

[77] *Table Talk*, 18 July 1890, p. 10. It remained in the Trenchard family until its sale to the National Gallery of Victoria in 1932. Prints of it were authorized in 1900 (see n. 29), as were loans to exhibitions (e.g., at the Athenaeum, Sydney, March 1920 — letter from Roberts to Mrs Burchill, 3 February 1920, A.G.N.S.W. file). Edward Trenchard is depicted second from the right in the front row of the balcony overlooking the royal party in Roberts' *The Opening of the First Commonwealth Parliament* (1901).

ANN GALBALLY: Aestheticism in Australia

[1] Ada Cambridge, *Thirty Years in Australia*, Methuen and Co, London, 1902, p. 135.

[2] For the best account of du Maurier and Aestheticism see Leonie Ormond, *George du Maurier*, Routledge and Kegan Paul, London, 1969, especially chapter 7.

[3] Ormond, op. cit., p. 250.

[4] The *Argus*, 5 March 1881, p. 5. [5] ibid.

[6] *Australasian Sketcher*, 27 January 1887, p. 7.

[7] *Australasian Sketcher*, 24 August 1886, p. 138.

[8] Unpublished MS., private collection, Melbourne.

[9] Tom Roberts Correspondence, A 2478, vol. I, E. St Kilda, Junction Road, Summer Hill, N.S.W., c 1890, Mitchell Library, Sydney.

[10] Tom Roberts Correspondence, op. cit., Daisy Cottage, Gembrook. Monday evening, postmarked 5 October 1891.

[11] 9 x 5 Exhibition Catalogue. Art Library, State Library of Victoria.

[12] Now called *Bourke Street*, oil on canvas 19½" x 29¾", National Library, Canberra.

[13] *Table Talk*, 5 April 1889, p. 6.

[14] *Table Talk*, 23 August 1889, p. 4. [15] ibid.

[16] U. Hoff, *Charles Conder: His Australian Years*, National Gallery Society of Victoria, 1960, p. 8. Her references are *Table Talk*, 11 October 1889, p. 6; *Table Talk*, 11 January 1889, p. 10.

[17] M.L.M., *The Australasian Critic*, 1 May 1891.

RUTH ZUBANS: Emanuel Phillips Fox

[1] *Sun* (Melbourne), 25 August 1893, p. 7.

[2] He studied there between 1878 and 1886. See *Report of the Trustees of the Public Library, Museums and National Gallery of Victoria*, 1878 to 1886, Melbourne, 1879-87.

[3] *Table Talk*, 23 January 1891, p. 8, a reliable article largely based on the artist's letters.

[4] Unpublished letter, Fox to Roberts, from Étaples, Pas de Calais, dated 30 July 1887, Tom Roberts Papers, Mitchell Library, Sydney.

[5] See the present writer's *E. Phillips Fox (1865-1915): The Development of his Art, 1884-1913*, Ph.D. thesis, University of Melbourne, 1979, ch. 2, 'Student Years in Paris, 1887-1890: Académie Julian, École des Beaux-Arts, Alexander Harrison'; and ch. 3, 'The Peasant Theme and Open Air Painting: Early Works in France, 1887-1890'. See also R. Zubans, 'The Early Works of Phillips Fox: France and Australia', *The Gallery on Eastern Hill*, ed. by C. B. Christesen, Melbourne, 1970, pp. 53-72. This article has been in part superseded by more recent research incorporated in the thesis.

[6] He departed from London aboard the *Orizaba* on 10 September, arriving in Melbourne on 20 October 1892, Shipping Records, Public Records Office, Victoria.

Fox returned to Australia three times, in 1892, in 1908 and in 1913; he died in Melbourne in 1915.

[7] The work was exhibited as no. 646 and reproduced as an engraving in Société nationale des artistes français, *Salon de 1891, Catalogue illustré*, Paris, 1891, p. 158. *Table Talk*, loc. cit., confirms that it was painted at St Ives. It was first shown in December 1890; see above, p. 8.

Fox exhibited at the Salon from 1890.

[8] See the thesis, chapters 3 and 5, and R. Zubans, op. cit. Fox remained in Australia between 1892 and 1901.

[9] St Ives Arts Club, *Suggestions and Hints*, 22 September 1890: 'That a separate book be supplied exclusively for Mr. Louis Reginald Monro Grier's signature' [signed with eight others], Emanuel P. Fox.' (Grier's signature spread widely over the page.) See below, note 29.

[10] St Ives Arts Club, *Minute Book*, entry for 8 August 1890 lists 'Fox' among 'those present'. See note 29.

[11] St Ives Arts Club, *Visitors' Book*. E. R. Fox was signed in as a visitor on 20 September 1890 and on 30 September 1893. See below, note 29.

[12] Unpublished letter, Aby Altson to Roberts, dated 22 July 1891: 'I met Longstaff but not Fox who is in Spain just now', Tom Roberts Papers, Mitchell Library, Sydney. *Melbourne University Review*, July 1891, vol. 8, no. 2, p. 101, confirms this: 'Mr Fox... at present is in Madrid ... studying the work of Velasquez'. See also above, pp. 11-12.

[13] Letter, Russell to Roberts, headed 'The Ship, Polperro, Cornwall, Wednesday the 24th (September ?) 1884', Tom Roberts Papers, Mitchell Library, Sydney.

[14] The Menpes, Sickert, Whistler winter sojourn at St Ives in 1883-84 is described in M. Menpes, *Whistler as I Knew Him*, London, 1904, pp. 135-44, and E. R. and J. Pennell, *The Life of James McNeill Whistler*, 2 vols, London, 1908, vol. I, p. 312, and vol. II, p. 20.

[15] This is deduced from the entries in the St Ives Arts Club *Suggestions and Hints* and its *Minute Book*. See also above, p. 7.

[16] The first exhibition (1885) organized by the Anglo-Australian Society of Artists was held in Melbourne, the 1889 exhibition in Sydney. The Society changed its name to The Royal Anglo-Australian Society of Artists, and thereafter held its exhibitions in more than one centre. Among the exhibitors in 1885 were Whistler and Menpes; the 'Newlyners' were represented by T. C. Gotch and Walter Langley, whilst W. Ayerst Ingram showed a number of Cornish scenes among his seascapes and landscapes. The 1889 exhibition contained a substantial number of works by the Newlyn group. Although Fox could not have seen this latter exhibition, nor those in 1890 and 1892, the exhibitions demonstrate an important link between the English painters and Australian art. Among the members of the Society who showed works in Melbourne in 1890 and 1892 were, for example, Adrian and Marianne Stokes and Edward Emerson Simmons, all painters with whom Fox came in contact at St Ives. See above, p. 6ff.

See exhibition catalogues, Royal Anglo-Australian Society of Artists, 1885, 1889, 1890, 1892.

[17] See J. Quigley, 'Some Art Colonies in Brittany', *The Craftsman*, 1906, vol. 10, pp. 701-72; 'Studio Talk — Concarneau', *Studio*, 1904, vol. 33, pp. 175-6; and E. E. Simmons, *From Seven to Seventy: Memories of a Painter and a Yankee*, New York, 1922, pp. 141, 145, 164-5.

[18] Most of these artists had received some training in France or Belgium and had painted in the European outdoor centres before returning to England. 'Mr. Stanhope Forbes is . . . making good use of his solid foreign technique, using it as his weapon in the expression of English scenes and English types', wrote a critic in the *Art Journal*, June 1890, p. 169, 'The Summer Exhibitions at Home and Abroad. II. The Royal Academy, The Grosvenor, and The New Gallery'. The comment could well have applied to the other artists mentioned above.

[19] Various writers in fact likened Newlyn to Barbizon; for example, a reference was made to 'Newlyn — the British Barbizon' in 'The New Associates', *Graphic*, 6 February 1892; see also C. Hiatt, 'Mr. Frank Bramley . . . and his Work', *Magazine of Art*, New Series I, 1902-03, p. 54.

[20] *Western Portfolio*, Plymouth, vol. 1, July 1888, no. 1, p. 4.

[21] A. Meynell, in 'Newlyn', *Art Journal*, April 1889, p. 98, speaks of the 'Newlyn brotherhood', while other writers refer to the 'brotherhood of St Ives'.

[22] In my discussion of the Newlyn school I am indebted to Mrs Joanna Lace from Cambridge, who was generous in her help and made available her undergraduate thesis, *Norman Garstin and the Newlyn School*, Cambridge University, 1973; Dr Virginia Spate kindly drew my attention to the thesis.

See also A. Meynell, 'Newlyn', *Art Journal*, April 1889, pp. 97-102, pp. 137-42; W. Meynell, 'Mr. Stanhope Forbes, A.R.A.', *Art Journal*, March 1892, pp. 65-9; *Paintings by Artists of the Newlyn School, 1880-1900*, The Newlyn Society of Artists, The Passmore Edwards Art Gallery, Newlyn, 1958 (Exhibition Catalogue), Introduction by M. Canney.

[23] ' "Adversity". From the picture by Fred Hall', *Art Journal*, 1890, p. 365.

[24] It should also be noted that the so-called 'Newlyn characteristics' tend to be over-generalized.

[25] *Catalogue of an Exhibition of Pictures by Artists Residing in, or Painting at, Newlyn, St Ives, Falmouth, etc. in Cornwall: A Collection illustrating the Artistic Movement which is associated with that part of England*, Dowdeswell and Dowdeswell's Limited, London, December 1890.

Illustrated Catalogue of the Special Exhibition of Pictures by Cornish Painters of Newlyn, St. Ives, Falmouth, etc., Nottingham Castle Museum and Art Gallery, Nottingham, September 1894. This catalogue identifies the St Ives painters.

Whitechapel Art Gallery, *Spring Exhibition, 1902*, 27 March-7 May, London [Catalogue], Preface by Norman Garstin.

[26] See Whitechapel Art Gallery (Catalogue), op. cit., p. 6; A. Meynell, 'Newlyn', op. cit., pp. 99, 142; W. Meynell, op. cit., p. 67; *The Artist*, 'Newlyn and St. Ives', 1 August 1890, p. 232; 'Current Art', *Magazine of Art*, vol. 13, 1889-90, p. 114.

[27] *Art Journal*, June 1890, p. 169, 'The Summer Exhibitions at Home and Abroad, II', op. cit. See also the *Echo*, 13 May 1892, 'Royal Academy. III. The Triumph of Newlyn'.

[28] Already in July 1888, the critic of the *Western Portfolio*, vol. 1, no. 1, p. 3, felt that 'the Newlyn men are essentially literary painters . . .'; see also *Spectator*, 10 May 1890, and *Star*, 28 December 1891; A. Meynell's articles, op. cit., show that this element had never been altogether absent from the Newlyn School, despite their sincere desire for an impartial portrayal.

Their acceptance and success is demonstrated by the Chantrey purchase of Bramley's *A Hopeless Dawn*, in 1888, and Stanhope Forbes' election as Associate of the Royal Academy in January 1892.

[29] Very little has been written on the 'St Ives School'. The following account has been pieced together from the previously unpublished records of the St Ives Arts Club — its *Minute Book* (dating from 1 August 1890), *Suggestions and Hints, Visitors' Book* (August 1890-December 1892, with a 'List of yearly members' and 'Monthly members' entered on the reverse side of the book, and terminating in December 1892), and a *List of Members [Book]*, 1892-3, all still in the possession of the St Ives Arts Club; the three exhibition catalogues cited above in note 25; catalogues of the New English Art Club, 1886-92; an identification of the principal artists' works through reproductions at the Witt Photographic Library,

London; *Grosvenor Notes*, 1888 and 1890, *New Gallery Notes*, 1888-92, *Academy Notes*, 1888-92, edited by H. Blackburn; *Pictures of the Year*; and an examination of paintings at the Tate Gallery, London, Liverpool Art Gallery, Nottingham City Art Gallery and Museum, Oldham Metropolitan Borough Council Art Gallery, Plymouth City Museum and Art Gallery, Truro County Museum and Art Gallery, St Ives Museum, Porthminster Hotel, St Ives, St Ives Guildhall, St Ives Library, St Ives Arts Club. Information is derived also from press cuttings, New English Art Club, for the years 1888-90, Archives, Tate Gallery, London; *The Artist*, 1 January 1891, p. 12, 'Dowdeswell's'; 1 August 1890, p. 232, 'Newlyn and St. Ives'; *Magazine of Art*, June 1902, pp. 380-1, 'The Chronicle of Art — June. Cornwall at Whitechapel'; the following issues of *Studio*: vol. V, no. 27, June 1895, pp. 110 ff; vol. VI, no. 33, December 1895, p. 182; no. 34, January 1896, p. 246; vol. VIII, no. 42, September 1896, pp. 242-4; vol. XIII, no. 61, April 1898, pp. 196-7; J. H. Matthews, *A History of Parishes of St. Ives, Lelant, Tovednack and Zennor in the County of Cornwall*, London 1892, pp. 11, 368-71; E. E. Simmons, op. cit.; and the anonymous 'St. Ives as an Art Centre', extract from *Historical Sketch of St. Ives and District*, 1896, pp. 62-3 (probably written by Henry Harewood Robinson). For the latter I am indebted to Mr Len Fox, who obtained it from the Town Clerk, St Ives.

Entries on individual artists in U. Thieme and F. Becker, *Allgemeines Lexikon der bildenden Künstler*, Leipzig, 1907-50, and C. Wood, *Dictionary of Victorian Painters*, London, 1971.

[30] St Ives Arts Club, *List of Members, 1892-3*, includes a D. Davies and Mrs Davies.

[31] See E. E. Simmons, op. cit., pp. 141-2, 145, 164-5, and W. Meynell, 'Mr. and Mrs. Adrian Stokes', *Art Journal*, July 1900, pp. 195-6.

[32] 'St. Ives as an Art Centre', op. cit., p. 63. For Whistler see above, note 14.

[33] ibid. This list is largely corroborated by J. H. Matthews, op. cit., p. 369, and the Catalogue of the Cornish exhibition at Dowdeswell's, December 1890, op. cit.

[34] St Ives Arts Club, *Minute Book*, 1 August 1890.

[35] 'St. Ives as an Art Centre', loc. cit.

[36] L. Grier, 'A Painters' Club', *Studio*, vol. V, no. 27, June 1895, pp. 110-12. I am indebted to Mr Gerard Vaughan for drawing my attention to this article. See also 'St. Ives as an Art Centre', loc. cit.

[37] L. Grier, loc. cit., p. 112.

[38] See *Catalogue... New English Art Club*, 1887, no. 86; 1888, no. 85. *Pall Mall Gazette*, 7 April 1888, notes that Adrian Stokes was elected to the selecting jury for the year 1888.

Marianne Stokes also exhibited with the N.E.A.C. in 1887 and 1888.

[39] See *Catalogue ... New English Art Club*, March-May 1890, no. 46; April 1891, no. 62; November 1891, no. 89; November 1892, nos. 61, 76.

Titcomb also exhibited there: in 1887, no. 18; in 1889, no. 32; in March-May 1890, nos. 96, 152.

Alfred East showed at the N.E.A.C. in 1887.

[40] ibid., 1887, no. 1; 1889, no. 29 (listed as a member, 1889); March 1890, nos. 2, 37; April 1891, no. 53. For contact between Fox and the 'Glasgow boys' see above p. 15 ff.

[41] See *Grosvenor Notes*, 1888-90, *New Gallery Notes*, 1888-92, *Academy Notes*, 1888-95, London, edited by H. Blackburn; and *Pictures of the Year*, 1888-92. See also below, notes 45, 46.

[42] L. Grier, op. cit., p. 111.

[43] Catalogue of the Cornish exhibition at Dowdeswell's, December 1890, op. cit., no. 73. At £150 it was one of the highest priced works in the exhibition. See also note 9 for the 'nonsense suggestion'.

[44] Institute of Painters in Oil Colours, *8th Exhibition, Illustrated Catalogue*, London, 1890-1; no. 336. Day dreams, Emanuel P. Fox.

[45] For specific paintings by these artists, see the writer's thesis, ch. 4, footnote 35, where one work is listed by Eadie, three by Titcomb, four by Simmons, two by Robinson, three by Olsson, five by East, seven by Stokes, one by Marianne Stokes and two by E. Noble Barlow.

[46] For Grier's works see thesis, ch. 4, footnote 36.

[47] See *The Artist*, 1 January 1891, p. 12; *Studio*, December 1895, vol. VI, no. 33, p. 182; April 1898, vol. XIII, no. 61, p. 196; *Magazine of Art*, June 1902, pp. 380-1.

[48] The moonlight scene, the twilight and the sunrise enjoyed a considerable vogue at St Ives, as may be deduced from the catalogue entries of the exhibitions at Dowdeswell's in 1890, the N.E.A.C., the Royal Academy and the Cornish Exhibition at Nottingham in 1894. In the Nottingham exhibition, in particular, many of the St Ives painters showed twilight and moonlight scenes: Will E. Osborn, Mary A. Bell, Alfred East, G. Walter Jevons, Julius Olsson, Algernon M. Talmage, H. H. Robinson, C. Greville Morris, Arthur Meade, S. M. Laurence, Louis Grier and J. Noble Barlow. Painters from the other Cornish centres by comparison showed fewer such scenes. Perhaps the St Ives environment was more important for the shaping of Phillips Fox's and David Davies' twilight preferences than is generally realized.

More broadly, in the later 1880s the twilight scene was evoked by many artists in England and Scotland. Reviewing the Grosvenor exhibition, for example, a critic wrote in the *Scottish Art Review*, June 1889, p. 9: 'This is a year of moons in landscape . . . She rises or sets in all the galleries'. At St Ives it rose perhaps with greater concentration than elsewhere.

[49] *Catalogue of a Collection of Paintings and Drawings illustrating the Duchy of Cornwall, by Alfred East, T. C. Gotch, W. Ayerst Ingram . . . at the Fine Art Society*, 1888 (Introduction by R. A. M. Stevenson), p. 4.

[50] See note 46.

[51] In the *E. Phillips Fox: Souvenir Catalogue*, Melbourne, 1949, for the retrospective exhibition in 1949-50 (travelling interstate), the painting, listed as no. 46 and lent by Ethel Carrick Fox, is dated to 1904. The type of signature inscribed on the work

would support this relatively late date. However, that may have been added later. On the grounds of mood, compositional layout and palette, I favour the earlier dating.

[52] For a discussion of the assimilation of Barbizon paintings and the resistance met by the Impressionists, see D. Cooper, *The Courtauld Collection*, London, 1954, chs 3-5, pp. 19ff.

[53] E. E. Simmons, op. cit., pp. 166, 168; and U. Thieme and F. Becker, op. cit., vol. XXXVI, pp. 556-8.

[54] E. E. Simmons, op. cit., pp. 141, 151-2, 155-6, 159-60, 162, describes his trip and his admiration for Velazquez. See also *Catalogue . . . E. Phillips Fox*, 1892, op. cit., no. 7, Sketch at Elche, Spain.

[55] See note 12.

[56] *Exhibition of Australian Art in London*, Grafton Galleries, April-May 1898 (Catalogue), lists the works exhibited by Fox as no. 51, *Portrait of Mr. Ellery*; 56, *Portrait of My Cousin*; 60, *Portrait of Mary, Daughter of Prof. Nanson*; 71, *The Art Students*; 79, *The Orphan*; 108, *Adelaide, Daughter of Professor Tucker*.

[57] *Table Talk*, 9 December 1892, p. 4.

[58] *Sun*, 9 December 1892, p. 14.

[59] No. 336 in the Catalogue; see above, note 44.

[60] Nos 28 and 49 in the *Catalogue . . . E. Phillips Fox*, 1892, op. cit.

[61] For example, Marianne Stokes' *Waiting for Santa Claus*, exhibited with the Royal Society of British Artists, according to a critic in *Magazine of Art*, 1889-90, vol. XIII, p. 114, depicted a child 'sitting in front of the fire with the glow of firelight upon him'.

[62] *Table Talk*, loc. cit.

As seen in *The Convalescent*, the combination of the 'Titianesque' hair and the close-toned colours in blue and green is also suggestive of Whistler's works. The liberal use of pure white which had characterized Fox's French paintings is replaced by muted colours. It is curious that his interest in Whistler should become manifest only in the St Ives context. He could have seen Whistler's work during the three-year stay in France, at the Salon, at Durand-Ruel's, at the Galerie Georges Petit and perhaps elsewhere. Among the works exhibited there may have been one of Whistler's 'Symphonies' in white.

[63] *Age*, 21 April 1893, p. 6; V.A.S. Exhibition . . . *Illustrated Catalogue*, April 1893, no. 13.

[64] *Standard*, 4 April 1898.

[65] See notes 38 and 39.

[66] E. R. and J. Pennell, op. cit., vol. 2, p. 151. Under Whistler's presidency Harrison had been invited to show works with the Royal Society of British Artists. Since 1887 he had also been involved with the N.E.A.C., remaining a member until 1892.

[67] *Whistler, Nocturnes, Marines and Chevalet Pieces, Goupil Gallery* (London, March-April) 1892, Catalogue.

[68] Among the works shown were Whistler's *Symphony in White No. II. The Little White Girl* (no. 33); and *Harmony in Pink and Grey. Portrait of Lady Meux* (no. 43) — both were later reflected in Fox's

My Cousin. The pose of *Mary Nanson* (c 1897) suggests knowledge of other pictures there: no. 44, *The Artist's Mother* (represented by a photograph) and no. 43, *Thomas Carlyle*. The profile standing figures in *The Art Students* (1895) and *Lady in Black* (c 1900, Art Gallery of New South Wales) are a further demonstration of Fox's absorption of Whistler's example. Fox's moonlight scenes, like *Moonlight on Swamp*, (1900, Australian National Gallery, Canberra) and *Moonrise, Heidelberg* (c 1902, National Gallery of Victoria), echo Whistler in their decorative scaling of colours; nevertheless Fox's healthy regard for atmospheric vibration and the sense of a specific locale distinguish his landscapes from those by Whistler. For Fox's later interest in Whistler's art see the present writer's thesis, ch. 6, 'Return Overseas: a Search for Direction, 1901-1904'.

[69] For the 'Glasgow School' see *The Scottish Art Review*, vol. 1, 1888-89, pp. 146-9, 'Art in the West of Scotland'; pp. 243-7, 'The Exhibition of the Glasgow Institute of the Fine Arts'; *Art Journal*, 1890, p. 128, 'Art in the Provinces. Art in Glasgow'; *Catalogue . . . N.E.A.C.*, 1886-92; John Lavery, Goupil Gallery, London, June 1891 (Exhibition Catalogue by J.F.W.); J. L. Caw, *Scottish Painting Past and Present, 1620-1908*, Edinburgh, 1908, chapters III-VI; J. L. Caw, *Sir James Guthrie*, London, 1932, ch. IV; F. Rinder, 'Sir James Guthrie, P.R.S.A.', *Art Journal*, 1911, pp. 139-44, 270-4; W. Shaw-Sparrow, *John Lavery and his Work*, London, 1911; A. S. Hartrick, *A Painter's Pilgrimage through 50 Years*, Cambridge, 1939, ch. 5; *Man of Influence: Alexander Reid*, Scottish Arts Council, Edinburgh, 1967 (Exhibition Catalogue by R. Pickvance); *The Glasgow Boys, 1880-1900*, Scottish Arts Council, Edinburgh, 2 volumes, 1968-71 (Exhibition Catalogue); *Helensburgh and The Glasgow School*, The Helensburgh and District Art Club, Helensburgh, 1972 (Exhibition Catalogue); D. and F. Irwin, *Scottish Painters at Home and Abroad, 1700-1900*, London, 1975, ch. 20; W. Hardie, *Scottish Painting, 1837-1939*, London, 1976, ch. 6, pp. 72-82.

[70] Millie Dow, William Kennedy and especially Lavery, who spent considerable time painting there, were the transmitters of ideas absorbed at this artists' colony. Alexander Harrison who was a popular figure at Grez, knew Lavery well.

[71] This point is well summed up in 'Studio Talk. Glasgow', *Studio*, vol. IX, November 1896, no. 44, p. 140.

[72] For example of their works see above, pp. 19-20.

[73] Both Guthrie and Lavery showed at the Salons of 1889 and 1890; Guthrie — also at the Salon 1891, Lavery — at the Salon, 1892. Guthrie had exhibited at the Royal Academy in 1882 and 1883, Lavery in 1886, 1887, 1890-92. One work by Lavery (no. 82) was displayed in the British section of the Paris Universal Exhibition in 1889. Many artists of the Scottish group showed at the N.E.A.C. regularly until 1890, but except for Alexander Roche, less frequently thereafter. Guthrie and Lavery are still listed as members in the Catalogues of 1892.

[74] See above, pp. 7-8, notes 38, 39, 40 and 66.

[75] See the writer's thesis, ch. 3, and R. Zubans, op. cit., pp. 58-9, 66.

[76] Letter, Fox to Roberts, op. cit.

[77] Information on the N.E.A.C. from: *Catalogue . . . New English Art Club*, 1886-92; press cuttings, New English Art Club, 1887-92, Archives, Tate Gallery, London; Pall Mall Gazette Extra, *Pictures of the Year*, 1887-92; W. J. Laidlay, *The Origin and First Two Years of the New English Art Club*, London, 1907; A. Thornton, *Fifty Years of the New English Art Club, 1886-1935*, London, 1935; *The Early Years of the New English Art Club*, The Fine Art Society, London, 1968 (Exhibition Catalogue by B. Hillier); A. E. Gruetzner, *The Formation and the First Four Exhibiting Years of the New English Art Club*, M.A. Report, Presented May 1975 (unpublished thesis, Courtauld Institute of Art), to which Mr Alan Bowness kindly drew my attention. See also above, note 69.

[78] They formed part of a small core at the N.E.A.C. who had exhibited at Goupil's in December 1889 under the name 'London Impressionists'.

[79] At the Glasgow Institute of the Fine Arts, in 1892, Fox exhibited a work entitled *Pigeonloft*.

[80] Guthrie's pastels at Dowdeswell's, according to *The Artist*, 1 January 1891, p. 13, were exhibited in a room adjacent to the Cornish exhibition, where Fox showed *The Convalescent*. Thus Fox very probably saw Guthrie's display. Among Guthrie's works was his 'Causerie', (c 1890, Glasgow University Collection), that slightly resembles Fox's painting *The Art Students* (1895) in its 'casual' Degas-inspired composition and in the pose of the seated profile figure in the foreground.

Among the pastels of interest to Fox may also have been the ploughing and harvesting scenes and the other little landscapes, all of which reflected concern with light and atmospheric effects. Many were twilight, sunset and moonlight scenes.

See also above, note 48.

[81] *John Lavery*, June 1891 (Exhibition Catalogue), op. cit., lists thirty-five works including 1 An Irish Girl; 5 Ariadne; 11 Girl in White; 18 A Tennis Party; 22 The Hammock; 24 Twilight—The International Exhibition; and scenes of Tangiers.

[82] A critic in *The Artist*, loc. cit., wrote for example of Guthrie's 'abstinence from literature'. F. Wedmore in his commentary on the work of the 'Glasgow boys' in 'Some Portraits of this Season', *Studio*, 1895, vol. V, no. 27, June, p. 123, observed that 'in them all, if a portrait is not in every case a likeness it is at all events a picture—it is not only an attitude'.

[83] G. R. Watts, *The Lady Catherine Thynne* (27 x 22 in.), was exhibited at the Royal Academy in 1891 as no. 304. Illustrated in *Academy Notes*, 1891, p. 72.

[84] Its present title is *The Setting Sun*. Judging by the description of *Homewards* in the *Age*, 10 May 1895, p. 6, they represent the same painting. See R. Zubans, op. cit., p. 65.

[85] For the Melbourne School of Art, opened by Fox and Tucker in Melbourne in 1893, and the later summer school held at 'Chartersville' and dating from about 1894, see R. Zubans, op. cit., pp. 67-8 and the writer's thesis, chapter 5. The contemporary spelling was 'Chartersville'. For Tudor St. George Tucker, see above, p. 5.

[86] Clausen's work is well discussed in two contemporary accounts, R. A. M. Stevenson, 'George Clausen', *Art Journal*, October 1890, pp. 289-94, and W. Armstrong 'George Clausen, A.R.A.', *Magazine of Art*, 1895, pp. 401-6.

For Edward Stott see J. S. Little, 'On the Work of Edward Stott', *Studio*, 1895, vi, no. 32, November, pp. 71-83, and A. C. R. Carter, 'Edward Stott and his Work', *Art Journal*, 1899, pp. 294-8; Fine Art Society, *William Stott of Oldham and Edward Stott ARA*, London, 1976 (Exhibition Catalogue). Mr Peyton Skipwith kindly made available the records of Stott's work in the possession of the Fine Art Society and I am indebted to Mr M. Cross for the Stott records in the Rochdale Art Gallery.

[87] I have borrowed this expression from the catalogue, *The Early Years of the New English Art Club*, 1968, op. cit., p. 2.

[88] In 'Some Remarks on Impressionism', *Art Journal*, 1893, p. 104, there are telling commentaries by the two artists. Edward Stott writes: '"Impressionism" . . . to me has no relation whatever with any of the technicalities of painting. To me it means a combined impression of the artist's feeling . . . in short, a recording of the impression of the painter's nature'. Clausen similarly asserts a subjective point of view: 'It is perhaps a pity that the term "impressionism" is narrowed down . . . to one of its phases (the rendering of effects of light); if its aim is to present, not a literal transcript of nature, but the impressions of emotion which nature gives to the painter, no exception can surely be taken to it in the base of all good art'. See also R. A. M. Stevenson, 'George Clausen', op. cit., pp. 290-1, who stresses the role of subjective experience in objective observation: 'painters have been led to consider more closely how we see nature, and how visual impressions affect us . . . They understand realism less as a blind striving after what is fact, and more as the realising of how we ourselves feel nature . . .'

[89] Fox left Melbourne for London aboard the *Oceana* on 12 March 1901, Shipping Records, Public Records Office, Victoria. He remained in England until 1905, when he married the former Slade student Ethel Carrick and settled in Paris.

[90] For the interest of Scottish painters in such themes, see for example note 80.

[91] For example, E. Stott's *The Horse Pond*, Rochdale Art Gallery, and earlier works by him, such as *The Sheep Pool*, illustrated *New Gallery Notes*, 1889, p. 51. A work entitled 'Homewards', incidentally, appears also among Stott's *oeuvre*, although this subject was frequently depicted by other English and Scottish painters of rural scenes.

[92] George Clausen, *The Girl at the Gate*, 1889. Tate Gallery, London, Chantrey Bequest 1890.

URSULA HOFF: The Everard Studley Miller Bequest

The author wishes to record her gratitude for the generous help received from Miss Patricia Reynolds and her staff at the La Trobe Library, State Library of Victoria, who have checked and corrected facts and footnotes.

[1] Alexander Sutherland, *Victoria and its Metropolis, Past and Present*, McCarron, Bird & Co., Melbourne, 1888, II, p. 487. Henry Miller's uncle, the late Dr Joseph Miller, was five times mayor of Londonderry; his cousin, Sir William Miller, was also mayor. *Daily Telegraph* (Melbourne) 8 February 1888, p. 5. Captain Miller was Captain of the guard of the convict ship *Isabella*.

[2] ibid., and Philip Mennell, *The Dictionary of Australasian Biography*, comprising notices of eminent colonists, London, Hutchinson, 1892, p. 232-4.

[3] As under notes 1 and 2 and obituary notice in *Table Talk*, 10 February 1888, p. 2. See also J. G. Steele, *The Explorers of the Morton Bay District 1770-1830*, University of Queensland Press, 1972, pp. 127, 129, 132, 186.

[3a] Robert Russell, 'Melbourne From the Falls, June 30 1837', watercolour, Dixson Gallery, Sydney.

[4] P. L. Brown (ed.), *The Narrative of George Russell*, Oxford University Press, London, 1935, p. 80.

[4a] Robert Russell, 'Melbourne 1854', watercolour, La Trobe Library, State Library of Melbourne.

[5] 'Melbourne's historic homes, VI. The Miller estates. A sporting family', in the *Age*, 1 July 1933, p. 5; D. J. Oppenheim, 'Henry "Money Miller". His Land and His Dealings', research essay, School of Architecture, University of Melbourne, n.d. p. 8 (later quoted as Oppenheim).

[6] Oppenheim, pp. 11-12 contains a plan recording all plots which Henry Miller had acquired or was trustee of between 1839 and October 1858. Among these are twelve Collins Street frontages, twelve Bourke Street ones and twelve Lonsdale Street ones. In the areas between Bourke and Lonsdale Streets are properties leased as merchant stores, warehouses, store yards for building materials, etc. These holdings increased in later years. A copy of the probate documents of 1888, attached to Oppenheim's report, shows much rental real estate; the basis of Miller's wealth was rent returning properties.

[7] Alexander Sutherland, II, op.cit., p. 487.

[8] *Argus*, 26 August 1949, p. 9; *Age*, 26 August 1949, p. 6; and *Business Who's Who of Australia* 1970-7, lists I. G. Miller as Director.

[9] Sutherland, II, op.cit., p. 487, says that 'the first of the "Union Terminating" series of building societies in Melbourne was founded under Mr Miller's auspices in 1850'; but building societies of this kind seem to have started in the late 1840s.

[10] Richard Twopeny, *Town Life in Australia*, London, Stock, 1883, p. 37; in the ˚60s Henry Miller founded the Free Selection Land Investment Society, perhaps the most important of the societies formed in this period, to lend money to prospective land buyers at comparatively easy terms. Members could pay off a mortgage in monthly instalments, but a two months' default — the inability to pay £6 — lost them the freehold. Miller made money available which helped to develop the colony, but evidently expected a good return for it. R. V. Billis and A. S. Kenyon, *Pastoral Pioneers of Port Phillip*, Macmillan, Melbourne, 1932, p. 114-5, lists thirty-eight properties as having been owned by Henry Miller. See also Margaret Kiddle, *Men of Yesterday*, Melbourne University Press, Melbourne, 1963, p. 237.

[11] *The Australian Builder and Railway Chronicle*, 19 February 1859, p. 53. A slide of Granite Terrace is in the School of Architecture, University of Melbourne.

[12] This suggestion came from Dr Miles Lewis, School of Architecture, University of Melbourne.

[13] Donald Sutherland Lyall, 'The Architectural Profession in Melbourne, 1835-1860', M.A. thesis, University of Melbourne, 1965, pp. 49, 55, 62-5, summarizes information on Robertson and Hale. Dr Miles Lewis informs me that the firm also designed the Bank of N.S.W. in Beechworth and the Oriental Bank in Melbourne. The latter is illustrated in *The Australian Builder*, 30 April 1859, pp. 130-1; it was situated at the south corner of Flinders Lane and Queen Street; *The Australian Builder*, 21 January 1860, p. 13, also illustrates a 'Greek' shop-front in Elizabeth Street by the same firm.

[14] *Victoria and its Metropolis*, op.cit., II, p. 487.

[15] Geoffrey Serle, *The Golden Age: a history of the Colony of Victoria, 1851-1861*, Melbourne University Press, Melbourne, 1963, p. 124-5.

[16] *Victoria and its Metropolis*, op.cit., II, p. 551.

[17] *Melbourne Directory for 1859*, Sands & Kenny, Melbourne, 1859, p. 29; *Melbourne Directory for 1862*, Sands and McDougall, Melbourne, 1862, p. 35; the *Age*, 5 June 1973, p. 27.

[18] Ian Robertson, "Lawcourts, Melbourne' in Australian Council of National Trusts, *Historic Public Buildings of Australia*, Cassell, Melbourne, 1971, pp. 234-41. I am indebted to Dr Miles Lewis for this reference.

[19] Maie Casey and others, *Early Melbourne Architecture, 1840-1888*, Oxford University Press, Melbourne, 1953, p. 39.

[20] ibid., p. 39; the architect's name appears in *Victoria Illustrated, Second Series*, Sands, Kenny and Co., Melbourne, 1862, where there is an engraving of the bank made from the architect's design, plate 3. See James Grant and Geoffrey Serle, *The Melbourne Scene, 1803-1956*, Melbourne University Press, Melbourne, 1957, p. 78: 'The new Melbourne Club and the Bank of Victoria were early promises of Collins Street's later grace.' The building was demolished in 1969: the *Age*, 5 June, 1973, p. 27.

[21] *Victoria and its Metropolis*, op.cit., II, p. 487.

[22] Letter from the Secretary, the National Gallery of Victoria, 2 August 1973.

[23] *Victoria and its Metropolis*, op.cit., II, p. 487.

[24] I am indebted to Dr Miles Lewis for this suggestion.

[25] Marnie Bassett, *The Hentys*, Oxford University Press, London, 1954, p. 538. Dorothy Rogers, *A*

History of Kew, Lowden, Kilmore, 1973, pp. 63-5. Stephen Henty had mortgaged 'Findon' to Henry Miller a few years before Miller acquired it. See also Oppenheim; F. G. A. Barnard, *The Jubilee History of Kew, 1803-1910*, Hodges, Kew, 1910, p. 36. The house 'Findon' was probably demolished in 1912, when the estate was subdivided. Information kindly supplied by Miss Patricia Reynolds, La Trobe Librarian. Reference: *Kew Mercury*, January 1912 to May 1913.

[26] 'An Appeal for Mercy, 1973' was exhibited at the 1888-9 Centennial Exhibition in Melbourne, as part of the Victorian Loan Exhibition. On that occasion it was lent by the executors of the Hon. H. Miller.

[27] Alfred Lys Baldry, 'Marcus Stone R.A.' in *Art Annual*, 1896, pp. 20-1. *An Appeal for Mercy, 1793* was engraved by G. Robert.

[28] Marcus Stone, *A Plea for Mercy* was sold at Lawsons, Sydney, on 18 September 1974, lot 124, oil on canvas, 121½ x 184 cm, exh. Melbourne 1893, signed bottom left.

Marcus Stone, *The Letter*, oil on canvas, 80 x 90 cm, was in the sale 'Seneca' Christie, Rome, 15 May 1972, lot 346; bt. Fabrizio Apolloni. I am indebted to Mrs Renée Free for drawing my attention to the Lawson sale and for a print of the photograph taken of the picture by Daniel Thomas.

[29] *Great Victorian Pictures, their path to fame*, an Arts Council Exhibition, 1978, Royal Academy of Art, London, Catalogue no. 53.

[30] *Table Talk*, 10 February 1888, p. 2. *Victoria and its Metropolis*, op.cit., II, p. 487.

[31] Oppenheim, appendix, copy of probate list, p. 26, no. 6; valuation made by Gemmel and Tuckett, auctioneers.

[32] James Grant and Geoffrey Serle, op.cit., p. 138. See also *Victoria and its Metropolis*, op.cit., II, p. 487 and *Table Talk*, 1888.

[33] Oil on canvas, signed and dated 1882, owner, Edward J. Miller, Melbourne.

[34] *Victoria and its Metropolis*, op. cit., II, p. 488.

[35] George Meudell, *The Pleasant Career of a Spendthrift*, Routledge, London, 1929, pp. 12, 69. Meudell's favourable treatment of Henry Miller is all the more important in view of the forthright criticism he meted out to Miller's contemporaries; see Michael Cannon, *The Land Boomers*, Melbourne University Press, Melbourne, 1966, chapter 9, 'The Meudell Mystery', and *Table Talk*, 10 February 1888, p. 2 (Croesus).

[36] *Table Talk*, 10 February 1888, p. 2. According to the *Daily Telegraph*, 8 February 1888, p. 5, Miller was a regular attendant at St Peter's, Eastern Hill.

[37] *Table Talk*, 2 March 1888, p. 1.

[38] *Table Talk*, 8 June 1888, p. 7, states that 'He bequeathed the whole of his real and personal estate to his executors upon trust to collect, sell and convert into money, and the proceeds to be equally divided between his eight children'.

[39] *Weekly Times*, 21 March 1903, pp. 11, 14; F. G. A. Barnard, *The Jubilee History of Kew, 1803-1910*, p. 37.

[40] *The Australasian Turf Register*, 1898, for 1889, 1892; see also 'Melbourne's Historic Homes, VI, The Miller Estates. A Sporting Family' in the *Age*, 1 July 1933, p. 5.

[41] La Trobe Library, brought to my notice by Miss Patricia Reynolds.

[42] The Hon. Edward Miller, MLC, became a member of the Melbourne Club in 1877 (listed as at Findon, Kew); he is listed in the Melbourne Directories as follows: 1900 at Romsdal, Heyington Place, Toorak; 1901-03 at Cradley, Studley Park Road, Kew; 1904-08 at Toorak House, St Georges Road, Toorak; in 1909 at Glyn, Boundary Road, Toorak (later called Kooyong Road). ·

[43] 'Linden', at 26 Acland Street, St Kilda, was built for the Michaelis family in 1870. Illus. in Maie Casey and others, *Early Melbourne Architecture 1840-1888*, op.cit., pp. 164-5.

[44] N. Pevsner, *Pioneers of the Modern Movement*, London, 1936, p. 65, fig. 8.

[45] See David Howard Alsop, *Walter Richmond Butler*, thesis, Melbourne School of Architecture, 1971; the same, *Rodney Howard Alsop*, research essay, School of Architecture, Melbourne University, 1970.

[46] I understand that Esmé at one time joined an expedition led by Professor Flinders Petrie, the English Egyptologist (whose mother was the daughter of Captain Matthew Flinders, the Australian explorer). Between 1883 and 1909 Petrie was engaged in extensive excavation in Egypt. Information received from Miss Diana Browne and Mr Edward J. Miller.

[47] As above.

[48] Letter to the author.

[49] Information received from Sir Daryl Lindsay.

[50] The E. S. Miller library of documents, photographs and negatives referred to on this page is in the library of the Royal Historical Society of Victoria.

[51] Documents as above.

URSULA PRUNSTER: Norman Lindsay and the Australian Renaissance

[1] 'Foreword', *Vision*, no. 1, May 1923.

[2] op.cit. See also Jack Lindsay, 'Aids to Vision', *Southerly*, XIV.3, 1953, p. 204: 'The overwhelming impetus for Vision came from my father Norman...'

[3] Norman Lindsay to Lionel Lindsay, n.d., c 1901. Lindsay Papers, La Trobe Manuscript Collection, State Library of Victoria.

[4] Judith Wright, *Preoccupations in Australian Poetry*, Melbourne, 1965, p. 136.

[5] R. D. Fitzgerald, 'The Lives of Jack Lindsay', *Meanjin*, 3, 1961, p. 324.

[6] Jack Lindsay, *Life Rarely Tells*, London, 1958, p. 205.

[7] John Docker, *Australian Cultural Elites*, Sydney, 1974, p. 30. [8] op.cit.

[9] See Norman Lindsay, 'The Hidden Symbol', *Creative Effort*, Sydney, 1920, where he makes the distinction between creative and objective vision in art.

[10] See John Docker, op.cit., p. 26, and note that Lindsay modifies Nietzsche's idea of eternal recurrence by proposing a 'futurity' — beyond earth life (*Creative Effort*, p. 33-5).

[11] Jack Lindsay, *Life Rarely Tells*, p. 205.

[12] Jack Lindsay, 'Australian Poetry and Nationalism', *Vision*, no. 1, p. 33.

[13] John Tregenza, *Australian Little Magazines*, Adelaide, 1964, p. 12. [14] op.cit.

[15] Jack Lindsay, *Life Rarely Tells*, p. 205.

[16] op.cit. [17] ibid.

[18] Norman Lindsay, 'The Sex Synonym in Art', *Vision*, no. 1, p. 22ff.

[19] Norman Lindsay 'The Inevitable Future', *Art in Australia*, February 1922, p. 38.

[20] See 'The Inevitable Future', p. 22-41, where Norman argues that the 'persistence of the savage' on earth is revealed by commercial greed, war and primitivism in the arts — all of which represent an attack on civilization by malevolent and disintegrative forces.

[21] Foreword, *Vision*, no. 2, August 1923.

[22] Jack Lindsay, *The Roaring Twenties*, London, 1960, p. 43.

[23] Hugh McCrae, Foreword to *Idyllia*, N.L. Press, Sydney.

[24] Judith Wright, *Preoccupations in Australian Poetry*, p. 111.

[25] Norman Lindsay to Professor Baldwin Spencer, (Springwood, 13 September 1917). (W. B. Spencer Papers, Mitchell Library Manuscript Collection; MSS 875.)

[26] Hugh McCrae to Norman Lindsay (n.d.), published in R. D. FitzGerald (ed.), *The Letters of Hugh McCrae*, Sydney, 1970, p. 68.

[27] Hugh McCrae to Norman Lindsay, *The Letters*, p. 28.

[28] See letter from Norman Lindsay to Hugh McCrae, (n.d.), Springwood, in the H. F. Chaplin Manuscript Collection, Fisher Library (RB1158.18). 'Your new poems from A. & R. turned up. I read them . . . with blood as well as spirit. I gave myself into their beauty . . . A big composition arrived in my mind, without an effort, and I sat down to it with a gusto that I thought had gone with youth, I called it "The Garden of Happiness" and it begins for me a new life with the pen . . .'

[29] Hugh McCrae to N.L., *The Letters*, p. 40.

[30] Quoted from Hugh McCrae, *Satyrs and Sunlight*, Fanfrolico, London, 1928, p. 126.

[31] 'Joan of Arc' initial letter printed from a woodblock reproduced in *Art in Australia*, December 1921, p. 51.

[32] Richard Fotheringham, 'Expatriate Publishing, Jack Lindsay and the Fanfrolico Press', *Meanjin Quarterly*, 1, 1972, p. 55.

[33] *Fanfrolicana*, June 1928: being a statement of the aims of the Fanfrolico Press, both typographical and aesthetic, with a complete bibliography and specimen passages and illustrations from books (London, Fanfrolico Press, 1928).

[34] Phillip Lindsay, *I'd Live the Same Life Over*, London, n.d., p. 109.

[35] The *Age* (Melbourne) quoted in *Vision* no. 2, 'These Liberties'.

[36] See Norman Lindsay to Baldwin Spencer, Springwood, 10 April 1922 (NL.MSS 875): 'I have been working for years past on a theory in constructive rhythm in picture making which is the whole secret of centralizations of vision . . .'

[37] Jack Lindsay, *The Roaring Twenties*, p. 84.

[38] Kenneth Slessor, 'Australian Poetry and Norman Lindsay', *Southerly*, September 1955, p. 62 and p. 65.

See also K. Slessor, 'Poetry in Australia', *Southerly*, 1966, p. 191. 'I did agree on one point of dogma . . . our insistence on the concrete image in art'.

[39] Jack Lindsay, *Life Rarely Tells*, p. 176.

[40] Norman Lindsay to Lionel Lindsay, Springwood, n.d., c 1920. Lindsay Papers, La Trobe Manuscript Collection.

[41] Kenneth Slessor, *Poems*, 2nd ed. Sydney, 1957, p. 32.

[42] Norman Lindsay, *Creative Effort*, 1920, Sydney, p. 222.

HUMPHREY McQUEEN: Jimmy's Brief Lives

[1] William Moore to Hans Heysen, 11 August 1933, NLA MS 5073.

[2] Interview with Bernard Smith, Sydney, 23 June 1976; the deleted passages were attacks on Lionel Lindsay's *Addled Art* (1942), which itself had two chapters cut out as libellous; see L. Lindsay to Hans Heysen, 22 July 1943, NLA MS 5073.

[3] R. Hughes, *The Art of Australia*, Penguin, Harmondsworth, 1970, p. 19.

[4] R. H. Croll, *Tom Roberts*, Robertson & Mullens, Melbourne, 1935, p. 20.

[5] Alan McCulloch, *Encyclopaedia of Australian Art*, Hutchinson, Melbourne, 1968, p. 349.

[6] Isabel Tweddle was president of the Melbourne Society of Women Painters and her husband was from a substantial firm of Flinders Lane wool merchants; her father-in-law was a trustee of the National Gallery of Victoria for twenty-two years until his death in 1943.

[7] NLA MS 430; hereafter quotes from these notebooks will not be footnoted.

[8] Interview with his daughter, Maud Bourne, Melbourne, 13 July 1978.

[9] J. S. MacDonald, *Australian Painting Desiderata*, Lothian, Melbourne, 1958, p. ix.

[10] F. Eggleston, 'Confidential Notes . . .', Menzies Library, ANU, Part 6, p. 37.

[11] S. Ure Smith to Lionel Lindsay, 27 December 1928, ML MS 1969/2/266-7.

[12] ibid., 3 August 1929, ML MS 1969/2/277.

[13] Stanley Lewis was a leading Melbourne barrister and a member, with MacDonald and Menzies, of the Melbourne Savage Club.

[14] R. G. Menzies to J. S. MacDonald, 8 October 1936, NLA MS 430.

[15] *Herald* (Melb.), 3 October 1936, p. 8c; and 'Editorial', 5 October 1936, p. 6.

[16] Extracted from Leonard B. Cox, *The National Gallery of Victoria, 1861-1968*, National Gallery of Victoria, Melbourne, 1970.

[17] Report dated 30 October 1939, NLA MS 430. Eggleston suggests that this report was intentionally designed to frighten the octogenarians on the Felton Committee, 'Confidential Notes', Menzies Library, ANU, Part 6, p. 38.

[18] According to MacDonald, Daryl Lindsay told him this story regarding a painting he did for Sol. Green's son:

> Young Green did some hanky panky so his father would allow him no money. He wanted me to paint his favourite horse. He asked if I would take a railway truck (or two) of chaff, oats, etc. in payment, as he could get away with that and his father none the wiser. I agreed. The fodder was sent to Frankston, where, for what I would have charged Green for the portrait of his horse, I sold a portion of it to the local produce merchant. What remained was enough for my two horses for a year. I told all this to Russell Grimwade. He said: 'It's a very good transaction — and — it saves you so much income tax'.
>
> That shows you how the Grimwade mind works.

[19] Keith Murdoch to Lionel Lindsay, 13 February 1940, La Trobe Library MS 8530.

[20] E. R. Pitt to under-secretary of Chief Secretary's Office, 20 October 1941, NLA MS 2823/29; see also Cox, *National Gallery of Victoria*, op. cit., pp. 168-70.

[21] J. Hetherington, *Australians, Nine Profiles*, Cheshire, Melbourne, 1960, pp. 81-103; C. Edwards, *The Editor Regrets*, Hill of Content, Melbourne, 1972, pp. 27-8.

[22] J. Gleeson, *William Dobell*, Thames and Hudson, London, 1969, pp. 116-23.

BRUCE ADAMS: Metaphors of Scientific Idealism

[1] Herbert Badham, *A Study of Australian Art*, Sydney, 1949, p. 146.

[2] Ralph Balson, letter to Michel Seuphor, April 1955.

[3] An English translation of Mondrian's 'Plastic Art and Pure Plastic Art' was available to Balson in the anthology *Circle*, edited by Ben Nicholson and Naum Gabo, London, 1937.

[4] *Circle*, p. 41.

[5] ibid., p. 46.

[6] ibid., p. 41.

[7] Grace Crowley, letter to the author, 20 June 1978.

[8] André Lhote, 'Cubism', *Undergrowth*, Sydney, March-April 1928.

[9] Grace Crowley and Anne Dangar, 'Jottings from a Sketch Book Abroad', *Undergrowth*, November-December 1927.

[10] Dangar, 'Today', *Undergrowth*, January-February 1928. [11] ibid.

[12] Dangar, 'Second Talk', undated notes to Crowley.

[13] Crowley, letter to the author, 20 June 1978.

[14] Jay Hambidge, *Dynamic Symmetry in Composition*, New York, 1923, p. 47.

[15] Crowley, undated letter to Ellen Waugh, Sydney.

[16] Eleonore Lange, catalogue essay, *Exhibition I*, David Jones' Galleries, Sydney, August 1939.

[17] *Daily Telegraph*, Sydney, 17 August 1939.

[18] Balson, letter to Seuphor, April 1955.

[19] Balson, catalogue note, *Pacific Loan Exhibition*, S.S. *Orcades*, October 1956.

[20] Laszlo Moholy-Nagy, *Vision in Motion*, Chicago, 1947, p. 341. [21] ibid., p. 344.

[22] Balson, letter to Daniel Thomas, Art Gallery of New South Wales, 28 March 1960.

[23] ibid.

[24] For example, Robert Hughes, *The Art of Australia*, Melbourne, 1970, p. 254.

[25] Balson, statement published in John Reed, *New Painting 1952-1962*, Melbourne, 1963, p. 30.

[26] ibid.

[27] James Gleeson, 'Art, Action and Accident', *Sun-Herald*, Sydney, 7 July 1963.

[28] Balson, letter to the Art Gallery of New South Wales, 1962.

LUCY GRACE ELLEM: Utzon's Sydney Opera House

[1] It took over fifteen years to build and the cost soared from an original estimate of $7.2 million to a final cost of about $100 million.

[2] Arup, Ove, 'Address to the Prestressed Concrete Development Group', London, 14 January 1965, text published in M. Baume, *The Sydney Opera House Affair*, Sydney/Melbourne, 1967, (pp. 118-30), p. 130.

[3] Arup, ibid., p. 118.

[4] Arup, ibid., pp. 118-19. For an account of the factors leading to the decision to build a music centre for Sydney see R. Emerson Curtis, *A Vision Takes Form*, Sydney/Wellington/Auckland, 1967, 'Historical Foreword' by R. Covell, p. 13ff.

[5] *Opera House Competition: Memorandum to Competitors* (known as the Assessors' Report) p. 2. The assessors were Professor H. Ingham Ashworth, Dean of the Architecture Faculty of Sydney University; Cobden Parkes, then New South Wales Government Architect; Sir Leslie Martin, then Chief Architect to the London County Council; and the architect Eero Saarinen.

[6] Professor Ashworth in the *Sydney Morning Herald* justified this choice on the grounds that the integration of the building with its site and the magnificence of its concept were part of its function. He wrote: 'All of the assessors were of the opinion that it was particularly important to realize that any building placed upon the site would be seen from all around the harbour and in many cases from a high level. Thus the building must look well from almost any point of view . . .'

'For this reason the assessors considered that the placing of a large massive boxlike building, however practical, upon this particular site would be wrong. It was felt that the building must have a unity, a sense of movement and should preferably build up towards the point thrusting out with the harbour. Thus the assessors considered that the first essential requirement should be a magnificent concept. The fact that any building must function was, of course, accepted as a *sine qua non*. Einstein once said perfection of means and confusion of aims seems to be characteristic of our age. Our aim in this instance was to find a fine piece of imaginative architecture — the means comprise a secondary issue'. (Quoted in J. Yeomans, *The Other Taj Mahal: What Happened to the Sydney Opera House*, London/Harlow, Longmans, 1968, pp. 35-6.) Ashworth's attitude extended that contained on p. 1 of the Assessors' Report: 'We are convinced that the silhouette of any proposed building is of the greatest importance. We feel strongly that a large and massive building, however practical, would be entirely unsuitable on this site'.

[7] Utzon's scheme was liable to disqualification under four of the six disqualifying clauses of the competition: it exceeded the limits of the site; it could not provide the seating accommodation required; it was not drawn and submitted in the manner prescribed in the conditions (it was only a series of sketches of an idea, blown up photographically); and its cost was excessive (although this was not known at that time). See Baume, op.cit., p. 17.

The problem of side stages was ingeniously resolved by the provision of an elaborate system of stage platforms or lifts by which prepared stage settings could be brought up from storage areas below.

[8] See Competition Drawings submitted by Jørn Utzon to the Opera House Committee, 1956, formerly held by the Public Works Department of New South Wales and now held by the Archives Office of New South Wales (A.O.N.S.W.). This collection of photographs of architectural drawings (which in this essay is referred to as the Competition Submission) contained only two references to the structure of the shell vaults: the label 'White ceramic tiles on concrete shell' on the drawing of the Section and Interior Elevation, and a reference to 'Light, suspended concrete shells' in the Report included with the Site Plan in the submission. (This brief Report will be referred to as the Competition Report.)

The author wishes to express her gratitude to both the Minister for Public Works and the Archives Office for access to this and other material in their possession and for permission to publish from their holdings.

[9] Jørn Utzon, 'Platforms and Plateaus: Ideas of a Danish Architect' in *Zodiac*, 10, 1962, p. 117.

[10] Utzon, Competition Report.

[11] Utzon, 'Platforms and Plateaus', op.cit., p. 114.

[12] Utzon, ibid., p. 116.

[13] S. Giedion in *Space, Time and Architecture: The growth of a new tradition* (5th edn), Cambridge, Mass., Harvard University Press, 1967, saw Utzon as one of the third generation architects whose work

demonstrated a 'stronger relation to the past; not expressed in forms but in the sense of an inner relationship and desire for continuity'. 'The attitude of the third generation to the past is not to saw out details from their original context. It is more an inner affinity, a spiritual recognition . . .', pp. 668, 670.

It is tempting to see in Utzon's use of a religious building as the basis of the Opera House design that transfer of values from the spiritual to the aesthetic sphere noted by Tom Wolfe in *The Kandy-Kolored Tangerine-Flake Streamline Baby*, N.Y. (1965), 1970, pp. 219-20, 226-7. (Wolfe suggests that art institutions have replaced organized religion as spiritual and social centres in modern society.) Indeed Utzon's association of the Opera House with sacred rather than secular places and buildings and his attempt in the use of the temple platform to recreate the emotional mood experienced at Yucatan, does suggest some compatibility of form and function between the Opera House and sacred architecture. He did in fact compare the Opera House to a Gothic cathedral (Utzon, 'The Sydney Opera House', in *Zodiac*, 14, 1965, p. 49) in the context of its sculptural qualities and the interplay of its forms with light, and its site had raised associations with ancient temple sites in his mind. (P. Westcott, *The Sydney Opera House*, Sydney, Ure Smith, 1965, Introduction.) But to suggest that Utzon's building is itself a temple, absorbing the role formerly played in civilization by the worship of the gods, would be to take the analogy too far. The secular adaptation of a sacred form does not necessarily imply the converse, the sanctification of that secular form.

[14] See Utzon's article, 'Platforms and Plateaus', op.cit., pp. 115-17. Utzon wrote of platforms as the 'backbone of architectural compositions' and described how on the platform of the mosque in Old Delhi one could survey the 'life and disorder of the town. On this square or platform, you have a strong feeling of remoteness and complete calmness' (pp. 115-16). He went on to discuss the use of platforms in some of his recent projects. The platform freed buildings from the traffic flow which he considered had disrupted the former relationship of buildings with each other across the street or square, and allowed them to stand 'in an undisturbed composition' (p. 117).

[15] Utzon, 'The Sydney Opera House', op.cit., p. 49.

[16] See J. Burnham, *Beyond Modern Sculpture*, New York, n.d. (1968).

[17] Henri Laurens, quoted in Trier, E., *Form and Space: The Sculpture of the Twentieth Century*, trans. C. Ligota, London, 1961, p. 278.

[18] Giedion, op.cit., p. 672.

[19] Utzon, Competition Report.

[20] Reproduced in Utzon's article, 'Platforms and Plateaus', op.cit., p. 117 and also in Giedion, op.cit., p. 675.

[21] On grounds of the symbolic functionalism of the Opera House and of its symbolic separation of the interior world of the theatre from the external world of reality, Utzon could justify the structural disassociation of the shell roofs from the acoustic interiors

within them. This disassociation had created controversy in architectural circles and led to the condemnation of the building by Frank Lloyd Wright and Lewis Mumford, and architect-engineers such as Candela, Nervi, Torroja and Alan Harris, because of its lack of structural functionalism. (See Yeomans, op.cit., pp. 48-49, and Baume, op.cit., p. 18.) Nervi, for example, described the Sydney Opera House as 'an eloquent example of the most straightforward anti-functionalism from the point of view of statics as well as construction'. (Quoted in N. Pevsner, 'Modern Architecture and the Historian or the Return of Historicism', lecture given at the Royal Institute of British Architects (RIBA) on 10 January 1961 and published in *RIBA Journal*, vol. 68, April 1961, p. 232.) Such criticisms were countered by Giedion, op.cit., pp. 676-7.

[22] N. Pevsner, op.cit., p. 232. In Mendelsohn's drawing of a summer house of 1920 (illustrated in U. Conrads and H. G. Sperlich, *Fantastic Architecture*, trans. C. C. Collins and G. R. Collins, London, 1963, p. 34), the dynamic tension set up by an upward thrusting major mass and a smaller forward thrusting one is echoed in the relationships of Utzon's early sketch for the Opera House (1), while the series of rapid lines drawn in beside the building in Mendelsohn's study for an observatory of 1919 (ibid., p. 34) are strangely prophetic of the series of shell shapes of Utzon's design. The similarity of a sketch for Utzon's design for the High School near Hellebaek (reproduced in *Zodiac*, 5, 1959, p. 73) and the latter design by Mendelsohn suggest Utzon's familiarity with the expressionist tradition.

[23] These early sketches (1 and 2) were reproduced by Utzon in a report entitled 'Sydney National Opera House' presented to the Premier and the Opera House Committee in March 1958, now held in the Archives Office of New South Wales. This report which is basically a collection of plans and elevations is known as the Red Book and is referred to as such in this essay.

[24] See the definition of picturesque grouping in Reyner Banham, *Theory and Design in the First Machine Age*, 2nd ed., New York/Washington, 1967, p. 32. The Opera House complex is picturesque in that it forms a succession of changing pictures as the visitor approaches by controlled route. It therefore fully utilizes the site. Utzon was aware that his design presented an ever-changing succession of views. (See his 'The Sydney Opera House', op.cit., p. 49.)

[25] The axis which divides each of the halls symmetrically bears no predetermined geometrical relationship to the longitudinal axis of the podium. Utzon's decision to set the minor hall further back is also purely arbitrary.

[26] Utzon, 'The Sydney Opera House', op.cit., p. 49. Utzon was here referring specifically to a Gothic church, but it is clear from the context that he intended his remarks to apply equally to the Sydney Opera House: 'If you think of a Gothic church, you are closer to what I have been aiming at' (ibid.).

[27] Utzon, quoted in Curtis, op.cit., p. 52.

[28] Utzon, 'Platforms and Plateaus', op.cit., p. 131.

[29] Ove Arup and Partners, 'Report to the Minister for Public Works, Government of New South Wales, on the roof structure for the Sydney Opera House', May 1965, p. 2 (A.O.N.S.W.). This report prepared by G. J. Zunz of Ove Arup and Partners is referred to in this essay as the Roof Report.

[30] The sculptural tendency of mid-century architecture was dramatically demonstrated in the chapel at Ronchamp by Le Corbusier, whom Utzon met in Paris in 1948. Utzon had visited Frank Lloyd Wright at Taliesin West and Taliesin East in 1949, and may have learned from him the importance of the integration of the building with its site. Alvar Aalto, with whom Utzon studied in 1945, and Le Corbusier both share Utzon's affinity for primitive forms. (See Giedion, op.cit., pp. 672-3 for a brief biography of Utzon.)

[31] See Conrads and Sperlich, op.cit., pp. 18-19.

[32] Eero Saarinen was engaged in designing the TWA terminal building in New York at the time he helped judge the Sydney Opera House competition. Like Utzon's design for the Sydney Opera House, the TWA building is a 'free' form which was not dictated by a specific geometrical principle. It was however a form determined by its structure, and grew 'out of the very nature of shell construction'. (See Siegel, C., *Structure and Form in Modern Architecture*, trans. T. E. Burton, New York (1962), 1975, p. 272.) Utzon's design, by contrast, was a free form unrelated to structure, although Utzon apparently intended that it express an 'ideal marriage between Architecture and Structure'. (See Arup, 'Address', op.cit., p. 127.)

[33] See Arup, 'Address', op.cit., p. 120, and cf. Yeomans, op.cit., p. 40 and Baume, op.cit., p. 18.

[34] Arup and Partners, Roof Report, p. 2.

[35] *Assessors' Report*, p. 3. Although the shells of the Opera House roofs were free shapes, they bore a strong visual affinity to parabolic surfaces, and indeed were translated into them without radical alteration in their design in the first geometric definition of the shells for construction purposes.

[36] Thin concrete skin construction is essentially suited to dome or pudding bowl shapes. Utzon's vaults did not follow the line of thrust — they should not have been pointed at the top. See Arup, 'Address', op.cit., p. 127. The difficulty of the project was immediately apparent to the engineers. Even at the time that they were assuring the Government that the Opera House could be built, they did not in fact know how it could be done (Arup, 'Address', op.cit., pp. 127-8). As Baume wrote, 'Utzon's ignorance about how to build his winning design was shared by all the experts involved in the project, including the international panel that awarded him first prize and the structural engineer who promised to build it' (Baume, op.cit., p. 13).

[37] See Arup, 'Address', op.cit., p. 121. Arup stressed the close collaboration between the two professions of architecture and engineering needed to build Utzon's design: 'the Structure here *is* the Architecture, or *vice versa*'.

[38] ibid., p. 127. In Utzon's 'ideal marriage between Architecture and Structure', structure was very much

[39] Arup and Partners, Roof Report, p. 3.

[40] Arup, 'Address', op.cit., p. 127.

[41] Without such definition, testing for strength and stability and the prediction of spatial points on the surfaces for construction purposes would be impossible. (See Arup and Partners, Roof Report, pp. 4-5.) Geometric definition also allowed the use of electronic computers essential to handle the enormous quantity of complex calculations — without computers the Opera House could not have been built.

[42] See Arup, 'Address', op.cit., p. 127. Brief histories of the structural evolution of the building are contained in Arup's 'Address' and Arup and Partners, Roof Report, and in Utzon's Descriptive Narrative with Status Quo (a report submitted to the Government by Utzon in January 1965, copy held by A.O.N.S.W.).

[43] Arup and Partners, Roof Report, p. 5.

[44] ibid. Some of these solutions were illustrated in the report, 'Sydney Opera House', submitted by Utzon to the Government in January 1962 and known as the Yellow Book (A.O.N.S.W.). They were also reproduced in Arup's Roof Report of 1965.

[45] Arup and Partners, Roof Report, p. 4.

[46] See Arup, 'Address', op.cit., p. 18 and Roof Report, pp. 5-6.

[47] See Utzon's reply to Yeomans' questionnaire in Yeomans, op.cit., p. 91.

[48] Arup and Partners, Roof Report, pp. 6-7.

[49] Utzon, quoted in Yeomans, op.cit., p. 91. Utzon's dissatisfaction with the finish of the podium concourse and his consequent desire to prefabricate the remainder of the building are expressed in his Descriptive Narrative, pp. 4-5.

[50] See Arup, 'Address', op.cit., p. 129. It was a form of prefabrication in which few of the units resembled each other. The roof vaults were still based at this point on elliptical geometry and the individualized shape of the shells meant that a complicated system of adjustable forms would have to be used. For details of the structural changes see Arup and Partners, Roof Report, esp. fig. 13, which illustrates a unit of the articulated structure.

[51] Utzon simply gives prefabrication as the direct cause of this spherical redesigning of the roof (Descriptive Narrative, p. 5). However Arup suggests that it was specifically a response to the problems of prefabricating the differential ribs of the elliptical design ('Address', op.cit., p. 129). The solution of spherical geometry simplified enormously the precasting of the rib segments. It made it possible to build the main rib segments using only three moulds, though more were used to speed up the work. (See Yeomans, op.cit., pp. 100-03 for details of the prefabrication casting process.) Most of the forms for the rib segments were used 30-40 times. In all, there were about 2,500 concrete segments in the roof, weighing seven to twelve tons each (Arup, 'Address', op.cit., p. 129). The final weight of the roof was 26,800 tons and its height 178 feet above the podium.

Utzon's plan to use spherical geometry also permitted the prefabrication of the weatherproof casing of the shells. This consisted of tiles which were cemented onto 'lids' and fastened to the surface; the tile slabs partially replacing the top 'slab' of the hollow tubes of the ribs. There were 4,000 tile lids weighing up to three tons each and 1,300,000 tiles. (See Arup, 'Address', op.cit., pp. 129-30.)

Spherical geometry solved the problem of precasting, but it did not solve the problems of assembly. The segments had to be laterally prestressed and then maneouvred into position, before being glued together and given vertical post-tension by means of cables. Arup likened the complexity of the building techniques used in putting up the prefabricated rib segments and tile lids to 'a mechanism with sliding joints and adjustable bolts' (Arup, 'Address', op.cit., p. 130). The Opera House must surely be the most complex assembly of precast concrete ever built and represents the earliest use of prefabrication on its scale. It was the first building of its scale to use adhesive techniques and its shell roofs reached the limits of what is technically possible in overhang stabilization. No wonder a critic in the Architectural Review (vol. 139, March, 1966, p. 167) could remark that Utzon's design had been 'heaved with medieval effort into architecture of almost medieval mystery'.

[52] Utzon, Descriptive Narrative, p. 4.

[53] ibid. See Giedion, op.cit., p. 679, where he cites his correspondence with Utzon. Giedion included a chapter on Utzon in the 1967 edition of this book.

[54] Quoted in Yeomans, op.cit., p. 57.

[55] 'You will see that I have succeeded in getting these great complicated forms under control and under control still with the freedom of the craft, paired with the precision of the machine age'. (Utzon in 'The Sydney Opera House', op.cit., p. 49.)

[56] Utzon, 'The Sydney Opera House', op.cit., p. 49, and Utzon, quoted by Westcott, op.cit.

[57] Giedion, S. 'Debasement of a Masterpiece', letters to the Editor, in Royal Institute of British Architects Journal (RIBA), vol. 74, no. 5, May 1967, p. 176.

[58] The vertical spring of the arch had already been abandoned in an earlier solution of 1961. The evident uniformity of the geometric solution based on the sphere is reinforced by the repetitive patterns formed by the tile lids on the surface of the main shells. These express the shape of each rib, and make very clear that the surfaces of each shell are identical. Utzon was aware that the fine lines of the tile lids would 'assist his (the patron's or tourist's) appreciation of the simple, yet living geometrical forms which might otherwise escape his comprehension' (Utzon, Descriptive Narrative, p. 3).

[59] This distinction between the main shells and side shells is carried through to the tile lids on their surfaces. On the side shells, the pattern, unlike the fanning pattern of the main shell, consists of horizontal, parallel segments which resemble large building blocks.

[60] Utzon, Descriptive Narrative, p. 1.

[61] Arup, Roof Report, p. 2.

[62] There have been allegations that the 1962 design

of the shell roofs shows a vastly different shape. This is not true and comparison with the 1958 sketch designs would satisfy the impartial observer on this point. Comparison with the competition design was avoided. See Opera House Executive Committee *Sydney Opera House* (reply to criticism of the Opera House Project), 14 September 1962, p. 11 (A.O.N.S.W.).

The verdict of historians seems to be that the Sydney Opera House was radically altered in the design changes of the Yellow Book of 1962 (cf. Yeomans, op.cit., p. 92, and Smith, V., *The Sydney Opera House*, Sydney/London/New York/Toronto, 1974, p. 95).

[63] The best account of the political history of the Opera House is that of Baume, op.cit.

[64] See Arup's opinion, recorded in Westcott, op.cit. The author of 'Sydney Opera House: engineer's view', *Architectural Record*, vol. 139, January 1966, p. 179, citing G. J. Zunz of Arup and Partners, notes that basically the shells behave as arches — 'more or less Gothic arches' — and that 'no new approaches to structural analysis have evolved from the project, only perhaps new "twists" on standard flexibility and stiffness theory'. He continues 'the mathematical calculations, though they involved nothing new in terms of mathematical process, presented an enormous problem in terms of their volume. There were single calculations in this process that took three hours of computer time before the machine could provide an answer'. See Arup and Partners, Roof Report, pp. 15-22, for a detailed account of the complexity of the actual construction. See also Yeomans, op.cit., pp. 100-16, and cf. footnote 51 above.

PATRICK McCAUGHEY: The Artist in Extremis

[1] 'French sees heroism as a cyclic, vegetative phenomenon of which Christ, Campion and the creative artist are but human exemplars . . . the problem of the hero is not only figured forth at the discursive level of symbols. It is a parable which illuminates the creative process itself.' Bernard Smith, *Australian Painting*, rev. edition 1971, pp. 378-9.

[2] The first half of this lecture was reprinted in *Meanjin*, vol. 36, no. 1, May 1977.

[3] *Arthur Boyd Recent Paintings*, May-June 1973, Fischer Fine Art Ltd. Catalogue introduction by Robert Melville. A rather general note which did identify the central figure of the artist in the series, quoting Giorgio de Chirico, '. . . we feel compelled to paint by an impulse even more urgent than the hungry desperation which drives a man to tearing at a piece of bread like a savage beast'.

[4] Twenty-six paintings, including the two outsize canvases, previously unexhibited, were shown at the University Gallery, University of Melbourne, in July 1977. All works were from the Australian National Gallery and the catalogue introduction was written by Jeffrey Makin.

[5] An excellent suggestion made by one of the editors of this book, Terry Smith, that *Figure by the Creek* owes an iconographic debt to the idea of the 'source figure' should perhaps qualify this view. One possible source for the pose of Boyd's is the seated nude in Giorgione's *Tempesta*, where the stream of water is associated with the suckling mother. The character of the Boyd figure is perhaps closer to Courbet. Although there are no close parallels for the pose, Courbet's consistent use of the nude figure bathing herself in the forest anticipates Boyd's *Figure by the Creek* in its broader iconographical aspect. See particularly *Woman Bathing*, 1853 (Montpellier Museum), *The Spring*, 1868 (Louvre) and *The Source* (Metropolitan Museum).

[6] *Dissent*, Spring 1964, vol. 4, no. 3, in which she mentions the use earlier in Boyd's art of 'the most hideous kind of bestial sex' and his depiction of 'the bestiality of human sex'.

NOTES ON CONTRIBUTORS

BRUCE ADAMS is a senior tutor in Art History in the Department of Art and Design, Western Australian Institute of Technology, Perth. He was formerly curatorial assistant, Newcastle Regional Art Gallery.

ANTHONY BRADLEY is a lecturer in Fine Arts at the University of Sydney and is at present working on a book on Justin O'Brien.

IAN BURN is an artist/tutor in the Department of Fine Arts, University of Sydney.

HEATHER CURNOW has recently completed an M.A. on the work of William Strutt. Her book on this artist will appear shortly, and she has begun work on a second book on Nicholas Chevalier.

LUCY GRACE ELLEM is a lecturer in the Department of Art History at La Trobe University.

ANN GALBALLY is a lecturer in the Department of Fine Arts, University of Melbourne. She has published monographs on Arthur Streeton and John Peter Russell and is currently researching the art of Frederick McCubbin.

URSULA HOFF is former senior associate, Department of Fine Arts, University of Melbourne. She was formerly assistant director of the National Gallery of Victoria and is at present the London advisor to the Felton Trust.

RÜDIGER JOPPIEN, an art historian from Cologne, Germany, has been closely associated with Bernard Smith in the study of art and exploration in the South Pacific. He is a curator at the Kunstgewerbemuseum in Cologne.

JOAN KERR wrote an M.A. thesis on 'The Development of the Gothic Taste in Churches in N.S.W. up to the 1840s' and a doctoral dissertation on the design of colonial churches up to the 1880s for York University. She is at present a post-doctoral research fellow in the Research School of Social Sciences (History), Australian National University, Canberra.

NIGEL LENDON is an artist and lectures in art theory at the Sydney College of the Arts.

PATRICK McCAUGHEY has been professor of Visual Arts at Monash University since 1967. He was formerly fellow in Fine Arts, University of Melbourne.

HUMPHREY McQUEEN has published several books including *The Black Swan of Trespass: the Emergence of Modernist Painting in Australia to 1944* (1979). He is writing a history of Australia in the 1970s.

PETER MORONEY is about to complete an M.A. thesis on the work of the Sydney architect Walter Vernon.

URSULA PRUNSTER was formerly a tutor in the Department of Fine Arts, University of Sydney, and is currently a guest lecturer in the Department. She is working on a doctoral dissertation on Norman Lindsay.

PETER QUARTERMAINE teaches Commonwealth Arts at the University of Exeter.

TERRY SMITH is an artist and a lecturer in the Department of Fine Arts, University of Sydney.

RUTH ZUBANS is a senior tutor in the Department of Fine Arts at the University of Melbourne. She recently completed a Ph.D. thesis on E. Phillips Fox and is preparing a book on the artist.

INDEX

BOSTON PUBLIC LIBRARY

3 9999 00437 977 0

WITHDRAWN
No longer the property of the
Boston Public Library.
Sale of this material benefits the Library

Boston Public Library

COPLEY SQUARE

GENERAL LIBRARY

N7400
.A79

82118397-01

The Date Due Card in the pocket in-
dicates the date on or before which this
book should be returned to the Library.

Please do not remove cards from this
pocket.